Wisconsin Death Trip

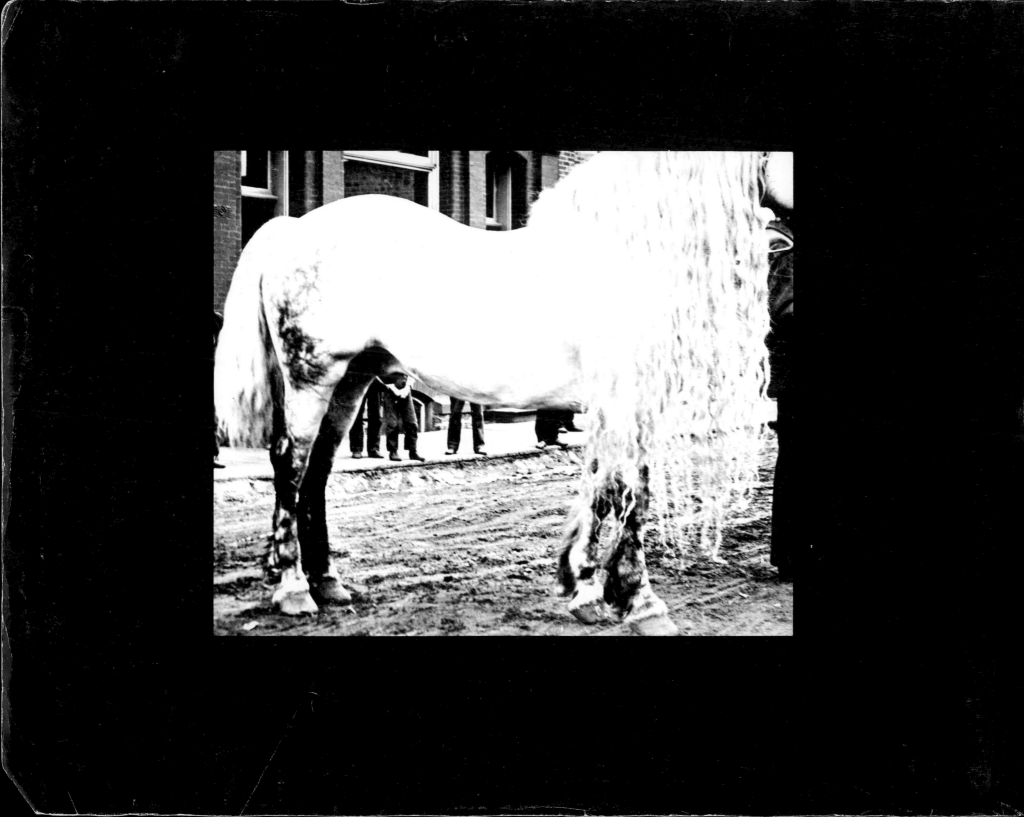

Wisconsin Death Trip

MICHAEL LESY

WITH A PREFACE BY WARREN SUSMAN

UNIVERSITY OF NEW MEXICO PRESS
Albuquerque

Library of Congress Cataloging in Publication Data
Wisconsin death trip / [compiled by] Michael Lesy ;
With a preface by Warren Susman.
p. cm.
Originally published : New York : Pantheon Books, c1973.
Consists chiefly of excerpts from the *Badger State Banner*, Black River
Falls, Wis., for the years 1885–1900 and of photos taken by Charles Van
Schaick from 1890 to 1910.
Includes bibliographical references (p.).
ISBN 0-8263-2193-3 (alk. paper)
1. Black River Falls (Wis.)—History—19th century Pictorial works.
2. Black River Falls (Wis.)—19th century Sources.
3. Black River Falls (Wis.)—Economic conditions—
19th century Pictorial works.
4. Black River Falls (Wis.)—Social conditions—
19th century Pictorial works.
5. Depressions—1893—Wisconsin—Black River Falls Pictorial works.
I. Lesy, Michael, 1945– . II. Van Schaick, Charles. III. Badger State
Banner. F589.B6W57 2000 977.5'51—dc21

Designed by Stevan A. Baron
Sequencing and montages by the author
Manufactured in the United States of America
Composition by American Can Printing Division

To My Mother and Father

with Special Thanks to

Bill Williams
Warren Susman
Paul Vanderbilt
Marsha Peters

Lillian Frary
Sal Sebastian
the Doanes
Morris Edelson
Heidi von Schreiner
Mark Knops

Jon Reilly
Donald Hilgenberg
Caroline Hoffman
Elizabeth Spalter

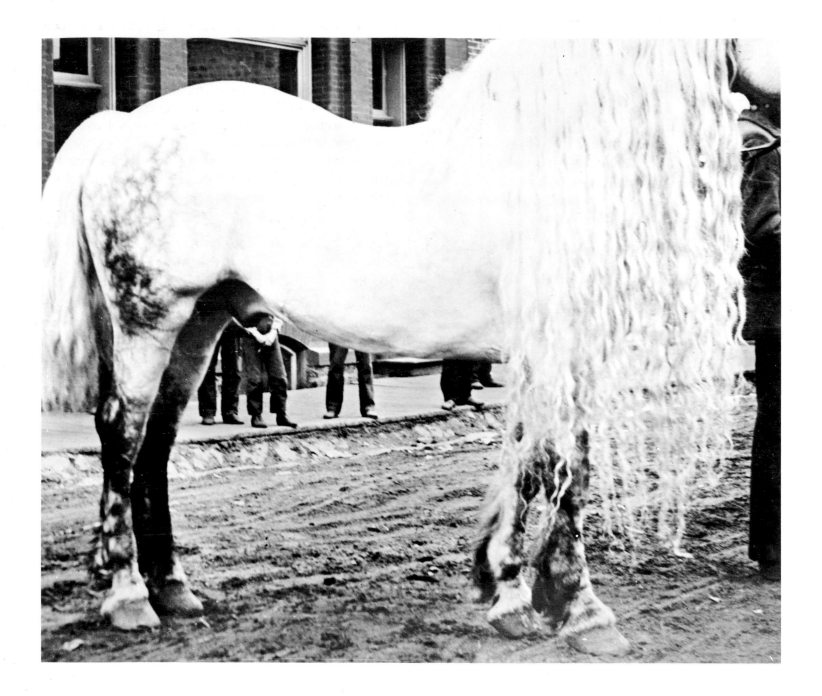

Preface

Writing over a hundred years ago, Hippolyte Taine congratulated those fellow historians who had preceded him for making "the first step in history" leading to a "revival of imagination" through a reconstruction of the past, no matter how incomplete, that enabled them to "*see* approximately the men of other days." In a particularly brilliant passage he now urged the taking of "the second step": using what the eye can see, "the visible man," to discover "the man invisible," or that center that is "the genuine man," that

> mass of faculties and feelings which are the inner man. We have reached a new world, which is infinite, because every action which we see involves an infinite association of reasonings, emotions, sensations new and old, which have served to bring it to light, and which, like great rocks deepseated in the ground, find in it their end and their level. This underworld is a new subject-matter, proper to the historian.[1]

It is in fact that "underworld"—or at least a small part of it —that this book proposes to explore. But in the course of that exploration the author soon discovered (and this he shares with many other creative young thinkers, scholars, and artists of his generation) that the old forms, bequeathed by a great historical tradition developed with enormous skill and energy most especially over the last century, will no longer serve his purposes. The structure of experience that most interests him cannot be captured by the logic of observation, description, or explanation traditionally deployed in the narrative (which tells a story), the monograph (which permits systematic analysis), or even the documentary (which records the "facts").

Many historians have become convinced that there was a major crisis in American life during the 1890s; some have gone so far as to call it a "psychic crisis" and have attempted to explain its existence or, even more commonly, to use the presumed existence of such a crisis as an explanation for a wide series of developments in American domestic and

[1] Hippolyte Taine, *History of English Literature* (New York: John Nurtele Lovell, 1873), p. 19.

international political life. But none of this interests Michael Lesy; his concern is rather with the psychology of a people in a particular time and place. Eschewing the hotter theories or generalizations, he prefers to present what he believes to be the authentic structure of the experience of the people themselves, especially that aspect of the structure that might be regarded as pathological. Again, in common with so many of the ablest of his generation, he wishes us primarily to know "the real thing" firsthand so that we may better understand. His first obligation as an historian, he clearly believes, is to find the patterns and rhythms of lives and to present them in a manner sufficiently artful so that we too sense those patterns and rhythms.

Lesy might have opted for a method more in tune with the modes of behavioral analysis now commonplace in history and the social sciences, more particularly, the gathering of data about types of human behavior readily quantifiable so that a series of statistically valid correlations might have been attempted. In point of fact, he has not failed to investigate, and make use of, some of the kinds of records commonly consulted by such behaviorists. But he realized that there were other kinds of behavior—in language and gesture, in persistent images preserved in newspapers and other written accounts, and perhaps most significantly in those extraordinary visual images captured by a local photographer. Not only are these kinds of behavior crucial for what we can come to know about Taine's "inner man" by interpreting them, but they take on special meaning when we realize that the record of this behavior was not simply an accidental accounting left for the historians of the future but in fact represents—especially in the photographs, newspapers, personal documents —the kind of record these people wished to preserve (itself an important type of behavior) *for themselves.*

For at the very time that the Frontier Myth or the vision of a happier agrarian America was reaching its apogee (witness Turner's classic essay of 1893) there was also a growing awareness of awesome problems of death, decline, delinquency, and even degeneracy as phenomena associated not only with industrial and urban America but with rural and agrarian America as well. It is this consciousness that Lesy demonstrates. Many historians have concerned themselves with American aspirations and hopes; few with its fears and nightmares. Lesy offers us a unique opportunity to face not the American Dream but the American Nightmare, a nightmare reflected not only in the mind but in other kinds of behavior as well. It is this general phenomenon and not a set of abstract ideas that attracts his particular method of inquiry.

That method of inquiry is certainly not traditional in the historical literature. It reminds me, if only by loose analogy to be sure, of Hannah Arendt's description of the method of Walter Benjamin in her brilliant introduction to his series of critical and historical essays, *Illuminations.* In discussing one of Benjamin's more important works, Arendt says, "The main work consisted in tearing fragments out of their context and arranging them afresh in such a way that they illustrated one another and were able to prove their *raison d'être* in a free-floating state, as it were. It definitely was a sort of surrealistic montage." Benjamin's ideal, we are told, was to produce a work consisting entirely of quotations. In a sense, this was Lesy's original objective also, although he proposed to use another kind of quotation than presumably Benjamin had in mind and added to the very idea of quotations the use

of "photographic quotations," selected images "quoted" from a remarkable body of photographic record. Arendt continues her explanation of Benjamin's intentions as follows:

> To the extent that an accompanying text by the author proved unavoidable, it was a matter of fashioning it in such a way as to preserve "the intention of such investigation," namely, "to plumb the depths of language and thought. . . . by drilling rather than excavating" so as not to ruin everything with explanations that seek to provide a causal or systematic connection. In doing so Benjamin was quite aware that this new method of "drilling" resulted in a certain "forcing of insights. . . . whose inelegant pedantry, however, is preferable to today's almost universal habit of falsifying them"; it was equally clear to him that this method was bound to be "the cause of certain obscurities." What mattered to him above all was to avoid anything that might be reminiscent of empathy, as though a given subject of investigation had a message in readiness which easily communicated itself, or could be communicated, to the reader or spectator.[2]

It may seem perverse of me to relate *Wisconsin Death Trip* to Taine's masterpiece of the 1860s or the provocative achievements of Benjamin in the 1920s and 1930s, but I do so deliberately, if only to welcome a new and imaginative young historian whose initial work offers what appear to me fruitful beginnings and yet whose origins, perhaps unknown even to him, relate him intellectually to a long tradition of striving to know and to understand by a willingness to see things anew. In his own very different way, Lesy has his

American predecessors too. My own reading of his book constantly called to mind the classic essay by Dr. Benjamin Rush written at the end of the eighteenth century, "The Influence of Physical Causes Upon the Moral Faculty." In that piece, Rush diagnosed a disease, Micronomia, "the partial or weakened action of the moral faculty"; he called the total absence of that faculty Anomia. The situation Lesy demonstrates, I would suggest, might easily be designated by more modern sociologists as anomic, and even Rush's detailing of the role of certain "physical causes" might readily suggest themselves (climate, hunger, silence, etc.). While reading Lesy's book, it is hardly easy to put aside Rush's warning that "it is of the utmost consequence to keep young people as ignorant as possible of those crimes that are generally thought most disgraceful to human nature. Suicide, I believe, is often propagated by means of newspapers."[3]

Indeed, Rush's psychologizing—primitive as it may be regarded—might still prove itself more "acceptable" than some of Lesy's efforts in that direction. But if that is true, why didn't Rush's hopes prevail, that education, pulpit, government, and men of science could overcome other environmental problems that might lead to Anomia? Lesy's work—suffering as it does from some confusions, laboring as many pioneer works do under serious methodological difficulties—has shaped the structure of those aspects of the Wisconsin experience of the 1890s that he has selected in such a way that we can never look at our past as before but rather are now forced to raise new questions: about the fascination with

[2]Walter Benjamin, *Illuminations*, ed. Hannah Arendt (New York: Harcourt, Brace & World, 1968), pp. 47–48. The quotations in the last extract are from Benjamin's own work.

[3]Benjamin Rush, "The Influence of Physical Causes Upon the Moral Faculty," in *The Writings of Benjamin Rush*, ed. Dagobert D. Runes (New York: Philosophical Library, 1947), p. 206.

death and the morbid, with suicide and murder, about consciousness of decline and degeneracy, about attitudes toward sex and the family. What does the horror of fire—what appears to be an obsessive horror—mean? Is it a natural response to natural problems in the environment or does it signify something beyond this? What are we to make of the constant theme of money (especially the lack of it) or religious piety (especially the excess of it) in the most generally held views about the cause of mental breakdown or suicide or murder?

Where Lesy has not succeeded, his relative failure is the consequence of his daring and his very daring ought to add a dimension to historical understanding. Taine had urged: "Let us make our past present; in order to judge of a thing, it must be before us; there is no experience to what is absent."[4] Lesy has achieved this objective and in so doing provided us, in his method, his special sources, and his use of them, a consciousness of a territory still unexplored. The result is a serious historical work that must be taken seriously. For Lesy has done what Taine proposed when he suggested the time had come for historians to take "the second step"; he has taken that step. It now remains as a challenge for the rest of us to see where further we can all go in some of the directions in which he has pointed us.

Warren I. Susman
Department of History
Rutgers — the State University
New Brunswick, New Jersey

[4]Taine, *History of English Literature*, p. 19.

Introduction

The pictures you're about to see are of people who were once actually alive. The excerpts you're about to read recount events these people, or people like them, once experienced. None of the accounts are fictitious. Neither the pictures nor the events were, when they were made or experienced, considered to be unique, extraordinary, or sensational. The pictures were taken by a careful, competent town photographer named Charles Van Schaick; they are artful only

in so far as he obeyed the most prosaic conventions of portraiture. The events were recorded by a father named Frank Cooper, and a son named George, who were equally competent, equally careful, equally experienced town newspaper editors; their articles are imaginative only in so far as they conformed to the inevitable demands of space and time dictated by a weekly paper. The people who looked at the pictures once they were taken weren't surprised, and the people who read about the events after they were printed weren't shocked. They preserved the pictures and the newspapers for the same reason that some people remember their birthdays, and others fail to notice each breath.

All the inhalations and all the exhalations were crystallized in silver emulsion on 30,000 glass plate negatives, and all the birthdays with all their best wishes were transferred to the fibers and inks of good rag paper. The glass plates were left to sit by themselves for thirty years after Van Schaick died. Occasionally, a lower lip or the whole side of a face would crack off and break away like the side of a glacier. Often the edge of a cornice or the crest of a hill would disintegrate into flakes the size of silica sand. The stacks of glass broke because of their own weight; their emulsions decayed because of too much or too little moisture. Twenty years of the common but multivariate life of a county seat, now transformed into images composed of elementary chemical ciphers, sat enclosed by the space of one dry and dusty four-walled and ceilinged room, and fell prey not to irony, not to remorse, and not to forgetfulness, but to vectors of force and the molecular composition of the air.

The newspapers were treated differently. Since they came from a county seat whose press had begun to operate nearly as soon as its plats were surveyed, each issue was re-

duced to the size of a stamp by technicians who had no time to notice anything but the title and date of each brittle paper rectangle they placed underneath the copy lights of their cameras. Two years, 104 issues, 300 accusations, 200 denials, 600 messages, 40 rumors, 3 declarations, and 2,000 factual recitations were wound around a spool, and the spool was sent to a reading room. The library assistants rarely even looked at each spool; rather they verified it by its weight, and then catalogued it by the place of its origin, the date of its publication, and the positive and negative nature of its photographic exposure. They stacked twenty years of the prose style of a father and his son on top of twenty years of ghost stories, epidemics, political careers, suicides, sales, insanities, bankruptcies, burnings, medical testimonials, and early deaths, and then they stacked them all somewhere in a gray metal drawer that slid vertically from its file bank like a radiator on casters. Twenty years of symbiotic exchanges between a system of social economics and the permutations and fruitions of 3,000 randomly assembled genetic patterns were catalogued and filed by library assistants employed on eight-month contracts to preside over the roaring silence of facts and lies that preceding assistants and technicians had been instructed and trusted to accumulate.

The 30,000 glass plates were all that was left of the records of flesh Charley Van Schaick had made between 1890 and 1910. The spools of microfilm were all that remained of the stories the Coopers had passed along over those same twenty years while the whole country teeter-tottered across the greatest time gap of its history. Since Charley used plates from St. Louis that permitted half-second exposures, he could take pictures of anything whenever the sun was out just so long as it didn't move any faster than a slow walk. Because the Coopers subscribed to state and national wire services, they were able to reprint dispatches from Cuba and St. Petersburg, as well as anecdotes from La Crosse and Prairie du Chien. Both Charley and the Coopers got paid for their records; they got paid for showing people what they'd already seen or for telling them what they'd already heard. Neither Van Schaick nor the Coopers were artists: they were businessmen with few pretensions. They were different from their customers only because they'd renounced their own lives so that they might record others. They didn't question events; they confirmed them. Eventually they may have become particularly sensitive to appearances, but they never doubted their meanings. Charley took hundreds and hundreds of pictures of horses because he was asked to; he took dozens and dozens of pictures of houses and their owners because he'd been offered the job. The Coopers vilified the Pullman strikers because everyone was Republican; they noted a departure, an arrival, or a visit because everyone always departed, arrived, or visited; they devoted a weekly column to abstinence because it was a Christian duty to remain temperate. Each of them said yes to what he was supposed to and no to what he was supposed to refuse. They were prosaic chroniclers of a conventionalized universe.

But something happened. Something changed. Somehow, sometime, somewhere in the middle of the time gap this country moved through, everything became different. It wasn't only that the demographic ratios of rural and urban populations changed. It wasn't only that the country became industrialized. It wasn't even that we left the nineteenth century running like a bunch of punks who'd rolled some drunk spic in an alley for a couple of islands and an isthmus and that, by the time we showed up in the twentieth cen-

tury, we'd turned into a crowd of middle-aged, Protestant philanthropists ready to set up European trust funds for semi-solvent but self-determined nations—it wasn't quite that. What was strange was that in the seventy years between then and now, in the time it takes a healthy man to live, learn a few lessons, grow old, and die—in that short time, in one lifetime, all of Charly's pictures and all of the Coopers' newspapers were changed from the most ordinary records of the most ordinary events into arcane remnants, obscure relics, antique mementos. What dark thing had changed the ordinary doings of ordinary citizens into messages received by radio telescope from a nebula judged to have exploded a million years ago? How did it happen? Why did it happen?

Of Van Schaick's 30,000 images, only 3,000 were initially selected by an experienced archivist to be of such visual and thematic interest to warrant preservation. Of these, I judged less than 200 to contain sufficient information to answer those questions about the changes at the end of the century. Of the ten years of the *Badger State Banner*, I examined only state, county, and town news items, and of these, I concentrated only on the stories and accounts that concerned the psychology or personality of events. The final text was composed of five types of people talking at once, sometimes about the same things, like witnesses to an accident, sometimes about different things, like the chroniclers of a court history. The major voice that drones throughout the ten years of loss and disaster—cold, sardonic, and clear, like black marble—belongs to Frank Cooper. His blocks of prose are veined here and there by the acute, sensual style of a novelist like Glenway Wescott, or the refined, cameralike writing of Hamlin Garland. In turn, their art is balanced by the clinical sterility and disavowal of a medical records keeper at the state

madhouse, and his frigidity is redeemed by the voices and words of two mythical creatures, one the easy, well-cooked understandings of a local historian and the other the crisp, bone-close insights of a town gossip. Together these five real and mythical voices sing a polyphony that flows about the ten years like sand and gravel raked around boulders in a courtyard. Their words are not so much written as sounded, not so much casual as descriptive, not so much chronological as inclusive. Together they speak not so much of sequential changes as variations in images of acceptance and denial. The text that is formed from their words is arranged year by year only so that your inner ear may pause and remember all that it has heard, and prepare for the alternations to come.

The text was constructed as music is composed. It was meant to obey its own laws of tone, pitch, rhythm, and repetition. Even though now, caught between the two covers of this book, it accompanies the pictures, it was not meant to serve them the way a quartet was intended to disguise the indecorous pauses in eighteenth-century gossip. Rather, it was meant to fill the space of this book with a constantly repeated theme that might recall your attention whenever it drifted from the faces and hands of the people in the pictures. These photographs were arranged according to their nature as both records made to order and aesthetic objects created by insight. No matter how prosaic a photographer Van Schaick was, he still practiced an art based upon compressions and elisions; he still presided over archetypal images that were originally created at the secret heart of this culture as silently and thoughtlessly as the blink of an eye. For these reasons, I thought his pictures were less like pieces of wood that could be nailed to a prose framework than like colors that had to be poured, and that once poured, once combined, formed

their own container and filled it with shades of meaning and emotion.

Van Schaick's pictures were arranged in five primary sequences. The introductory and concluding series are highly compressed summaries: they have to do with being born and dying young, with living either together or alone, and with ending well or badly. The middle three series have to do with the lives of women and men, and how they changed, separated, and united over time. Throughout these sequences, I have inserted pictures that Van Schaick would never have made. The insertions were intended to emphasize emotions or elaborate meanings contained by his original pictures. Such additions and variations of images are in a certain way similar to the additions made to the Coopers' newspaper accounts. All were made so that text and photographs might suggest certain abstract ideas not only about the town of Black River Falls, county of Jackson, state of Wisconsin, but about the entire region and era in which the town, county, and state were enmeshed. The insertions and additions were rationalized in this way: the only way to go against a photographer's intentions is to destroy his negatives; the only way to falsify a newspaperman's point of view is to forget what he said. Whether or not Charley or the Coopers knew all their own intentions, they're there anyway, locked into their compositions and their sentence structures, and nothing but a hammer or a hot fire is ever going to change them. The only problem is how to change a portrait back into a person and how to change a sentence back into an event. Van Schaick never thought his plates would end up in an archive's negative-file, and the Coopers never imagined their paper would end up on film. The thing to worry about is meanings, not appearances.

There are two final things you should know before you begin to look and read. One has to do with the pictures; the other with the accounts. You should first know that none of the pictures were snapshots, that their deepest purpose was more religious than secular, and that commercial photography, as practiced in the 1890s, was not so much a form of applied technology as it was a semimagical act that symbolically dealt with time and mortality. Knowing this, you should understand that there was a direct link between photography and the presence of such epidemic diseases as diphtheria, smallpox, and cholera. These diseases were awful and perverse not only because they paralyzed and destroyed whole countries, but because they inverted a natural order—that is, they killed the youngest before the oldest; they killed the ones who were to be protected before their rightful protectors; they killed the progeny before the forebears; they killed the children before their parents. When such diseases created circumstances of fate so grotesque, so perverse that they permitted parents to outlive their infants, they permitted them to live on not only in grief but in guilt, since it was they who had failed to preserve their bloodline; it was they who had failed to maintain the immortality of their genes.

You should know a second thing, before you read the accounts: these writings transformed what were private acts into public events. In a time that was disjointed by a depression as epidemically fatal and grotesque as the most contagious disease, these articles created temporary but intimate bonds between creatures who had been separated and divided by a selfish culture of secular Calvinism. These accounts permitted people to share their misery by turning strangers into relatives. They attributed and articulated the motives of the most secret and private of undertakings, the act of suicide,

and so permitted desperate people to be solaced by others' despair. These accounts turned grief inside out; they turned murderous sorrow outward toward the eyes of a crowd that could not only comfort it, but, by participating in it, could be immunized against it. Such weekly articles and notices served purposes similar to those of commercial photography: they were symbolic ways of dealing with an inhuman fate that made some men helpless by making them suddenly and inexplicably poor, and that drove some women mad with grief and remorse by quickly killing their children.

This book is an exercise in historical actuality, but it has only as much to do with history as the heat and spectrum of the light that makes it visible, or the retina and optical nerve of your eye. It is as much an exercise of history as it is an experiment of alchemy. Its primary intention is to make you experience the pages now before you as a flexible mirror that if turned one way can reflect the odor of the air that surrounded me as I wrote this; if turned another, can project your anticipations of next Monday; if turned again, can transmit the sound of breathing in the deep winter air of a room of eighty years ago, and if turned once again, this time backward on itself, can fuse all three images, and so can focus who I once was, what you might yet be, and what may have happened, all upon a single point of your imagination, and transform them like light focused by a lens on paper, from a lower form of energy to a higher.

"I desire to express my thanks through the press to Dr. Cole, W. R. O'Hearn, and the other citizens of Black River Falls for aid rendered and sympathy extended for several months past since the amputation of my leg. Eric Peterson" [1/9/85, Town News]

E. Y. Spaulding, who ran a dry goods store in Black River Falls, "was last week taken with strong symptoms of derangement, a misfortune doubtless superinduced by overwork and anxiety over business matters." [1/30, Town]

"Admitted January 20th, 1896. Town of Garfield. Age 52. Norwegian. Married. Two children, youngest 19 yrs. old. Farmer. Poor. Illness began 10 months ago. Cause said to be his unfortunate pecuniary condition. Deluded on the subject of religion. Is afraid of injury being done to him. Relations say he has tried to hang himself. . . . September 29, 1896: Discharged. . . . improved. . . . Readmitted May 4, 1898: Delusion that he and his family are to be hanged or destroyed."
[Mendota State, 1895 Record Book (H., Male), p. 508, patient # 7036]

"La Crosse was somewhat agitated last week by an alleged ghost, manifesting itself by the usual symptoms." [3/13, State]

1885-6

The private made public Insanity
Ghost Clairvoyant Poetry Suicide
Incendiary fire Incendiary fire
Insanity Suicide – moral disgrace
Insanity – poverty Railway accident
Railway accident Morphine Suicide
Hearse Carbolic Acid Arson Frozen
Death in delirium Ghosts Respectable
Suicide Suicide – morphine Electricity
Epidemics Insanity – religious Suicide
Tramps Suicide – murder – insanity
Obscene matter Delirious insanity
Diphtheria Miraculous medicine
Temperance
Incendiaries False teeth

A local fire story; two case histories from Mendota State Hospital for the Insane; a farm lady in town, from Hamlin Garland; Glenway Wescott's patent medicine story

"Dr. Anfin, the clairvoyant revealer of the past and future, went to Merrillan last week." [3/13, County]

"More poetry is said to come from Wisconsin than from any other state in the Union." [4/10, State]

"The wife of Hans Nelson committed suicide at her home in the town of Washburn, Grant County, the other morning, by cutting her throat. She had been deranged for some time." [4/24, State]

"The Neilsville *Times* tells of an unsuccessful attempt to burn the O'Neil House, Thursday evening of last week. The account says that the would-be incendiary gathered a quantity of inflammable material in the laundry room. . . ." [4/24, County]

O'Hearn, the Bank Treasurer, sold his house to A. P. Jones, the Indian Agent from Mineral Point. A. P. Jones sold it to McNab. McNab just decided he could do with a smaller house, so he burned it down in 1915 and used the insurance for a new one. Everyone knew. [Town Gossip]

"At 2 o'clock the other morning, someone set fire to the McKey Building, in Monterey, Waukesha County." [4/24, State]

"Mrs. Thomas Buell of the town of Albion was declared insane by a board of physicians last Friday . . . Sheriff Peterson took her to the asylum at Madison, Saturday morning." [6/8, Town]

"Admitted July 19th, 1893. Town of Black River Falls. Norwegian. Married. Age 29. Seven children. Youngest 8 months. Housewife. Poor. First symptoms were manifested . . . when patient became afraid of everything and particularly of mediums. She is also deranged in religion and thinks everyone is disposed to persecute her and to injure her husband. . . ." [Mendota State, 1889 Record Book (Female, F), p. 354, patient # 6229]

The 80 year old mother of an imprisoned man threw herself in front of a train and was cut into 3 pieces. She was crazed by the disgrace.　　　　　　　　　[7/5, State]

"A woman was recently found wandering about the streets of Eau Claire with a dead baby in her arms. She was from Chippewa County and had lost her husband and was destitute."　　　　[7/5, State]

"The grocer greeted [her] in a perfunctorily kind manner and offered her a chair, which she took gratefully. She sat for a quarter of an hour almost without moving. . . .

At length she rose and went out on the walk, carrying the baby. . . .

She walked up and down the street, desolately homeless. She did not know what to do with herself. She knew no one except the grocer. She grew bitter as she saw a couple of ladies pass, holding their demitrains in the latest city fashion. Another woman went by pushing a baby carriage in which sat a child just about as big as her own. It was bouncing itself up and down on the long slender springs and laughing and shouting. Its clean round face glowed from its pretty fringed hood. She looked down at the dusty clothes and grimy face of her own little one and walked on savagely. . . .

The grocer was familiar with these bedraggled and weary wives. He was accustomed to see them sit for hours in his big wooden chair and nurse tired and fretful children. Their forlorn, aimless, pathetic wandering up and down the street was a daily occurrence, and had never possessed any special meaning to him."
[Hamlin Garland, "A Day's Pleasure" in *Main-Travelled Roads*, pp. 176–78]

"Charles Gregory of Sheboygan Falls, while jumping on a moving freight . . . was run over . . . the top of his head [was] taken off and his brains strewn on the track."　　　　　　　　　[7/5, State]

"Mrs. Ettie McCoy of Elroy, Juneau County, wife of conductor John McCoy who was killed in a railway accident . . . has received $1,000 and a 1,000 mile ticket from the Omaha Company."　[7/5, State]

W. B. Porter, a Black River Falls druggist and general merchandiser, died in his home at the age of 56 from "an overdose of morphine taken Sunday night to allay [the] nervousness from which he had been suffering."　　　　　　　　[7/26, Town]

The 60 year old wife of a farmer in Jackson, Washington County, killed herself by cutting her throat with a sheep shears.
　　　　　　　　　　　　　　　[8/3, State]

"A new hearse, recently purchased in Chicago by the residents of this city, arrived here last Saturday night."[8/10, Town]

N. H. Young of York went "to Loyal . . . and brought home a bottle of whisky which he put up in the house near a bottle of carbolic acid which had been there for some time. He arose in the night, drank about 4 ounces at one swallow and lived about 4 minutes."　　　　[8/10, County]

"Milo L. Nichols, sent to the insane hospital a year or two ago after committing arson on Mrs. Nichols' farm is now at large . . . and was seen near the old place early last week. . . . He has proven himself a revengeful firebug." [8/31, County]

The naked body of the wife of Fritz Armbruster, a woman who had worked in Best's Butcher Shop, was found frozen by the roadside near Albion, 6 miles from Black River Falls. She and her husband had separated, he living in town, she living alone in the house. Although no one had noticed that she had been suffering from any physical or mental disorder, "2 years ago, the loss of a child is said to have affected her very deeply and may have led to her becoming partially demented. The probability is that she rose in a fit of delirium and wandered away." [12/4, Town]

"It is reported that a house owned by Adolph Wollmer, situated one half mile south of Tess's Corners in the town of Muskego, Waukesha County, is haunted. It is perfectly quiet around the house until the dread hour of night approaches when it is suddenly illuminated. . . . Distinct sounds of footsteps are heard pacing the floors, and doors [swing] . . . to and fro . . . yet no object is perceptible. This scene is of very short duration, lasting one or two minutes only, and is repeated several times during the early morning hours." [2/5/86, State News]

"Our citizens were shocked last Friday to learn that Amos Kotchell of Sparta who formerly resided in this vicinity had committed suicide by shooting himself with a revolver in Mr. Potts' harness shop at Sparta. Mr. Kotchell was one of the most enterprising farmers and exemplary citizens when he resided here and it is singular that he should thus take his own life, but . . . I presume it is best that we not judge harshly." [3/5, County]

"About 11 o'clock Tuesday forenoon, David C. Hodge, a resident of 'Hardscrabble,' took a large dose of morphine which resulted in his death about 12 o'clock that night. . . . The deceased left a note saying that no one but himself was to blame for the act. He leaves a wife and 4 little girls in destitute circumstances. He was a sober and industrious workman, quite well known and generally respected." [4/2, Town]

"An electric machine at the corner of Main and Mason Streets attracted considerable attention last week, many people paying a nickel to see how much of the fluid they could stand." [4/30, Town]

"Dr. H. B. Cole, health officer, reported to the council, as a board of health, that the present year, according to the opinions of celebrated authorities, is to be a year of great danger as regards to epidemics, etc., and recommended that our citizens be required to use unusual care in the disposition of garbage and slops, that all pig stys in the thickly settled portion of the city be declared nuisances, and that none be allowed except they maintain a floor and it be cleaned twice a week during the summer, that privies be thoroughly disinfected, and that slaughter houses be not permitted to run the blood on the ground and let the hogs create as much filth as before." [5/7, Town]

"Mrs. Hiram McDonald of Eau Claire, rendered insane by religious excitement, attacked her children recently and wrecked the furniture and windows in her house." [5/7, State]

"The dead body of an unknown suicide was found hanging a few days ago to a tree near Potsoi, Grant County. That body was supposed to have been that of a railway workman." [5/7, State]

"Tramps are overrunning Grant County, raiding sheep and stealing horses. The farmers [are] organizing a vigilance committee." [5/7, State]

"Mr. Axel, a farmer living about 6 miles east of Kiel, Manitowoc County, cut his wife's throat a few days ago so that she might not recover and then killed himself. There were various rumors as to the cause of the tragedy such as domestic infelicity etc., but a few who had dealings with Axel of late attributed the act to an aberration of mind." [5/14, State]

"Victoria Hanna, a middle aged woman of Kaukauna, Outagamie County, was bound over to Commissioner Bloodgood the other day in the sum of $500 on the charge of sending obscene matter through the mails. The woman had a spite against a neighbor and mailed her a letter of the filthiest description." [5/14, State]

"Tuesday last, A. Snyder, a man about 35 years of age and a bachelor who resides at Morrison's Creek, was found wandering in the streets of this city in an insane condition." [7/30, Town]

"The malignant diphtheria epidemic in Louis Valley, La Crosse County, proved fatal to all the children in Martin Molloy's family, 5 in number. Three died in a day. The house and furniture was burned." [10/1, State]

"Mrs. F. Oats of Shamwam, Illinois, writes: 'When I had used Dr. Pierce's "Favorite Prescription" one week, I could walk all over the dooryard and I could get into a wagon and ride 2 miles to see my neighbors. I had not been able to walk out in the dooryard for 6 months. After using the "Favorite Prescription" 2 weeks, I rode in a wagon 10 miles: my neighbors were surprised to see me up and going about and helping to do my housework, after doctoring with 13 of the best physicians we could get—and the last one told my husband that I would never be able to do my housework any more. I am thankful to my God that I wrote to you for I had suffered from "Female Weakness" until I had almost given up in despair.'" [10/1, Ad]

"[The old man] feared and despised doctors, and read all the patent-medicine advertisements in the newspapers, believing for a moment each flowery promise of an end of pain. He received many pamphlets by mail—testimonies of miraculous healing, illustrated by photographs of ugly men and women who had been sufferers—and wrote for salves, powders, and tonics. His wife sighed and shook her head whenever an agent drove into the yard with a valise full of samples; but the old man invariably described his symptoms, the ambitious salesman invariably expressed his sympathy, gave advice, and received a large order. Every druggist in the neighboring towns also prepared for him personal recipes."
[Glenway Wescott, from his novel *The Grandmothers*, p. 33]

All the men of the White Cross, a newly organized Temperance Society, have promised "by the help of God to treat all women with respect and endeavor to protect them from wrong and degradation; to endeavor to put down all indecent language and coarse jests; to maintain the law of purity as equally binding upon men and women; to endeavor to spread these principles among my companions and help younger brothers; to use every possible means to fulfill the command: Keep Thyself Pure." [10/29, National Temperance News]

"There seems to be an organized body of incendiaries in Clark County judging from the numerous barn fires that have lately occurred in that locality." [11/26, State]

"Monday, a man from near Fairchild, came here to get Dr. Cole to help him out of a bad fix. It seems that while masticating a piece of tough beef steak, his artificial teeth of the lower jaw became misplaced and were swallowed plate and all. . . . They lodged though, in the lower part of the throat and refused to go down or come up. It was a full set. The doctor was unable to extract them, and so poked them down." [12/31, Town]

Local historians tell a lot of stories about how everything got started. Everyone agrees that it all began with Jacob Spaulding. But after that there are a lot of questions about how and why Jacob did whatever he may or may not have done. The way things got told in the nineties, Jacob pulled the first keelboats up the Black River by his teeth. The way things actually happened then may have been a little different.

In 1818 there'd been a Frenchman called Rolette who'd come up river from Prairie du Chien. He got run off the land by the Winnebagos who held claim to all of Jackson County, along with all of the land between the Mississippi and Wisconsin Rivers and all of the land between the Wisconsin and the east fork of the Black River. Twenty years later they sold all of this land to the government for $428,000 and the promise of a million-dollar trust fund in government bonds at 5 percent. Once they got paid, they were supposed to disappear into Iowa. Most of them stayed and the few that left came back to wait for a better deal. The government tried again in 1866 with a promise of better land in Nebraska and forced immigration. Anyway in 1839, on paper, the Winnebagos didn't own anything any more.

The expedition that Spaulding belonged to had originated in St. Louis and made it to La Crosse on one of only two steamboats that made that journey in 1839. Spaulding didn't head the expedition; he was a paper partner, formerly employed as a millwright by Robert and Andrew Wood. He had signed on along with his brother Jeremiah, his brother-in-law Van Nostrand, a

fellow called Yateman, and another pair of brothers called Stickney. These brothers and brothers-in-law and twelve others built a keelboat and got up the Black River in a week. On August 1 they met up with twenty-eight head of cattle that had been driven overland and settled in for the first winter.

In the spring thaw of 1840, Spaulding and Andrew Wood made it down to Warsaw, Illinois, by canoe. Wood went home to Quincy for a year and left Spaulding to buy mill machinery and move it up to Prairie du Chien. Spaulding managed to get the equipment up the Mississippi, but there weren't any boats or crews at Prairie du Chien to move it further up the Black River. So he had to go up to the sawmill site to get a boat to carry a crew down the river to get the machinery back up the river again. When he got up to the set of rapids that was eventually to turn into Black River Falls, he discovered that the boat he had planned to use had been taken by the Winnebagos to carry a big load of elk, bear, and deer down river. Spaulding found it where they left it, near Decorah's Village. By the time he and his crew got down to Prairie du Chien, loaded the machinery, and started back up again, they and their ox teams were caught in the middle of the river in the middle of winter. Those oxen could pull three-quarters of a ton, but it was 30 degrees below zero and the loads kept crashing through the ice. It took them until January to cover the 140 miles to the Falls. By February the supplies were too low to support a full crew. Spaulding stayed until March, living on whatever meat he could bring down. The

others left to wait at Prairie du Chien for the thaw.

Two things happened just before and just after the camp break-up in February. The thing that happened first was the Winnebagos; the thing that happened second was the Wood brothers, and both had to do with property rights.

When the crew got into camp in February it must have been pretty clear from all that machinery and all those ox teams that something had come to stay. The Winnebagos had run Rolette out twenty years before and they had just taken a keelboat and abandoned it downstream. This time they came into camp with a chief called Menominee. As soon as they showed up, Jacob stopped everything. He said he felt that since they were reasonable people and he was a reasonable man, maybe they could all sit down and talk things over. He invited them inside. Once they were all in and everyone was comfortable, he excused himself for a second; he said he'd be right back. The next thing the Winnebagos saw was Jacob standing there with seventeen men holding guns on them. They got up and left. Not that they left forever; they just kept a good watch until the odds were a little more even and the white men had hauled up something unusual enough to be worth taking. Sometime in March, four years later, when there were only twenty-five white men around and the trading post that Doc Snow ran at the mouth of Levi's Creek had plenty of cloth and whisky, the Winnebagos came back for another try. A hundred and fifty of them hauled off a whole barrel of whisky for themselves and a big load of cloth for their women.

About a day later they were just finishing up on that barrel when they were interrupted by twelve white men who'd gotten their guns and come looking. Since there was nothing left in the barrel and the cloth had disappeared from sight, the white men got a little nasty and started to take a few shots. Only this time things were different: the Winnebagos had gotten themselves some guns, so they stood their ground. The two sides traded shots for more than an hour, then they called it a draw. Since, according to a report that Minnie Jones Taylor made to the Tuesday Club in 1927, the Winnebagos weren't really a fighting tribe, and since the white men, like Jacob, weren't really interested in anything else but a good timber profit, things sort of settled down without benefit of atrocities or reprisals. It turned out that Chief Menominee and Jacob became good friends. It even turned out that Jacob liked those Indians and they liked him. They liked him so much that they called him Baldy or "Shop-Shaw" and he liked them enough to have Chief Winnesheik, and Chief Blackhawk, and Big Nose, the medicine man, and his wife Betsy Thunder, the nurse, to dinner after everything settled down. Jacob even went to Washington a couple of times to speak up for them, but when he came back from his last trip and went up to tell them how things had gone, he just gave out and died on the reservation. For years afterward, whenever the Indians came into town, they'd drop in on Jacob's daughter, Mary Jane. They'd come in and stand around looking at a life-size portrait of old Jacob and wait for Mary Jane to offer them something to eat.

Jacob's face-off with the Indians had started with a polite ambush, but had ended with a steady stream of uninvited guests. His run-in with the Woods wasn't quite as mannerly. Jacob had been partners with them, but they had probably begun to suspect his loyalty when Andrew spent that year in Quincy and Jacob spent those two months alone in the snow seeing that the machinery didn't end up the same way the keelboat did. Once the 1841 thaw came they tried to more than gently ease him out of the contract; they probably threw him out of the camp, since he ended up in Prairie du Chien looking for the sheriff and some justice. By the end of 1841 he'd bought them out by assuming $5,000 in debts and promising to deliver 400,000 feet of timber at Quincy. For the next fifteen years, he and Andrew Wood took turns having each other hauled before a judge. Andrew began by complaining that Jacob hadn't fulfilled the terms of the settlement. Jacob got even by having him arrested for perjury. By 1850, everyone had gotten a little raw: one time when Jacob was away, Andrew sneaked into town with an ax so that he could chop a few trees and lay claim to the old property. When Jacob found out what was going on, he caught up with him and punched him a couple of times in the mouth.

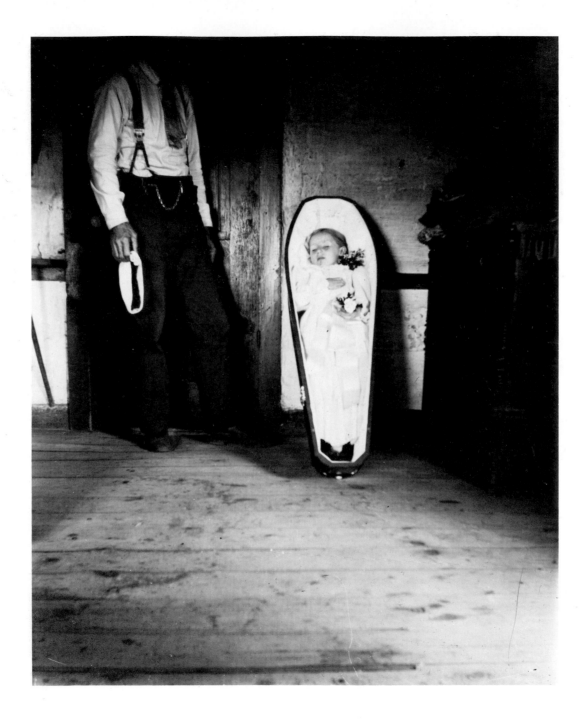

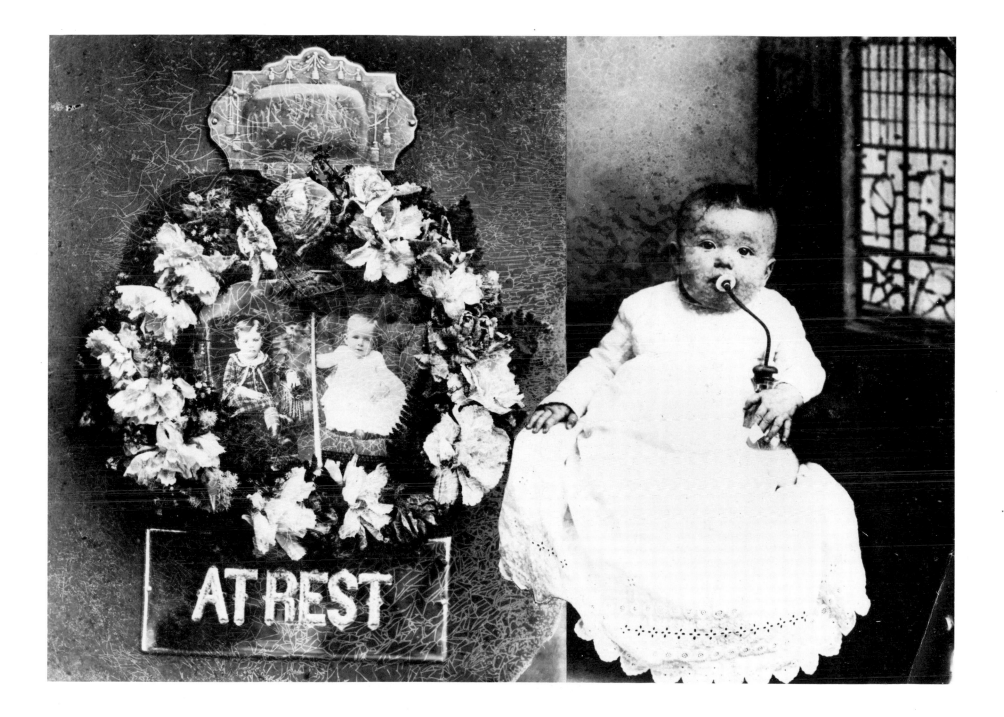

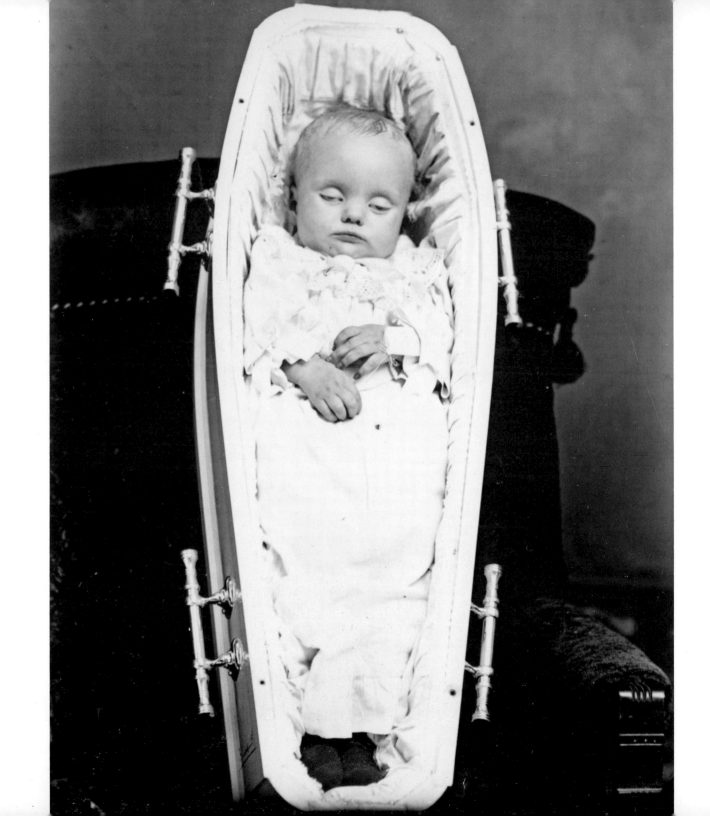

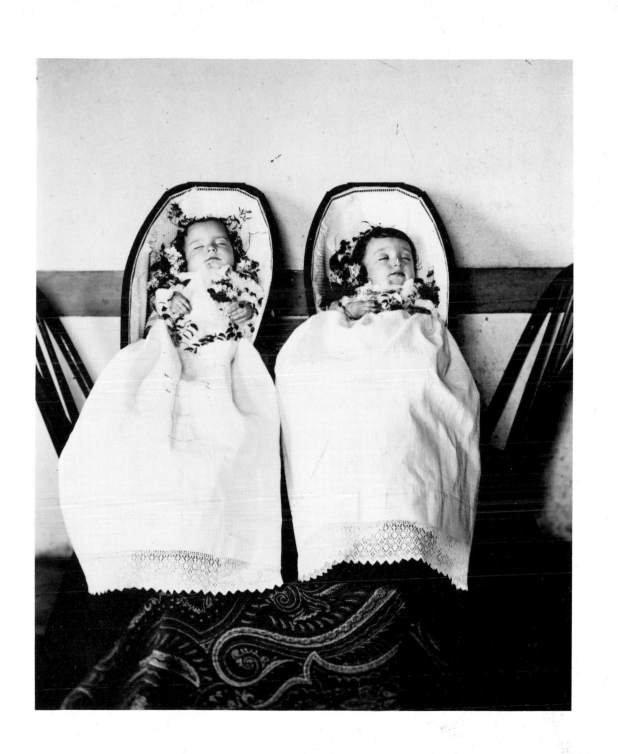

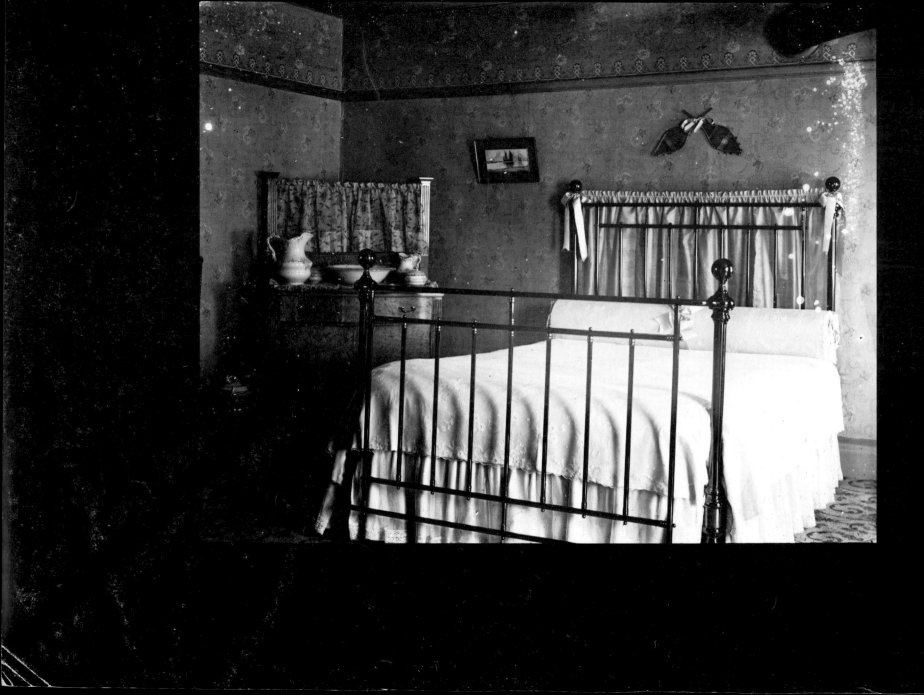

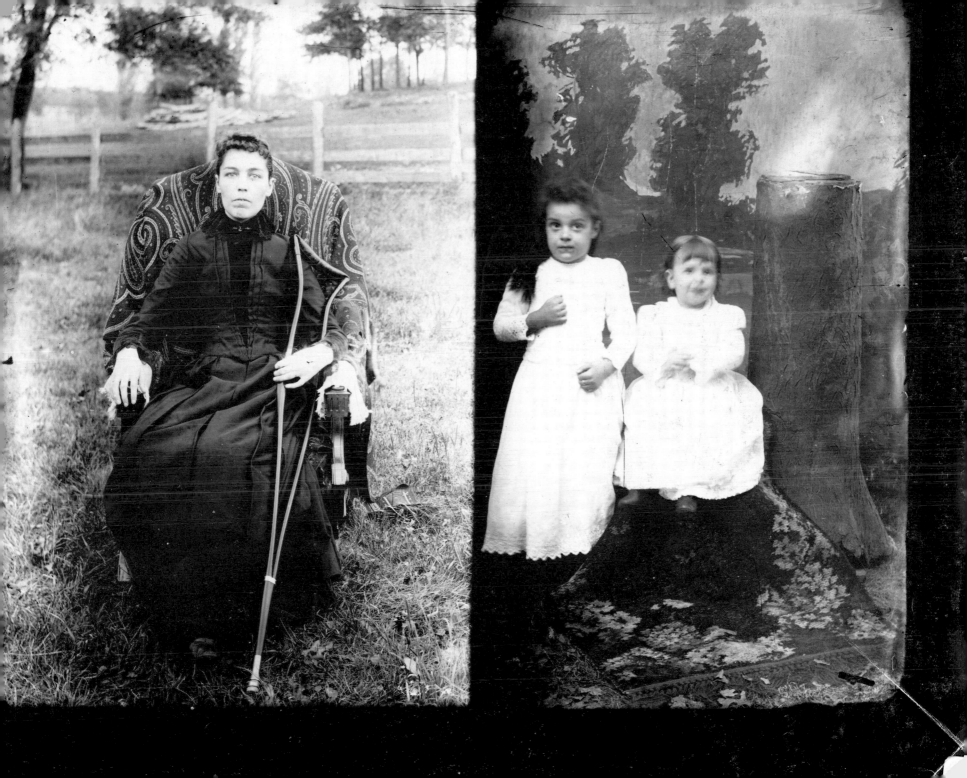

"W. W. Crombie and wife, near Wrightsville, have lost 3 children within the past 3 weeks from diphtheria. The oldest, a young lady 17 years of age, died last Friday. Indeed they are sorely afflicted . . . [but] all their neighbors can do is extend sympathy from a distance. Their house is quarantined." [1/16, Local News]

"John Kuch, a farmer living in the town of Oakland, was found in his barn the other morning hanging by his neck. . . . No cause was known. About 12 years ago, his father hanged himself in the same barn." [1/16, Local]

"The recent disastrous fire at Cashton which destroyed the business center of the village is supposed to have been the work of incendiaries. . . . Andrew Halleck, an old offender of Norwalk, is under arrest." [1/16, State]

"Diphtheria was epidemic in Linxville a few days ago. Cove Prince had lost 2 of his children and a dozen cases were reported in the village." [1/23, State]

"Old Min Foote said: 'Now you stay away from them. Who's going to cook for the hungry mouths if you come down with it? I'm childless; I've nothing to fear. They're not yours, anyway—they're God's now, till the fever is past.'

1890

Diphtheria Suicide—despair Fire—
incendiary
Diphtheria Murder—religious Suicide
Poisoning—envy Starvation Arson
Grotesque insanity Brothel in the
Woods Amnesia and delirium Epidemic
Suicide Death—exhaustion and epidemic
Obscene matter Sabotage—dynamite
Suicide—unrequited love Public
drunkenness
Lake monster Fire—incendiary Insanity
Insanity Firebugs Bastard—murder
Infant death—memorialized Grotesque
Marriage Suicide—despair Fire—
incendiary
Incendiaries

Children's deaths from Wescott; money-less women, according to Sinclair Lewis; a case history from Mendota State Hospital

Polly and Ada died. Life was teaching her methodically; this was the second lesson; she was a strong woman and could learn. On the day of the funeral the heat was broken by a thunderstorm. The cheap little coffins were of the same length. Rose attended two other funerals that week, children's funerals, saying, 'It shall never be said that my sorrow has hardened me toward others.'"

[Glenway Wescott, *The Grandmothers*, p. 58]

"John Kuhni, charged with the murder of William Christian in the town of Primrose, December 12, 1888 . . . pleaded guilty and was immediately sentenced to life imprisonment. . . . [His] crime was the most atrocious ever committed in Dane County. . . . About December 23, 1888, 2 boys while fishing found a sack in the water. They opened it and found . . . portions of a human body. It was found that Christian had been killed, his body cut in small pieces, part of the remains burned, part placed in a sack and thrown in a creek, and others packed in a valise and carried away by the murderer. . . . In his confession . . . Kuhni says that he killed Christian because he ridiculed his religion and laughed at him for reading the Bible." [1/23, State]

"Mrs. Frederick North, a widow, was found dead the other day at Sparta with her head in a barrel of water. She was thought to have committed suicide."
[1/23, State]

"News reached Beaver Dam recently of the suicide . . . of Edwin Miller, 20 years old. Miller shot himself in the head. . . . He left letters for a young woman with whom he was madly in love." [3/6, State]

"George Boyer and John Kline were recently arrested at Merrill [and] charged with blowing up a Chinese laundry."
[6/5, State]

"Mrs. John Leiniger, who lives on a farm 3 miles south of Madison, was recently arrested [and] charged with poisoning her husband. Leiniger found her in the poorhouse from which he took her to be his bride." [3/6, State]

"As she entered she heard Mrs. Dyer demanding, 'Dave, I've got to have some money.'

Carol saw that her husband was there, and two other men, all listening in amusement.

Dave Dyer snapped, 'How much do you want? Dollar be enough?'

'No, it won't! I've got to get some underclothes for the kids.'

'Why, good Lord, they got enough now to fill the closet so I couldn't find my hunting boots, last time I wanted them.'

'I don't care. They're all in rags. You got to give me ten dollars—'

Carol perceived that Mrs. Dyer was accustomed to this indignity. She perceived that the men, particularly Dave, regarded it as an excellent jest. She waited—she knew what would come—it did. Dave yelped, 'Where's that ten dollars I gave you last year?' and he looked to the other men to laugh. They laughed."

[Sinclair Lewis, *Main Street*, p. 74]

"James Carr, residing in the town of Erin, Vernon County, was discovered dead in his log house recently, having died of starvation." [3/6, State]

"C. C. Clark and his son-in-law John Evans were arrested at La Crosse recently on a warrant charging them with burning Clark's mill at Brownsville, Minn., the night of Jan. 26, 1889. The insurance companies paid the loss, but afterwards a man [who] claimed to have put up the entire plan to burn the mill and . . . been cheated out of his share divulged the fact to a detective." [3/6, State]

"Henry Johnson, an old bachelor of Grand Dyke, cut off the heads of all his hens recently, made a bonfire of his best clothes, and killed himself with arsenic." [4/3, State]

"Admitted May 10, 1888. Town of Albion. Born in Germany. Aged 42. Married. Farmer. First symptoms in '83 or '84. He imagines his neighbors visit his house at night to poison his cattle and try to injure his property. . . . Is apparently rational on all business subjects. . . . June 14th: Having seen no signs of insanity about him, he was allowed to return home today with his wife."

[Mendota State, 1887 Record Book (Male, F) p. 193, patient # 4781]

"Charles Barker's place, near Eau Claire, one of the most notorious pinery dens in that section, was burned at 4 o'clock the other morning. It was supposed it was set on fire by inhabitants of the neighborhood. The occupants, 10 women, barely escaped. . . . Barker's wife owned the place since his narrow escape from state prison as a keeper of that place a year ago." [4/17, State]

In winter, the only men left in town were either so young they were in school or so old they were in bed, or so spineless they sold things to ladies. Everyone else was off in the pineries. They got up at four and turned in at ten. They swamped and sawed and snaked the trees. They caught smallpox from each other and clap from the girls in the dens. They drank a lot and got caught by chains and crushed by log jams. Grudges got settled fast: if a man was your friend, that was all; if he was your enemy, God help him or you. The old fools got beaten and strung up just to scare some sense into them. The younger ones got run out. Sometimes a man would get so used to the woods, or so bitter about the people in town, that he'd never go home. He'd just put up a shack and wait for the next freeze and the next drive.

"Etta Walker, the girl who disappeared the other day from Boscobel on the eve of her marriage, was found at 2 o'clock the next morning but could give no account of herself . . . being in a completely dazed condition. Fred Stahel, who was to have married her, would not fulfill his engagement." [4/24, State]

"The household of Lewis Bartel of the town of Scott within one week recently suffered the unusual affliction of the death of 5 members, one being a young woman of 21 years . . . 2 other children were not expected to recover." [4/24, State]

"Mrs. John Sheehy of Manitowoc committed suicide recently by cutting her throat with a small case knife and was found dead in the woods by her house."

[4/24, State]

"Mrs. James Baty of Merrillan, while visiting the family of John Baty at La Crosse, died suddenly of a hemorrhage of the lungs. She leaves a husband, her family of 6 children having died of diphtheria last summer."

[5/8, County]

"Mrs. Jennie Jones of Oconto, charged with sending obscene matter through the mails, pleaded guilty in U.S. Court recently and was sentenced to one year imprisonment."

[5/8, State]

Right after Jacob Spaulding and the Woods first parted ways, Jacob had a little set-to with a crowd of Mormons. The Mormons had bought half an interest in the Nichols' mill at the mouth of Roaring Creek in 1841. By 1842 they began to have second thoughts about the whole concept of earthly ownership on that section of the Black River. It had been revealed to them that the land was the Lord's, especially the land and timber on the east side of the Black River that happened to belong to a Gentile named Spaulding. Since the Lord needed cut wood for His new temple in Nauvoo, Illinois, they began to cut down Jacob's timber. Jacob didn't hear about their revelation until they had felled no less than 100 and probably no more than 600 of his trees. By then he'd dropped in on them with twenty men packing guns. He told them he'd give them an hour. Otherwise he said he couldn't be sure how many Saints would end up in heaven, but he guaranteed them there'd be a whole lot less of them left on earth. The Mormons understood: the Lord still needed His timber but He wouldn't hold it against them if He had to wait until they could even the odds. They went back down to Nauvoo with a plan to bring back 100 more Saints with sixty more guns. Jacob found out pretty early what they had in mind, so he decided to tell them before anything got started that he was going to invite some federal troops up from Prairie du Chien if any of those new settlers ever showed up. Since everyone knew exactly what everyone else intended, the only thing the Mormons did was to let Jacob sell them his mill for $20,000 worth of lumber probably cut from the same trees that had been the object of the first revelation.

"Fire at Cambridge, the other night, destroyed 13 buildings being the principal part of the town. . . . The fire originated in a barn and was supposed to be the work of an incendiary."

[6/5, State]

"William Oliver, a respected farmer of Poygan, killed himself by taking a dose of carbolic acid the other day. He was a widower, aged 70. The cause of the suicide was said to have been the refusal of a woman to become the third Mrs. Oliver."

[6/26, State]

"The beer garden recently started on this side of the river, by permission of our town board, continues to grow offensive. The rabble from the city and the country meet there and sometimes form nothing less than drunken mobs. It is not safe for women to pass along the road near this place. Bloody fights are of a daily occurrence and drunken men may be found lying around in the bushes on all sides. Wife whipping has come into vogue since the new institution was forced upon us. . . . What it may end in need hardly be conjectured."

[7/10, County, from Pleasant View]

"A farmer owning land at Red Cedar Lake claims to have seen a reptile about 40 ft. long in the water, carrying off one of his hogs, which was squealing vigorously."

[8/21, State]

"About 10 o'clock last night a fire was discovered in the rear of W. J. Thompson's residence in the first ward. . . . The fire is thought to have been incendiary."

[8/28, Town]

"Mrs. Carter, residing at Trow's Mill, who has been in charge of the boarding house at A. S. Trow's cranberry marsh, was taken sick at the marsh last week and fell down, sustaining internal injuries which have dethroned her reason. She has been removed to her home here and a few nights since arose from her bed and ran through the woods. . . . A night or two after she was found trying to strangle herself with a towel. . . . It is hoped the trouble is only temporary and that she may soon recover her mind."

[9/8, County, from Merrillan]

"Nels Peterson died at his home in the first ward . . . yesterday morning. One day less than 2 weeks [ago] he drove over . . . to look after a cranberry marsh which he owned, and was there taken sick with what proved to be the bloody dysentery . . . the following [day] he took to his death bed. Before his death, the disease was complicated with malarial typhoid fever and heart trouble. He suffered much pain."

[9/18, Town]

"Mazomanie is plagued with firebugs and the principal hotel has been burned."

[9/25, State]

"Lena Watson of Black River Falls gave birth to an illegitimate child and choked it to death."

[10/9, Town]

"The funeral services of little Bertie Carpenter who died . . . last week were conducted . . . in the Congregational Church at Hixton last Sunday. A large gathering of relatives and friends were present, and all mourned and wept with the bereaved ones. He had been an intense but patient little sufferer for a long time before his death, which was really not death but a release from suffering and pain into life and happiness. His remains were sweetly placed in the bosom of the earth at the cemetery here where he will be rocked in God's great cradle during his peaceful sleep."

[10/30, County]

"Israel Love, aged 80 years, was married for the sixth time at Beloit." [10/30, State]

"Frederick Windex, an aged farmer, committed suicide at Janesville by drowning himself in the pool where his little daughter had been accidentally drowned 2 years ago." [10/30, State]

"Early the other morning the barns of Fred Kroeger, A. B. Piper, and W. F. Hanche, together with 11 horses, 13 head of cattle, farming implements, grains, and hay at Berryville were totally destroyed. . . . The fires were undoubtedly the work of incendiaries." [10/30, State]

"George Sherer, 17 years of age, is under arrest at Waukesha on the charge of burning J. H. Phillip's barn in the town of New Berlin. During the past 6 years there have been no less than 26 incendiary fires in that town. Sherer, it was thought, would confess to the whole series of crimes, although there was a strong suspicion that he was but a tool in the hands of the real criminal." [12/18, State]

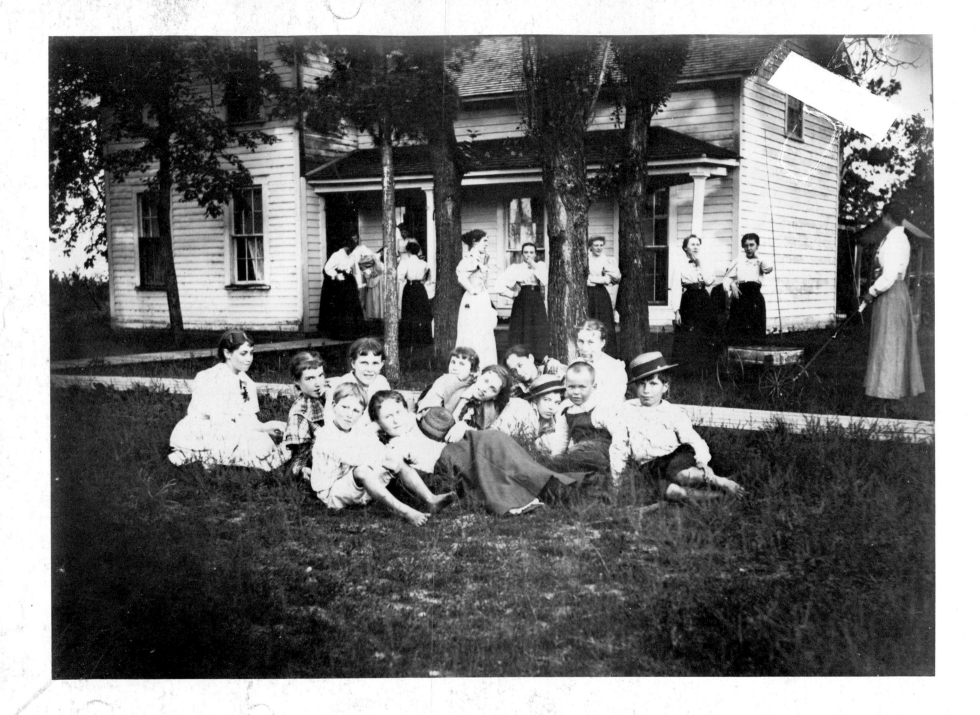

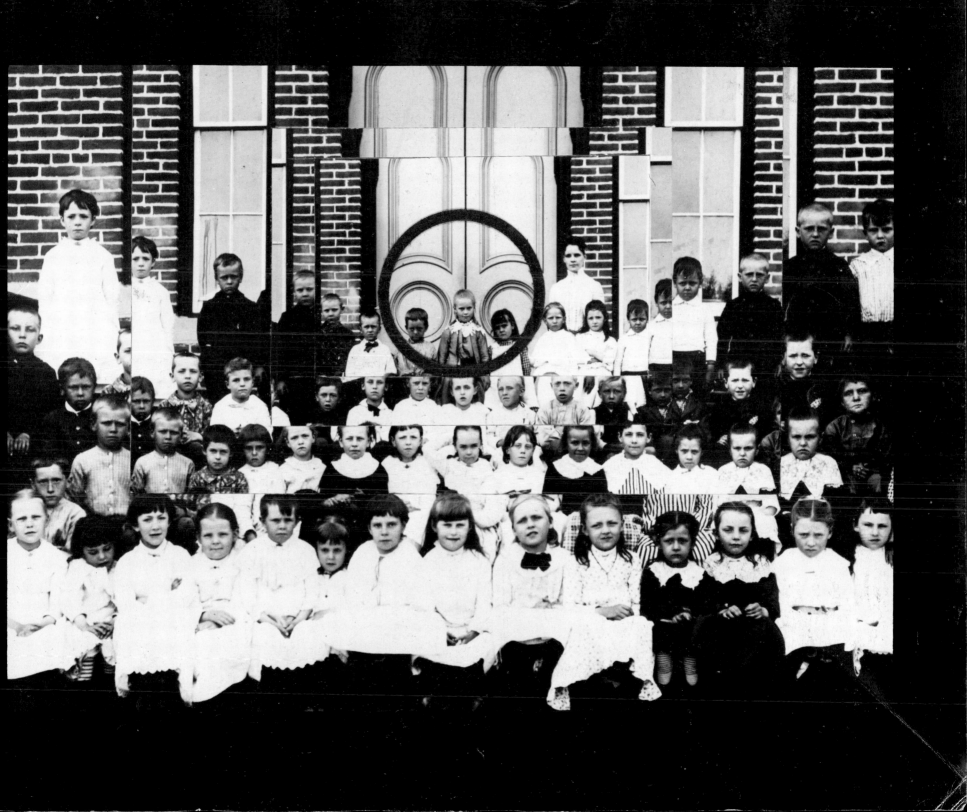

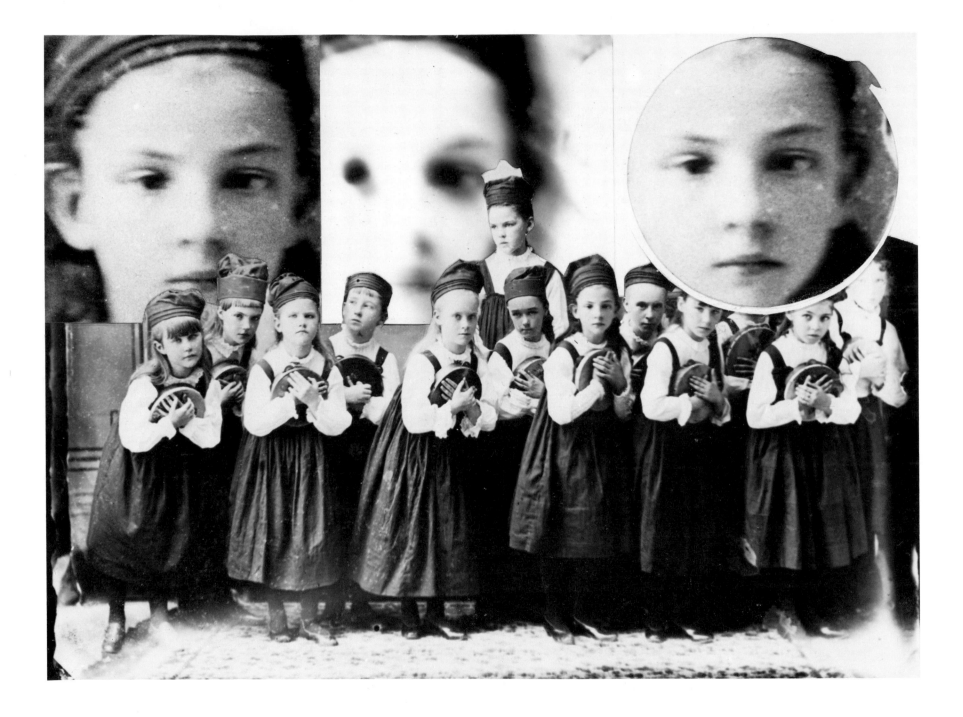

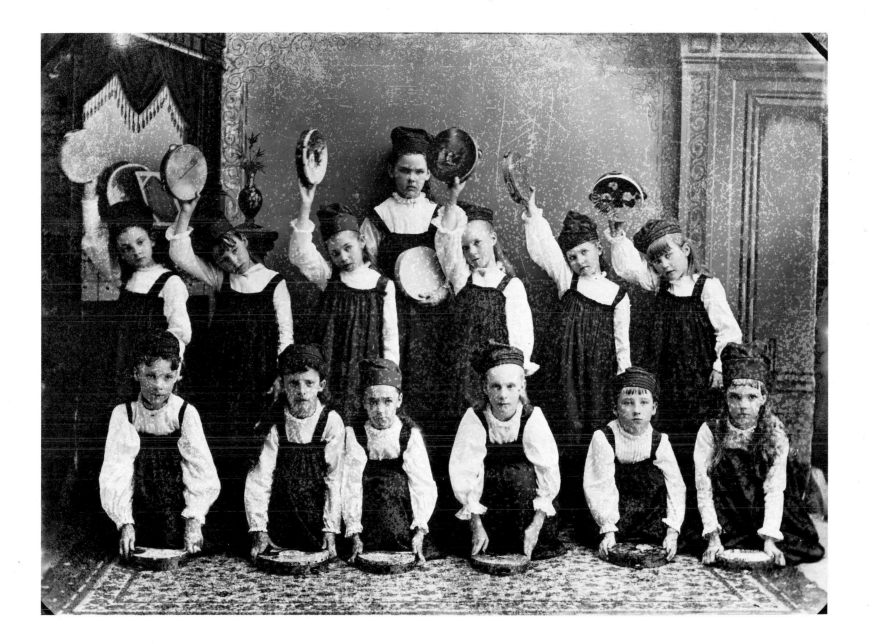

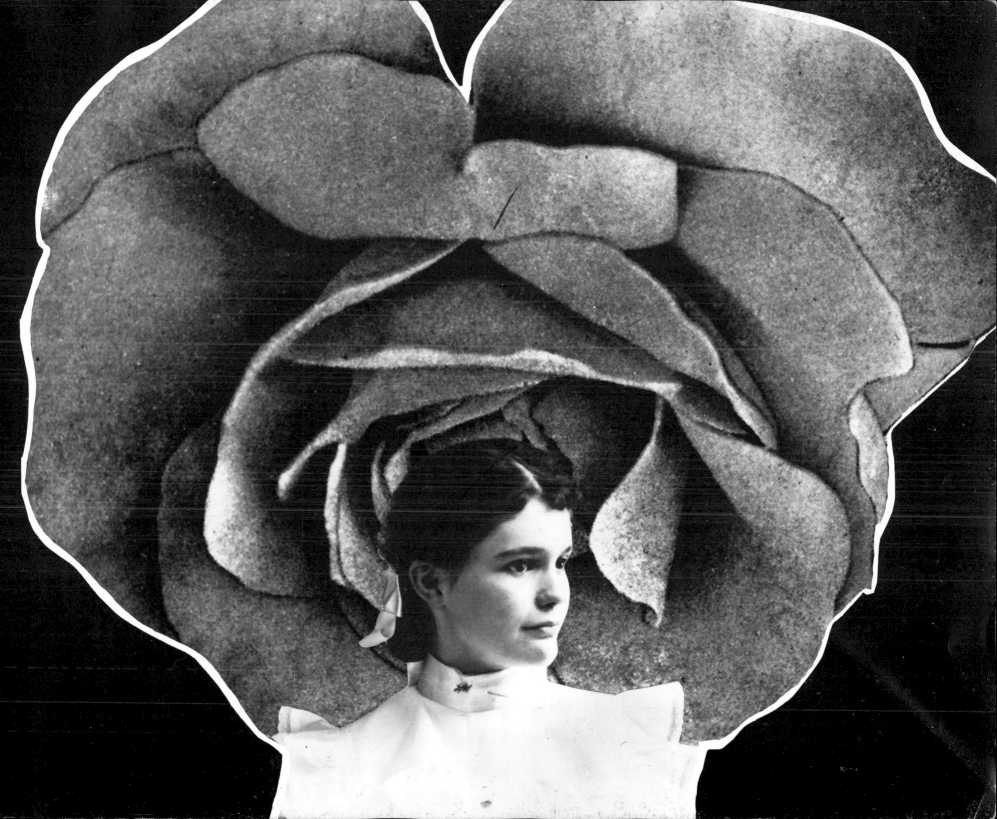

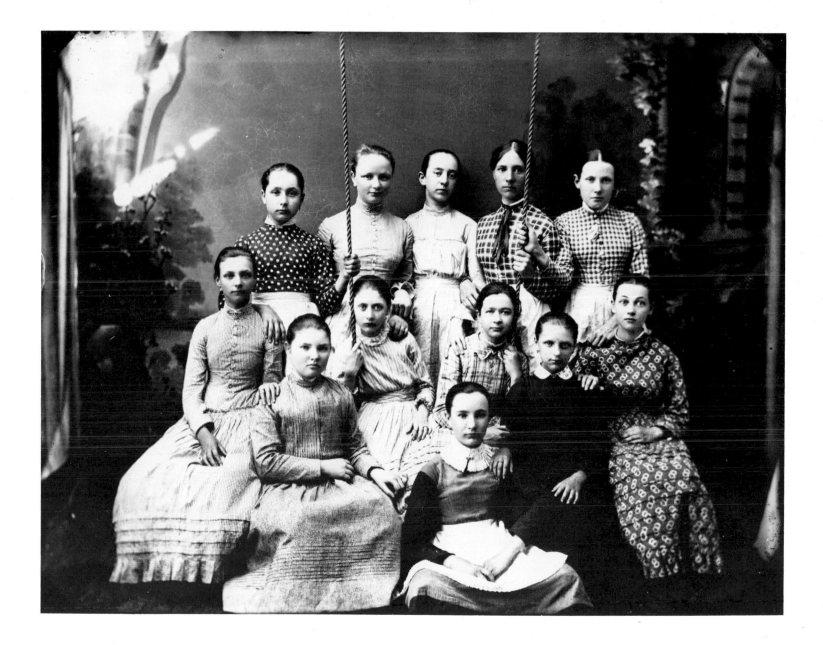

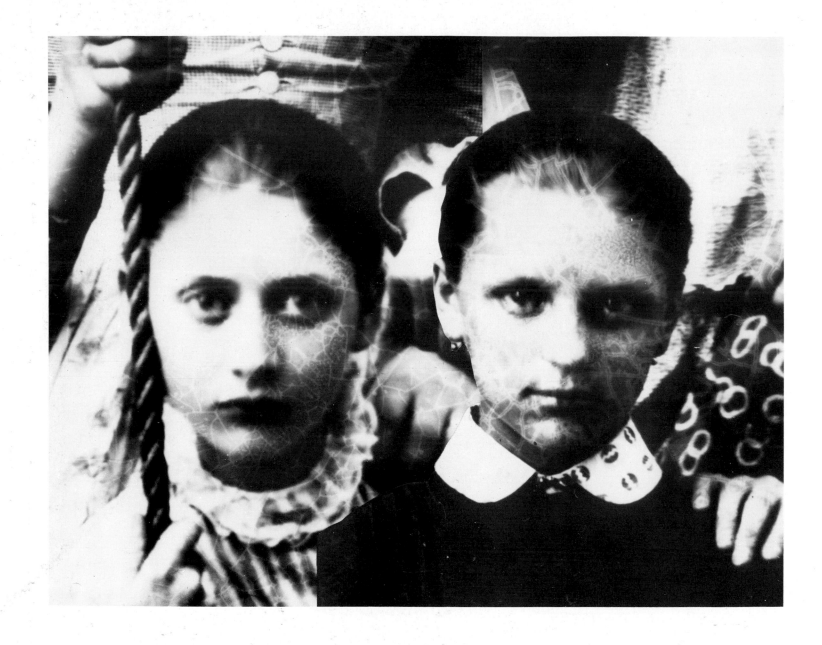

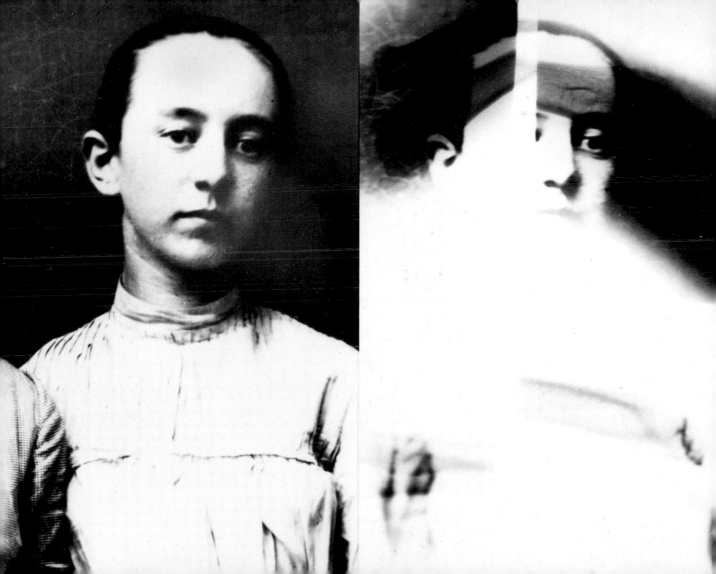

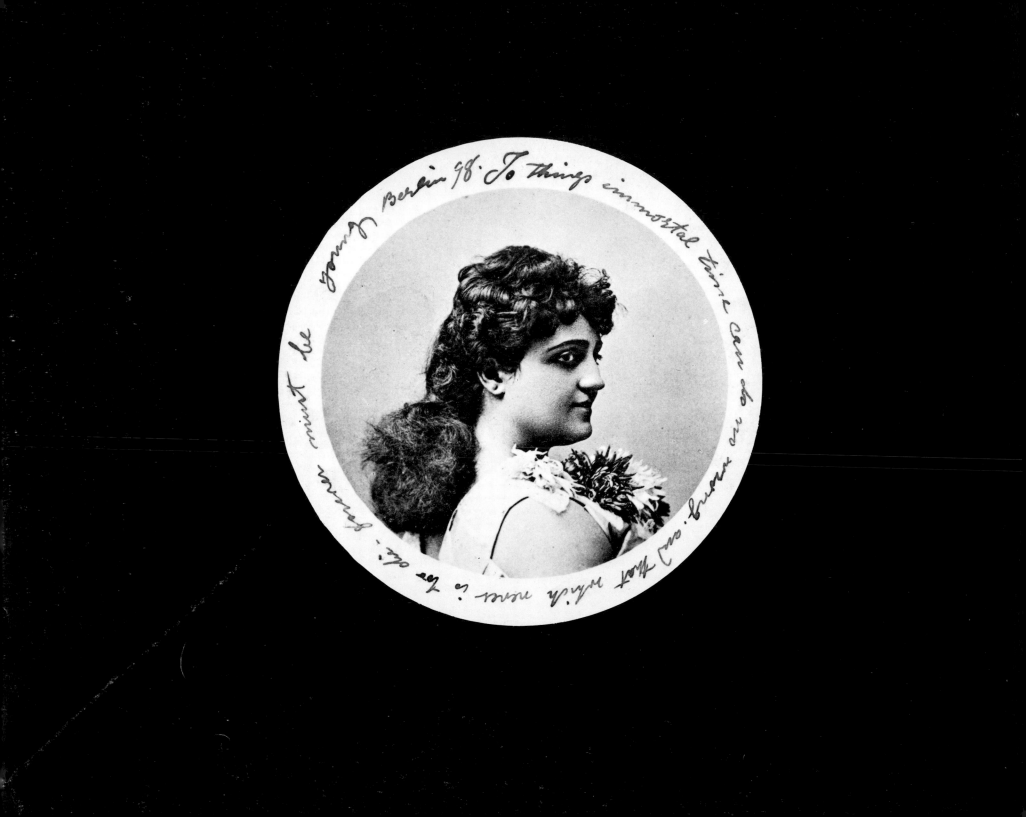

"Diphtheria is epidemic at Eagle, Richland County." [1/8, State News]

"The little child of Newton and Etta Riggs Loomis was removed to the home of its grandparents, Mr. and Mrs. J. C. Loomis, after diphtheria was pronounced to be in the home of Mrs. Ann Riggs, in the hopes that it might escape the dread disease. But the monster followed it and the child died Monday, aged 2 years."

[1/15, County, from Alma]

"Louis Lawrence, aged 39 years, a stout, burly fellow administered a terrible beating to his father . . . aged 82 years, at Manitowoc, from the effects of which the old man died." [1/15, State]

"Once when Alwyn was nine he came round the corner of the house suddenly. His aunt Flora and his grandfather were going to the village; the horse and buggy stood by the porch. But the old man strode up and down, trampling the wild violets which were planted there, and muttering. Flora wrung her hands and absent-mindedly tore the veil which hung from her hat. His father was there, sobbing—Alwyn had not known that grown men ever wept. In the doorway his grandmother stood with her arms folded, a look of resignation that was half scorn on her face.

The trouble had something to do with the horse and buggy. Suddenly the old man sat down on the porch and stared

1891

Diphtheria Infant death Parricide
Arson Suicide French hermit Death
Memorialized Death memorialized
Obscene letters Violent insanity
Death in the asylum High school motto—
innocence
University arson Transcendental
spiritualism
Insane butcher Starvation Hideous
Suicide Resigned suicide Old
Suicide Infant death memorialized
Insane incendiary Suicide—poverty
Diphtheria—infant deaths Insane
eccentricity

Wescott's description of sons who fight their fathers, and fathers who fight their sons; three histories from Mendota State; Wescott's stories of old age and senility

straight ahead with his farsighted eyes. Alwyn's father stammered then that he was tired of being bullied, and the girl defended him and reproached their father—both speaking loudly because he was deaf. They were telling him that his life was over and he must not interfere any more—things were hard enough for them without that."

[Glenway Wescott, *The Grandmothers*, pp. 32–33]

"John H. Phillips, the wealthy farmer who in the past 4 years has suffered losses aggregating $17,000 by incendiary fires, is under arrest, charged with arson. It is alleged that he has started no less than 10 fires and is the famous 'New Berlin fire bug,' who has been such a terror to the rural districts." [1/15, State]

"The body of an unknown man was found hanging from a tree in Rochester."

[1/28, State]

"An old Frenchman by the name of Boullion, who lived among the hills north of this place died February 8th. He lived a solitary and almost hermit life for the last 25 years and came near dying alone. A man chanced to go by his house and the hermit crawled to the door and called for aid. . . . He was a well educated man, and at one time studied for the ministry, but some early disappointment embittered his life. His relatives, who live in Chicago, are wealthy people and have repeatedly urged him to make his home with them, but he preferred a secluded life. He lived in squalor and poverty, but at his death he proved to be worth $10,000." [2/19, County, from York]

"Again we have been reminded of the brevity of life by the taking from among us of Mrs. E. A. Hamond . . . Saturday morning at 4:30 o'clock. The angel of death placed a period at the end of a long season of much suffering."

[3/5, County, from Pine Hill]

"Paul Sechler, only son of Charles Sechler, died at his home in Sechlerville, March 14, 1891, aged 15 years.

"He has gone, but he had not far to go—only through the gates into the city—then came the glad, happy meeting of mother and son. He started home long ago and has been waiting outside for weary months. . . . He left his suffering and weakness all this side the gate. . . .

"His father sat by him in the closing hours, yet heard not the flutter of angel wings as they came so gently and bore his dear one away. . . ." [3/19, County]

"Mrs. Elizabeth Beckman was arrested by Post Office Inspector Pulcifer, charged with sending obscene letters through the United States mails." [4/16, State]

"Last Friday, Mrs. Anna Nelson of the town of Irving was brought before Judge Perry, examined as to her sanity, and adjudged insane. . . . She was quite violent." [5/14, Town]

"Admitted June 20th, 1901. Resident of Jackson County. Age 34. American. Married. Seven children. Youngest, 2 years. Housewife. Poor. . . . Melancholia—fear of injury by the devil or some other person. Insomnia. . . . Filthy. Emaciated, extreme weakness—Tremor—very religious. . . ."
[Mendota State, 1896 Record Book (Female, G), p. 637, patient #8848]

"This morning Sheriff Williams received a letter from the insane asylum at Mendota stating that Johanes Norelius, whom Mr. Williams took there about 4 years ago, escaped. The unfortunate man was from the town of Cleveland." [5/14, Town]

"Admitted Feb. 22, 1888. Town of Garden Valley. Aged 41. Born in Wisconsin. Married. Farmer. There have been numerous attacks of insanity since '81. . . . These attacks are manifested by violent spells alternating with fits of melancholia. Easily excited at little things when he becomes violent and profane. His family is afraid of him although he has never attempted to injure anyone. . . . March 28th: Discharged today. Went home with his father. Recovered. . . . Readmitted August 15, 1894. Married. 3 children, youngest, 18 years. Farmer. Limited means. . . . Insanity now manifested by seclusion and a tendency to violence when opposed. Neglect of business affairs etc. . . . Has used tobacco to excess. . . ."
[Mendota State, 1887 Record Book (Male, F), p. 156, patient #4717]

The motto of the high school graduating class of 1891 was "Standing with reluctant feet/where the brook and river meet." The speeches given by the young men were entitled: "The Age of Progress," "Chivalry," and "The Massacre of St. Bartholomew." The speeches given by the young ladies were: "Hero Worship," "Russian Nihilism," "Uncrowned Kings," "Simon Says," "Lo, The Poor Indian," "Mind Culture," "Abraham Lincoln," "Dante," and "Conflict and Character." [6/18, Town]

"Fire broke out in the University gymnasium building at Madison. . . . it was totally destroyed. The fire was the work of incendiaries." [7/2, State]

"Dr. Joquish, a well-known citizen of Osseo, claims that his soul recently separated from [his] body and went up to the heavens where it met and talked with his old father. He professes to remember the circumstances well. The doctor is a man of strong mind and this story is an alarming one to some of his relatives who think he is somewhat insane." [7/2, State]

"C. Langdon, a meat market man at Eau Claire went violently insane over the loss of $2,000 by business reverses." [7/2, State]

"Admitted May 17, 1900. Town of Curran. Norwegian 35 years. Widowed. Three children, youngest 6 years of age. Farmer and laborer in poor circumstances. In the winter, the patient became low spirited. . . . He thought everything and everybody was against him. . . . Imagines he is persecuted and writes abusive letters to friends and acquaintances. Thinks his friends are trying to injure his children. Has threatened injury to others. Neighbors say he has been erratic and acted strangely for years. After putting in his crop last summer, went off and left it without harvesting."
[Mendota State, 1899 Record Book (Male, J), p. 209, patient #8495]

"The body of a man supposed to be Thomas Wach was found in the woods of Northern Wisconsin. He left Ashland last April and was supposed to have starved to death." [7/2, State]

"Mrs. John Larson, wife of a farmer living in the town of Troy, drowned her 3 children in Lake St. Croix during a fit of insanity. Her husband, on finding her absent from the house, began a search and found her at the lake shore . . . 2 of her children lying in the sand dead. The third could not be found. Mrs. Larson imagines that devils pursue her." [7/2, State]

Old Jacob Spaulding's Massachusetts wife had come out the year that he bought out the Woods. She brought their son Dudley, who was only six then, but who lived long enough not only to inherit old Jacob's property in 1860 but to invest it so wisely and so extensively in lumber, land, farming, milling, wagon building, and commercial construction that by the nineties he'd declared bankruptcy. She and Jacob must have slept together as soon as she got off the boat, since a year later she bore her girl child Mary Jane. She then proceeded to waste away, probably secure in the knowledge of having bestowed upon her daughter the precious title, long memorialized in local history, of the first white child ever to be born in Jackson County. Mary Jane never got raised by anyone since her daddy was always out acquiring his fortune. And since there were only twenty-five single ladies in the town, they were kept so busy taking care of the town's 400 single men that they never had a chance to look in on the little girl. Old Jacob left her pretty well off, even though he went through a couple more wives. She ended up playing hostess to the Winnebagos at odd hours of the day and marrying Sam Jones who was partner with his brother Rufus in the Jones Lumber and Mercantile Company.

"Bernfid Krause, of Little Chute, left church, walked to the bridge upon which he placed his coat, hat, and prayer book, and drowned himself in the Fox River. He was 72 years of age." [7/23, State]

"Mrs. Phillip Fredericks, aged 82 years, who was partly insane, threw herself in her neighbor's cistern at Beloit and was drowned. She had long planned death in this manner." [7/23, State]

"At first her sense of time grew morbid; she would forget the events of the previous day or the previous hour, and remember instead things which had been forgotten for fifty or sixty years.

Then she began to hide things. . . . As wanton as a magpie in her black bodice and white apron, she slipped [her husband's] spectacle case into a closed umbrella, carried a paper-covered song book out to the privy, explaining that these were Unitarian hymns and she was a Presbyterian, and put an almanac on the organ in its place, opening it at a page on which the signs of the zodiac sat in a circle around a disemboweled man. She hid a valuable ring of fresh-water pearls so well that it was never found; and her husband expressed his disgust in pompous phrases, which she remembered.

Her modesty became a sort of madness. The human body exposed below the chin offended her as cobwebs had done when she had been a housewife, and like them aroused her industry. She made lacy curls with a pencil all over a nude photograph of one of her grand-daughters, two years

of age. The man of the almanac wore a bathing suit of ink. There was a history of the conquest of America with innumerable illustrations, in which the savages offered their daughters to the discoverers in dresses which she drew, and even the slain lay beneath shrouds as fanciful as valentines—the work of many weeks. If Alwyn left his collar unbuttoned, she would steal up behind him and wrap a handkerchief about his neck, murmuring, 'I can't abide nakedness.'

. . . she had always kept everything of an improper nature out of sight. She had had no roosters in her flock of hens, and bought eggs for hatching from her neighbors. She had persuaded her husband to plant a great hedge of cedars far from the house, behind which the cows and bulls together had been led. She had never allowed her babies to be seen until they were a month old."

[Glenway Wescott, *The Grandmothers,* pp. 262–3]

"The funeral services of the little child of Jimmie McWilliams that died last Friday was held at his house last Sunday. . . . The whole community deeply sympathize with Mr. McWilliams and wife in this doubly deep-pained affliction, this being their only boy, and the fourth one that death had taken from them during the past few years. Surely this is the point where faith must take the place of reason." [8/27, State]

"Charles Stangel who had been in jail at Chippewa Falls since last May, charged with burning several buildings in the town of Edison, was adjudged insane by County Judge J. A. Anderson and taken to the asylum." [9/10, State]

"Poverty and no work caused August Schultz of Appleton to shoot himself in the head while sitting in his little home with his wife and 5 children." [9/24, State]

"The authorities in the town of Hewett, Clark County, burned a house last week on account of diphtheria. Six of the children living in that house died from the dread disease." [10/15, State]

"John Matson was brought up from Melrose last Saturday for examination as to his sanity. . . . He was adjudged insane by the court. . . . Mr. Matson is well known by nearly everybody in the county and even by many outside of the county . . . having obtained . . . a considerable reputation as a walker. He also obtained some notoriety through his insane notion that he was a great potato culturist. Nobody who knows him will doubt for a moment that he is demented; but it is a case of such long standing that we fear there is no cure." [11/26, Town]

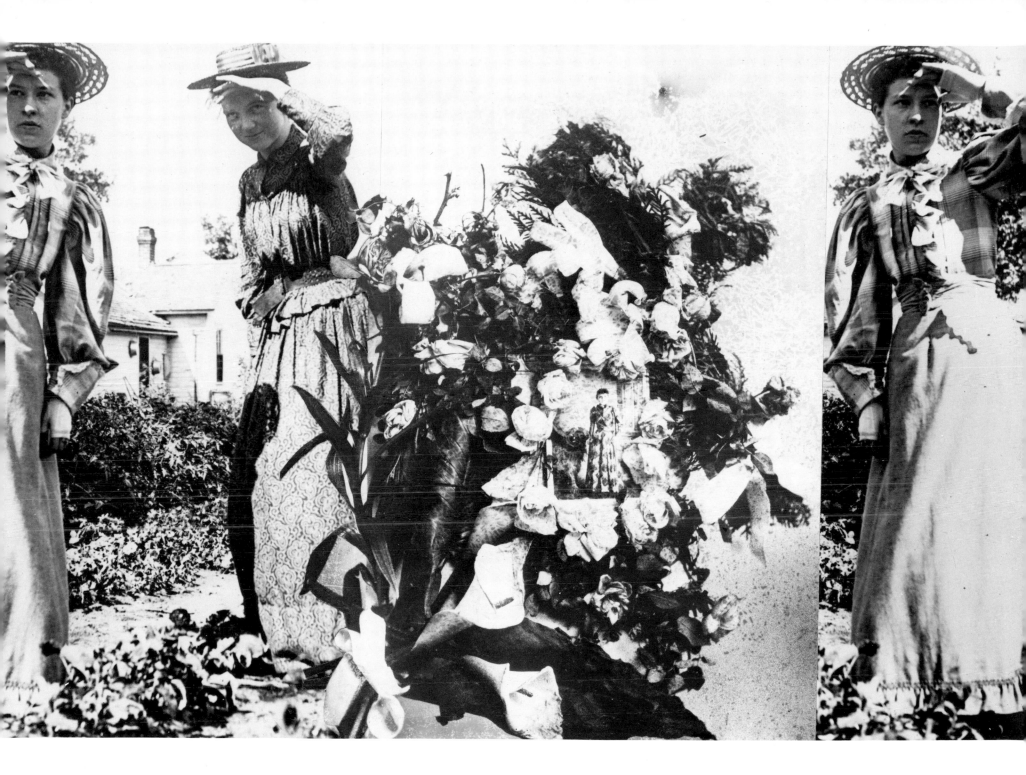

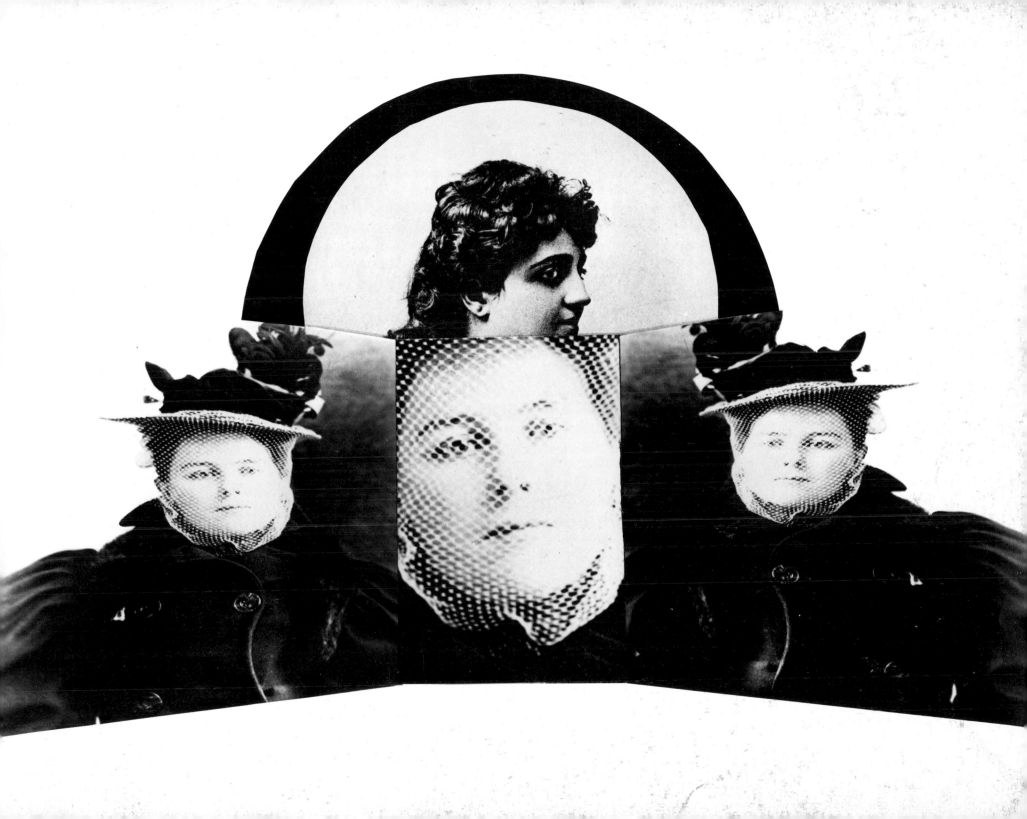

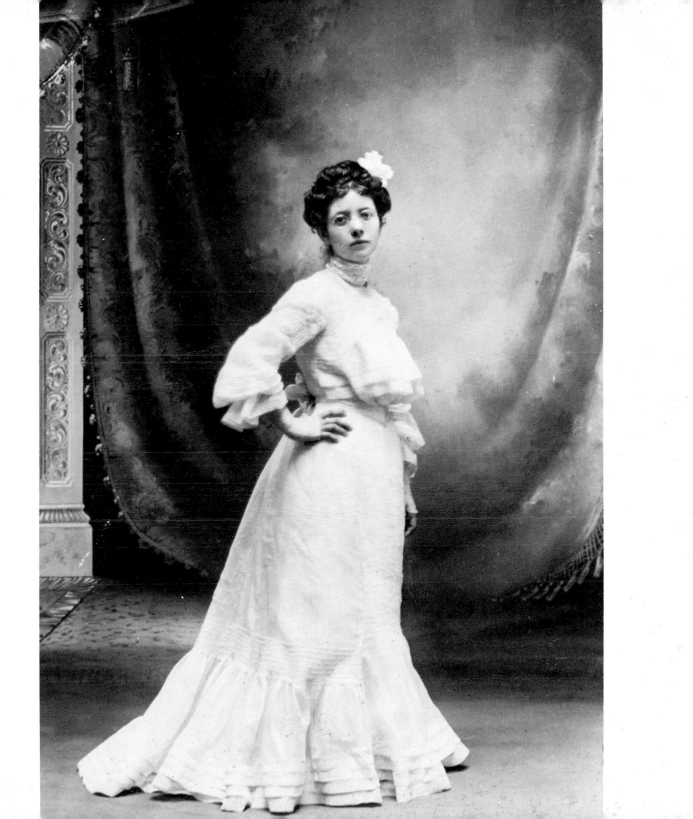

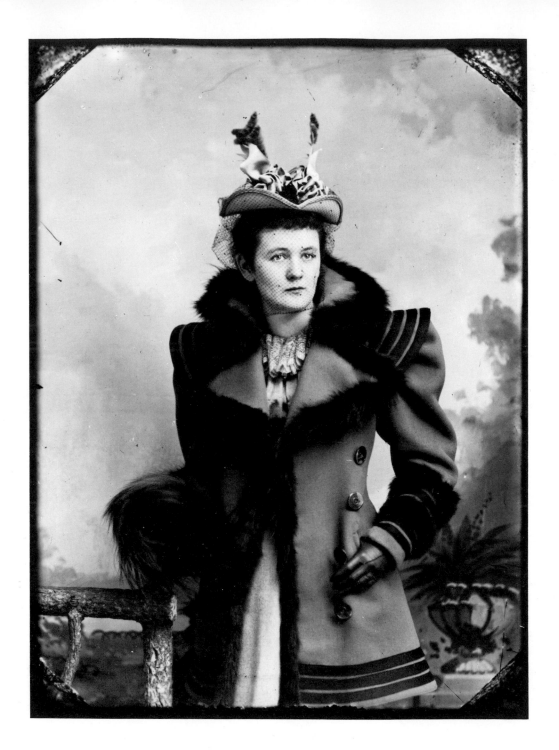

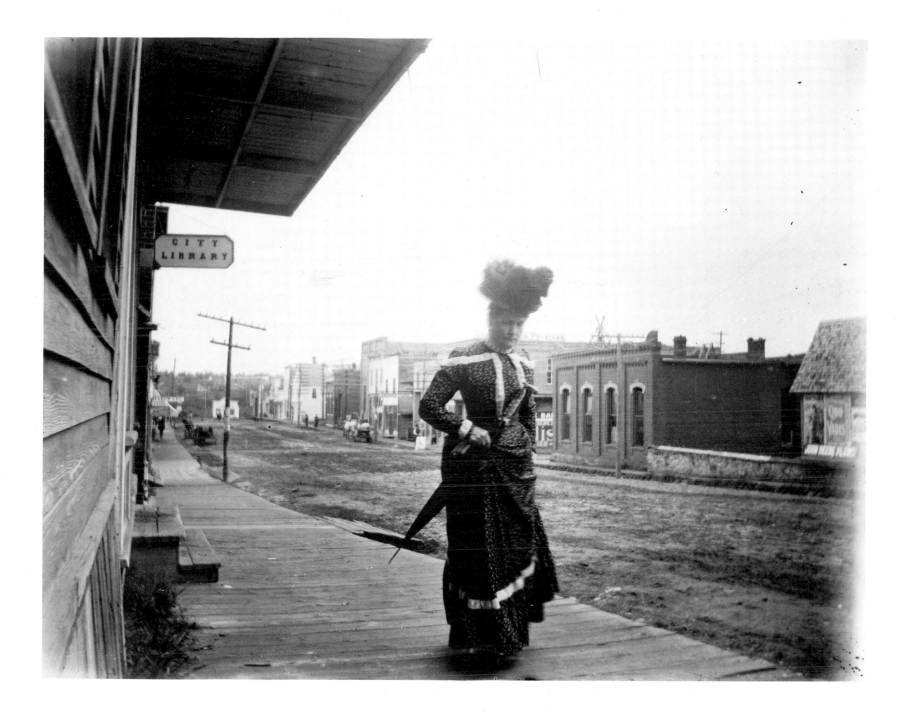

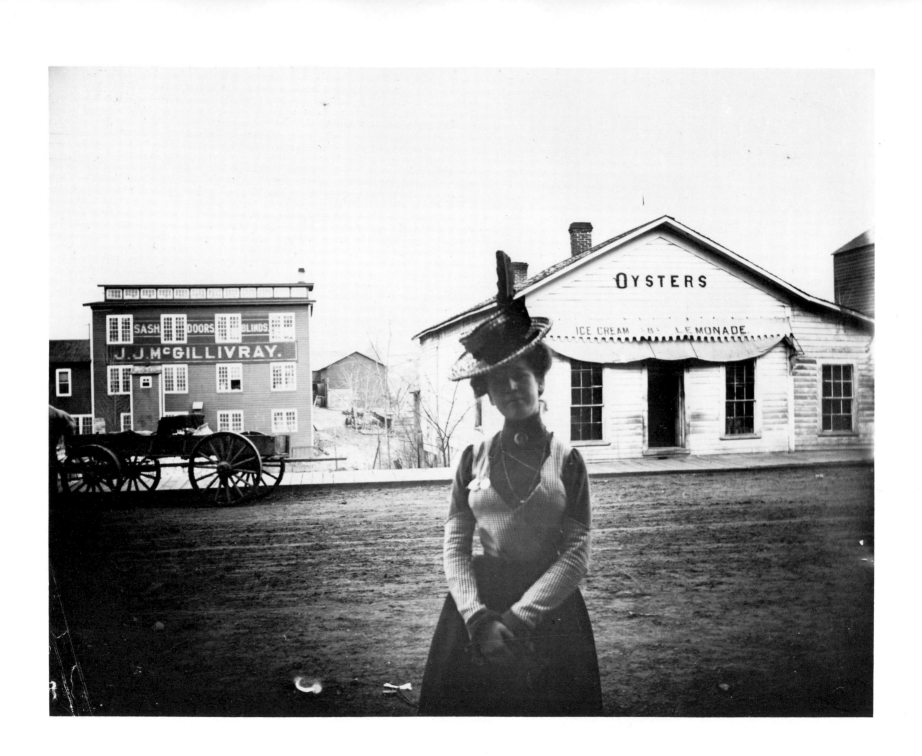

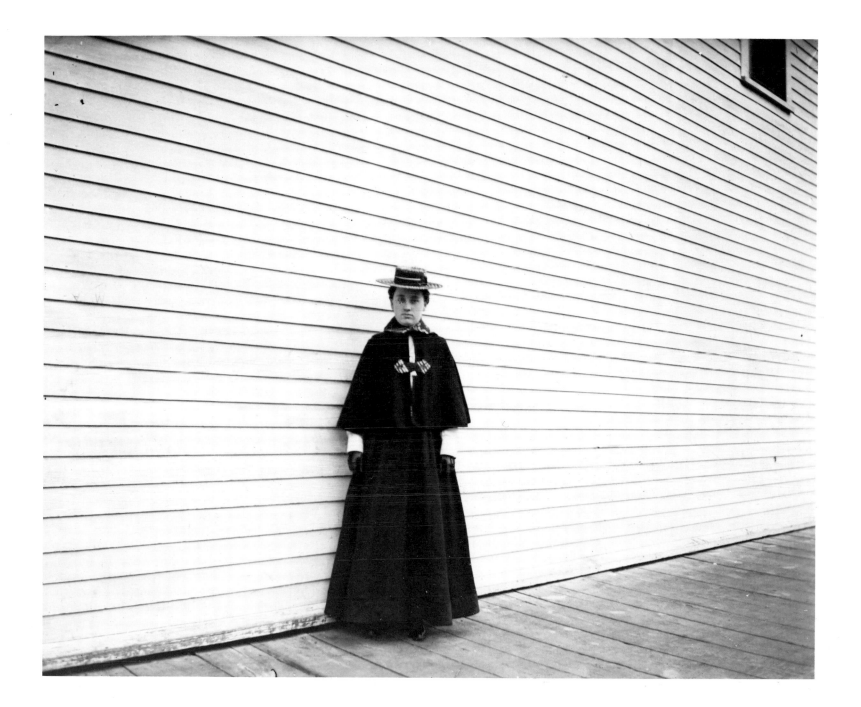

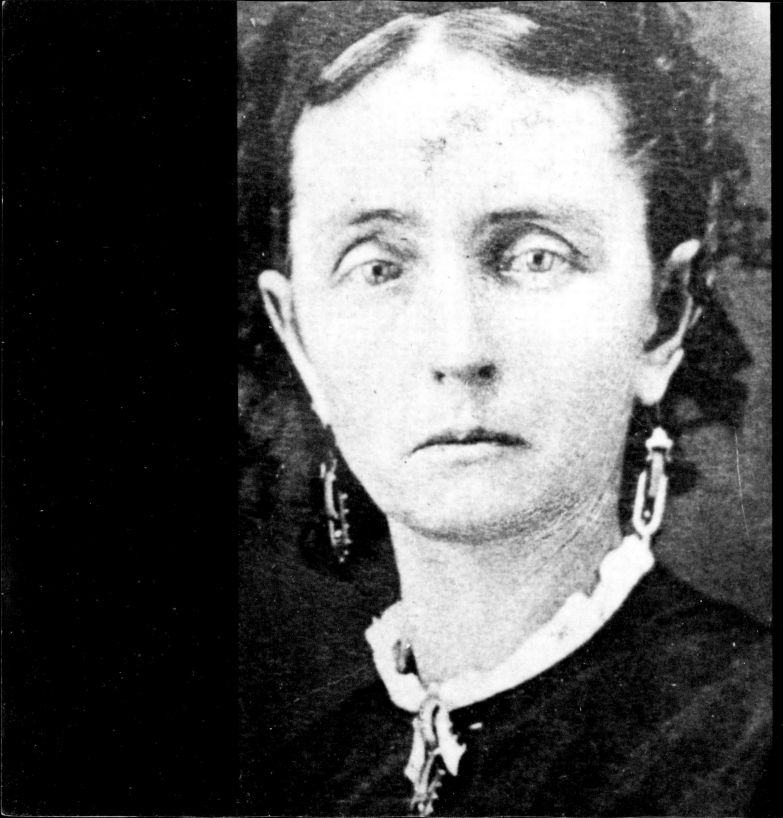

A few years after Mary Jane Spaulding had become the first white child ever to be born in Jackson County, local historians are unanimous in recording that Mr. William T. Price came to town from Mount Pleasant, Iowa, with an ax over his shoulder and fifty cents in his pocket. He and old Jacob hit it off at once, probably like old Will Varner and Flem Snopes did some time later. Jacob put him to work as his foreman and clerk at a little less than a dollar per week. Jacob probably started him so low because he knew that such an experience would one day be worth its weight in gold as a stepping stone in the political career of a would-be U.S. congressman. A few years later he was paying him twice as much. Bill probably saved every cent of it, since by 1851 he not only had gotten hold of some timber in Clark County but had managed to start a stage line between Stillwater and Prairie du Chien. By 1852, Jacob wasn't paying him anything, because he'd quit to open the town's first law office with C. R. Johnson. That law practice lasted on and off for maybe five years. By then Bill had gotten himself elected county treasurer, then county judge, then state senator on the Republican ticket. In between times he moved his whole family down to La Crosse so he could run a livery stable and another stage line, and took a plunge in the wholesale grocery business, only to get wiped out by a panic in 1857. That little market fluctuation ended up costing him $25,000, but he made it all up with interest by speculating in some more timber. According to his official biography, his creditors presented

1892

Anti-dipsomania gold
Cure Jailhouse incendiary
Incest Lake monster Early death
Memorialized Insanity Old death
Memorialized Death in the asylum
Window smasher Ossified man
Bloody vandalism Suicide—moral
Disgrace Self sabotage Incendiary
Fires Old lady miser Transvestite

Sinclair Lewis' exasperated Americans and ungrateful Svenskas; a case history from Mendota State

him with a $300 gold watch and chain out of appreciation for his scrupulous honesty. That honesty got him elected state senator six times between 1858 and 1881, but he had to wait until 1882 to get a crack at the U.S. House of Representatives. The local papers say that he managed to die in office in 1886, even though his stomach cancer made things pretty painful. Toward the end he was attended by a professional magnetic healer who came of his own free will from St. Paul, offering only to lessen the pain with the touch of his hand.

"We are about to have a gold cure institute in this city. Dr. A. E. White and E. Krohn have purchased the right for this section to use the celebrated improved 'Tri Chloride of Gold Cure' and are about to establish here an institution for the cure of the liquor, opium, morphine, and tobacco habits. . . . They guarantee a cure for a stipulated fee. The time required for treatment is 3 weeks. The patient is required to deposit the full fee in the bank, payable to the doctors when a cure is perfected, the patient agreeing to follow directions strictly. Medicine is taken internally every 2 hours, and 4 hypodermic injections are given each day. . . . We presume they will have few patients for the cure of other than the liquor habit." [6/2, Town News]

"The sheriff's house and jail at Medford were burned." [6/2, Town]

"Mamie Weeks, a 15 year old girl at Beaver, has made complaint against her father Jacob Weeks of being the father of her unborn child. Weeks has disappeared." [6/9, State]

"Red Cedar Lake near Ft. Atkinson is again agitated by a monster who has lain dormant through the cold months. . . . William Ward lost 5 sheep by the visit of the serpent. Their bodies were found in the mud partly devoured." [6/9, State]

"The golden bowl is broken, the silver cord is loosened, and the manly heart of Frank Warren Bathrick ceased to beat at 5 o'clock the afternoon of July 23, 1892. His sudden death was a fearful shock to his many friends who, in the midst of the annual harvest of the earth, were brought so swiftly into the presence of the heavenly garnering of this young life by the reaper 'who with his sickle keen/ cuts the bearded grain with his breath/ and the flowers that grow between.' What brilliant broken plans, what baffled high ambitions, what sundering of strong, warm friendships, what bitter rending of sweet household ties. . . . Around his bedside, father, mother, brother, and sister lingered, praying for a ray of hope, dreading the inevitable shadow of the death angel's wing. What could be more tender or a source of sweeter joy than the memory of his parting words to his beloved mother, when he spoke, as if already within the portal, this blessed assurance of affection: 'I love you.' "

[7/28, County, from Sechlerville]

"Judge Perry sentenced Mrs. Ira C. Miller of the town of Irving to the Mendota insane asylum. . . ." [8/11, Town]

"Died, September 20th, 1892, at his home in Sechlerville, Wisconsin, Samuel McWilliam, in the 84th year of his age. The death angel hovered over the home of Uncle Sammy for many months, threatening and retreating until gently and silently it wrapt its dark mantle around his wasted form and winged its flight to that bourn from whence no traveler returns. Born in . . . 1809, the deceased . . . was the father of 8 children, 6 of whom (2 sons and 4 daughters) remain to comfort the last days of their widowed mother. . . . His sufferings were such as only those with cancer endure. He longed for release. His eyes, closed in the darkness of here, [have] opened (we trust) in the brilliant presence of his Redeemer."

[9/29, County, from Sechlerville]

"The body of Mrs. Ira Miller was brought here from Mendota asylum on the early train Sunday morning. . . ." [10/6, Town]

"Admitted May 1, 1904. Town of Manchester. Age 47. Born in Wisconsin, father was French-Indian, mother, French-German. Married, 14 children, youngest 2 years. Housewife. Poor. Symptoms first noticed 12 years ago following loss of child. Deranged on religious matters. . . . Addicted to smoking. . . ."
[Mendota State, 1904 Record Book (Female, H), p. 366, patient #9835]

"Marie Sweeny, who ran away from her husband at St. Paul and has been creating trouble at Ashland with her wild mania for breaking windows, has finally been captured. Reports from St. Paul say that she was a model wife and mother, but some injury to her brain entirely changed her character. She ran away from home 2 years ago, and since then . . . has been in more than 100 different jails, serving short sentences for indulging in her wild sport." [10/6, State]

"Curtis Ricks, the ossified man, died at his home in Racine. Mr. Hicks since 1879 [has] been a helpless invalid. About 8 years ago his joints began to stiffen and his flesh to turn to bone. . . . For the past 2 years he has been traveling as a 'freak.' Hicks was formerly a well-known engineer on the Chicago, Milwaukee, and St. Paul road. He leaves a wife and 7 children." [10/27, State]

"James McDonald, a drayman, went to his barn in Eau Claire to feed his horses and found 2 of them dead with their throats cut. On the barn door was pinned a note saying that there were too many horses around and that 15 more would have to be killed. McDonald has no enemies. It is believed to be the deed of an insane man. McDonald is a poor man and had to mortgage his home to buy the horses." [11/24, State]

"Emma Tenn, a Swiss girl whose home is at Fontaine City, Buffalo County, and who has been working in the linen mills at Eau Claire, threw herself in front of a moving freight train at the Omaha depot. The yardman dragged her off the track just in time. . . . She said she wanted to die because of the stories that had been told about her." [12/8, State]

" 'My husband says the Svenskas that work in the planing-mill are perfectly terrible—so silent and cranky, and so self-ish, the way they keep demanding raises. If they had their way they'd simply ruin the business.'

'Yes, and they're simply ghastly hired girls!' wailed Mrs. Dave Dyer. 'I swear, I work myself to skin and bone trying to please my hired girls—when I can get them! I do everything in the world for them. They can have their gentlemen friends call on them in the kitchen any time, and they get just the same to eat as we do, if there's any left over, and I practically never jump on them.'

Juanita Haydock rattled, 'They're un-grateful, all that class of people. I do think the domestic problem is simply becoming awful. I don't know what the country's coming to with these Scandahoofian clod-hoppers demanding every cent you can save, and so ignorant and impertinent, and on my word, demanding bathtubs and everything—as if they weren't mighty good and lucky at home if they got a bath in the wash-tub.' "

[Sinclair Lewis, *Main Street*, p. 91]

"James McDonald and his wife were ar-rested in Eau Claire on the charge of hav-ing killed their own team of horses which were found in McDonald's barn with their throats cut about 2 weeks ago . . . it was supposed a lunatic had killed [them]. They were insured. . . . The claim is made that the McDonalds want the mon-ey." [12/8, State]

"In an interview, Chief Foley of the fire department made the unqualified state-ment that all the recent fires in Milwau-kee were of incendiary origin." [12/8, State]

"Mrs. Anthony Gregg of Dover recently left her home for a trip to Milwaukee. On the way she was taken sick and died. Af-ter her death it was discovered that she had secreted large sums of money about her home. Fifteen hundred dollars was found in the bottom of a crock filled with lard. In an old rag bag was found another $1,000. In the woodshed and other out-buildings were discovered sums ranging from $500 upwards. In a Milwaukee bank she had deposited $8,000 and besides owned a couple of farms." [12/15, State]

"The society people of Kenosha are worked up over the discovery that a per-son known as 'Mrs. Howe' is not a woman but a man. He went there some time ago to get up a 'Kirmess' for a church, and several ladies joined in the performance. The peculiarity of her manners was com-mented on at the time, but none suspected the real truth. Now there is regret on the part of the participants that they joined 'Mrs. Howe's troupe of dancers.' "

[12/22, State]

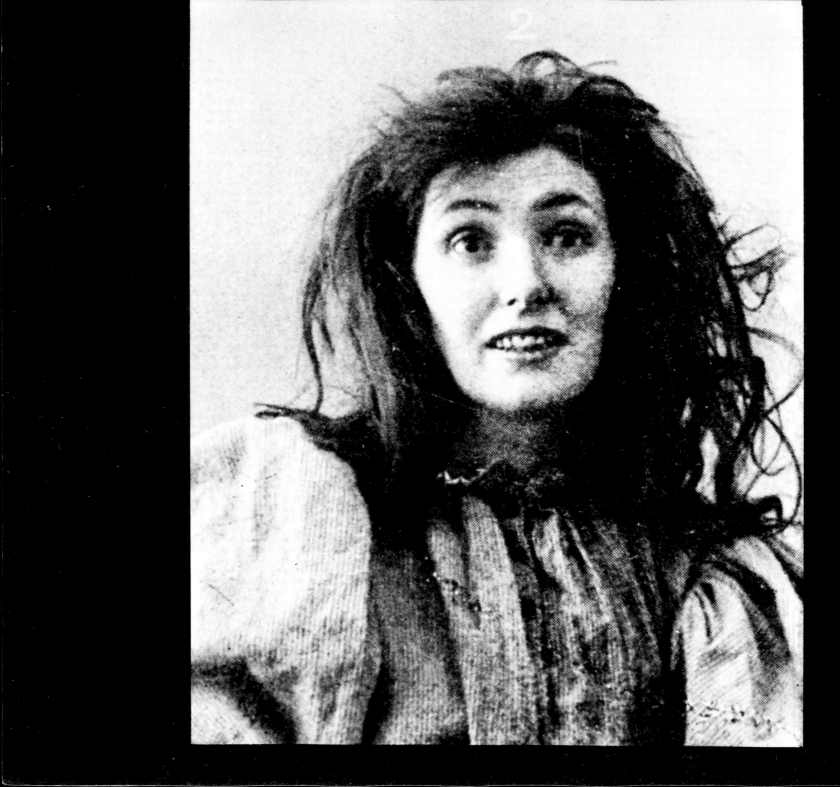

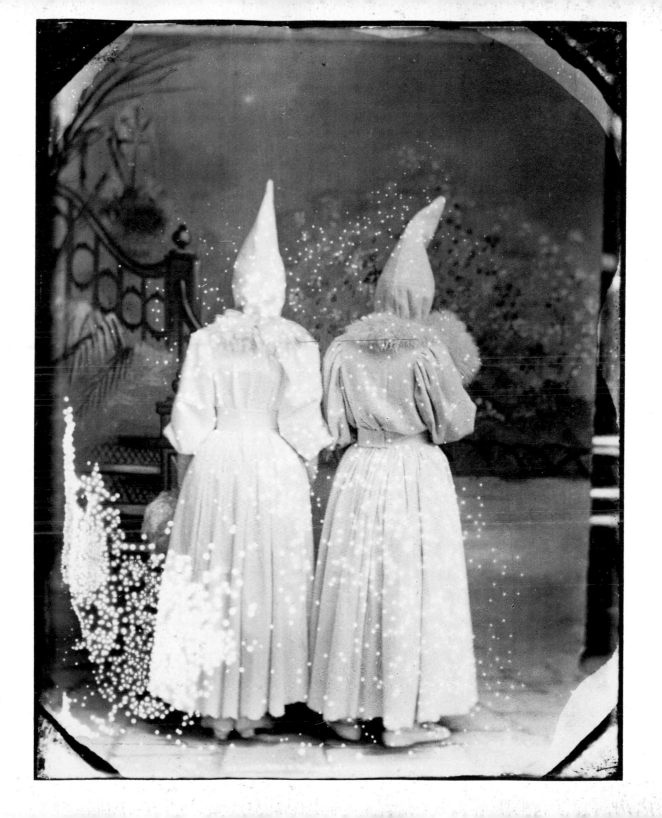

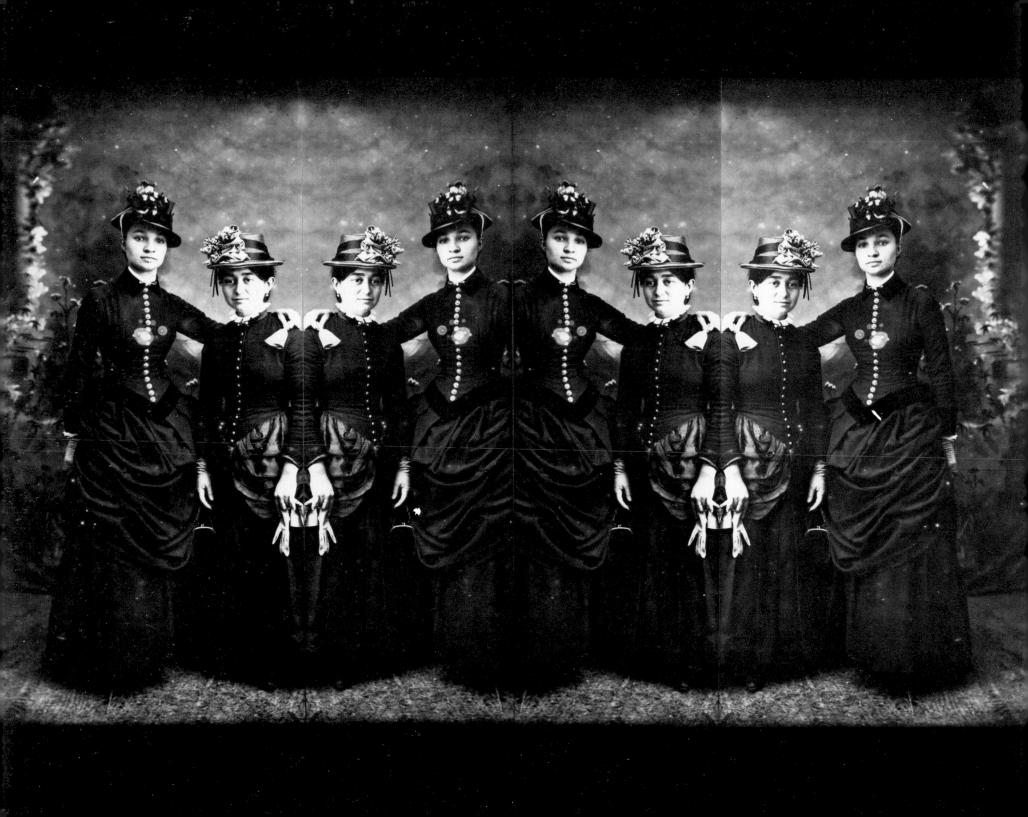

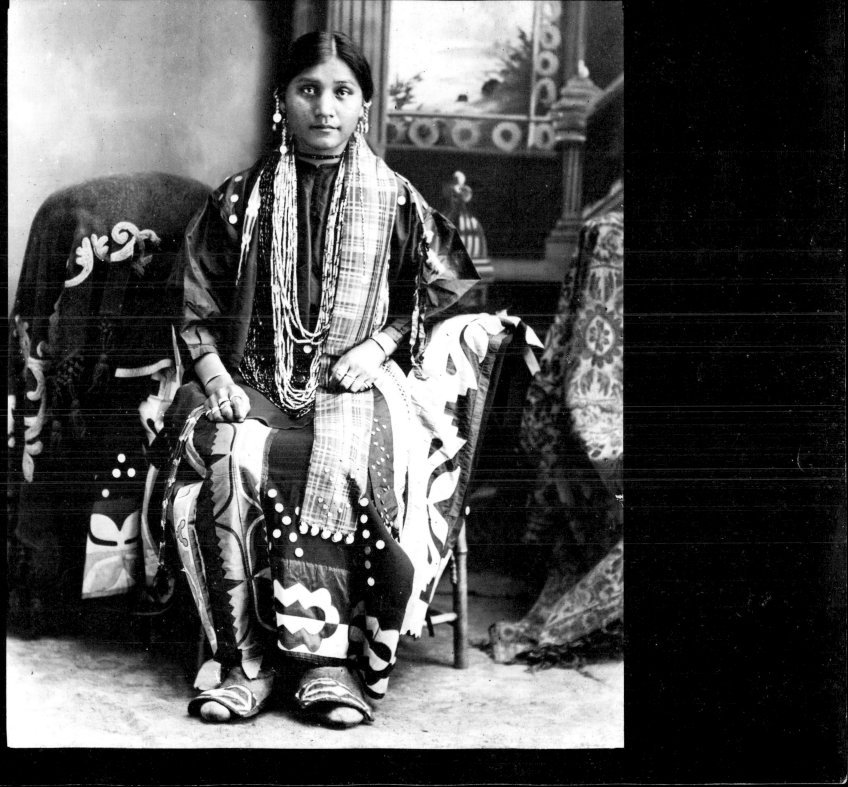

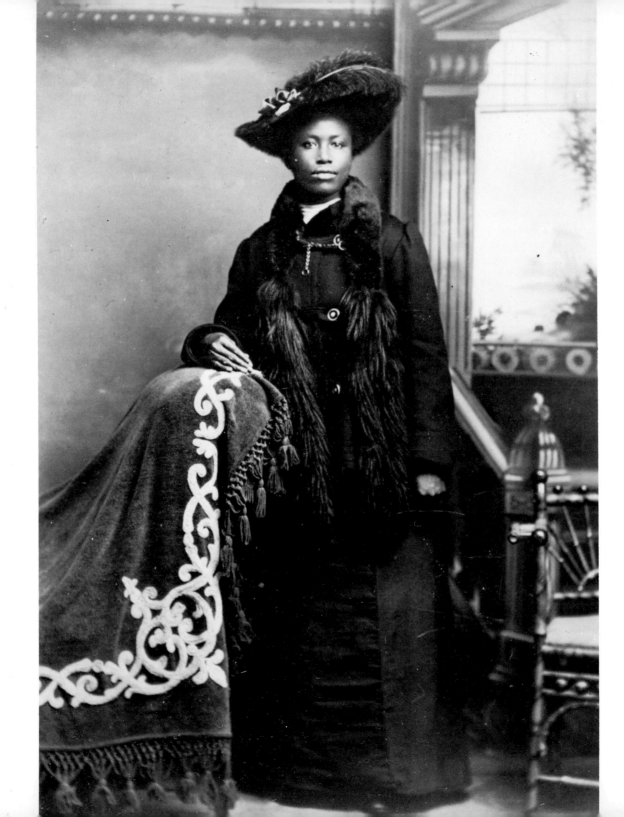

"Within 5 miles of Milton Junction and in a thickly settled part of Rock County, Mrs. Ira Ames starved and froze to death. The case was reported to the authorities at Janesville and it was found that the father had spent most of his time fishing while his wife and 7 children were in a rickety shanty without fuel or food. The youngest child died a week ago and was buried under the snow by the father in a soap box." [3/16, State News]

"Mrs. A. J. Cowles, aged 87 years, died at Beloit. She had been married to Deacon Cowles, who survives her, for nearly 68 years. On the occasion of her last birthday her eccentric husband presented her with a coffin which he had made with his own hands and in which she was buried." [3/16, State]

"A woman who gave her name as Wilson died at Chippewa Falls from a criminal operation performed upon herself. Her parents live near Eau Claire . . . her brother took charge of her remains. The woman was young and pretty and visited every physician in Chippewa Falls to accomplish her object, but without success." [4/6, State]

1893

Frozen starvation Death – anticipation
Fatal abortion Insanity Incendiaries
Armed tramps Tramps Window smasher
Black diphtheria Incest Unemployment
Business fairy tales Farm depression
Mill failure Retail failure Bank
 examination
Factory failure Retail failure Bank
 failure
Bank failures Bank treasurer shooting
Retail failure Bank failure Incendiaries
Sabotage – tramps Insanity Diphtheria
Diphtheria Child death – diphtheria
 General
Unemployment Black sex Fatal anti
Dipsomania gold Cure Diphtheria –
 epidemic
Frozen helpless no work poverty
Starvation Family wipe out – diphtheria
Miserly hermit Insanity – perpetual
 motion

Three case histories from Mendota State; how everyone in town who lost their money first made it

"On Wednesday evening of last week, Mrs. Thea Gilbertson from the town of Franklin was adjudged insane by Judge J. D. Perry and was taken to Mendota on the Thursday afternoon train by Sheriff Buckley. . . ." [4/13, Town]

"Admitted Oct 1, 1897. Town of Merrillan. Swedish. Age 46. Widow. Four children. Youngest, 5 years old. Housewife. Very Poor. First symptoms 2 weeks ago: 'foolish talk.' Cause thought to be death of husband and other trouble. . . . Deranged on subject of religion. Thinks she will die. . . . Oct 6th: Died at 12:45 from Exhaustion of Acute Mania." [Mendota State, 1897 Record Book (G, Female), patient #7647]

"Seventeen business buildings and residences were burned at Montfort, Grant County, the other morning. The business part of the village was practically wiped out. . . . It was Montfort's second fire in 8 weeks and it was believed incendiaries were at work." [6/1, State]

"Waunakee was raided by tramps the other evening and nearly every business house and many residences were burglarized. The occupants of dwelling houses in many instances were driven into the street at points of revolvers while other members of the gang ransacked the buildings." [6/22, State]

"Tramps were never so numerous here as for the past week or two. Sometimes they come in large droves. Station agent Moran says that he one day counted 24 about the depot at once. Some of them are quite persistent and somewhat insolent in their methods of obtaining sustenance." [7/27, Town]

"Mary Sweeny, of window breaking fame, attempted to throw a satchel through one of R. Katz's Clothing Store windows at Fond du Lac. . . . She was arrested [and] . . . given 5 days in the county jail."

[8/31, State]

"The Ashland health officers have become alarmed about black diphtheria which has made its appearance at that place in its worst form. . . . It has been confined to a single tenement house up to the present time. . . . Policemen have been stationed to guard the house." [8/3, State]

"General Grant Olson, of Pleasant View, was placed under arrest Friday afternoon last on the charge of adultery. . . . The victims of the villain are his own step-daughters, one of them being but 11 years old and the other not much older . . . one having become a mother nearly 3 months ago." [8/3, Town]

"The labor situation in Northern Wisconsin, especially in the lumber district, is not encouraging. The refusal of the employees to accept a reduction in wages has caused the shutting down of numerous mills." [8/10, State]

"Admitted May 6, 1891. Town of Brockway. Age 39. Anglo-Saxon. Widower. No children. In lumber and shipping business. Poor. First symptoms began about 2 years ago. Melancholy and desires to avoid people . . . lost wife about 2 years ago."
[Mendota State, 1887 Record Book (Male, F), p. 576, patient #5560]

"With many banks and other business houses falling in every direction and in all parts of the country almost daily during the last few weeks, it speaks well for the careful and conservative business houses in Jackson County to be able to say that there has not been a single business failure in the county; and there has not been what could be properly called a run on either bank. . . . What scare there was has now practically blown over. The money is returning and the banks will soon have more than they know what to do with. . . . Whatever comes we will not be affected as are the great industrial centers." [8/17, Town]

The Yankees were the first white men in the county. The Norwegians were the greenhorns. They'd come because the Yankees calculated they'd be useful. Things might have been simpler if they'd been sealed in tins and sent directly from Gulbrandsdalen. As it was, Dudley Spaulding would tell some shipping agent in Prairie du Chien that he'd guarantee the passage if the fellow could get together fifty hands who could cut wood and bring them up river. Once the agent had his load and Dudley had his men, he'd play them along. First he'd tell them about his good camp cook, then he'd promise them credit. He'd be very honest. He'd tell them exactly how things were in the lumber trade: everyone had to trust everyone else until the end of the season and the logs were cut. While the men were in the woods, Dudley would be in a law office. At the end of the season, they'd come to him, hat in hand. And he'd stand in the doorway and turn his pockets inside out. "I can't help you boys. I'm a poor man. I'm in debt to my wife. She's got it all." And of course she had, thanks to Dudley's signature on the forms his lawyer had prepared. In this way, he left men without money and forced the weaker ones to work and wait through another season. Some of the others, who weren't so timid, left for Minnesota.

In the nineties, a rich man from St. Louis imported a whole bunch of Rhine Palatinate Germans to work the local iron mine. As long as the ore stayed at 60 percent, everything was fine. Even when it dropped to 40 percent, everything was still pretty good since they could steal timber on the side to make their charcoal. But when the trees gave out, the whole thing stopped. That rich man from St. Louis moved the smelting plant up to Spring Valley and left the Germans behind living on German Hill. Pretty soon, people began to call it Poverty Hill.

After the trees went, there was nothing left to do. It had been hard enough to begin anyway. After all, the only reason that those trees had waited around for old Jacob back in the forties was because they'd been nearly impossible to get to, and nearly impossible to raft down the river. They were all so high upstream that by the time they got to the Mississippi, they were so full of sand that they dulled the planers. [Local History]

"The W. W. Cargill Company, the large grain buyers of La Crosse, have sent out a circular advising farmers not to rush their grain upon the market as soon as threshed, but to hold every bushel above what has to be sold to meet forced obligations. Above this, which will exhaust all the money held by country merchants, there does not seem to be any way to handle the crop until times improve. The banks are all unwilling to cash drafts on bills of lading, or advance money on warehouse receipts for grain in the safest public elevators. They state that if any large volume of grain or seed should now go on the market, it would force prices still lower. . . ." [8/24, Town]

"The employees of the John R. Davis Lumber Company at Phillips refused to accept a reduction of 10% in wages, and as a result, the mill has been shut down." [8/24, State]

"The general merchandise store of R. M. Goodwin of Antigo was closed on a judgment of over $7,000 by the First National Bank of Aurora, Illinois." [8/24, State]

"The examination of the affairs of the First National Bank of Ashland by U. S. Bank Examiner Bates is finished and he declares the bank perfectly solvent." [8/24, State]

"The Baun Wagon Co. and the Chicago Brass Co. in Kenosha have closed down for an indefinite period of time. The shut down throws 500 men out of employment." [8/24, State]

"Executions on judgments aggregating $117,000 were served on the Hudson Furniture Company. The company has been supported by local loans for several years and has no large outside creditors." [8/24, State]

"At Rice Lake the Barron County Bank closed its doors. The liabilities are $20,000; assets, 5 times that sum. Every cent of the indebtedness will be paid in full and the bank will resume business in the course of a few weeks." [8/24, State]

"The Bank of Black River Falls, capital $10,000, and the Bank of Ellsworth, capital $35,000, have closed." [8/24, State]

"An attempt was made to assassinate W. L. Seymour, cashier [treasurer] of the defunct Seymour Bank of Chippewa Falls. One shot passed between his arm and body, and the other went wide of the mark." [8/31, State]

"At Greenwood, E. Peterson and Son, small dealers in general merchandise, made an assignment to L. W. Larson for the benefit of their creditors. Inability to collect so as to meet their bills as they became due was the cause." [8/31, State]

"The Commercial Bank of Eau Claire which closed recently will be reorganized and reopened." [8/31, State]

"Four attempts have been made by incendiaries to burn the Venner House, Superior." [9/21, State]

"Tramps who were refused food at the home of John Ovenbeck in the town of Friendship, Winnebego County, entered the barn at night and cut the throats of 3 cows, which bled to death. A card attached to the horns of one bore the following message: 'Remember us when we call for something to eat again.'" [9/21, State]

"Nels Stadig of Northfield was adjudged insane . . . Monday afternoon last and was taken to the asylum at Mendota . . . by Sheriff Buckley." [9/28, Town]

"Admitted Jan. 4th, 1907. Town of Cleveland. Age 65. German. Widowed. Youngest child, 25 years old. Farmer. Fair circumstances. First symptoms began several years ago. Acted queer, starved cattle. . . . Believes witches and bad people are around and keep things going wrong. Sees them every day. . . . was so mean that family couldn't live with him. . . Has destroyed or starved several hundred dollars worth of cattle, claiming that witches were the cause. . . ."
[Mendota State, 1907 Record Book (L, Male), p. 226, patient #10758]

"There has been an unusual mortality among the children at Grantsburg and vicinity lately. The many deaths have caused a feeling of great uneasiness and alarm, and it was decided to close the schools. . . . The deaths have been so frequent that in many cases 2 members of the same family have been buried on the same day. The doctors differ in opinion as to the nature of what seems to be an epidemic." [10/12, State]

"Diphtheria is reported to be epidemic in Chippewa County. Stanley is in a state of quarantine. The schools of Cardott, Boyd, and Thorp have been closed." [10/19, State]

"The double funeral of 2 children of Mr. and Mrs. Charles Hopke of Racine was held Thursday, this making 3 out of the family that have died of diphtheria in 2 weeks, and there are 2 more lying at the point of death." [11/16, State]

"Regarding the condition of the unemployed in the new county of Iron, Governor Peck states that nothing further has been done. He has however been informed that the town authorities are doing all they can to relieve the sufferers though their resources are inadequate to the demand." [11/16, State]

"Clifford Bell, a colored attaché of a traveling show, was arrested at Plainfield and taken to Mauston. He is charged with the abduction of a pretty Mauston girl." [11/16, State]

"Thomas Galt died at his home in this city Friday night last . . . from the effects of the Ackerman anti-dipsomania gold cure which he was taking. He was 37 . . . he contracted the drink habit and it so obtained the mastery of him that he was much of the time incapacitated for labor. He was so anxious to break the fetters that enslaved him . . . that he risked and lost his life. . . . He was a great sufferer throughout the treatment." [11/16, Town]

That law practice that Bill Price and C. R. Johnson shared for a while must have been responsible for turning Bill toward Temperance. Local historians say the idea came to him while he was standing around the bar of a hotel called the Shanghai House which Jacob Spaulding had put up in 1846 and christened with a party that ran for a couple of days. According to other people, like Colonel C. C. Pope and P. H. Howell, who were old enough in the 1880s to write reminiscences for the local paper, nothing of any sort ever happened anywhere to anyone in that whole town without a bottle coming out. After all, they

said, one of the first keelboats that ever reached Black River carried as cargo two barrels of flour, five barrels of pork, and twenty-five barrels of whisky. Some other people even claimed that the only reason the mile stakes were uniform on the state road that got laid out in 1849 between Prairie du Chien and Hudson was because the gallon jugs that the surveyors carried contained enough brandy to last them exactly 5,280 feet until the next refill.

About forty years after that first keelboat, Colonel Pope recalled that even though there were a lot of shootings and burnings, there weren't so many murder trials. This was probably because the mill owners and the lumbermen settled most of their serious arguments outside of court. Sometimes they used shotguns, sometimes a little kerosene. Most of their disagreements had to do with log stealing. The sawmill owners up river understood that the only way they could make a living was to cut timber, so they dragged any and all logs going down river into their booms, cut them, and sent them on again minus a few hundred feet of timber. They said they only sawed the logs; the lumbermen said they not only stole them but ruined them. Sometimes there'd be a lumberman who'd rafted down river with his logs, standing there, chopping away at the boom that had broken up his log drive, and sometimes there'd be a mill owner on the bank watching him down the barrel of a shotgun. Those were the times when somebody got killed and someone else eventually got burned out. Other times there was just one mill owner burning out another to protect his right to make an honest living.

"The epidemic said by some to be diphtheria, that prevails at Grantsburg among the young people, goes on without abatement. A large number of deaths have occurred. . . . The schools have been closed. . . . It has taken hold of the Chippewa Indian papooses and a large number of deaths are reported. The epidemic has given such alarm that it is hard to induce the living to bury the dead." [11/30, State]

"There were 2 feet of snow on the ground [in Iron County] and the mercury [hovered] below the zero mark most of the time. . . . The mines began shutting down last June, and at present there is not a single mine in operation on the entire [Gogebic] range—a region that mined something like 10,000,000 tons of ore last year. There are altogether about 15,000 people in a helpless condition . . . strong men were found weeping because their sick wives and helpless children had nothing to eat and next to nothing to wear. . . . Many of the single men are leaving the country, seeking a means of livelihood elsewhere, the railroads furnishing free transportation." [12/7, State]

"The family of Andrew Hoffman of Oshkosh is an unfortunate one. Diphtheria made its appearance in the family 5 weeks ago and since that time 4 children have passed away. The children are now all dead with the exception of a boy who ran away from home some time ago. The parents are heartbroken and Mrs. Hoffman, whose health has been poor, is in a precarious condition." [12/4, State]

"Searchers from Glidden, Ashland County, have thoroughly gone over the premises of James Beckey, the hermit, who was found dead in his hut . . . but no money has been found excepting 15 cents. It is generally understood that Beckey had hidden about $50,000 in government bonds. . . . He was a formerly wealthy man, living near Eau Claire. His wife left him 10 years ago and after that time Beckey became morose and solitary. He built a hut near Glidden and had lived the life of a hermit up to the time of his death." [12/21, State]

"Albert Proch has been adjudged insane by the La Crosse physicians. For some years he has been working over a perpetual motion machine . . . a short time ago he applied to the Common Council for financial assistance that he might perfect and patent his machine." [12/21, State]

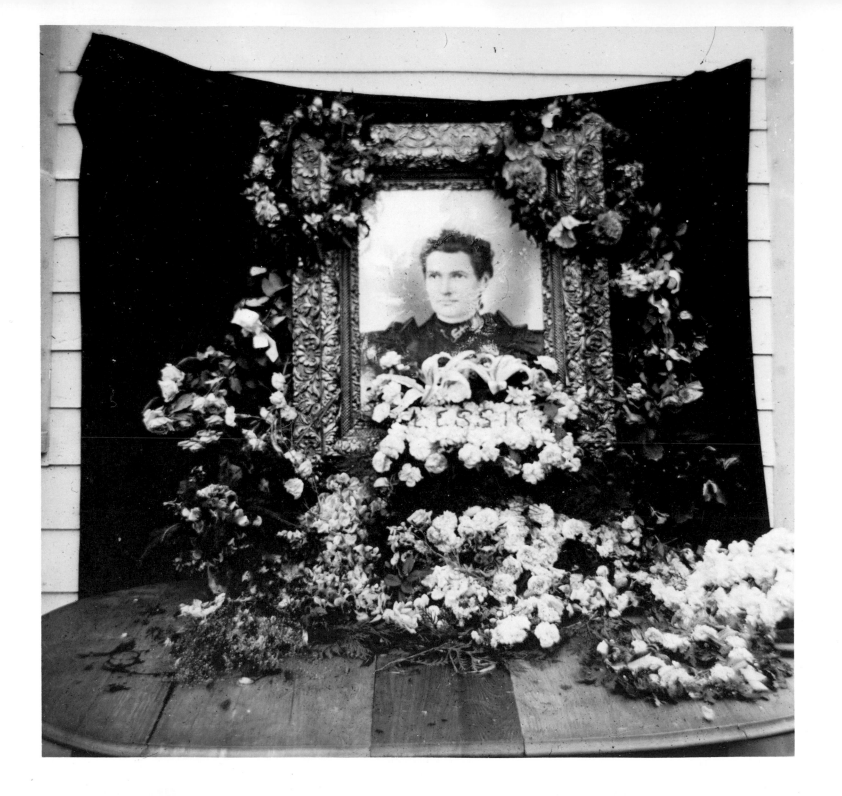

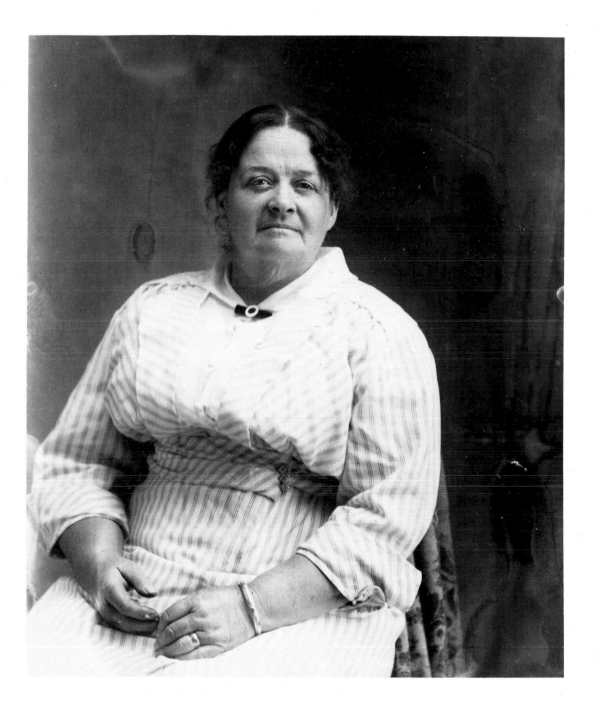

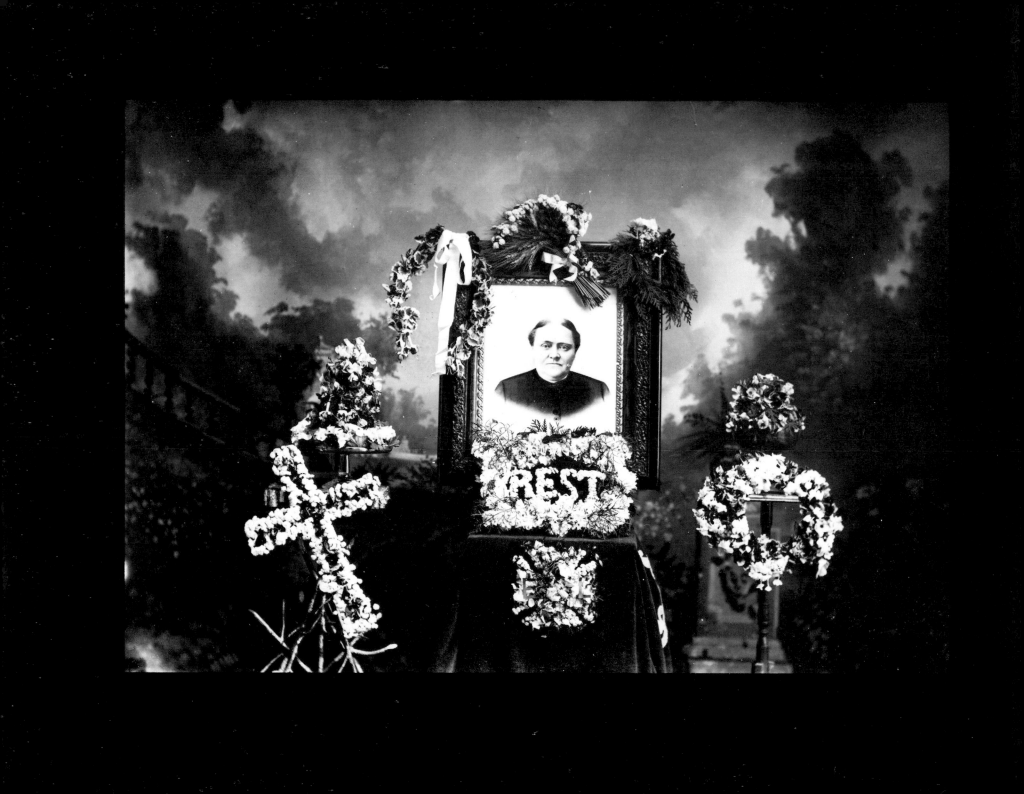

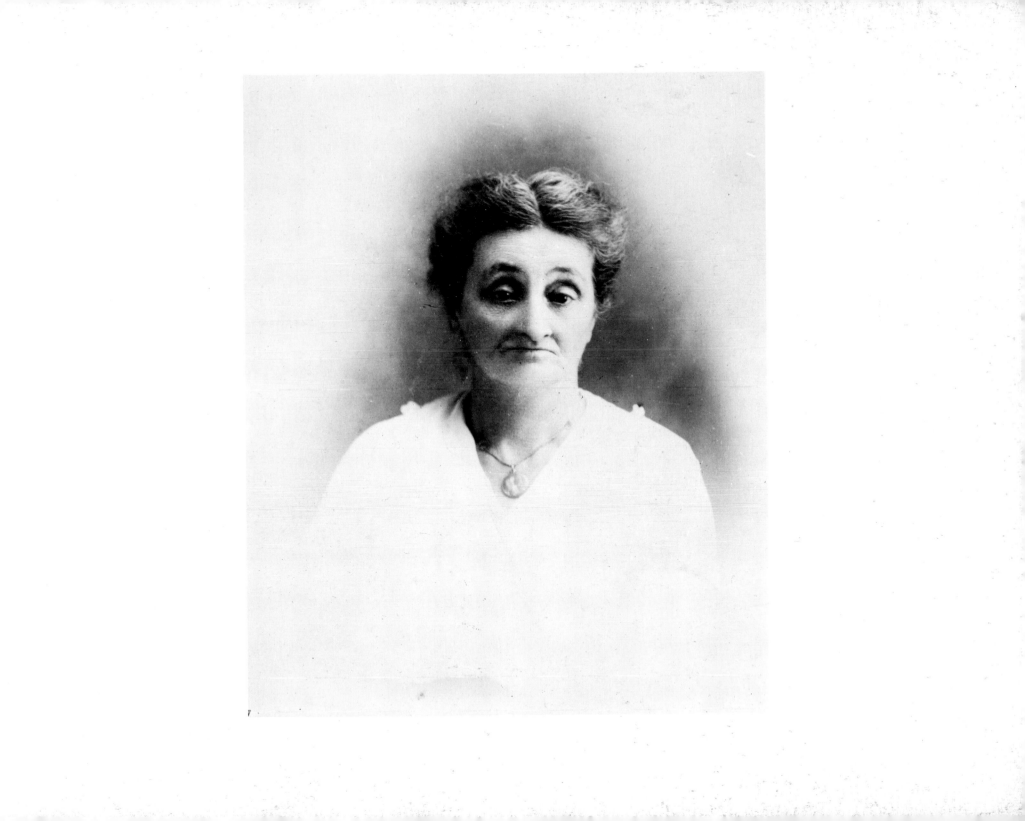

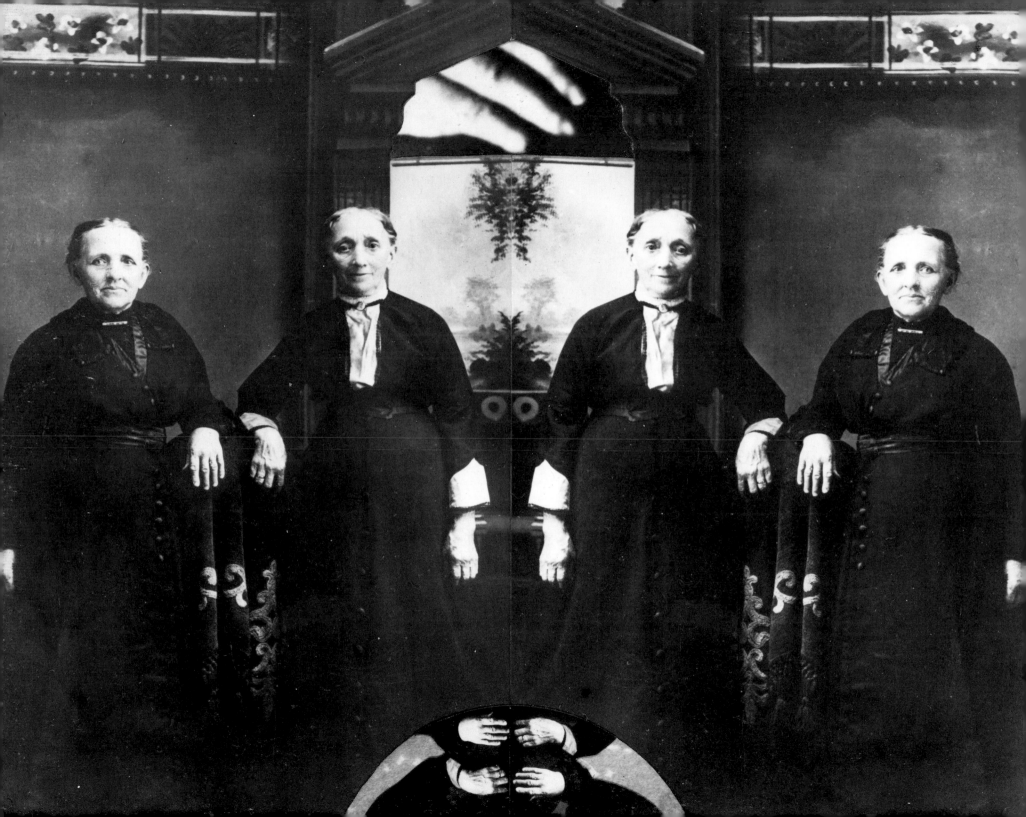

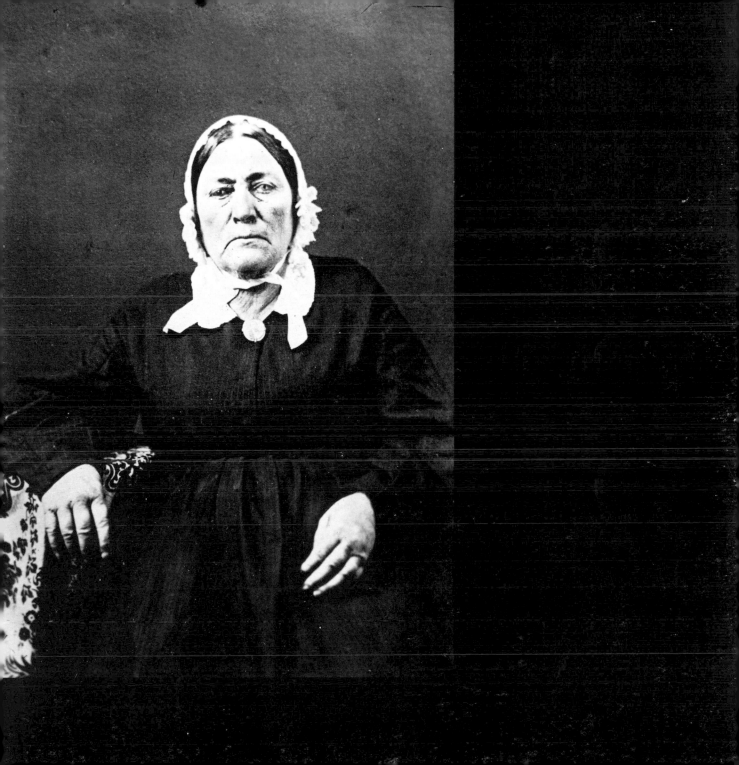

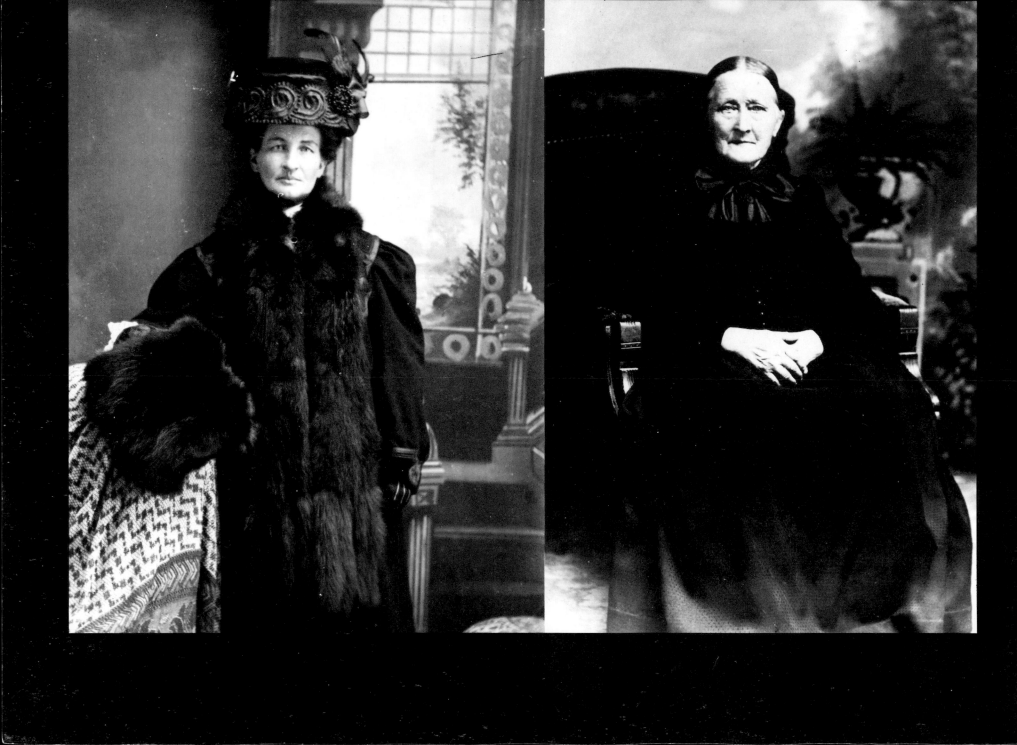

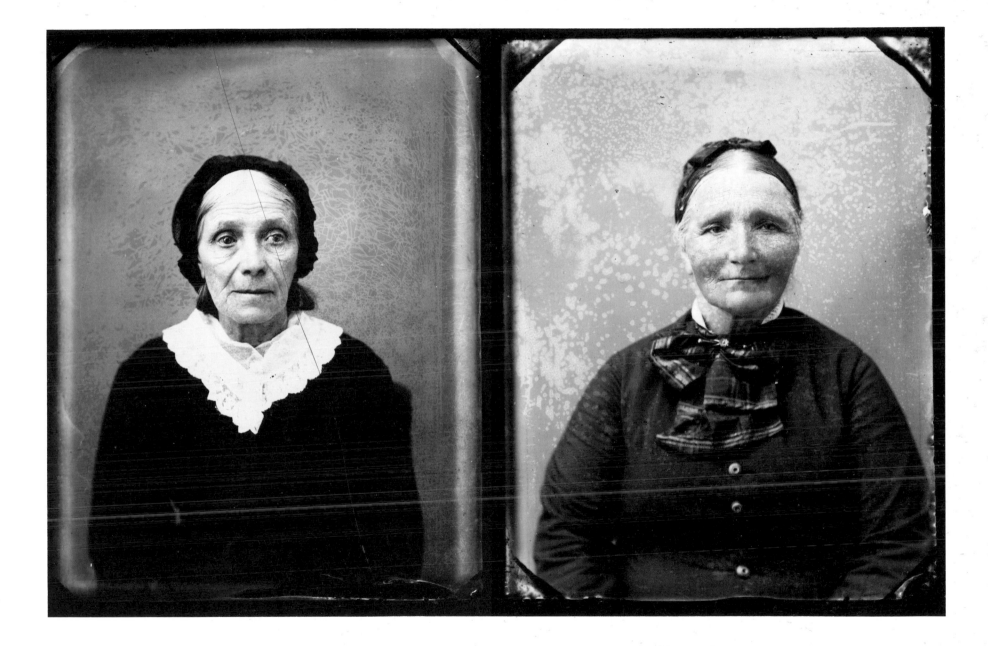

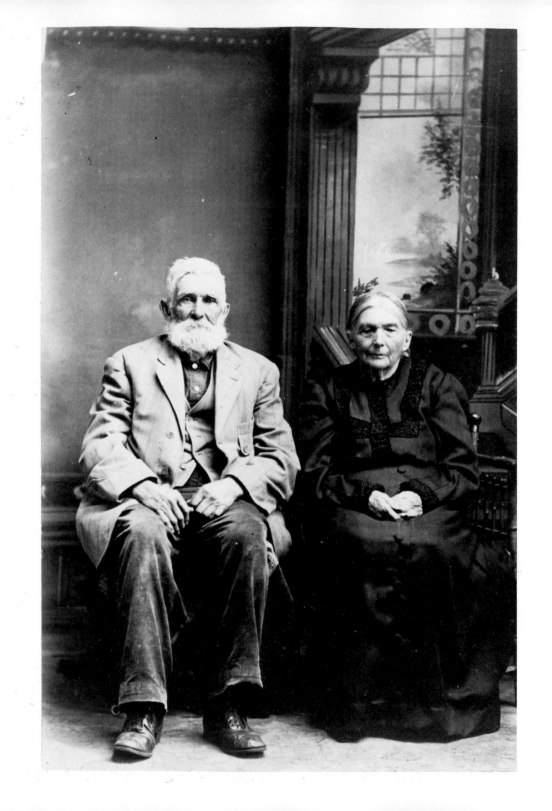

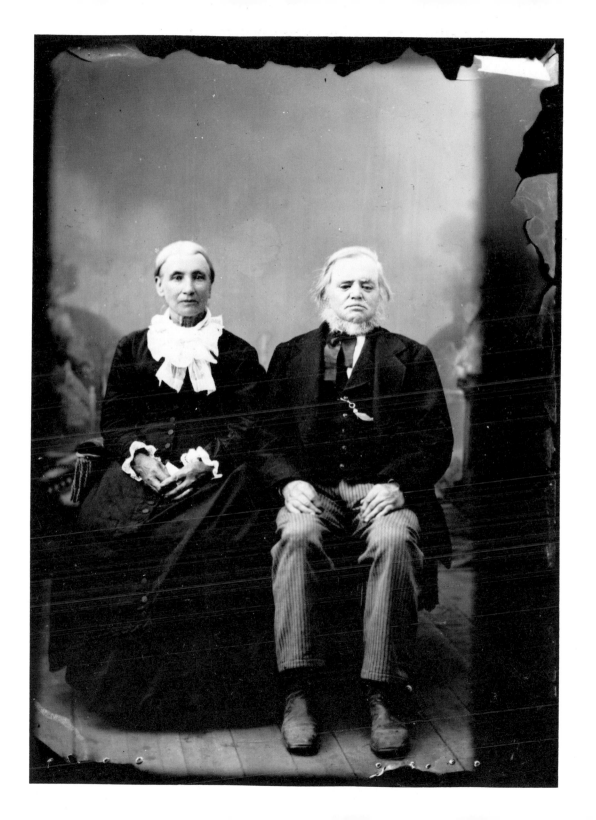

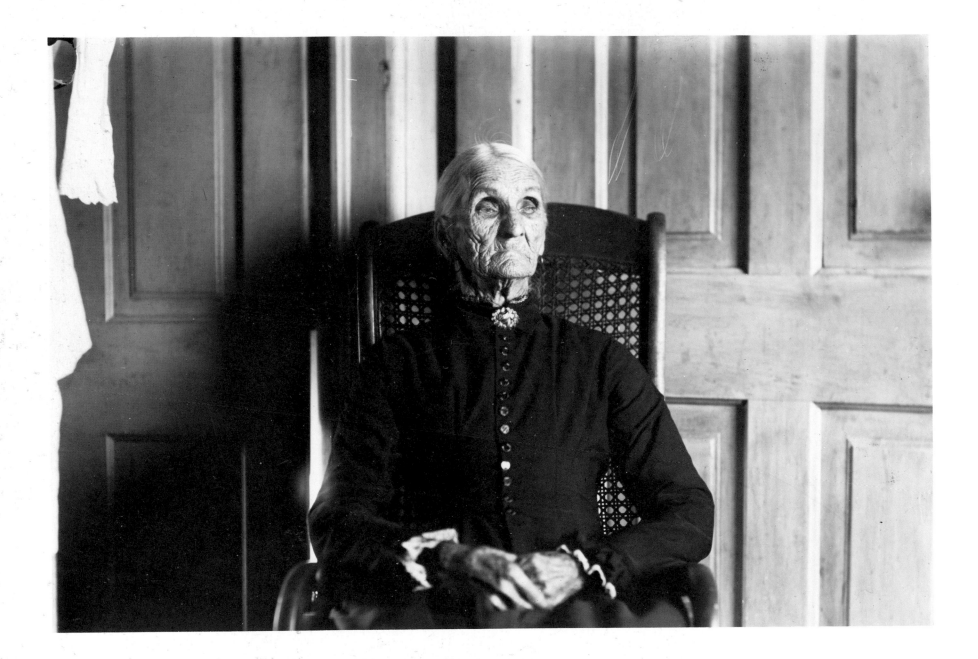

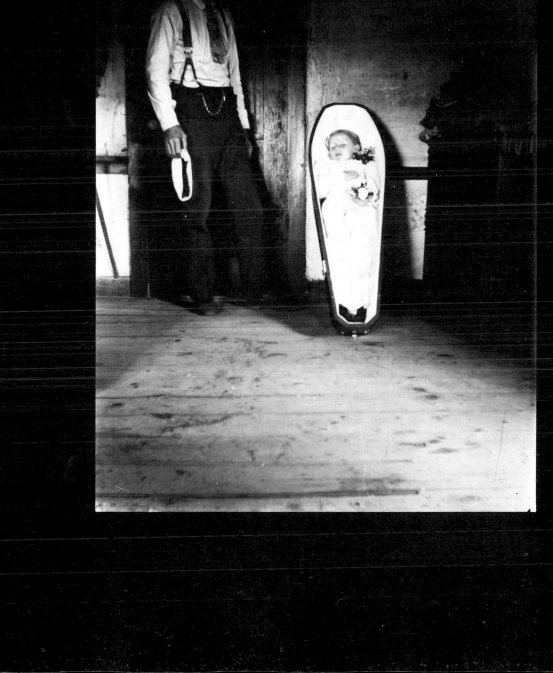

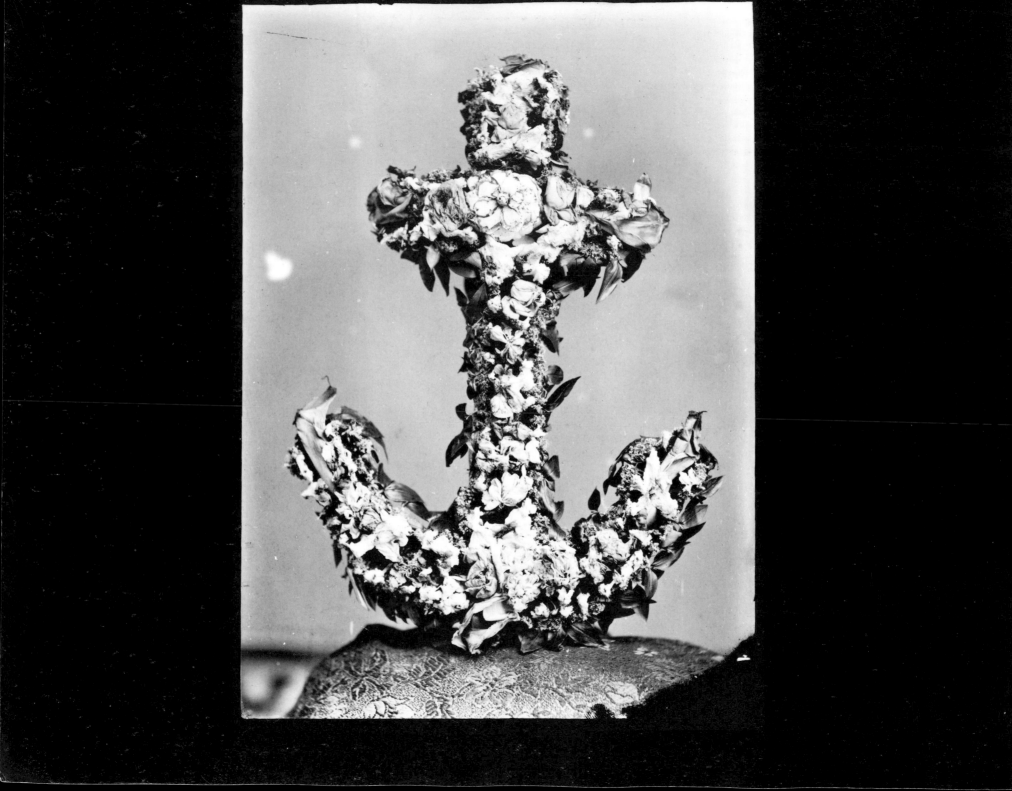

"Anna Morris, alias Frank Blunt, the woman who has tried to be a man for the last 15 years was sentenced to the penitentiary for one year. . . . She was arrested several months ago in Milwaukee, charged with stealing $175. . . . It was then discovered that the prisoner was a woman, although she had worn masculine attire nearly all her life. . . . After the sentence had been passed, Gertrude Field, a woman who claimed to have married the prisoner in Eau Claire, fell upon the neck of the prisoner and wept for half an hour. This woman has furnished all the money for Blunt's defense and now proposes to carry the case to the Supreme Court."　　　　　　　[1/18, State News]

"There is a house situated about 5 miles east of Albany in Rock County that farmers claim is haunted. Several families have rented the house within the past year, but in every case they got out as soon as possible."　　　　　[2/22, State]

"Mary Ricks, the Wisconsin window-smasher, has put in an appearance at Eau Claire. She was taken into custody by a policeman as she was about to wreck a fine plate glass window."　　[2/22, State]

1894

*Tragic lesbian romance Ghosts
Window smasher D. J. Spaulding –
Bankruptcy Hugh Price – bankruptcy
W. C. Jones – bankruptcy Railway
Suicide Absolute familial disaster
Typhoid Sadistic boredom Tramps
Child murder – mother Suicide crazy
Insanity – blindness Armed tramps
Insanity – she-wolf Suicide – repeated
Diphtheria – epidemic deaths Insanity –
Violent Wildman Crazy Socialist –
Sabotage Incendiaries Crazy Socialist –
Sabotage Forest fires – towns incinerated
Forest fires – families obliterated
Forest fires – suspected arson
Forest fires – deliberate corporate
Negligence Insanity – forest fires
Rosenberg Bros. – bankruptcy Epidemic –
Croup – diphtheria Retail failure
Insanity Sabotage – blackmail
Diphtheria – family obliterated Oriental
Xenophobia refuted*

How some people in the town talked about the Spaulding girls and the Yateman sisters and the Knight girls; how Norwegians resembled Americans; Edgar Lee Masters' story of Nancy Knapp; two Mendota case histories

"Last Saturday, Sheriff Buckley sold the D. J. Spaulding water power, including the boarding house, the wagon factory, the large barn west of the factory, the large warehouse near the end of the county bridge, the feed mill, and various lots and unplanted land surrounding the power, to satisfy a mortgage . . . of $35,061. A man from Eau Claire bought it for $10,000 and then offered to sell it to Black River Falls businessmen for $15,000. A committee consisting of Daniel Stiehl, J. J. McGillivray, H. H. Price, M. Martens, and J. E. Bensen met to discuss the offer."　　　　　　　[3/15, Town]

Those Spaulding girls, Mary and Jane. They were Dudley's children, so they were old Jacob's grandchildren. They were hard working, but slow witted. They went to Oberlin. When they came back they were courted by Tom Van Schaick, Charly's handsome brother. He kept books for old man Bright, another Yankee lumber millionaire. Tom might have even worked for Dudley at one time. Anyway, he read the financial news quite a bit.

The trouble was that Tom was in love with one of the twins, but she wasn't in love with him. And the other twin was in love with Tom, but Tom wasn't in love with her. They all just stayed good friends for the rest of their lives. The girls never married. They remained true to one another till the end. In the meantime, Tom watched the financial page like a hawk for them, and told them how to invest.

Then there were the Yateman sisters. . . . They were cousins of the Spaulding girls, but the twins wouldn't have anything to do with them. It was probably because they were jealous since old Jacob had left the Yatemans an inheritance that the twins thought they didn't deserve. But it was such a small little inheritance that, in order to live on it, the sisters had to put up their own jam and grow their own garden and make their own clothes. And every summer, they had to work picking berries.

They never married either. And they lived to be quite old. It was the deaf one who went out picking berries along the railway track. She got hit by a train and that took care of her old age.

And there were, dear God, the Knight girls. Old man Knight actually had a million dollars at one time. He had one son, Ted, and four daughters, Lorraine and Anna and Rose and Helena. He died and only one of them married, but she got divorced. They all lived together in a house that had been a hotel before their daddy bought it. They lived on his capital.

Anna, the one who married, married a fellow who had worked for her daddy up in Monroe County. She taught in some private boys' school in Minneapolis or somewhere. But late in life, something happened and they got divorced. So she moved back home. They all lived there in that house, but they had nothing to do with each other. Each one stayed by her-self. They must have had meals together. But they weren't on speaking terms.

The funny thing was that every single member of that family died of cancer. First Ted. Then Helena. Anna, Rose, and Lorraine lived a while longer, staying down there hating each other like poison.

Lorraine, she had a real father fixation. She wanted to keep her father's memory green in town. So they had a handsome headstone for him and kept it supplied with flowers every holiday. [Town Gossip]

"The first business failure in Jackson County, during or resulting from the worst financial crash and commercial depression the country has ever known, was announced Monday night when the Honorable H. H. Price assigned all his property to attorney B. J. Castle for the benefit of his creditors. . . . Mr. Price has . . . stated that with an improvement in the times . . . his debts could be paid dollar for dollar and leave him a handsome surplus with which to begin anew. He owned and operated the large flour mill and starch factory at Hixton, the electric light plant in this city, was the principal owner of the mill at Taylor, had considerable pine and hardwood land . . . and had been a logger on a heavy scale. Misfortunes in his logging operations several years ago were undoubtedly at the bottom of his financial embarrassment. [4/12, Town]

Those Norwegians were even better Lutherans than the Yankees were Puritans. They went to church, they took orders, and they died with a nest egg. Then their children worked even harder and were even more careful. But the Yankees' children were either barren or reckless, since they had too much to live up to.

[Local History]

"One of the sad results of the assignment of Mr. Price was the business failure of W. C. Jones which it precipitated. . . .He had the largest grocery store in town and was really one of our most successful businessmen." [4/12, Town]

"Jerry Murphy, a chopper employed in Herrick's camp near Minocqua, was killed by the Northwestern Limited. . . . The engineer noticed him on the track, standing with his arms extended and facing toward the approaching train. The engineer could not stop the train until the man was struck." [4/12, State]

"The family of William H. Verken, a farmer residing 2 miles south of Norwalk Monroe County, has had a great deal of hard luck the past year. On Easter of last year, Mr. Verken's mother died, and a short time afterward he lost $100 worth of sheep. A valuable colt fell dead later on. A month later, his 8 year old son died after an illness of 4 weeks. Last fall, another horse broke his leg and had to be shot, and a week afterward, a 2 year old boy, the only remaining child, broke a leg. A few days ago, the residence was destroyed by fire, the insurance policy having expired a week previous. Mrs. Verken, who was confined to her bed with newly born twins, was obliged to leave the burning house during a severe snow storm. . . . Recently, Mr. Verken lost his entire lot of pigs." [4/12, State]

"Well, don't you see this was the way of it: we bought the farm with what he inherited, and his brothers and sisters accused him of poisoning his father's mind against the rest of them. And we never had any peace with our treasure. The murrain took the cattle, and the crops failed. And lightning struck the granary. So we mortgaged the farm to keep going. And he grew silent and was worried all the time. Then some of the neighbors refused to speak to us, and took sides with his brothers and sisters. And I had no place to turn, as one may say to himself, at an earlier time in life; 'No matter, so and so is my friend, or I can shake this off with a little trip to [town].' Then the dreadfulest smells infested the rooms. So I set fire to the beds and the old witch-house went up in a roar of flame, as I danced in the yard with waving arms, while he wept like a freezing steer."

[Edgar Lee Masters, "Nancy Knapp," in *Spoon River Anthology*]

"State Chemist Daniels has furnished an analysis of Ashland's drinking water and says that it is contaminated with sewage . . . the typhoid fever epidemic from which Ashland is suffering is now directly attributed to the water supply. Efforts will be made by the Attorney General to have the water company's franchise annulled." [4/9, State]

"A man at Eau Claire gave a colored boy $1.00 to shear a big Newfoundland dog and anoint him with kerosene oil. When the job, which was done in a livery stable, had been completed, and no hair was left on the dog except a tuft at the end of his tail, one of the hangers on around the barn touched a match to [it]. The dog was instantly a sheet of flame and ran howling down the street." [5/3, State]

In the early days, people set fires for business as well as pleasure. The courthouse got burned down before it was even built in 1857. In 1861 the town's entire business block, valued at $30,000, went up in smoke. Nine years later the Spaulding block, worth about twice as much, got burned down. About three years after that, the same thing happened to the Masonic block.

In 1866 John Parsons, who had been on the dole for twenty-five years as postmaster, wrote down his version of the first courthouse burning for the town paper. He said that it was still his opinion, as it had then been the opinion of the town's more respectable citizens, that the people who had done the burning were nothing more than a bunch of thieving low lives who'd decided to stop Justice before she even got a roof over her head. Parsons recalled that these respectable citizens had held an indignation meeting after which they ran two whores and their pimps out of town. Then they took a young fellow named Billy Smith out into the woods. They dug him a grave, put a rope around his neck, and encouraged him to tell them everything

that he knew about the burning. Poor Billy said he didn't know anything about anyone, so the men threw the other end of the rope over a convenient limb and jerked him off the ground. They held onto him until he nearly strangled and then they let him down. As soon as he could talk they asked him to tell them about it again, but poor Billy just told them exactly what he'd told them the first time, so they heaved him up again and let him jiggle up there some more, then set him down and waited for his next explanation. This time he didn't say a thing; he just took the ring off his finger and the silver out of his pocket and handed them to one of the fellows at the other end of the rope and asked him if he would please let his sister have them after he was dead. This must have been a very touching gesture, since they carefully put everything away and then yanked him up again for a third time. Since he was still breathing when they let him down again, they let him leave town without further incident.

Not that they were satisfied. They decided they'd been wrong; they shouldn't have run those pimps out of town without asking them some questions. When they went out looking for them again, they found Abe Carr. They surrounded his cabin and put him in chains. Carr was a little older than Billy so he was a little smarter. He decided pretty early that they were probably going to hang him, so sportsman that he was, and adventurous entrepreneurs that they were, he suggested to them a game of chance, a passing amusement, a pleasing distraction having within it a grain of truth: why not let him jump in the river

chained as he was and see if he could make the other side. If he made it across — well fine, it was all a matter of luck anyway, and if he didn't, it would look like some rash suicidal act they'd had nothing to do with. Those men may have been his captors, and he may have been nothing more than a pimp while they were respectable citizens, but they were all men nonetheless, all equally trapped in the battle for a buck and a good lay. And so, just as they had been touched by Billy's simple but eloquent gesture, so too were they touched by Carr's foolhardy daring. They decided to let him try since the water was pretty high and the river was running good and fast. They were pretty surprised that he managed to make it two-thirds of the way across before he went down. One of the crowd, probably a man with no sense of fair play, jumped into a boat and pulled him out just as he was coming up for the third time. Parsons never did say what they finally did with him after that.

"There is an army of about 50 tramps making Racine their headquarters. . . . The other evening, the vagabonds took possession of Racine Junction and ran things to suit themselves. A number of them entered farmer Sheldon's barn and proceeded to behead 18 chickens. Others . . . entered stores and carted off meat wholesale. . . . The tramps took to the woods and had a feast." [5/10, State]

"Mrs. Edwards, wife of De Witt Edwards, a well-to-do farmer of the town of Honey Creek near Waterford, and her 10 year old daughter were found the other day in terrible pain . . . in the evening the child expired. It appears that Mrs. Edwards placed a quantity of arsenic in a cup of chocolate and that both drank of its contents. For some time Mrs. Edwards has been partially out of her mind. . . . she confessed that she preferred to die rather than become an inmate of an asylum. She will recover." [5/17, State]

"Peter St. Martin of the town of Arthur, Chippewa County, who was driven insane by adversity and the loss of his eyesight, and set to the asylum, died after 10 days of confinement." [6/7, State]

"Five tramps went in Groshong's store and restaurant at Beloit, drove the proprietor and help out at the point of revolvers, emptied the till, and made themselves at home . . . finally having a free-for-all fight over the division of the spoils." [6/21, State]

"While Mrs. John Manning was picking berries a short distance from Arcadia, she came face to face with a large she-wolf with a number of whelps. The woman was terribly frightened, her screams attracting the attention of some workmen nearby who carried her home. She is in critical condition and it is feared she will lose her reason." [6/28, State]

"E. Andrews of Lodi shot himself in the head with a revolver and cannot recover. Three years ago he hung himself while temporarily deranged, but was cut down and never knew of the matter, his people keeping it from him. He was 60 years of age." [7/5, State]

"Diphtheria is spreading in the town of Marshland near Grantsburg. . . . People are afraid that there may be a repetition of last fall's epidemic. During the past year nearly 100 deaths have resulted from diphtheria in that vicinity."
 [7/26, State]

"Gutturom Johnson, from the town of Franklin, violently insane, was taken to the Mendota asylum, Saturday, by Sheriff E. V. Buckley." [8/2, Town]

"Admitted Sept 25, 1893. Town of Northfield. Age 38. Norwegian. Married. One child, 2 years old. Brought handcuffed to hospital. First symptoms noticed 7 years ago, then 5 years ago, and 2 years ago, and again in July 1893. Thinks his neighbors are afraid of him and intending to injure him and drive him away. . . ."
[Mendota State, 1893 Record Book (Male, G), p. 279, patient # 6286]

"William McCarty, the wild man of Spaulding's Lake, Rock County, has been captured again . . . he is now confined in the county jail awaiting the arrival of officers from the Mendota insane asylum. . . . He was found hidden in a haystack." [8/2, State]

"An unknown man giving the name of William Harper and calling himself a Chicago socialist threatened to blow up the Ashland National Bank. He was overpowered in the bank, with police assistance. Fifteen bottles of green liquid and a package of an unknown powder were found on him." [8/2, State]

"Four fires of incendiary origin were started in La Crosse, Tuesday night. . . . The firebug was . . . thought to be a tramp." [8/9, State]

"At Ashland, William Harper was held on a 10 days' sentence pending investigations and analysis of his bottled liquids. . . . Harper states that 8 months ago he attempted to break a window in a bank at Centralia, Illinois, and was arrested but not held. He claims to be a wheelwright and is intelligent. Besides his bottles of liquid, another containing a powder resembling strychnine was found on his person." [8/9, State]

"Late reports from the scenes of the forest fires in Northern Wisconsin augment rather than decrease the number of fatalities and the amount of property loss. The following towns are known to be entirely wiped out. . . . Shell Lake, Barronett, Bashaw, Haugen, Cardott, Spencer, Fifield, and Benoit. . . . Washburn was scorched and Glidden and Coplar are now burning. . . . The loss of life is variously estimated between 200 and 400."
 [9/13, State]

"The reports from the burnt districts show that entire families have been destroyed." [9/20, State]

"Settlers around Marengo, which place was destroyed by the recent fires, have caused the arrest of Mike Roepler, charging him with having set the forest fire which swept over that region, destroying Marengo and Agnew with a loss of 8 lives. The prisoner was hustled off to Ashland and has been placed in the county jail there for safe keeping as the feeling against him among the homesteaders is very bitter." [9/20, State]

"The fire stricken people of Minnesota and Wisconsin, having buried their dead . . . are asking themselves how such tragic and destructive conflagrations can be prevented. . . . It is the opinion of the *Milwaukee Sentinel* that laws are needed to compel lumbermen to burn timber tops at suitable seasons and also to keep all timberland free from accumulations of dead timber." [9/27, State]

"Mrs. Otto Olson, of Hinckley, Minnesota, is wandering about Northern Wisconsin and Minnesota looking for little ones who are supposed to have been burned to death in the great fire at Hinckley last summer. The woman is nearly crazed with grief and clings to the belief that her children are alive." [11/29, State]

"The sensation of the week has been the crash in the financial affairs of Rosenberg Brothers. It is more sensation from the fact that they were generally regarded as one of the most substantial and financially responsible [clothing and dry goods] houses in the city." Claims against them amounting to $10,200 were made by a number of Chicago dry goods houses. [12/6, Town]

"For the past 2 weeks, an epidemic of croup has raged among the children at Appleton and the death rate has been very high. The disease has been of the malignant form complicated with diphtheric symptoms." [12/6, State]

"At Racine, Sheriff Batty attached the stock of J. W. Flood and Company, one of the largest dry goods houses in the city." [12/13, State]

"Theodore Amundson, about 19 years of age, son of Mrs. John Larson of the town of Garfield, was . . . adjudged insane by Judge Barclay." [12/13, Town]

"Admitted Jan. 3, 1894. Town of Melrose. Norwegian. Age 27. Single. Farmer. Poor. First symptoms noticed 1889 and have reoccurred every winter. . . . Rational most of the time during the summer. . . . Deranged on the subject of finances. Disposed to injure others. . . ."
[Mendota State, 1894 Record Book (Male, G), p. 329, patient #6389]

"Two farmers living in the town of Cooperstown recently received a letter mailed from the post office at Manitowoc saying that if they did not deposit $150 each in a tin box which they would find on a certain stump on a certain road . . . their buildings would all be burned. The farmers reported the matter and a large number of people gathered near the place designated. They found the tin box, but no trace of the blackmailer." [12/27, State]

"The family of Henry Miller of Cedarburg is sorely afflicted. A 6 month old child died of diphtheria a week ago and now a 7 year old boy is dead. A few weeks previous, 2 children had died, all of the same disease . . . one child survives out of a family of 5 children and that too is down with the disease." [12/27, State]

"Some of the boys in this city have been indulging in a kind of sport of late which may soon prove to be something besides sport. They have been harassing the Chinese laundryman by tapping on his windows, throwing stones and sticks of wood against the side of the house, against the doors, and even through the windows. They have even gone so far as to open the door and throw in a dead cat. . . . We advise the boys to desist or some of them may soon be called to answer for their folly before the magistrate."

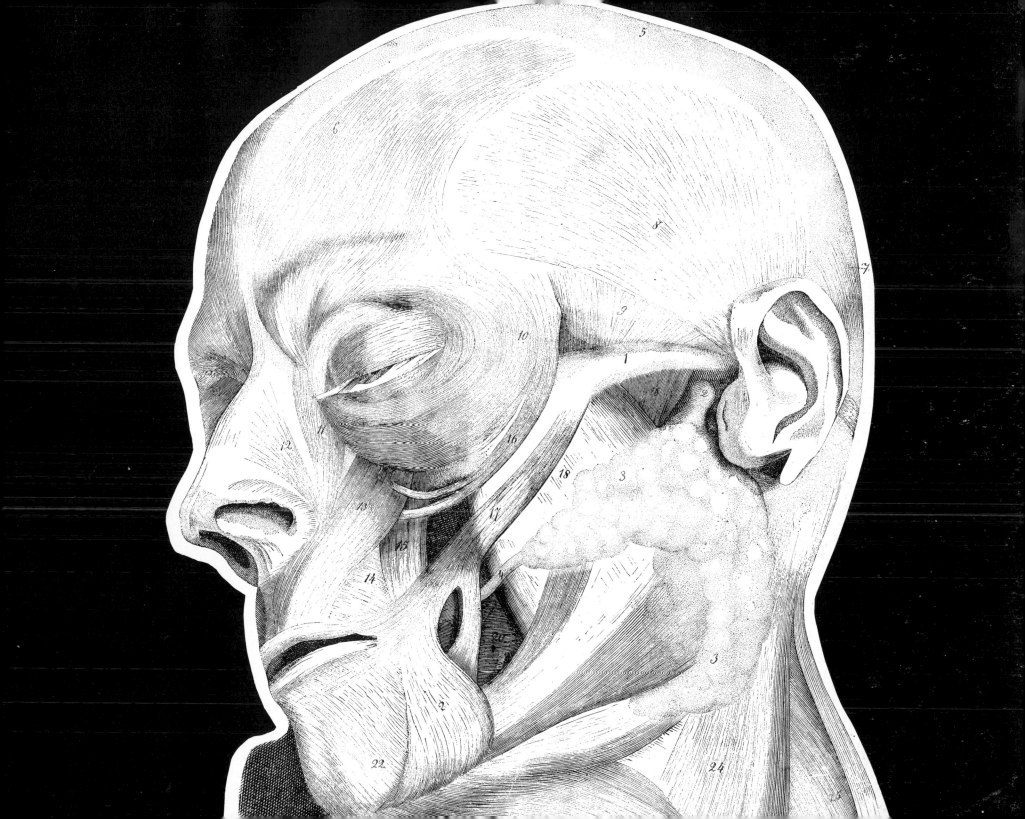

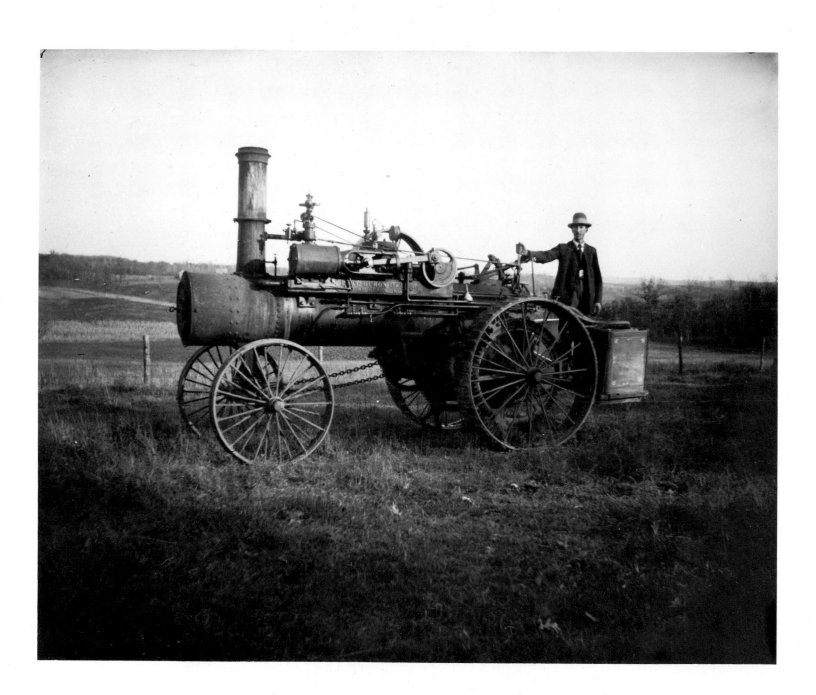

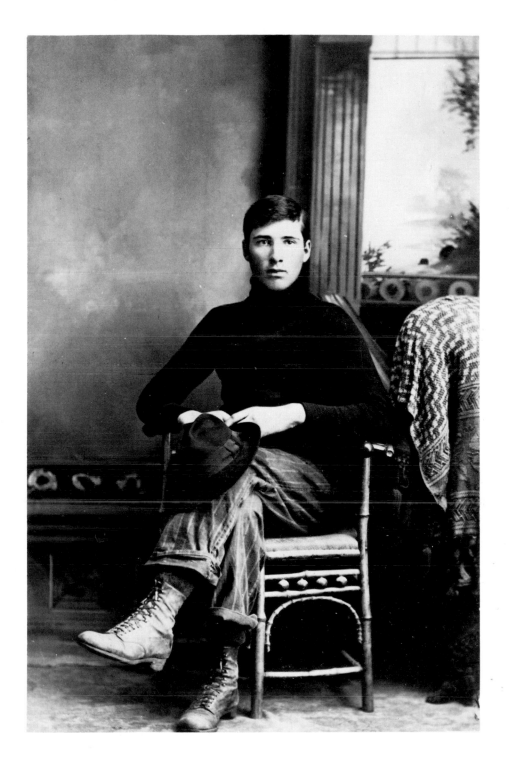

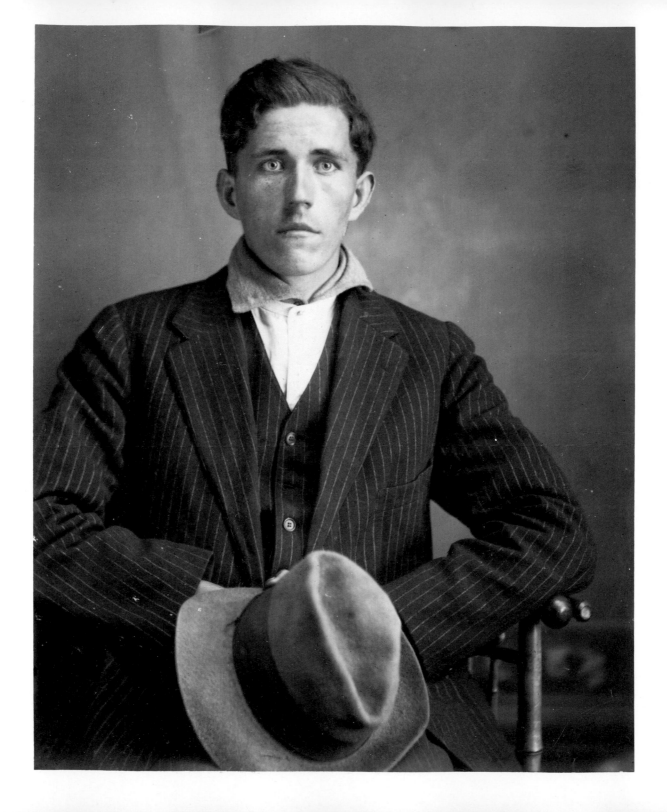

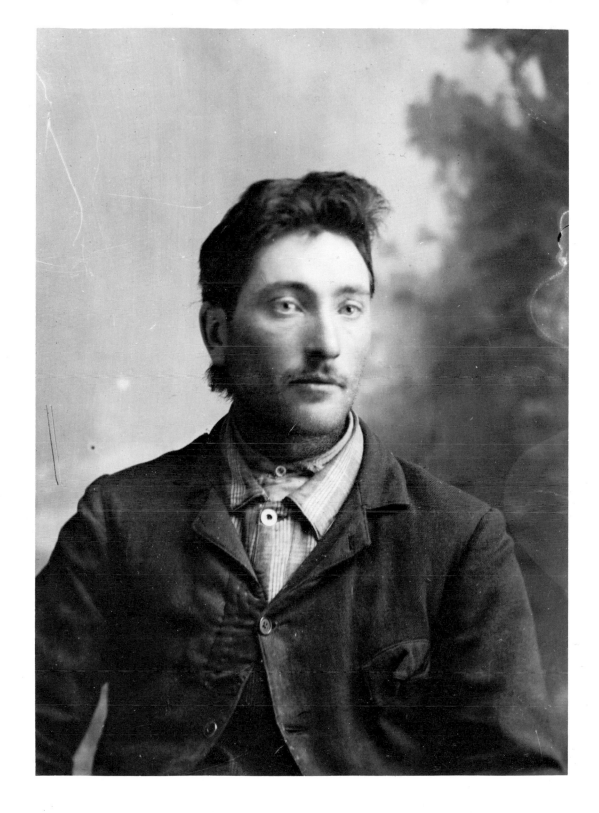

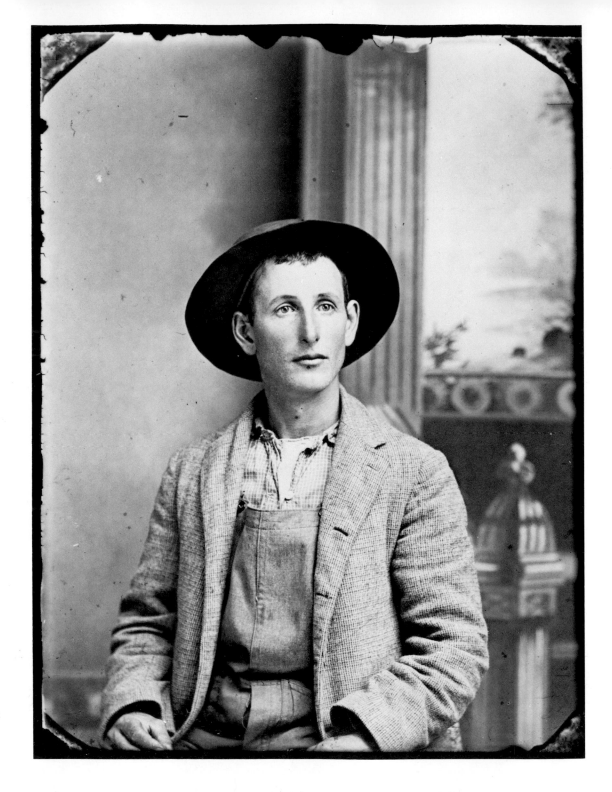

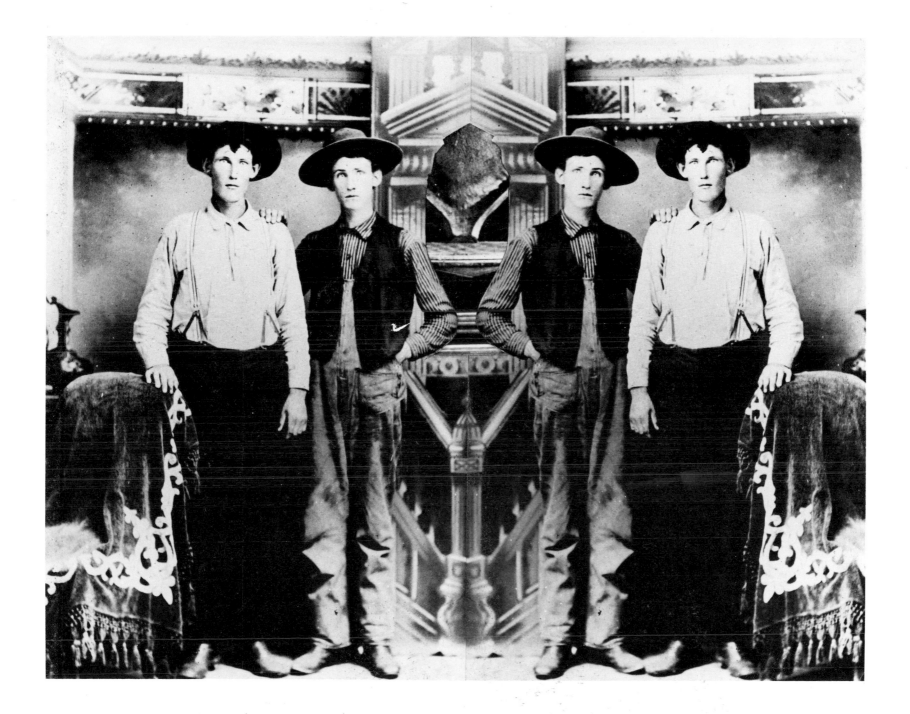

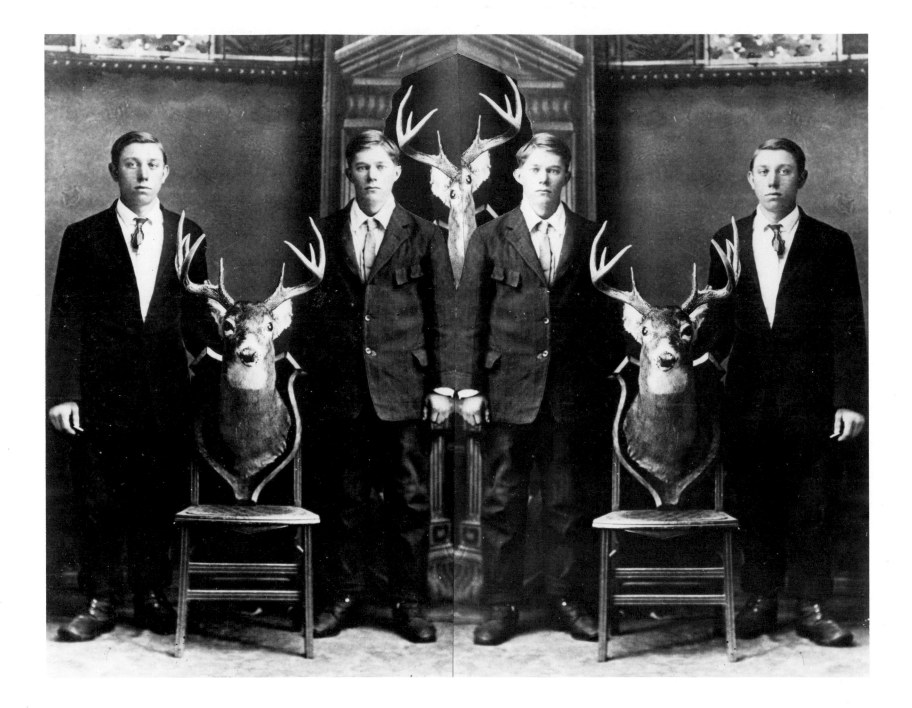

"A strange case is occupying the attention of Drs. Gregory and Lindors of Stevens Point and Dr. Wheet of Plover. The patient, Miss Cora Simonds of Plover, is a young woman about 23 years of age. As she was bitten by a dog 2 years ago and from her symptoms of barking and frothing at the mouth it was thought at first she had hydrophobia, but as her case develops, it seems more probable that she has hysteria. She claims to have an inspiration of all that is taking place in the village. She says she has died and gone to heaven, talked with her loved ones who have gone before, seen the angels, and returned to earth. The physicians are puzzled over the case and are unable to determine just what her complaint is."

[1/3, State News]

"One day last week, Mrs. Thomas Buel of the town of Albion, who has been demented for some time past, slashed herself across the abdomen with a butcher knife. . . . She will soon be brought before the County Judge with a view to getting her into Mendota asylum." [1/3, County]

Billie Neverson's wife was a wierdie. They took over the old Creston place at the other end of the valley. No one knows what really happened. Some say it went back to Billie finding out about her having a kid before they got married. Anyway, she just stayed by herself. Once a year, maybe, someone would see her in town, but she wouldn't even nod her head to say hello. Acting like that nobody ever bothered to visit them either. [Town Gossip]

1895

Hysteria – hydrophobia Insanity
Smallpox – whole town quarantine
Murder – Suicide Smallpox – infant
Death – Carbolic Acid Succinct death
A. F. Werner buys out Rosenberg Bros.
Insanity – black barber Suicide – another
Suicide – dynamite in a railway car
A. C. Folger – bankruptcy Window
smasher

High school motto – secular Calvinism
A. F. Werner buys out A. C. Folger
Insanity – patent medicine Bank
Treasurer shooting – drunk alderman
Astonishing bank failure Incendiary
Fire Grotesque suicide – unrequited
Love Trusting yokel panicked in the
City

What people said about Mrs. Billie Neverson; a case history from Mendota

"Dr. Ralph Chase, health officer of Eau Claire, visited Chippewa Falls with a view to arranging for cutting off traffic between that town and Eau Claire, but decided it was not necessary as there is a rigid quarantine at Chippewa Falls. There is . . . one known case of smallpox there, and about 40 houses have been quarantined." [1/17, State]

"Joseph Shotgoe, aged 45 years, who lived in the town of Rose, Waushara County, tried to kill his wife with a kettle of hot water. A 14 year old daughter sprang between them and saved her mother but was badly burned herself. The father then got a rope and . . . attempted to hang himself, but being discovered by neighbors was rescued before life was extinct. His wife soon [afterward] went to the barn and discovered that her husband had taken the lines out of the harness, put them over a beam, and hung himself."

[1/24, State]

"The first death from smallpox at Appleton occurred Tuesday, the victim being the 3 year old Schwanke boy." [1/24, State]

"Mrs. G. W. Adam, wife of a prominent Wausau druggist, ended her life by taking a dose of carbolic acid. It is thought the acid was taken by mistake. . . . Mr. Adam says his wife was in the habit of drinking blackberry wine . . . which was in the same kind of a bottle [as the acid]. He thinks in the dark she got the wrong bottle." [1/24, State]

"Alexander Gardapie, aged 90 years, died at Prairie du Chien. He walked into a saloon, drank a glass of gin, asked the time of day, sat down, and died." [1/31, State]

A. F. Werner bought out Rosenberg Brothers stock at 65 cents to the dollar.

[1/31, Town]

"William West Hendricks [the well-known colored barber] died at the Mendota asylum last Friday . . . as the result of the affliction which had deranged his mind. The funeral services were held at the Methodist-Espicopal Church and attended by a large congregation of sympathizing friends. The only relatives present were the son Clark and the father-in-law Thomas Moore. . . . [Mr. Hendricks] prospered in his earlier days but family troubles were followed by business reverses . . . he assumed debts which endangered . . . his property. These things worked on his mind and undermined his condition. Last fall he had a run of typhoid fever and never recovered so as to be himself again." [3/28, Town]

"Another suicide occurred in this city Sunday afternoon last." It was a man named Bernt Simonson. [5/2, Town]

"Admitted June 6th, 1890. Town of Black River Falls. Age 31. Born in Norway. Single. Talks rational but says that everything seems wrong. What he used to think was right now seems wrong. . . . Would run away, climb trees, and do such queer acts. Had been at several parties in February and March and drank considerable whisky and alcohol before this attack began. . . . June 30th: Patient is not doing very well . . . tried to choke himself one night with a handkerchief. Says he killed his brother etc. . . ."
[Mendota State, 1887 Record Book (Male, F), p. 485, patient #5332]

"John Lock, a resident of Phillips, made several attempts to blow himself into eternity while on the southbound Central train. . . . He had a dynamite cartridge tied around his body under his vest and passed out on the smoking car platform and lit the fuse. During his excitement, the cap became misplaced, fell on the platform, and was lost. He then went back into the car . . . to try again. This cap was also lost. There were about 20 persons in the car and some of them noticed his peculiar actions. At Prentice, he bought another cap and made [a] third attempt. Bystanders interfered and he was placed under arrest. Lock recently came into possession of a large fortune from Germany and has a wife and 4 children."
[5/9, State]

"The store of A. C. Folger, doing business under the name of Folger Brothers, was closed by the Sheriff last Friday forenoon on an execution. Mr. Folger had done a careful and safe business here . . . but . . . he was one of 2 sureties for an accommodation note amounting to $1,500, and the other surety and the principal maker failed. So he was obliged to take care of the note or let the note take care of him."
[6/6, Town]

"Maria Sweeny [alias Mary Ricks], the window smasher . . . reached Eau Claire from St. Paul [and] sat up all night in the waiting room of one of the depots. In the morning she demanded a ticket to Hayward from the Chief of Police. He refused but offered to send her to Chippewa Falls. She gave the chief till 3 o'clock in the afternoon to accede to her demand and then moved on the depot windows. Before she could break any glass, she was arrested."
[6/6, State]

The Motto of the high school class of 1895 was "Work is the Law of Life." [6/13, Town]

A. F. Werner bought out the stock goods of Folger's at 50 cents on the dollar.
[6/27, Town]

"J. W. Freeman, proprietor of the Freeman House, went to Hudson yesterday in charge of his sister . . . and J. W. Cole for treatment at the sanitarium in that city. It seems that he had been physically ailing for some time and had been taking a patent medicine. One day he took an amount that should have lasted him 2 weeks, and soon after this . . . he became mentally deranged." [6/27, Town]

"J. W. Freeman . . . died at the sanitarium . . . of cerebral meningitis."
[7/4, Town]

"A sensation was caused at West Superior late Saturday evening in connection with the failure of the Superior National Bank. Alderman Brennan who had $1,700 deposited there came to the door of the bank and demanded the money. He pulled a revolver and threatened to blow the brains out of the officers. He had been drinking. . . . This is the same bank that A. A. Cadwaller was president of when he embezzled the $27,000 3 years ago for which he is now serving a term in the state prison." [8/8, State]

"Kenosha financial circles were astonished Sunday morning when a notice appeared in the window of the Dan Head and Company Bank: 'This Bank Closed Until Monday.' Dan Head and Company were incorporated with a capital stock of $750,000 and advertised that the stockholders were worth over $3,000,000. . . . Last week, the cashier [treasurer], Urban J. Lewis, resigned on account of ill health. This caused the depositors who were mostly farmers to make a run on the bank. . . . The deposits in the bank are said to have amounted to something like $150,000." [9/5, State]

"A 2 story residence on the outskirts of Marinette, known as the Parlor House, was burned to the ground. The occupants barely escaped with their lives. The fire was the work of an enemy and was surely incendiary." [9/5, State]

It was those first, early fires that probably reminded the more respectable of the respectable to look to their souls as well as their mortgages lest they wake one morning and find themselves tested by a blaze more devilish and infernal than any set by a sneak thief firebug. People say that the first preacher that the town hired didn't work out too well. He was some kind of an itinerant Baptist named Snow who ended up in the federal penitentiary in Iowa for horse stealing. The second preacher was hired by Bill Price himself, and was a Methodist-Episcopalian named Wood. The only trouble was that Reverend Wood had to conduct services in the Shanghai's lobby which was so close to the Shanghai's bar that no one paid too much attention to what he had to say. That was the sort of problem that was pretty typical of the town in those early formative years: no matter where you went or what you did, you just couldn't get away from those barrels of whisky and jugs of rum.

Even if you walked into court something was liable to happen. Bill's law partner, C. R. Johnson, said that one of the first trials that old Jacob Spaulding presided over as Justice of the Peace was a kind of mad hatter's tea party full of mock testimony and false witnesses. The drunk plaintiff falsely accused an innocent man of selling liquor to the Indians, and the drunk jury that found him guilty fined him four gallons of whisky, which they drank on the spot. Colonel C. C. Pope claimed that most court cases began and ended with friendly bottles passed between the judge, the jury, the defendants, the plaintiffs, the witnesses, the lawyers, and the spectators who were

so suspicious of one another that they came to court with things other than pen knives in their pockets. He recalled a trial in 1886 over the ownership of a cow. He said the testimony and argument were interrupted at least a dozen times by as many drinks, all of which were toasted by the trial judge breaking into a verse from "Old Rosin and Bow."

"Ludwig Senglaub, a German resident of Manitowoc, aged 74, committed suicide Friday morning at the home of William Radins. The old man had become enamored of Mrs. Radins and had been a frequent visitor at the house. She told him not to come any more. He went to the house, however, walked into the front room, and deliberately shot himself while looking into a mirror." [9/19, State]

"John Martin, a farmer from Sheboygan, went to Chicago, Monday. While looking for lodgings he met with what he terms an 'honest-faced' boy whom he asked to guide him to a suitable house. The boy led him to a hotel and then asked and received permission to sleep with the farmer. When the latter awoke, he was surprised to find his newly found friend had disappeared as had Martin's wearing apparel and money. The boy had left his ragged clothes behind. All day long Martin waited for the boy with the honest face to come back. Then Martin put on the clothes the boy had left and went into the hotel office. He was immediately taken for an insane man and sent head-long into the street. The trousers Martin wore reached only to his knees, while the coat would hardly stay on his shoulders . . . the newsboys began to tease him. Soon the farmer was so frightened he started down Van Buren Street in a full run, then south on Clark Street . . . excited people declared a crazy man was running loose. Detective Shubert started in pursuit and at Polk Street caught Martin who was badly frightened, and took him to the Harrison Street Station where he waited until some philanthropist gave him a suit fit to wear." [11/21, State]

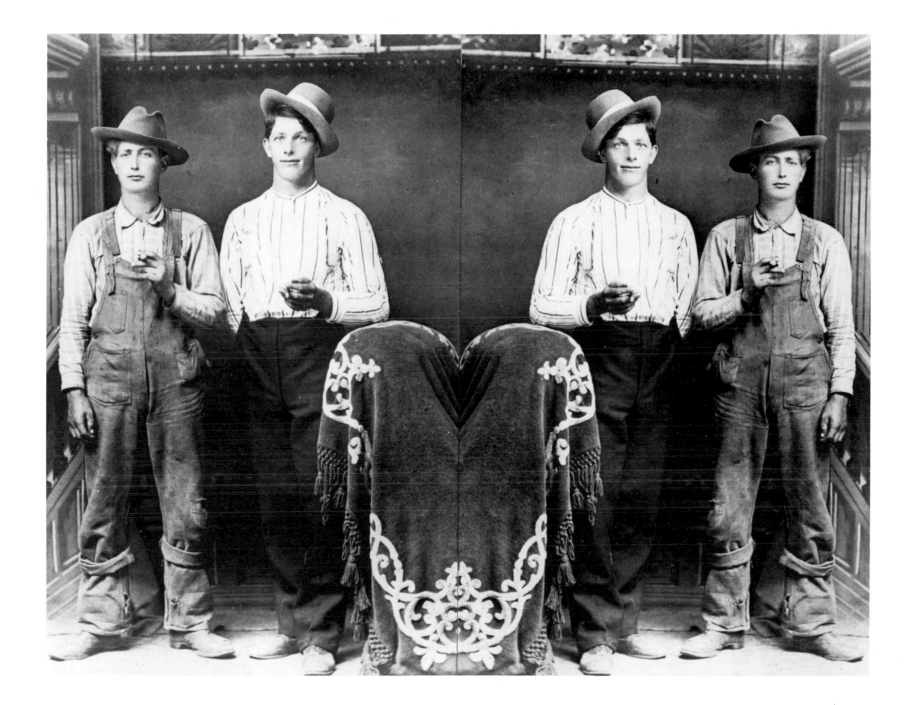

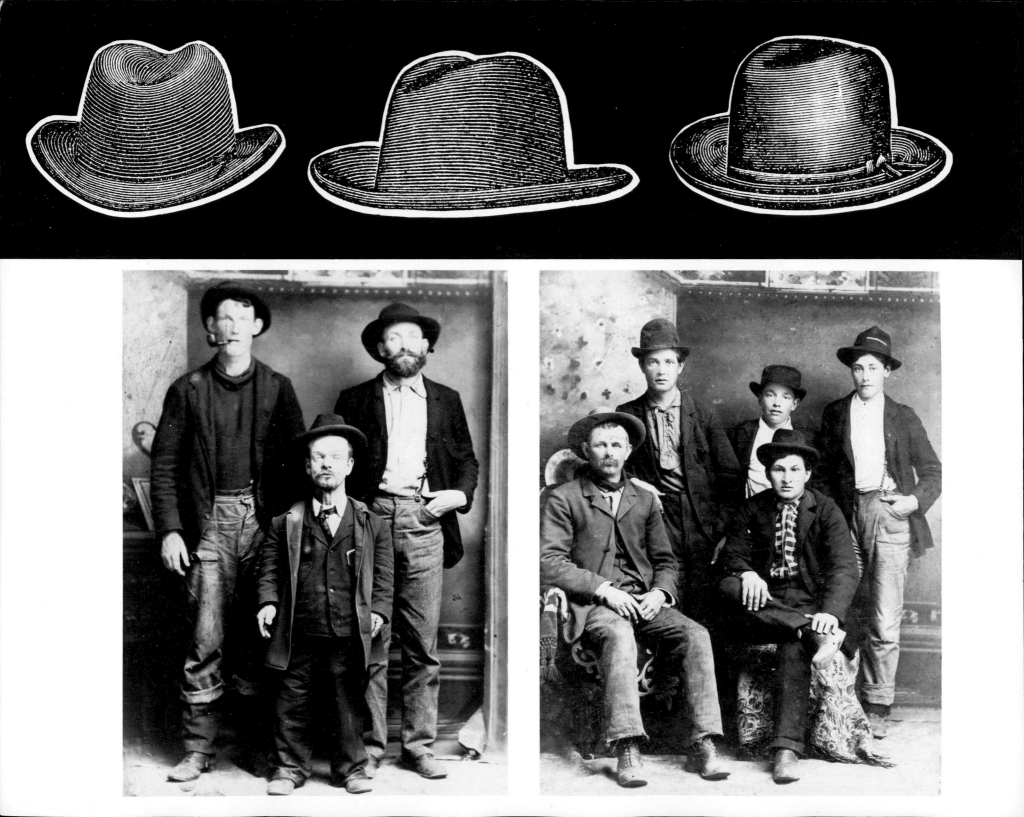

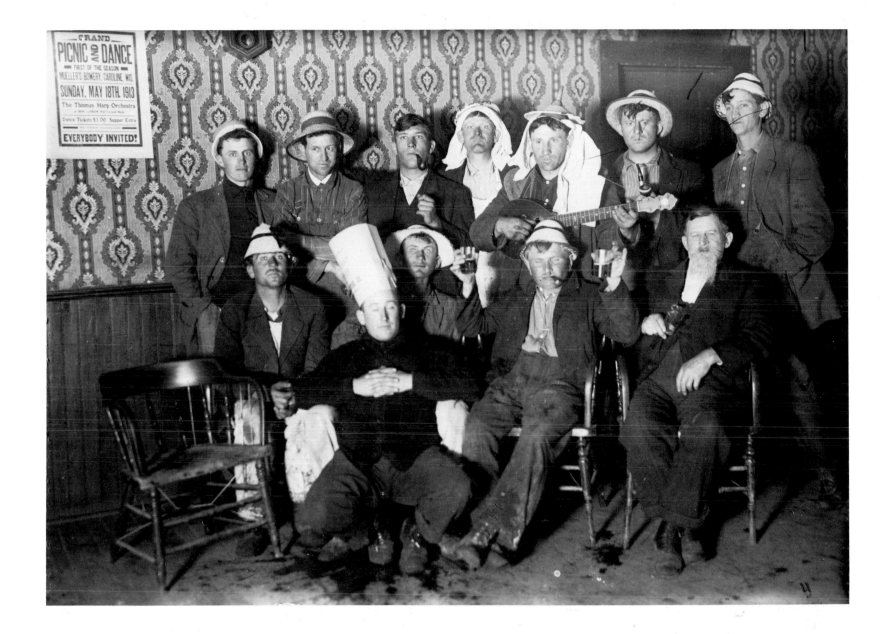

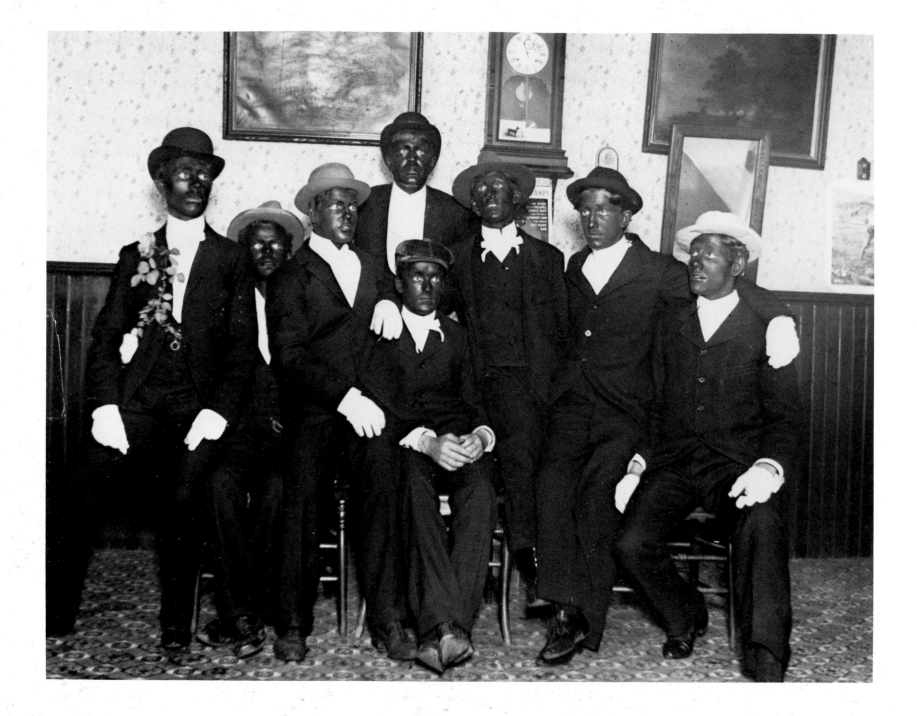

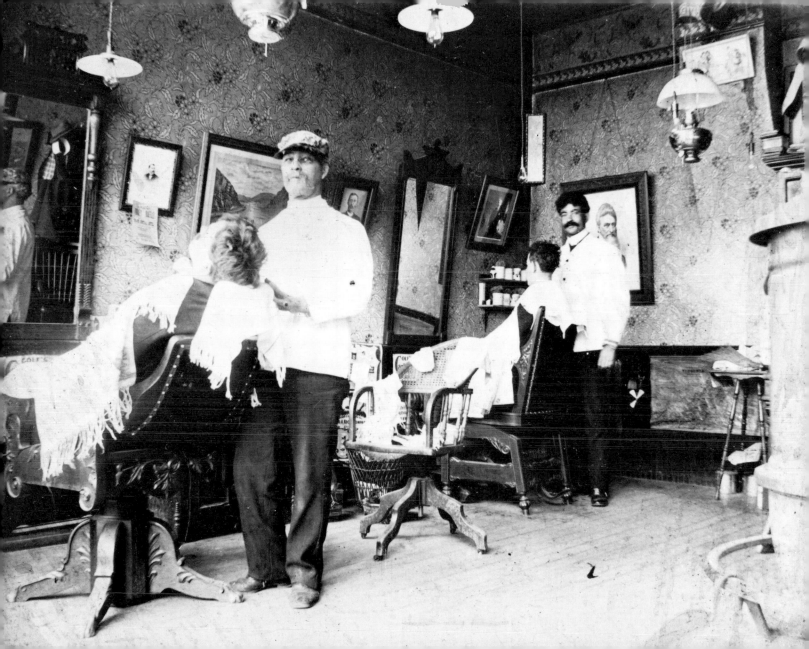

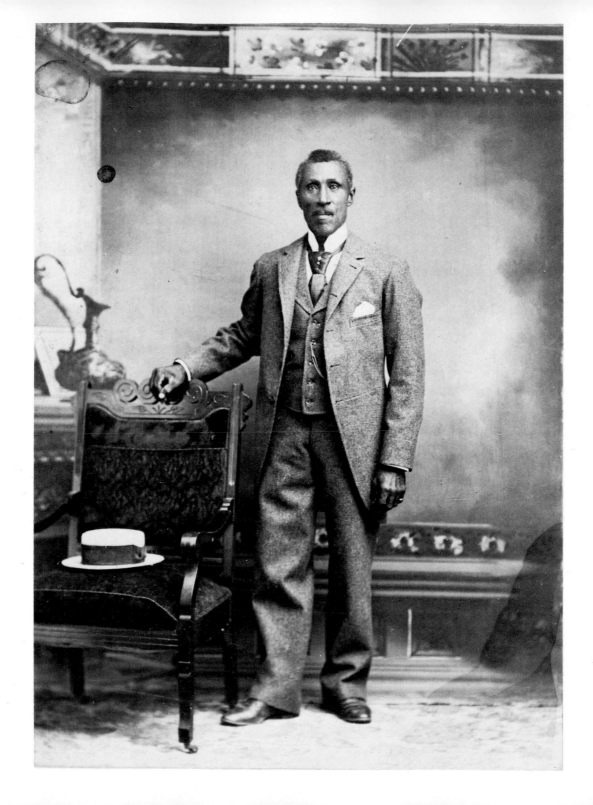

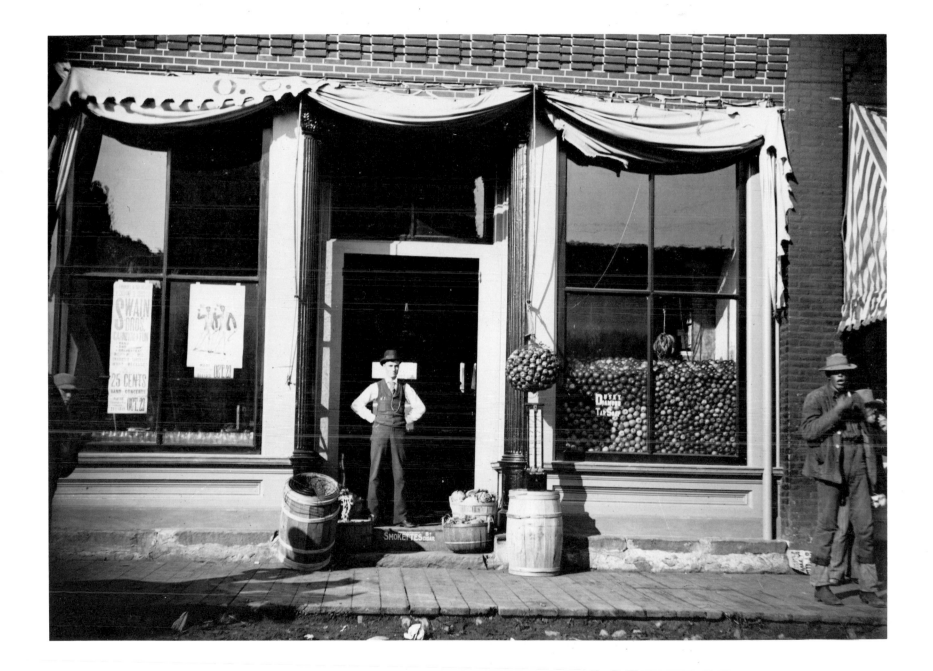

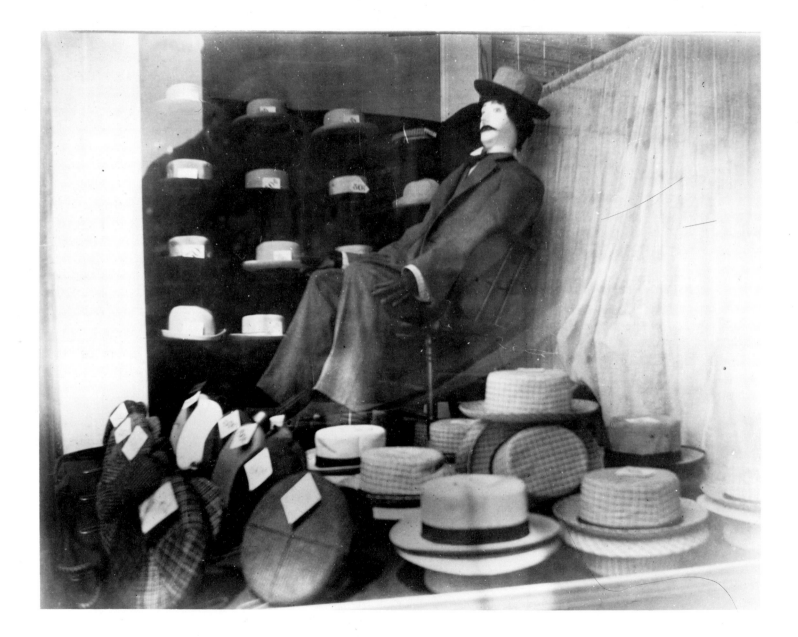

"Thursday morning, a man who was sent to the City Restaurant by the village authorities for breakfast dropped in a fit on the floor and it took the attention of Dr. Moore to bring him out. The fellow said he had ridden from Baraboo in the cold during the night and had eaten nothing for 24 hours. He was subject to fits and the doctor thought this was brought about by hunger and exposure . . . there are many such. Almost every night they tax the capacity of the village lockup, and what to do with them causes no little trouble to Marshal Owens who is a humane man and can not turn them out in the cold."

[1/9, County News from Merrillan]

"There was one [story], however, which he told on various occasions, and Alwyn could not understand why he remembered it or what it meant: 'Early one morning, when I was a young fellow and going to the barnyard to milk, I saw a man leaving the strawstack and running down the road. After a time I saw him coming back again. The day was foggy—you couldn't tell about a man more'n six rods away. He turned round and got out of sight. I wondered what was wanted, so I watched through the horse-stable window. Pretty soon, there he was, stopping once in a while and going toward the stack. I ran out and shouted, "Look here, stranger! What in creation are you after?" He was as white as a sheet and shook from head to foot. "Excuse me, partner," said he. "I

1896

Pitiable tramp Sets herself aflame
The high brought low Firebug—
A Simpleton harried by boys A dead
* Taxidermist*
Crazy family Miser—reproached
Suicide—no job The hard times
Sabotage—tramp High school motto—
Smiling youth Insanity—alcohol
Suicide—drowning Bank panic
Insanity—religious suicide—public
Disgrace Miraculous cure Jackson
County Bank failure Suicide—head
on the rails Fire—incendiary Fire—
Industrial sabotage A whole town
Poisoned Murder—insane hired hand
Insane Wandering delirium

An old man's story about a tramp, from Glenway Wescott; Wescott's descriptions of a taxidermist and of grief; Hamlin Garland's transcript of a hard-times farm conversation; a case history from Mendota State

slept in your stack. I left a pair of shoes there." "My stars, man! Go and get them!" I told him. "I don't want any man's shoes but my own."'

He told this mysterious anecdote and one or two others like it, with an air of great satisfaction. But of his more important experiences, never a word. . . ."

[Glenway Wescott, *The Grandmothers*, pp. 34–35]

"Miss Polly Nichols, aged 62 years, committed suicide in a most horrible manner at Ogdensburg, a small hamlet near Manawa. She became impressed with the idea that a small sore on her back was a cancer and that it would kill her. She went into the back yard, saturated her clothing with kerosene, and then touched a match to it."

[1/30, State]

"Judge S. C. Simonds, one of the best known pioneers of St. Croix County, was taken to the poor farm at Hudson. He has held public office in the county most of the time for the past 30 years. . . . Mania for speculation unbalanced his mind years ago which led him to squander his earnings in bucket shops and other forms of chance. This frenzy his family interpreted into willful neglect and nonsupport. He has been an object of chance charity among his old neighbors. Some weeks ago he was taken seriously ill and became a county charge."

[2/14, State]

"Aristide Griffel, known as 'Frenchy,' was arrested at La Crosse in the act of firing a barn on the North Side. He confessed to a multiplicity of incendiary fires that have occurred in North La Crosse during the past 2 years. . . . At least 50 fires can be laid at his door. Griffel had a mania for excitement, and this kind suited him best. He had always been the first at the fires and took great interest in the work of putting them out. At home he would keep the alarm clock continually ringing."

[3/12, State]

"The spectacle of a middle aged man rushing madly along the avenues, pursued by a mob of howling, jeering school boys who hurled tin cans, sticks, and other missiles at him, was witnessed by scores of indignant citizens at East Superior. The boisterous mob was reinforced at every corner by urchins of all sizes and descriptions . . . there were perhaps 100 in the crowd . . . the fleeing man was pelted unmercifully from all directions. Finally he rushed into a private residence and the crowd dispersed. The man was a resident of West Superior, sometimes called 'Simple Joe.' He had been to church at the East End, and when leaving . . . was attacked." [4/2, State]

"Charles Deiminger, the well-known taxidermist of Sauk City, committed suicide by shooting. It is claimed he had the largest private collection of rare birds and animals in the state. He was 70 years of age. . . ." [4/9, State]

"During the winter months his father earned money as a taxidermist, having taken lessons from a man who had spent a vacation at Hope's Corner when he was a boy, and later having studied it from a book. He was remarkably skillful, and many sportsmen brought him their dead trophies to mount, so they might hang permanently in the lodges of secret societies, in dining rooms and dens. Alwyn invariably felt sick when he went into the room at one end of the house which was his workshop. Bodies of birds and small animals bleeding slowly on newspapers, while his father imitated them with wire, tow, string, and wet clay; the pelts drying on wooden forms and the bird skins turned inside out, and dusted with cornmeal and arsenic; scraping-knives in the skulls of deer; the odor of stale meat and green bone; the rank odor of water birds' flesh, almost black with oil. . . ."

[Glenway Wescott, *The Grandmothers*, p. 175]

"In a family consisting of 3 maiden sisters and 2 bachelor brothers named Niedtke in the town of Liberty, near Appleton, 2 sisters and a brother have gone insane within the past few weeks, one of the sisters being a school teacher. Saturday, the insane brother became violent and was taken to the asylum. The 2 sisters are being cared for at home." [5/7, State]

"A farmer of Buena Vista buried $2,600 in gold under his doorstep. When he went to dig it up, it was gone. It turned out that his wife, who had been allowed to wear nothing but calico dresses for 14 years and who had been compelled to work on the farm like a common hand, had taken the money . . . everybody in the neighborhood is glad of it." [5/7, State]

"While in a fit of despondency, brooding over his inability to find employment, Howard Lanning of Stoughton committed suicide. . . . he leaves a wife and 6 children. He was 50 years of age." [5/21, State]

" 'The worst of it is,' said Grant . . . 'a man can't get out of it during his lifetime, and *I* don't know that he'll have any chance in the next — the speculator'll be there ahead of us.'

The rest laughed, but Grant went on grimly:

'Ten years ago Wes, here, could have got land in Dakota pretty easy, but now it's about all a feller's life's worth to try it. I tell you things seem shuttin' down on us fellers.'

'Plenty o' land to rent?' suggested someone.

'Yes, in terms that skin a man alive. More than that, farmin' ain't so free a life as it used to be. This cattle-raisin' and butter-makin' makes a nigger of a man. Binds him right down to the grindstone, and he gets nothin' out of it — that's what rubs it in. He simply wallers around in the manure for somebody else. I'd like to know what a man's life is worth who lives as we do? How much higher is it than the lives the niggers used to live?' . . .

'A man like me is helpless. . . . Just like a fly in a pan of molasses. There ain't any escape for him. The more he tears around, the more liable he is to rip his legs off.'

'What can he do?'

'Nothin'.'"

[Hamlin Garland, "Up the Coulee," in *Main-Travelled Roads*, pp. 85–86]

"Olga Assman, a young woman aged 20 years, attended a hypnotic exhibition the other night, and while laughing heartily at the antics of the subject under hypnotic control, was seized with a severe fit of coughing which became hysterical and has continued almost [without stop]. . . . Unless the coughing can be stopped soon the results will probably be fatal."

[5/28, State]

"Admitted May 9, 1899. Town of Garden Valley. American. Aged 21. Unmarried. Lives at home with parents. First symptoms noted on Dec. 28th, 1898. Religious Mania. Thinks she has the power of saving people. Maniacal. Delusions and hallucinations."

[Mendota State, 1899 Record Book (6, Female), p. 343, patient #8149]

"A tramp who was refused admission to the house at the farm of Robert Toombs near Tomah set fire to the straw stack in the middle of the night. . . . it was with difficulty that the flames were prevented from destroying all the buildings on the place. Officers began to scour the country for the tramp and found him about noon. . . . He admitted having set the fire."

[6/4, State]

"The Motto of the graduating class of '96 was 'Vim, Vigor, Victory.'"

[6/18, Town]

"Sheriff Austin took Ingebret Iverson Brystad of the town of Franklin to the state asylum at Mendota, Monday afternoon. His insanity was caused by family troubles coupled with alcoholism."

[6/25, Town]

"Mrs. Dora E. Nisson, wife of C. H. Nisson, committed suicide at Grand Rapids by drowning. She deliberately walked into the Wisconsin River back of her home [and] lay down in about 3 feet of water. . . ."

[7/9, State]

"But when her daughter Flora died. . . . this fortitude came to an end, and serenity gave way to despair. Death was acceptable twice during life: before it began in earnest, and after it was over. Little children died—death deprived them of nothing; their mothers were strong and could bear it. Those who were old belonged to death, as if by contract; she was willing that nature should take its course. But the death of a lovely, unmarried girl was intolerable and against nature. She herself should have been allowed to go instead; life had had its way with her for more than half a century; she could have said Amen.

Hitherto, time had been given her in which to recover, to develop new habits and enjoy new hopes. Now it was too late; she would not live to see the end of this anguish; she could never begin again. She had always accepted things as they were; having protested, she had folded her arms and given in; but her will would never be at peace with the Will which had determined Flora's death. There was nothing to do but leave the world, unreconciled, and, because of the insubordination of her heart, half ashamed."

[Glenway Wescott, *The Grandmothers*, pp. 118–19]

"An unfounded rumor caused a run on the First National Bank of Kenosha, Thursday. . . . A few days ago, one of the manufacturers paid all his men off in checks. Thursday morning, the men went to the First National to have their checks cashed. There was a great many of them, and the fact that they were standing around the bank caused a rumor . . . that the bank was in financial distress . . . within an hour a run had been begun by the small depositors. There was a long string of people at the bank doors all morning. During the forenoon, the bank paid out $300,000. . . ." [7/16, State]

"Mrs. Lizzie Dishane was adjudged insane at Janesville and taken to Mendota hospital. . . . She went to Janesville . . . to visit a friend at Emerald Grove . . . while on route she became [violent]. . . . When the train pulled into the depot, she knelt in prayer. . . . Her delusion is religion. She is 56 years old and has property worth $17,000." [8/6, State]

"E. F. Granger, a wealthy farmer, was found dead in his home 4 miles north of Chilton. At the inquest, physicians found a large quantity of paris green [an insecticide] in his stomach. It is the general impression that he committed suicide. His body, when found, was smeared with tar and feathers, and was either done by himself to create the impression he was murdered, or by unknown parties for whipping his wife." [8/13, State]

"Henry Lloyd, a bachelor, who resided 5 miles and a half from Janesville . . . was found dead in his bed on Sunday. . . . He was 83 years old. . . . Disappointment in love had made him a recluse. . . . It is said Henry fell in love with a girl from New York, years ago, but never confessed . . . he determined to go east and ask her hand in marriage. He made the trip only to find she had married another man the day before his arrival. He returned to Wisconsin brokenhearted, and from that time to his death, he avoided female society. No woman ever crossed his threshold, and when he rented a pew in the Congregational Church at Emerald Grove, it was with the understanding that no woman should ever enter it. He devoted his attention to horses and farming." [8/20, State]

"William Saddler of Janesville says that he is recovering his eyesight after being blind for 12 years by taking the 'Kniepp cure.' A local faith-cure believer rubs his head and feet, and Saddler walks barefooted in the dewy grass each morning before sunrise." [8/20, State]

The Jackson County Bank of Black River Falls went into receivership. Its deposits had simply drifted away. It had loaned $74,000, but had only $48,000 on hand. [9/10, Town]

From all these reminiscences you'd think that no one was ever sober enough to make any killings on the market, but that just wasn't so. Bill O'Hearn started out just as poor as Bill Price; he even worked for old Jacob Spaulding as his bookkeeper. But he kept up on everything and didn't indulge his vices. He invested wisely, grew to be president of the Jackson County Bank, prospered even more, and ended up just as bankrupt as Dudley, Jacob's son, did in 1894. James J. McGillivray's official biography claimed he hadn't touched a drop since 1871, which was about the same time he started work as foreman on the construction of Dudley's sawmill. From there he went on to run Dudley's sash, door, and blind factory. He kept working for the shop until he could rent it for three years running and use it to build the Opera House, the Jackson County Bank, and Bill Price's office and residence. In 1883, Bill made him superintendent of

the Price Manufacturing Company, capitalized at $25,000. By 1890, McGillivray had bought the whole outfit and built himself a two-story commercial block on the corner of Main and Water Streets worth $12,000.

There were others too. There were the Jones boys. Sam married Mary Jane Spaulding and Rufus started the Jones Lumber and Mercantile Company. There was also Rollin, who was partners with old man Murray in a big hardware store. Then there was Warren who owned a nice sized grocery on Water Street. And there was Louis who went into a dry goods store with John Marsh. Then there were the Cole brothers, the patent medicine magnates. One of them, Halbert, was a real doctor; the other two, Jerome and Mayland, ran a big drugstore. All of them operated out of the same building: Halbert had his offices on top, Jerome and Mayland had the store underneath, and then down below in the basement was the factory that produced and packaged Cole's Carbolisalve. They said it was good for aches, pains, burns, and abrasions. The Coles were not the only ones in the business though; there was a Norwegian named Hendrickson who operated out of a shack on some creek bank. He made something called Olio which was used just like Carbolisalve. Then there was Dr. Eugene Krohn, also Norwegian, who made plenty of money on his surgical degree from Heidelburg, but who added to it with the sales of his green salve. Dr. Krohn owned the fastest horses when that was the best way to get to his patients; later he owned the town's first automobile when that seemed

even better. Eventually he owned quite a few shares of Anaconda Copper, but managed to get rid of them just before the twenties Crash. Once his two sons got their medical degrees they all went into the business together, opened a clinic and sort of cornered the market so to speak. Before that, he and Charley Van Schaick, the photographer, shared the same building for maybe thirty years.

"A man who will not give his name was found with his head upon the rails, near the . . . depot at Rhinelander, awaiting the approach of a freight train which was being backed onto a siding. He was taken from his perilous position by force . . . it required the united efforts of 2 men to keep him from throwing himself under the wheels. He is a German about 35 years old and has been in this country 15 years. . . ." [10/10, State]

"P. Zimmer, a farmer living near Fairhill, Pepin County, was burned out, losing all his crops, barn, outbuildings, and farm machinery, besides a crib of corn from last year's crop. . . . The fire is believed to have been incendiary." [10/10, State]

"Fire destroyed the barn on the premises of the West Bend Lumber Company. The horses, a double carriage . . . and a lot of hay and oats were devoured by the flames. . . . It is thought that tramps set fire to the barn." [10/10, State]

"The Superior roller mill located on Connoc's Point, built 14 years ago, the first mill in West Superior, burned Friday night. . . . The fire was of incendiary origin." [10/15, State]

"An unsuccessful attempt at wholesale poisoning by paris green has been discovered at Almond. While preparing a can of milk for shipment, John Bibby, a wealthy milk shipper, noticed a peculiar color and on investigation found a large quantity of paris green at the bottom of the can. John Burns, another farmer, found a score of piles of paris green and salt scattered in his pasture. . . . Thomas Brown lost 5 of the most valuable cows of his herd from the same poison deposited by unknown parties on his grazing land." [10/22, State]

"A horrible murder was committed in the town of Melrose, on the old Marshall farm, near North Bend, on Tuesday afternoon. The perpetrator was George Palmer, between 17 and 18 years of age. . . . The victim was Hazel, the little 4 year old daughter of Oscar Marshall. The murderer seems young for his age and would not be taken to be over 14. He had recently been adopted by Mrs. Marshall from the state school for dependent children. . . .

[The murderer] was found lying on the sawdust in the ice house, apparently unconscious, with a smell of carbolic acid about . . . he said that he had taken poison because he had killed the girl. . . . The murderer made a statement to the authorities saying that he had always been well used by the Marshall family and had nothing against them. [He] said he thought a good deal of the child and did not kill her out of any spirit of revenge, but it had been in his head all day that he ought to kill the girl and her mother, and he could not be satisfied till he had gone at it. . . . It seems that he took the child to the barn and struck her on the head with an ax. . . . It was thought that the taking of the poison was only a sham, but he is now reported in serious condition. . . . The young man's father is an inmate of the Oshkosh insane asylum . . . the general belief is that the malady has cropped out in the boy." [10/29, County]

"A young woman, 20 years old, who gave her name as Edith Eberhardt occupied a cell at the La Crosse police station Friday night. She came from Winona and wanted to go to St. Louis, but was without money. She was evidently suffering from some form of dementia, for she persisted in sitting on the floor of her cell, refusing food, and [talking] strangely. She claimed something terrible had befallen her, but she refused to say what it was. She was sent on." [12/17, State]

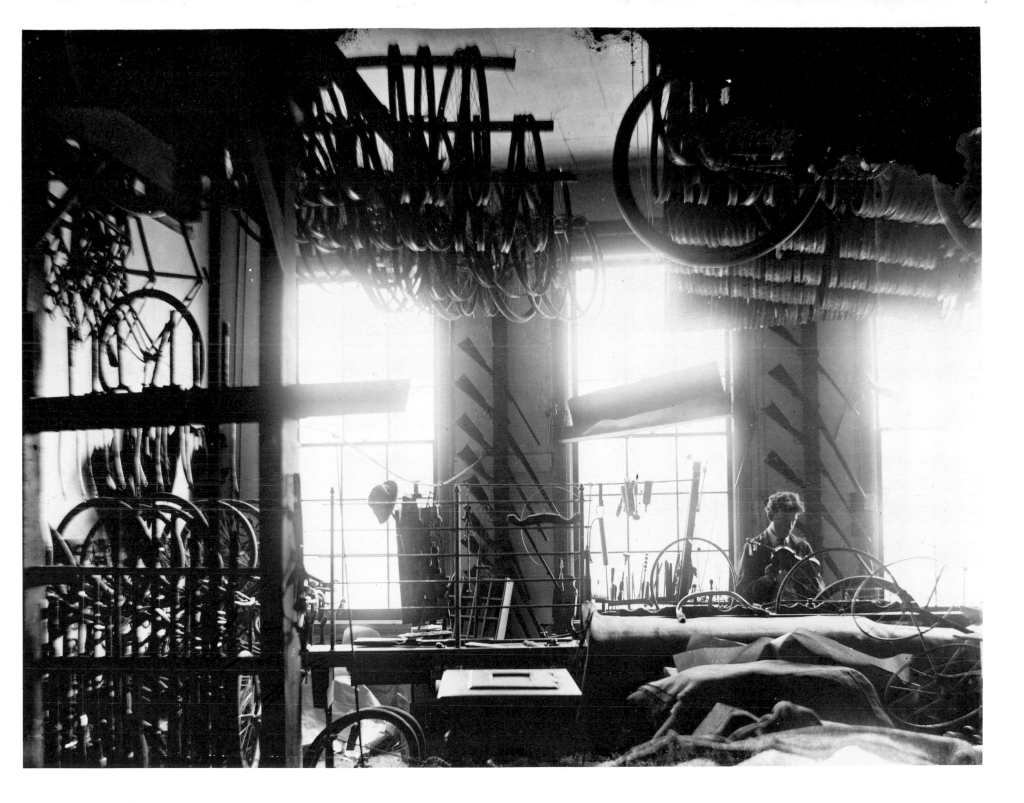

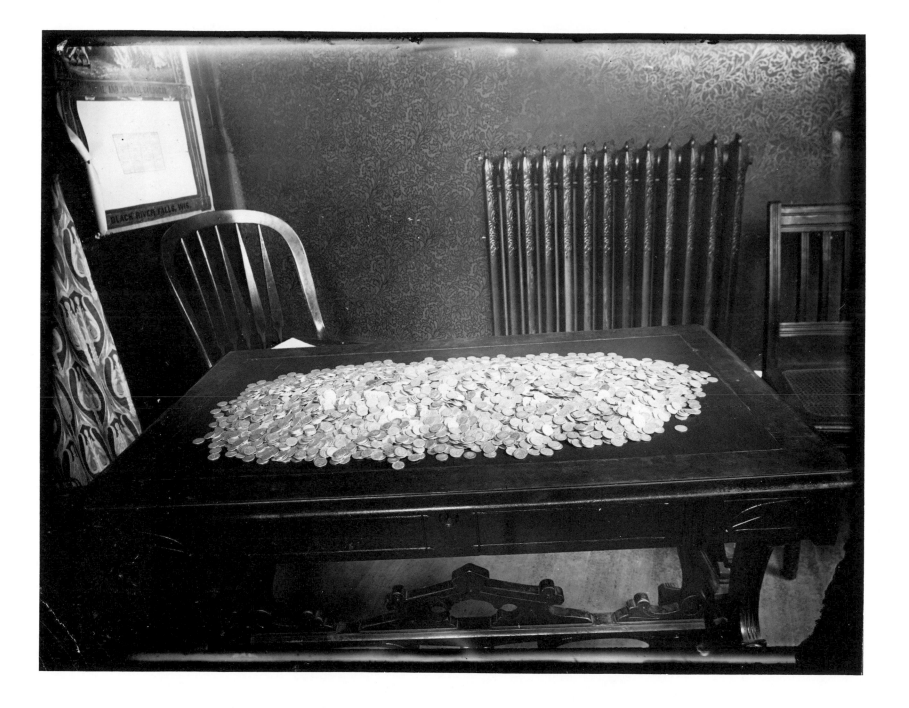

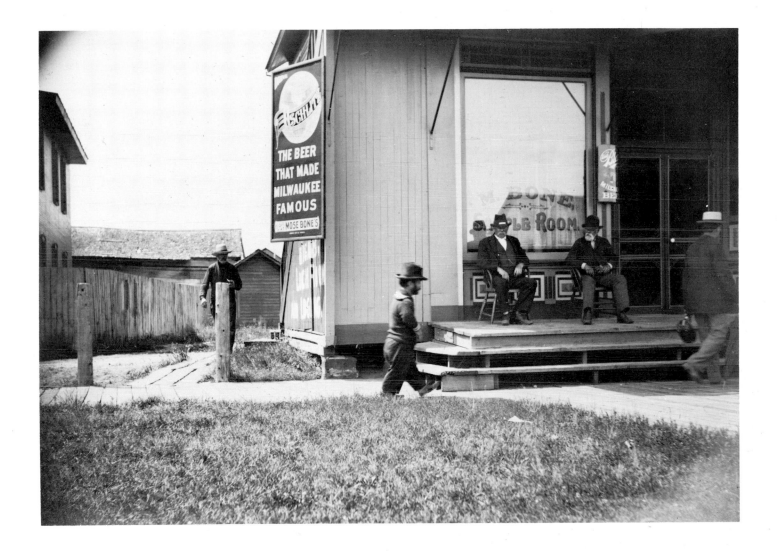

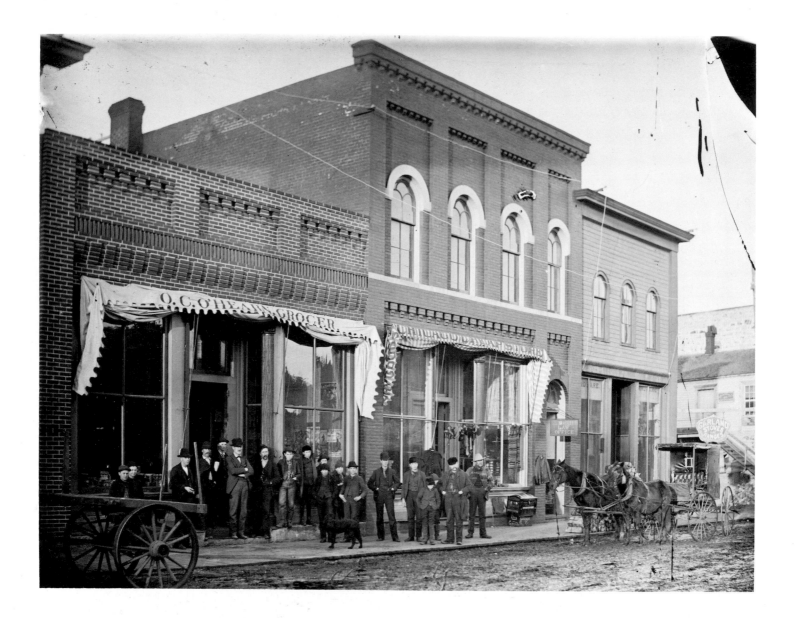

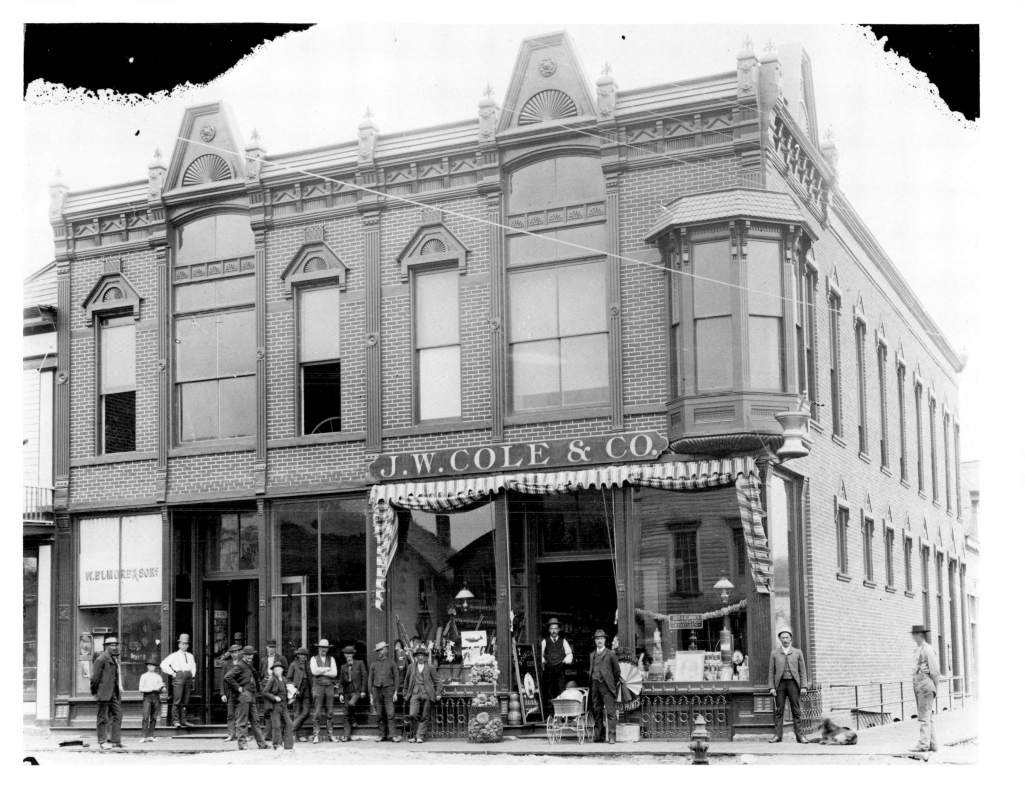

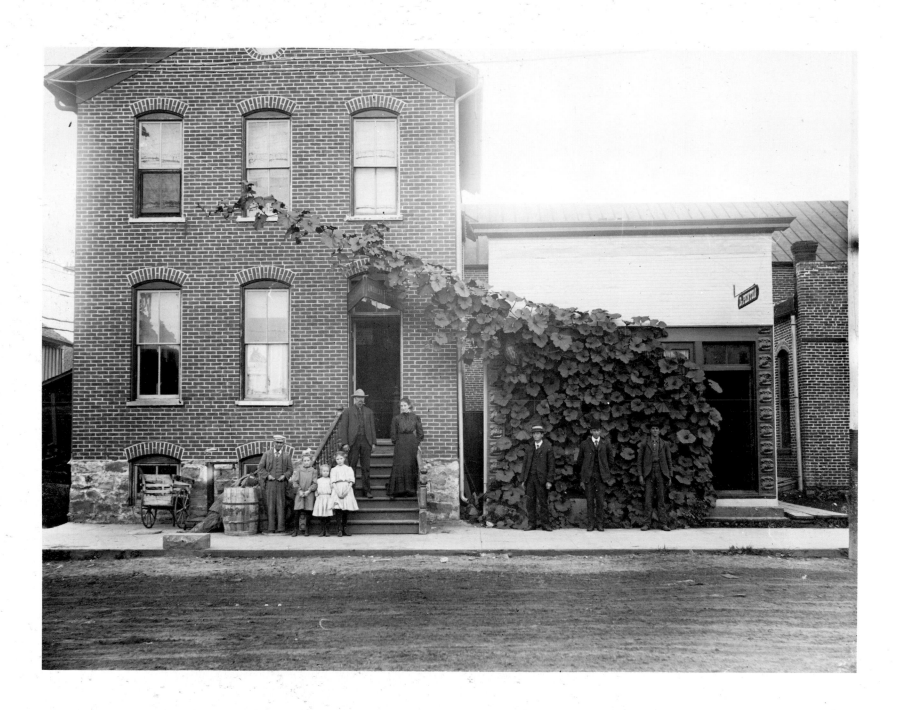

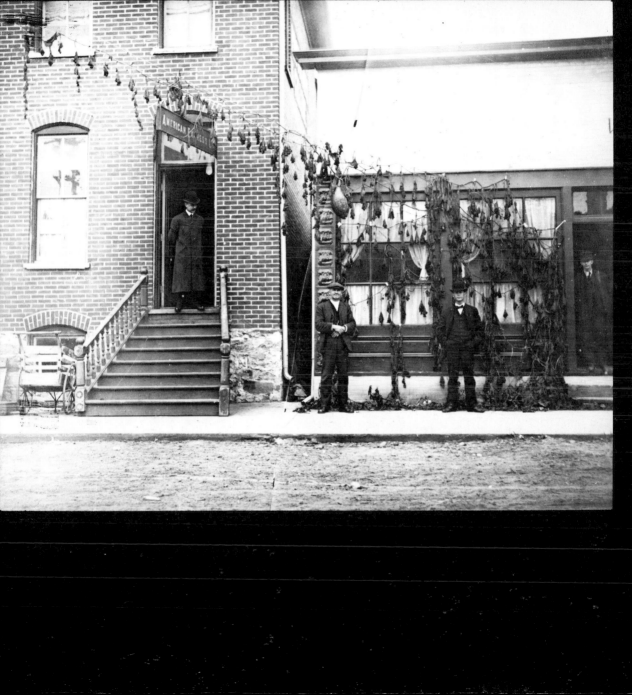

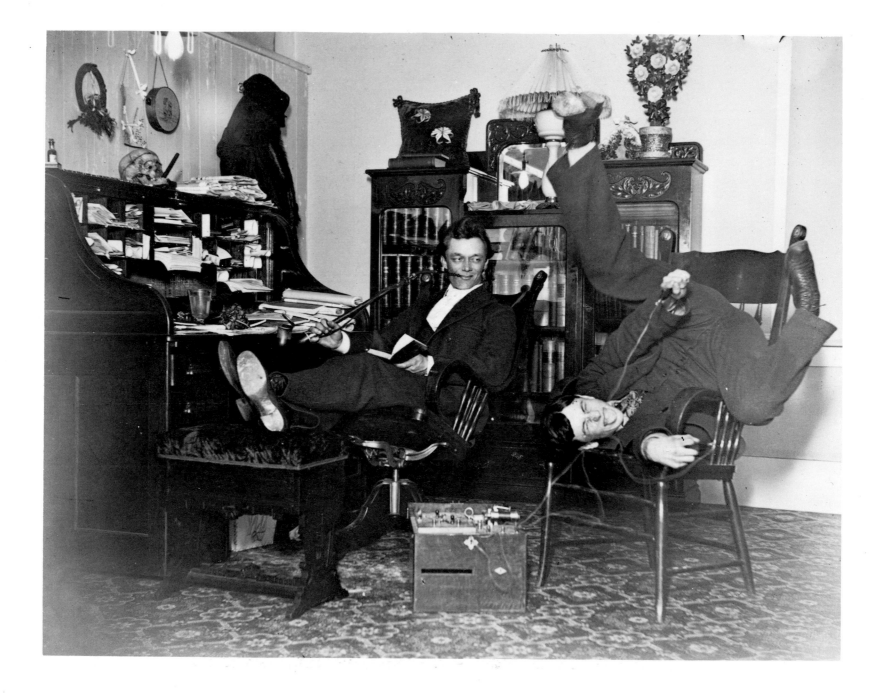

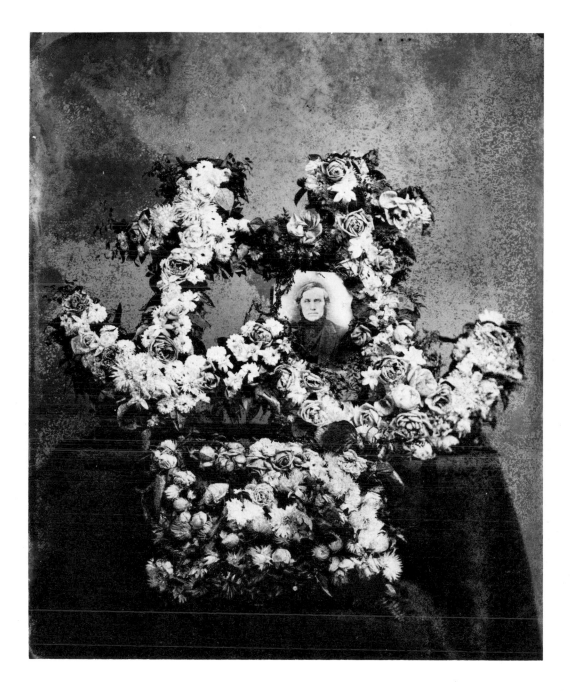

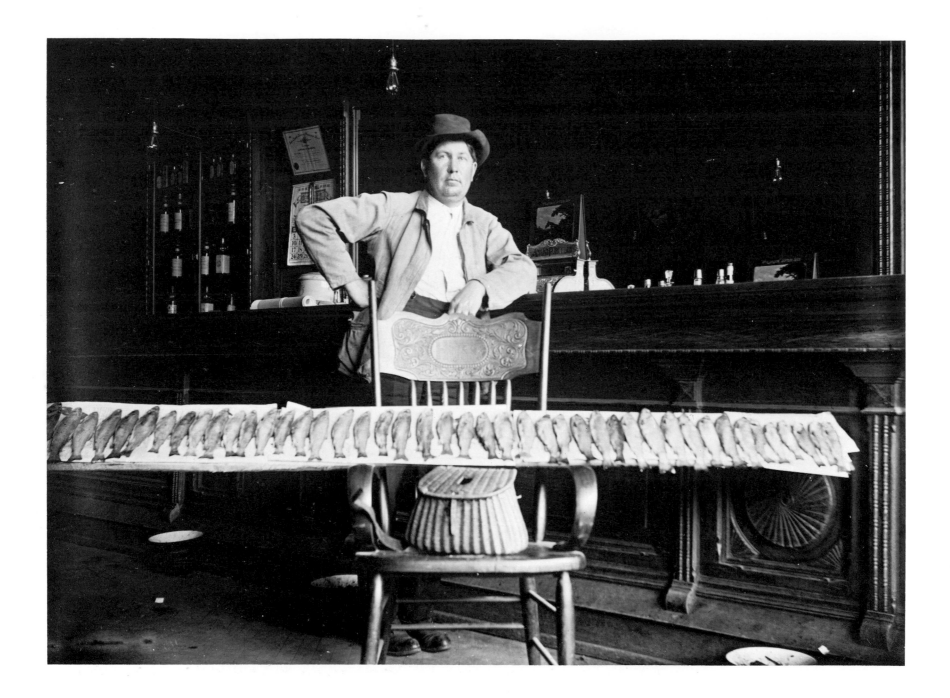

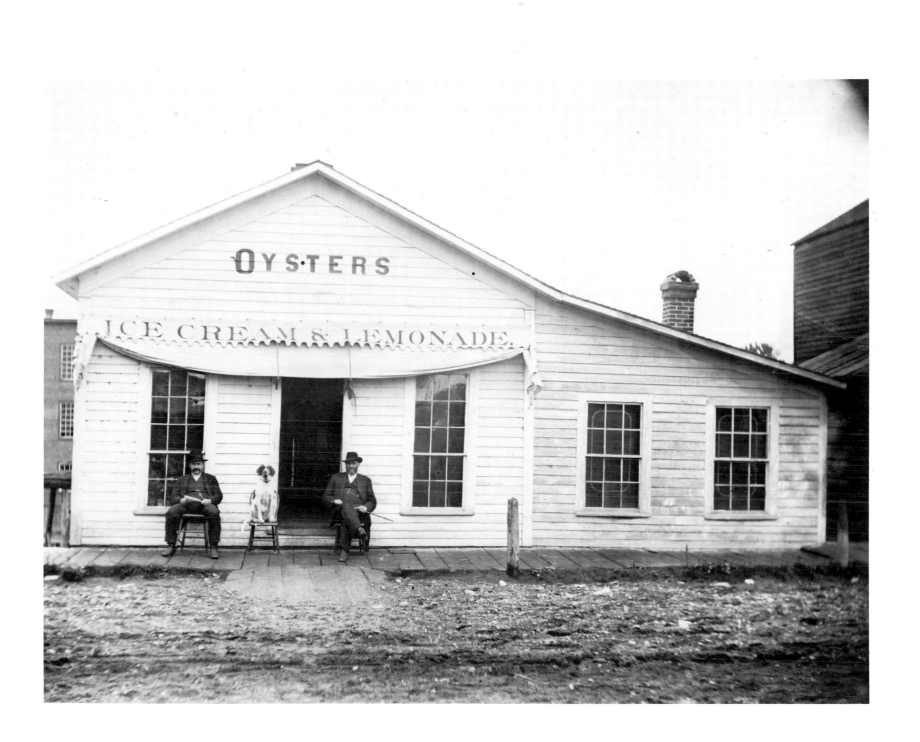

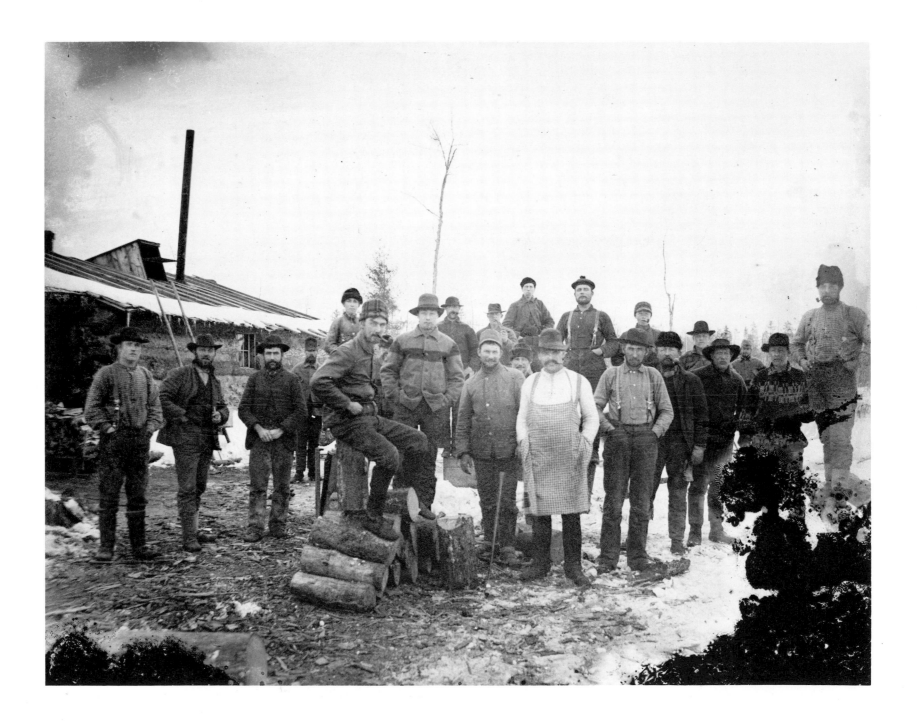

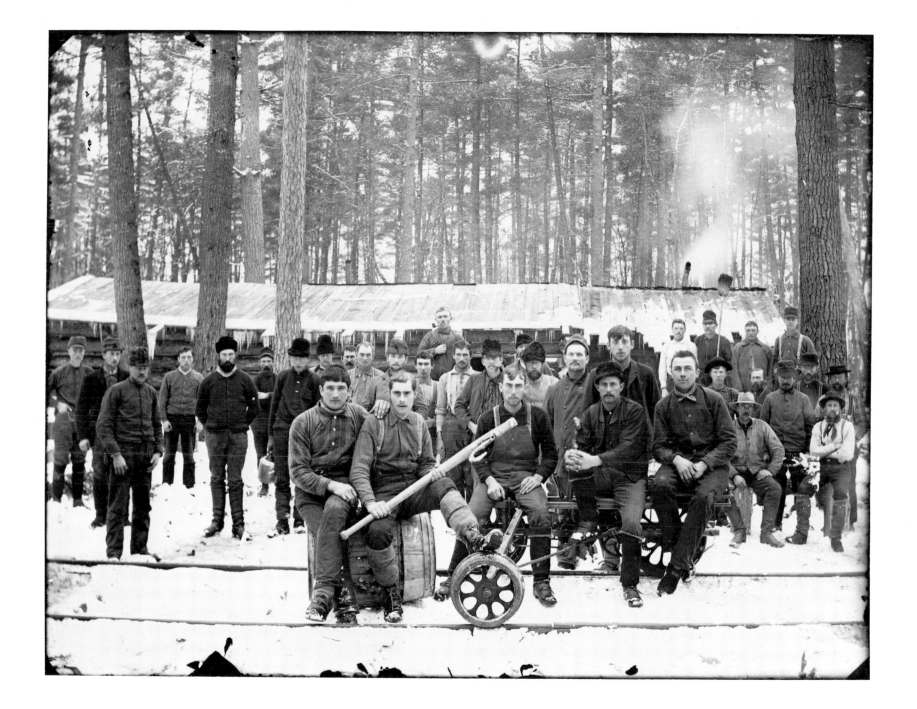

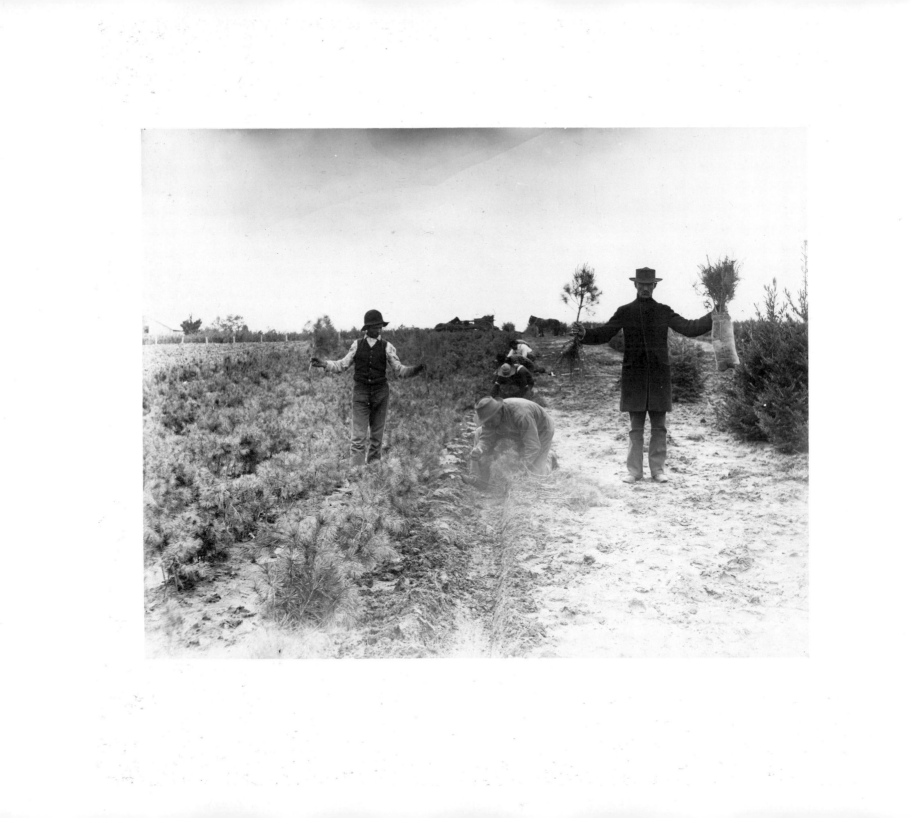

"Lewis Durham, aged 20 years, was committed to the Northern Hospital for the Insane by Judge Millard at Dartford. He resided in the town of Marquette. . . . the insanity is the result of hazing by boys." [1/7, State News]

"Out of the 13 Superior banks which were doing business a year ago only 4 are in business at the present time. In view of this fact, the officials of the various banks are said to be interested in a plan to reorganize and consolidate in one large institution with a capital stock of $1,500,000. . . . The city of Superior during the last 15 months has lost upwards of $200,000 in the failures of the city banks." [1/7, State]

"The Bank of Superior, doing business at the East End, suspended Monday on account of a run [with] which it was threatened on account of the recent failures. . . . The city of Superior had $13,210 in the bank, making nearly $30,000 of the city funds tied up in failures during the last week." [1/7, State]

A national news article, reprinted from *Dunn's Review*, was entitled: "Failures of the Year. Statistics of Commercial Collapses in 1896." The number of failures in 1896 was larger than any previous year except 1893. In 1896 there were 14,890 failures; in 1895, there were 13,797. [1/14, National]

1897

Insanity – hazing by boys Bank Failures Bank failure Nation Wide Failure Infant death – cerebral meningitis Infant death – cerebral meningitis Army of unemployed A factory Reopened Bad tramp Incest Cemetery Association Crazy Frozen exhaustion Lost and frozen Armed tramps Arson Morphine Despair Race with death Somnambulism Insanity – legal Reverses Metal eating wife murderer Window Smasher Cocaine Consumption – family wipe out Witchcraft Insanity Arson Oldest Colored Lady Mesmerism – hysteria Hearse Association Bankruptcy – tragic Honor Mystery woman Graduation Exercises Obscene matter Pitiable tramp Retail failure Family poisoning – hired Girl Sabotage Tramps Legal fees The solitary vice of young men Tramp Racism refuted O'Hearn Arrested Workers become tramps Business booms Bank reorganized No job – starvation Larceny Arson – despair High Brought low Diphtheria O'Hearn freed Mill reopened Sentimental suicide Assault and battery – Returned prosperity Diphtheria Arson Miserly hermit Resignation Delirious Wandering Diphtheria Diphtheria Mysterious kidnapping

Three Mendota State Hospital cases; a local story of H. F. Lyons

"Isolde, the infant daughter of Rev. and Mrs. B. F. Laukandt, died quite suddenly Sunday night. . . . aged 4 months and 10 days, of cerebral meningitis." [1/14, Town]

"A 5 month old son of Mr. and Mrs. Arne Erickson of Spring Creek settlement, in the southwestern part of the town of Albion, died on Sunday last. . . . of meningitis." [1/14, Town]

"The army of unemployed is greater at Iron Belt than it has been for the last 3 years largely because there is less work done in the woods than in previous years. Mines work but very few men, and some shafts have been shut down presumably till spring." [1/14, Town]

"There is less work in the woods of Northern Wisconsin this year than there has been for several years past, caused partially by the amount of logs left over from the previous season in the various logging streams, partly by the stocks on hand at the mill docks, and also by the fact that the outlook in the lumber market without a protective tariff is such that the big operators are not very aggressive this winter." [2/11, State]

"At Racine the big works of the Case Thrashing Machine Company resumed operations on Monday morning. They have been closed for 6 months. Several hundred men will be given employment." [2/11, State]

"August Dempke, a baker over 60 years old, was assaulted in his store at Stevens Point by an unknown tramp, who came into the store and lay down before the fire. Dempke ordered him to leave the place. . . . The fellow jumped up and brutally beat the old man." [2/11, State]

"Witt. Goucher of Merrillan, charged with incest and rape, his own daughter being the victim, was arraigned before Justice P. H. Hoffman. . . . and pleaded not guilty to the charges above specified."
[2/11, County]

"A committee of the cemetery improvement association, which was organized last week, has been soliciting members the past few days with signal success."
[2/11, County]

"Mrs. Ole Ellingson, living in the town of Lund, 8 miles from Evansville, was found in a field, frozen. She left home to visit her sister about a mile distant. She remained there about 2 hours and started back home early in the evening. Not much was thought of her absence, as she had remained away for several days before, but search was commenced and the body was found about 80 rods from where she had started, lying in the snow, huddled up as if going to sleep. Examination showed she had no underclothes on but a thin petticoat. The husband said she was not in her right mind." [2/18, State]

"Two sons of W. D. Rounce, a farmer west of Shell Lake: Arthur, aged 17, and Albert, aged 21, are in the hospital suffering from the effects of an awful experience in the woods Sunday. They had been visiting friends at Orange. . . . and had started to walk across the country to their home, a distance of 25 miles. The weather was bitter cold and a strong wind was blowing. They were not dressed well around the feet, and becoming lost in the drifts. . . . they struggled along during the night . . . until, when almost dead with exhaustion and the cold, they came upon a lumber camp where they were taken care of. Arthur will lose both legs, and Albert one foot." [4/1, State]

"When the 3:23 southbound freight train switched on the side track at Juneau Friday afternoon, Brakemen Keeler and Ruggles discovered a number of tramps in a box car. When the trainmen ordered the tramps to get off the train, 2 of the tramps drew revolvers and fired. . . . the tramps left the train. . . . and were not caught."
[2/25, State]

"Charles Folsom of Clinton was arrested . . . at that village on the charge of arson and is now in jail. It is charged that Folsom fired and burned the hay barn owned by his father-in-law. . . . this fire was one of the series of blazes at Clinton that stirred the people up. . . . the burning of the Cheeseman Hotel and the fire that nearly wiped out the village occurred later, and the only charge made against Folsom is that he fired the barn." [3/4, State]

"A man registered at the La Crosse European Hotel as Edward Folsom, Grand Meadow, committed suicide by taking morphine. He was crippled, old, and out of work." [3/4, State]

"Admitted July 27, 1894. Town of Franklin. Age 65. Norwegian. Married. Two daughters, age 17 and 13 years. Farmer. Poor. First symptom . . . about July 4th, 1894 . . . cause unknown. Possibly hard work or depression as a result of the failure of crops. . . . Is getting worse and more violent. . . ."
[Mendota State, 1894 Record Book (Male, G), p. 432, patient # 6584]

"Admitted July 29, 1894. Town of Melrose. Age 65. Born U.S. Widower. Three children, youngest 30 yrs. of age. Railroad employee. Has no property except what is in his trunk. . . . Derangement manifested on subject of 'Bugs and Flies.' Blind. . . . Sept. 12th: Sudden attack of vomiting and fainted. . . . Sept. 19: Much better—resisted all attempts at physical examination. . . . Dec. 1st: A bedsore . . . has become gangrenous. Dec. 2nd: Failing—Dec. 5th: Died 7 o'clock P.M. *Discharged.*"
[Mendota State, 1894 Record Book (Male, G), p. 434, patient # 6586]

"The 17 year old boy who killed the 4 year old daughter Hazel of Mr. and Mrs. Oscar Marshall pleaded not guilty by reason of insanity. His plea was rejected by the jury, who first deliberated and found on the basis of the prosecution's evidence that he was sane and then further deliberated and sentenced him to life in prison." [3/4, Town]

"Richard H. Cantillon died at his home in Janesville Sunday and the special train bringing his mother, brother, and sister to his bedside arrived 10 minutes after he passed away. Cantillon was the brother of Assistant Division Superintendent W. D. Cantillon of the Chicago and Northwestern of Milwaukee. His last request was to see his mother. There being no special train, Cantillon ordered out a special, but the race with death failed although the trip was made in 2 hours. Cantillon died suddenly, supposedly from appendicitis." [3/18, State]

"Miss Lulu Reeder of Janesville was much astonished when she got up and looked in the glass to find that during the night her hair had been cut off close to her head. She was positive that no one could have cut it off as she slept and was most mystified. When the family went downstairs, the mystery was explained. Lying on the sitting room floor, with the shears on top, was the young lady's hair. She had been walking in her sleep and cut her hair off without knowing it, the marks of the shears showing on her thumbs. The young lady's hair was 27 inches long and she was very proud of it." [3/18, State]

"Peter Gaca of Two Rivers, aged 38 years, was adjudged insane by Judge Anderson. He was taken to the asylum at Oshkosh. A recent lawsuit in which he was defeated is supposed to be the cause of his insanity." [4/1, State]

"Porter Ross of Kaukauna, the alleged wife murderer who is confined at the county jail at Appleton awaiting his trial, called for a doctor during the night. The physician found that Ross has abandoned eating tin, and taken to devouring the wire springs of his bed. He got away with a considerable quantity during the night. . . . he claimed he had eaten 60 pieces in all. . . . An examination of the springs showed that considerable wire was missing." [4/1, State]

"Gov. Schofield will take steps to provide, if necessary, for the care of Mary Sweeny who has caused so much trouble . . . by smashing plate glass windows. This woman. . . . once taught school in Marquette, Michigan, and Stevens Point in this state. . . . Mary says she doesn't know why she breaks windows and only does it when the craze seizes her. She uses cocaine liberally on such occasions, saying it quiets her nerves." [4/1, State]

"A sadly afflicted family is that of Joshua Bibby, residing near Galesville. A few years ago, the father died leaving a wife and 5 grown-up children — a son and 4 daughters. At that time the children were apparently in good health. Soon the son, the eldest of the family, was taken ill and consumption carried him quickly to the grave. Within a few months one of the daughters died of the same disease. In less than a year the disease seized on 2 more of the family, and hoping to stay the malady, the young women, accompanied by the remaining sister, went to Florida this winter. Two weeks ago one of the invalids died and last week the other one was carried to her grave. . . . The sister who had accompanied the invalids to Florida came home alone. She too is in delicate health. It is probable that within a few months, the widowed mother will be left alone. The family has been almost entirely wiped out within 2 years." [4/29, State]

"A peculiar case of superstition has come to light at Merrill. A man who was engaged at the tannery there boarded with a man and his wife for some time, but failed to pay his board. He then went to board elsewhere. The hard times, he claims, make it impossible for him to pay the bill all now. His landlady has composed a song concerning her debtor, and according to her convictions, if she sings the song a certain number of times a day for a year, her debtor will die, but if she ceases her song at any time before the expiration of the year she will die. Whenever the matter is mentioned in the presence of the victim, he grows pallid and acknowledges that he must die at the stated time, as he cannot pay his bill." [5/6, State]

"Dan Mills, from the town of Brockway, and Emil Emberson from the town of Franklin, were this forenoon adjudged insane and committed to the asylum at Mendota by Judge Barclay." [5/6, Town]

"Admitted May 20th, 1888. Town of Millston. Born New York. Aged 48. Married. Laborer. . . . Imagines his neighbors are trying to injure him. . . . May 21: Always talking about being 'put down,' 'undermined,' and abused by his brothers. Says they are always trying to injure him. Says he is not insane and don't belong here. . . . June 30th: Always asking to go home. Says he was brought here by misrepresentation. . . . Dec. 10th: Discharged. . . . Readmitted June 16th, 1891. He is 68 yrs. old. . . . Cause said to be loss of property. He thinks there is a conspiracy to defraud him and do him bodily injury. Thinks he has loss of Manhood. . . . April 21, 1893: Much the same. Still talking continually of a 'big job' being put up on him. . . ."
[Mendota State, 1887 Record Book (Male, F), p. 201, patient # 4719]

"A mysterious and devilish act at the home of J. A. Bailey in the town of Albion, by some unknown person on Wednesday of last week, fell short of. . . . the destruction of the fine residence, on account of the ignorance of the perpetrator. . . . Somebody entered the house unnoticed . . . and tore some leaves from a music book, despoiled some articles of clothing belonging to Mrs. Bailey and Miss Eppa Davis, a teacher who was boarding there . . . and then emptied the oil from a Kerosene lamp in the center of a mattress in the chamber and set it on fire. . . . it was discovered in time to prevent a conflagration. . . . This disgraceful deed was evidently the work of jealous spite or revenge." [5/13, County]

"In St. Joseph lives Mrs. Helen Lewis, a colored woman who claims to be the oldest woman in the state. She has positive proof that she is 107 years of age. . . . She was formerly a slave." [5/13, State]

"Marinette physicians have interested themselves in the case of Nestor Provancher of Menominee who has been unable to talk above a whisper for 16 weeks. They have certified that Provancher is still under hypnotic influence. In the early spring, a mind reader put Provancher under his spell. . . . the last night of the performance in Marinette he told the lad he could not talk, and since then, the boy's speech has been almost gone." [6/3, State]

"The annual meeting of the Melrose Hearse Association was held last Sunday. The Association has sold about $175 worth of stock. $155 was paid for the hearse at Black River Falls. The hearse has earned $82 during the past year. A dividend of 10% was voted to the stockholders. . . ." [6/3, County]

"There was a dramatic scene in the courtroom at Oshkosh Saturday morning when Judge Burnell pronounced sentence upon T. C. Shove, the Manitowoc banker who was convicted of receiving deposits when he knew the bank was insolvent. . . . Many persons were forced to wipe tears from their eyes out of sympathy for the aged banker. The climax came when Mr. Shove drew forth a knife and tried to plunge the blade into his side, but was prevented from committing suicide by friends." [6/10, State]

"The 'woman in white' was taken into custody in Marinette after scaring half the inhabitants of the city. She is evidently insane and dresses entirely in white with black crepe bands around her arms. She hid herself in the Sons of Veterans Hall and scared several members by stalking suddenly among them. It is claimed she was in a Michigan insane asylum for a year." [6/10, State]

High school Class Speeches:

 Has the Senate Degenerated?
 Something Still To Do
 Sons and Daughters of Liberty
 Economy of Time
 The Nation's Hero [U.S. Grant]
 Our Aristocracy [A Criticism]
 The Uncrowned King [Parnell of Ireland]
 Our Martyred President
 The Persecuted Jew
 A National University [6/10, Town]

"The case of C. S. Matheson of Fond du Lac, indicted for sending obscene matter through the mails, came up in U. S. Court at Oshkosh." [6/24, State]

"Michael Mooney, who was one of the many unfortunates homeless and out of employment, met death here last week in a particularly sad manner. He was riding on the front platform of one of the night passenger trains of the Omaha, and evidently as the train neared the lights of the station he jumped with a view of keeping out of sight. In some way he fell backward, his right arm coming under the wheels of the train. . . . he was carried to the Exchange Hotel, where Drs. Moore and Breakay amputated the arm. . . . It was thought he might recover, but though everything that sympathizing strangers could do was done . . . he died early Saturday evening. He was man aged 50 years, and had no family and no residence." [7/1, County, from Merrillan]

"Reitz and Haugen, former residents here . . . who have been in the merchant tailoring business at Neillsville for the past 16 years, have just made an assignment for the benefit of their creditors. . . . It is the result of a gradually failing business during the past few years of financial depression." [7/15, Town]

"Some time ago, the family of Julius Semrow of Freedom, father, mother, and 3 children, were mysteriously poisoned twice within a week's time. Since that time . . . Under Sheriff Mitchell went to Freedom and arrested Alma Glimm, 16 years of age, who had been an employee at the Semrow household. She was accused of having put 'Rough on Rats' in the food." [7/29, State]

"Tramps are supposed to have set fire to the barns on the James S. Banfield farm, 3 miles east of Janesville." [7/29, State]

"Rudolph Pietzel, who was arrested here last week for stealing a horse, committed suicide night before last, in the Lancaster jail. Getting cheated when he traded away the stolen horse probably continued to work on his mind until it drove him to the rash act. It is probable that he did not realize what a lot of good fees he was thus snatching from Grant County attorneys and court officials." [7/29, Town]

"Young men who have become the victims of solitary vice, that dreadful habit that sweeps annually to an untimely grave thousands of young men of exalted talent and brilliant intellect, can call with confidence."
[8/5, Front page ad for visit of Drs. Mosley Lee and Helen Lee]

"Ward Rausch, a 13 year old boy of this city, was yesterday afternoon ordered by Judge Barclay committed to the reform school at Waukesha as an incorrigible. It seems that he had become entirely unmanageable by his grandparents, with whom he had lived, and frequently ran away, traveling from town to town about the state, beating his way on the railroads and earning money to purchase food by playing violin in saloons and other houses of vice." [8/5, Town]

"H. F. Lyons finished painting the front of his [barber] shop, 2 coats, Monday, and arose the next morning to find the front daubed and spattered from top to bottom and side to side with shoe blacking liquified with some oily substance. . . . It was indeed a contemptible trick. . . . It was surely not intended as a practical joke but was doubtless a piece of petty spite work by some low-lived enemy with a brain about as big as a pin head." [8/12, Town]

There were two black barbers in town. One was named Nichols and the other fellow was named Lyons. Both had been brought up North as orphans by Civil War veterans. Both of them were unmarried but probably had Winnebago mistresses. They were different sorts of men, but both of them died disastrously.

Lyons was a poor black man. Everything he owned he kept in his shop on Water Street by the river. He slept there, he washed there, he ate there. In 1911, the river rose and flooded the town. It drowned Water Street and washed away everything Lyons owned. He died in the poor house. [Local History]

"W. R. O'Hearn was arrested Friday afternoon last, on a warrant issued by P. B. Castley, court commissioner, on a charge of receiving deposits as cashier of the Jackson County Bank, which went into the hands of a receiver nearly a year ago, knowing that the institution was insolvent. . . . In view of the fact that the poor assets of this bank are of a deteriorated rather than a fictitious nature, it would seem to us that the charge might be a rather difficult one to prove." [8/19, Town]

"At the rate laboring men have gone out of Ashland within the past week, there is liable to be a scarcity of labor there. The exodus for the harvest fields has been unusual, the Northern Pacific train was loaded so that even standing room was almost unobtainable. The steamer, Hunter, carried away several dozen men bound for the harvest fields. . . . this heavy traffic . . . has been the case for several days. . . . It is estimated that between 300 and 500 men have left Ashland within the last week to obtain work elsewhere." [8/19, State]

"Business is booming at the Mitchell and Lewis Company wagon factory at Racine which is one of the largest in the United States. One hundred farm wagons are being turned out each 12 hours, and still the orders can not be filled. There appears to be no let up. . . . the fact that the orders are from the farming district is an indication that the revival is felt by the farmer as well as the manufacturer. What is true of this enterprise will apply with equal force to the J. I. Case Plow Works, which is running 12 hours a day and with more orders than it can fill. In addition to this, the lumber dealers have noticed a stimulus to their trade." [8/26, State]

"The reorganized Jackson County Bank opened for business at the old stand at 9 o'clock last Monday morning."

President: F. F. Oderbolz
Vice-Pres.: George F. Cooper
Cashier: J. H. Mills
Directors: Frank Johnson
Charley Franz
David Barclay

[8/26, Town]

"An old man was found in a brush shanty a mile south of Peshtigo. He was unable to move owing to hunger and exposure. He came from Canada a month ago in search of work."

[9/2, State]

"John Munskey and his wife Pauline residing near Fish Station were arrested on the charge of grand larceny. It is alleged that their children were taught to hang on buggies and other vehicles . . . passing the farm house and secure what articles they could, such as ropes, whips, straps, etc."

[9/2, State]

"William Ash, a Beaver Dam man, is in jail as a result of very peculiar circumstances. Thursday the barn of Andrew Willard of Beaver Dam was destroyed by fire and there was unmistakable signs of incendiary origin. The fire took place in the forenoon, and on the afternoon of the same day William Ash, age about 29 years, made his appearance at the county jail and requested the sheriff to lock him up. He said he [had] set fire to Willard's barn that forenoon. . . . He said he hoped the sheriff would prosecute him to the full extent of the law. . . . He said he was distracted on account of being out of work for a long time, and on the impulse of the moment, committed the crime for the sole purpose of being sent to prison where he would at last receive enough to eat."

[9/9, State]

"Ex-Mayor Lochead of Glenwood, who was confined at the county poor farm when his term as mayor expired, made a murderous assault on Keeper Walby in the darkness."

[9/9, State]

"Owing to the extent that diphtheria is prevailing at Two Rivers, the School Board, upon advice from health authorities, deemed it advisable not to open the schools."

[9/9, State]

"Mrs. Lizzie Larson, of Merrillan, was adjudged insane and was taken to the asylum at Mendota last Friday. Poverty and the loss of her husband were the causes which brought about the sad affliction. She raves about religion and imagines she is going to die. At times she has been so violent that it took 2 men to keep her from injuring herself and others. She has 4 children that are in destitute circumstances."

[10/7, Town]

The circuit court dismissed the case against W. R. O'Hearn.

[10/7, Town]

"Arrangements have been made by which the Kennedy mill at Ashland will run night and day the rest of the season and during the winter. Eight million feet of logs will be hauled to Ashland."

[10/14, State]

"John Persons, the 16 year old son of Mr. and Mrs. E. D. Persons who killed himself on October 5th, left this in his pocket: 'To relatives and friends:—Dear mother and father, brothers and sisters—I am going to rest. I am tired out. I leave my love to all and we hope there is a better day to come. God is with us. Comfort yourselves. Lose no sleep. I hope I have left no enemies. I regret all sins I have committed. Goodbye, dear friends.'"

[10/14, County, from Millston]

"Three cases of assault and battery in our city justice courts so far this week are another indication of returned prosperity. Times have been so hard the past few years that when a man got mad at another he would swallow his wrath, go home, and pound his dog. Now that the good times have returned, he gets into a scrap with the cause of his anger and winds up with a round in the justice court."

[10/21, Town]

"At Ahnappe 5 new cases of diphtheria were reported, and every precaution is being taken to prevent the spread of the disease. No deaths have occurred and the schools are still open."

[10/28, State]

"There was another dwelling house fire in the city about 3 o'clock Monday morning, resulting in the total destruction of M. J. Moran's house . . . known to old settlers as the R. D. Squires house. . . . The indications were that the fire started in the shed in the rear end of the house and can be accounted for in no other way than as incendiary "

[11/4, Town]

Moses Paquett went into fire insurance just before the depression. Once it had begun, it seemed that anyone who could strike a match was always doing it inside of someone else's nice, tindery barn. Sometimes it was tramps who'd gotten a kick instead of a handout. Sometimes it was just kids fooling around. Sometimes it was strange men who'd be caught standing stiff as boards, their hands in their pockets, rocking in front of the fire. Lots of times it was farmers who'd run out of credit and figured they might as well put their policies to some use. No matter who did it, Moses came out of the depression the owner of a saloon with money in the bank. Whenever anyone asked him why he'd gone into it in the first place, he'd always say it was because his matches had got wet.

"A cup containing $970 was found concealed underneath the Northwestern freight depot, where it had been placed some months ago by one Joseph Schuch, a peculiar old man who lives the life of a hermit in the northern part of Fond du Lac. Some weeks ago Schuch went to the depot in search of the gold, but his memory failed him and he was unable to remember just where he had concealed it."

[11/25, State]

"At La Crosse, John Rhine, about 60 years of age, committed suicide by hanging to an evergreen tree in Oak Grove Cemetery. . . ."

[12/2, State]

"Mrs. Louis Ross of Janesville, who was found wandering in the streets of Chicago in search of her husband, will be sent to the Mendota insane asylum." [12/16, State]

"The children of Rev. John Rathke, pastor of the Lutheran Church at Brillion, are sick from diphtheria, and the house has been quarantined. No services will be permitted in the church." [12/30, State]

"At Sheboygan, a mysterious woman dressed in black and wearing a heavy dark veil enticed from school George Alfred Preston and Hattie May Preston, aged respectively 11 and 9 years, children of George Preston. The children were hurried away in a closed carriage which started in a northerly direction, supposedly for Plymouth where a train could be taken." [12/30, State]

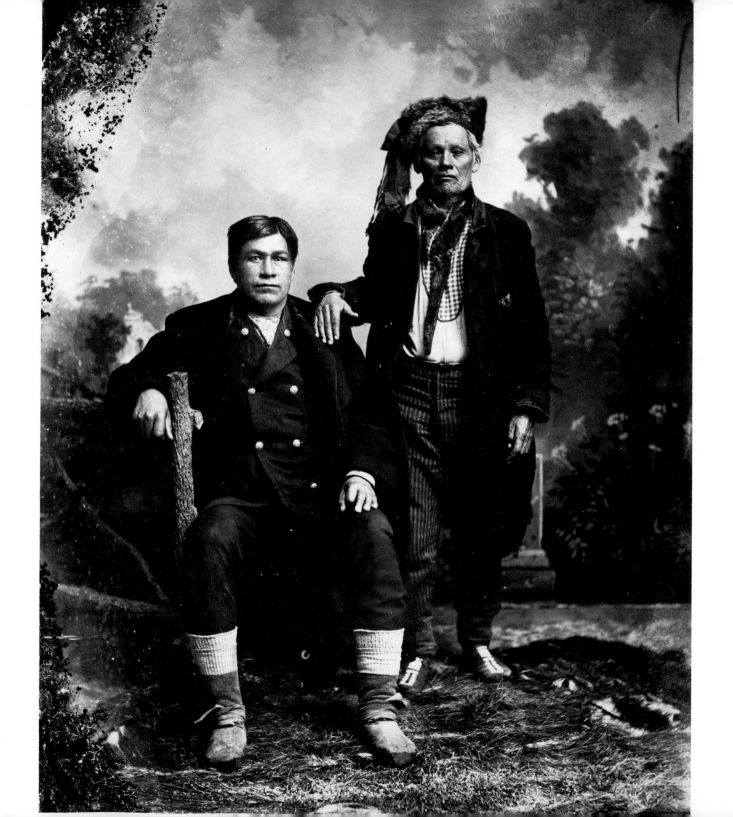

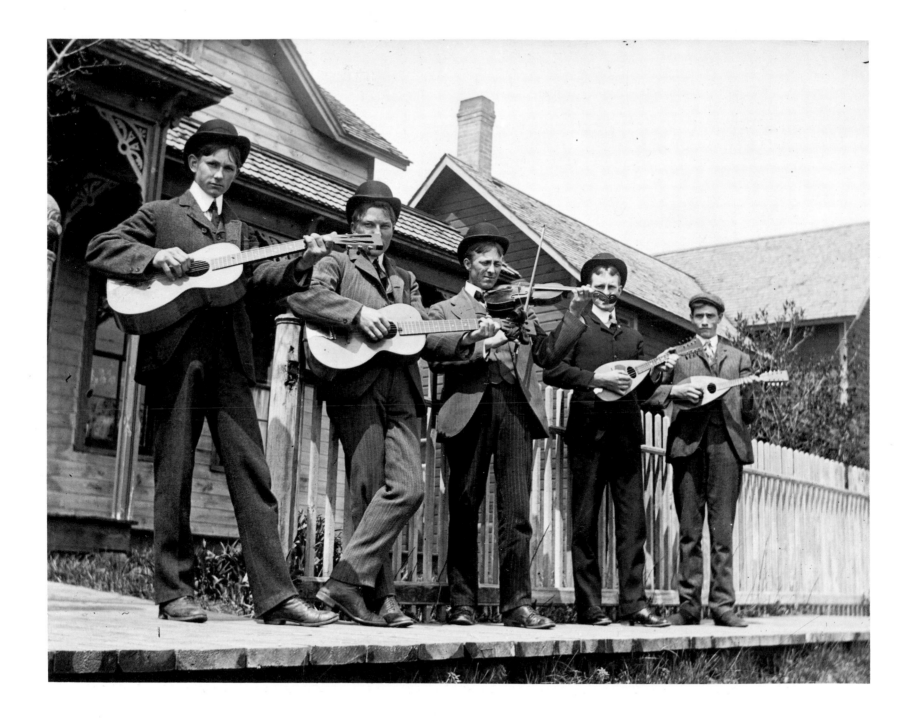

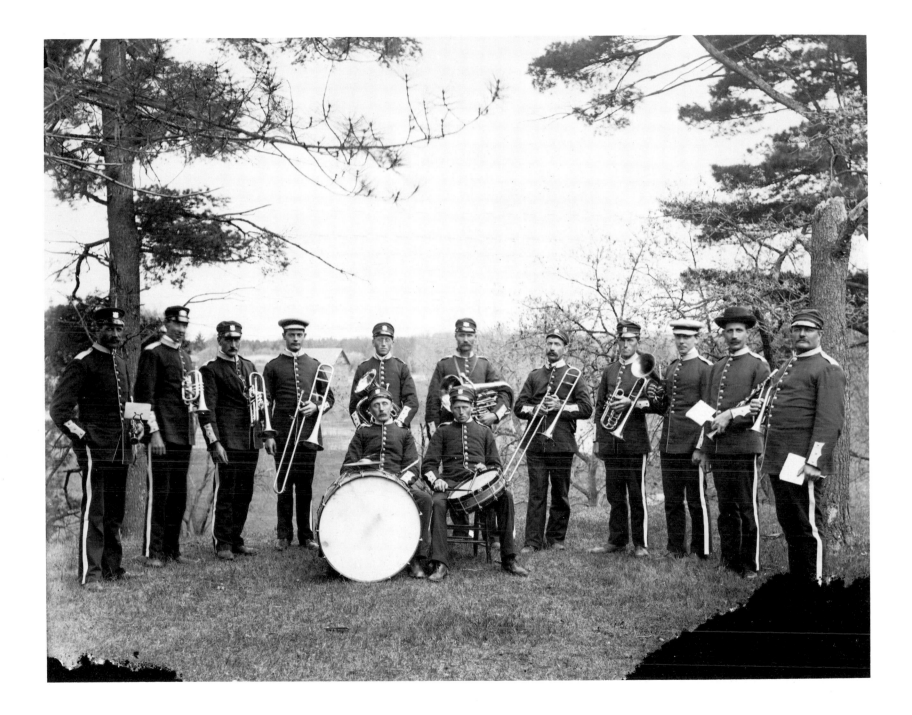

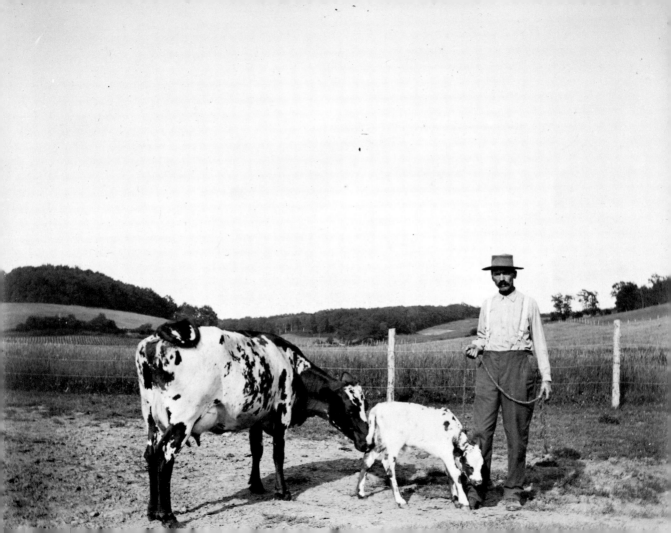

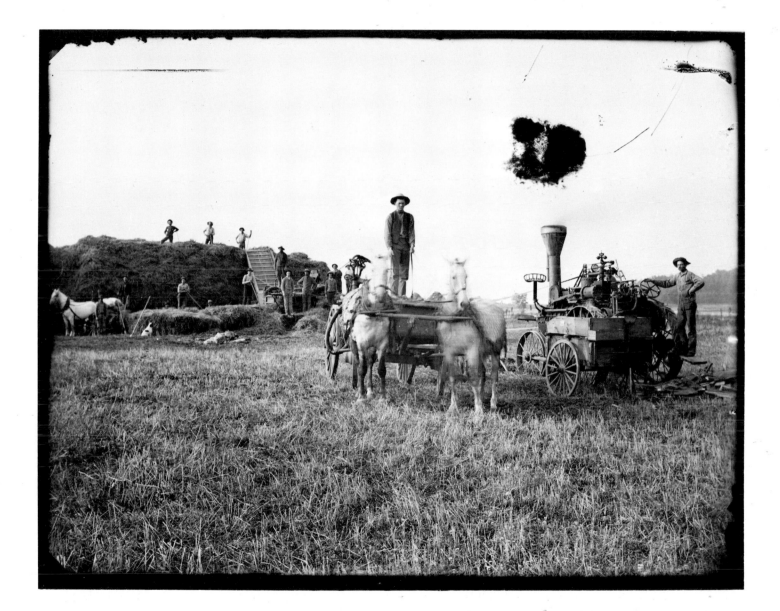

WM. TENNANT
BLACK RIVER FALLS. WIS.
MAGAZINE AND NEWSPAPER AGENT

Mr. E. H. Erickson, Minneapolis, Minn., made me these legs on credit August 1, 1908. Since then I have made nearly every county in the state, and a good many in Minnesota, selling magazines and newspapers. My credit is good wherever I am known and my legs have carried me thru a great many counties during the last five years.

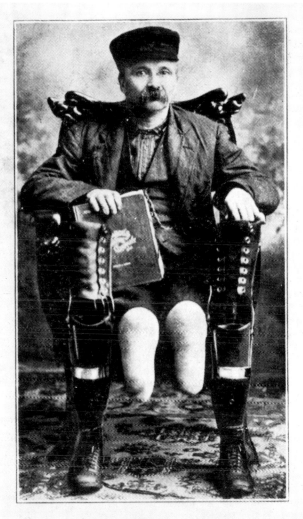

WM. TENNANT
BLACK RIVER FALLS. WIS.
MAGAZINE AND NEWSPAPER AGENT

Mr. E. H. Erickson, Minneapolis, Minn. made me these legs on credit August 1, 1908. Since then I have made nearly every county in the state, and a good many in Minnesota, selling magazines and newspapers. My credit is good wherever I am known and my legs have carried me thru a great many counties during the last four years.

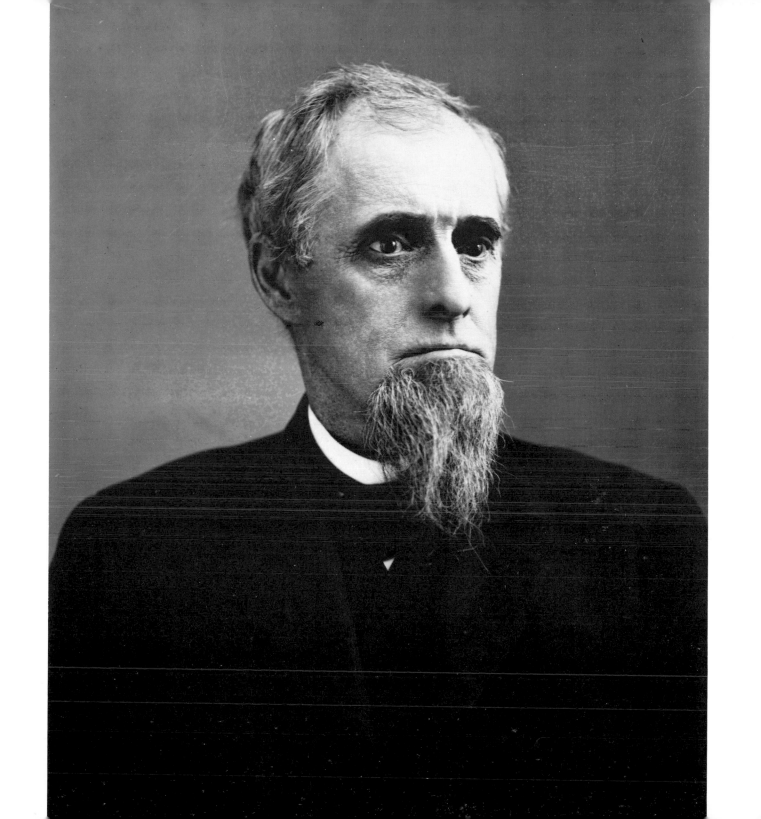

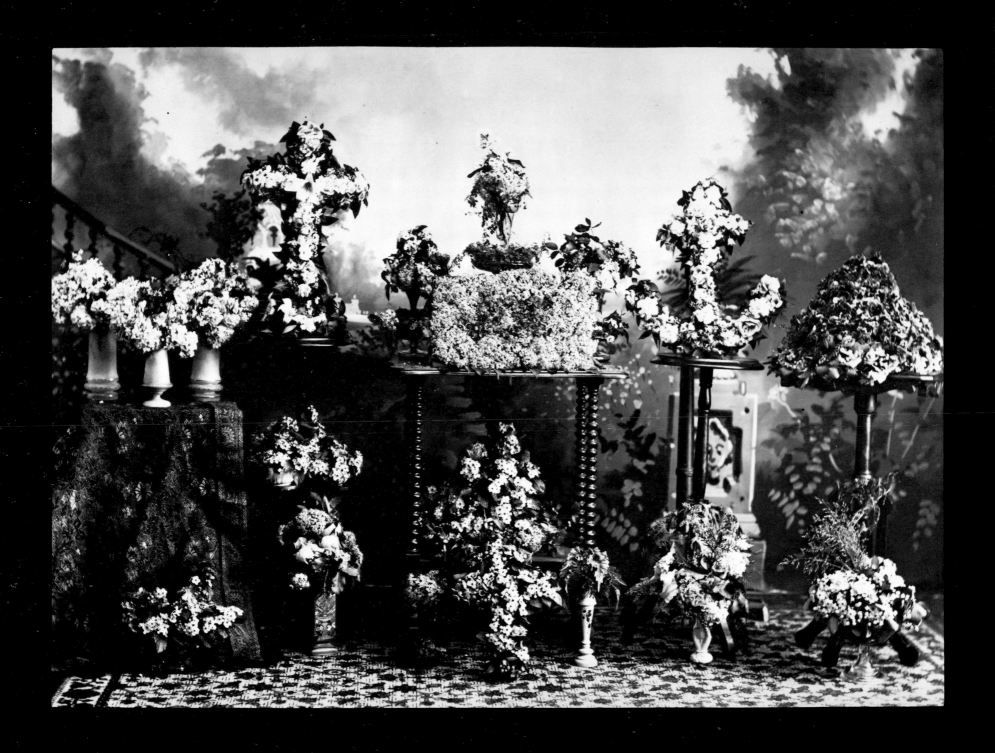

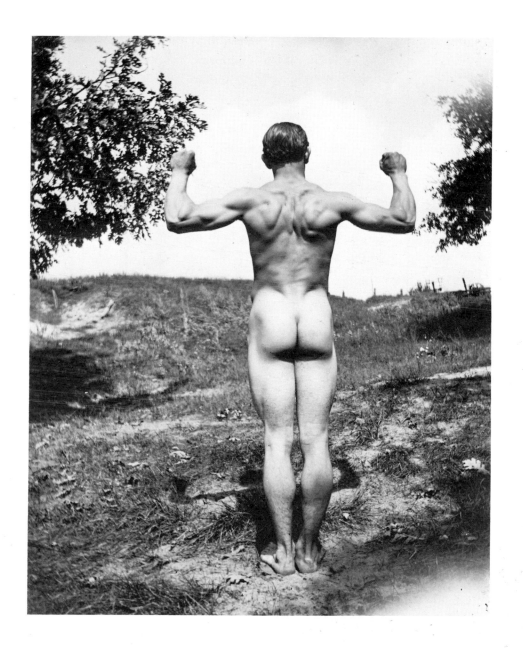

"Harold Ingoll Holven, the 5 month old son of Mr. and Mrs. Ed Holven who live about 4 miles west of the city, died quite suddenly last Friday morning of heart failure. Mrs. Holven had been in the city with the child for a short visit with relatives and on the way home it died in the mother's arms, she not knowing it was dead until she carried it into the house." [1/13, Town News]

Mrs. Friedel had a picture taken of her little baby in its coffin. Then when a fellow came up the road who did enlargements, she had just the baby's face blown up to a two foot picture. But, since the baby's eyes were closed, she had an artist paint them open so she could hang it in the parlor. [Town Gossip]

"Mrs. Sophia Engebretson of the town of Albion was examined before Judge Barclay yesterday and . . . adjudged insane. . . . It was a very sad case. She leaves her husband with 5 children. . . ." [1/13, Town]

"Racine is having a smallpox scare. A high school girl was taken sick with the disease. Her school books were burned and the school house thoroughly fumigated. No spread of the malady is anticipated." [1/27, State]

1898

Sudden baby death Sad insanity
Smallpox scare Sets fire to herself
Suicide – dread of old age Factories
Running full time Hysteria –
hydrophobia
Buried alive Incendiary terror
Spanish War Arson No war news
Obscene matter High school optimism
Suicide – financial despondency
Volunteers
Bouquets for the Volunteers Morphine
Suicide Infant death memorialized
Writing home to Mother Volunteers
farewell
No one's suicide Arson No job suicide
War industry Apparition Army of
Tramps Mothers protest army hardships
Railway insanity Cemetery association
Grim death Mysterious disappearance
Insanity The boys come home angry
Diphtheria Murder – hired hand. Hired
Hand suicide Infant death memorialized
Baby murdered White girl marries
Black man D. J. Spaulding declared
Bankrupt He set fire to himself
Religious insanity Suicide – moral
disgrace obliterated by electricity

Local stories about dead baby pictures, funerals, and family albums; Glenway Wescott's story about hair albums as memory devices; his description of a lynching; a Mendota State case history

"Mrs. Reuben C. Bartlett, an elderly woman living near the western limits of Eau Claire, partly filled a washtub with kerosene, partially disrobed, and poured kerosene over her head and set fire to it. She died in a horrible agony before help reached her. She was undoubtedly insane. . . . She leaves several adult sons and daughters and a husband." [2/10, State]

"At Manawa the aged father of Daniel and John McKinzie attempted suicide by cutting his throat with a razor. He was found by the roadside insensible. The cause of the deed is thought to be a dread of old age." [2/10, State]

"For the first time since 1893 all the Sheboygan factories are running full time and with a full force of men employed in all departments. All arrears in wages have been paid to the employees in some factories where the accounts had been behind for many months." [3/3, State]

"Charles Good, residing near Valton, is afflicted in a peculiar manner. About 18 years ago he was bitten by a dog and about 2 years after that became subject to epileptic attacks. Early in this month he was taken with the symptoms of hydrophobia by imitating the barking of a dog for a time. Water does not affect him, and for this reason the attending physician does not think he is afflicted with rabies." [3/30, State]

"A horrifying discovery was made at the Rosedale Cemetery in Pardeeville. The grave of Mrs. Sarah Smith was unearthed for the purpose of removing the remains and on opening the coffin it was discovered that she had been buried while in a trance. The body was partly turned over and the right hand was drawn up to the face. The fingers indicated that they had been bitten by the woman on finding herself buried alive." [4/14, State]

She fainted dead away at her little brother's funeral. He'd taken ill in January from nephritis and they'd nursed him at home till June. When he died, they decided to have the services at home, so the undertaker didn't embalm. She never did understand why, but they all had to stay up nights with it and put cold ice cloths on his face so he wouldn't turn. He'd been 18 or 19 and she'd stayed up the whole night. The next day, at the funeral, it was so hot, and the air was so damp and heavy, and she hadn't eaten right. All of a sudden, she was on her back in the middle of the grass and her brothers and sisters were running around screaming. They said they thought she was dead. They said they thought Freddie was dead and so was she. Because they'd seen him die right at dinner and they thought that since he didn't make any more of a fuss than she did—well, they thought people just dropped like flies. [Town Gossip]

"Farmers residing in the southeastern limits of Eau Claire are living in terror. Within the past 4 or 5 weeks, 3 barns and a large number of cattle, horses, poultry, and farm machinery have been destroyed by fire . . . that the fires were started by an incendiary is beyond doubt. The farmers of the neighborhood are of the opinion that some crazy person is responsible for the destruction of the buildings and the livestock." [4/14, State]

War With Spain
Local Enlistments!
Bands!
Flags!
Troop Trains! [4/12, Town]

"There was quite a serious fire at the fairgrounds late Sunday afternoon, the result being the complete destruction of the large and well constructed horse barn and all the stock sheds, probably 500 feet in length. . . . It is thought that the fire must have been set by boys either carelessly or mischievously." [5/12, Town]

The only war news is in feature stories. There is no local, county, or state mention of it except for scattered anecdotes. [5/12]

"Between 2 and 3 o'clock yesterday morning, fire broke out in C. F. Tester's saw and shingle mill, located near the depot. It is not known how the fire originated but it is thought to have been set by tramps as some were seen in the vicinity the evening before." [5/26, Town]

"Mrs. Emma Dingman who has been tried several times for sending improper matter through the mails was again up before the Special Court Commissioner Bloodgood at Milwaukee for the same offense. Letters have been received by federal authorities in Milwaukee for the past 5 years, all of which were of an offensive nature. All these letters were read before the court commissioner and it was clearly proven that Miss Dingman could not have written them." [6/2, State]

The high school Class Motto was: "We'll Find A Way Or Make One."

There were 10 boys and 10 girls. It was the largest class ever graduated. These were the speeches:

Girls:
A Woman's Sphere
The Norsemen
The Knighted of the Earth
William E. Gladstone
The Mission of Birds
Home Training
Our Duty to Unfortunates
Faith and Doubt as Motors of Action
A Modern Reformer [a heroine of the Women's Christian Temperance Union]
What Shall We Make of Life?

Boys:
Success
Individual Independence
Is the Cuban Capable of Self-Government? [If he isn't, it's Spain's fault, since she kept him ignorant and unimproved.]
The Cost of an Idea
The Stars and Stripes
Spain's Colonial System
Should the United States Extend Its Territory? [No, it shouldn't, lest it, like the Roman Empire, be overwhelmed by debts, overextension, and the incorporation of barbarism.]
War and Its Effects on the Nation
Ambition
The Class of 1898 [a poem] [6/9, Town]

"John Bleichman, a well-known farmer living near Sullivan, attempted to commit suicide by hanging. He was discovered and cut down but the attending physician had doubts about his recovery. Financial troubles are supposed to have been the cause of the act." [6/16, State]

"The boys who went to Sparta yesterday morning to enlist with the volunteers from there for the Cuban War sent back word that they had enlisted and successfully passed the examination and stated that there was room for 5 or 6 more from here. In response to this information the following young men started for there at 8 o'clock last evening: George Franz; Ara Preston; Ned Olson; Orin Brist; and John Smith." [6/16, Town]

"Mrs. Hattie Roddy sent a bouquet of flowers to each of the boys who enlisted with the Sparta company, on the noon train today, with a letter containing expression of good cheer." [6/16, Town]

"James Price, aged about 60 years, committed suicide at Omro by taking paris green and morphine. All attempts to save him he resisted. Despondency was the cause of the act. He fell last spring and broke the patella of his right knee and has been unable to work since. He leaves a wife and one daughter." [6/23, State]

"Died Saturday morning June 11, 1898, Laura May, daughter of William and Denada Halled, aged 2 years, 5 months, and 9 days. Birdie (as she was familiarly called) was a bright and lovely child. Bright beyond her years, the pet of the household. Her death, as an affliction, falls with crushing weight on the circle of mourning friends who knew her but to love her. For the past few months the little sufferer battled with disease without a murmur, and then yielded to our common enemy and ceased to suffer. The funeral was observed on Monday afternoon at the residence in the presence of a large concourse of sympathizing friends. And now another little mound of earth dots the cemetery while the little form beneath consecrates and makes it sacred to human hearts. Another pair of little feet tread the golden streets, another lamb is folded safely in the arms of the good shepherd, another bud has burst on earth to bloom in heaven. May the mourning ones remember that 'It is not the will of our Father in Heaven that one of those little ones perish.'" [6/23, County, from North Bend]

They'd put the funeral pictures right alongside the rest in the family album. Everyone had a center table with shelves. They'd put the album on top, and the family Bible on the bottom. When company came, they'd sit them down and open the album. It was the polite thing. They'd turn the album pages and every once in a while the company would say something about how long Arthur's hair had been when he was little, or how they hadn't seen that picture in ages, or how sweet the baby looked, and which one was it, since they knew you'd lost little Robert, and Lawrence, and Ida. [Town Gossip]

"Serena Cannon had made the hair album which was the show piece of the collection, a copy book bound in vermilion paper with two or three tiny garlands of hair on each foxed but substantial page. In all there were fifty-six names, badly faded, in a script full of old-fashioned flourishes, and fifty-six garlands, having a great variety of designs: braided hoops, medallions like bits of Spanish lace, and spider webs, combinations of loops and zigzags and coils and shadowy scallops, executed in every quality and shade of hair—gray of tin and gray of iron, sandy and chestnut and dead black, one maroon and one almost orange; fine, coarse, wiry, or subtle; long threads spread out in spirals, and threads not long enough to encircle a space as big as the end of one's thumb, and stiff locks in which the form of a curl still pulled at the

knots which held them. Most of the names were unknown to Alwyn: Letitia, Judith, Clara-Belle, and Sophonisba; Enoch, Luther, Cyrus, and Phineas; Cannons and Standishes and Crosbys and Valentines— families which had died out or gone West. But he found, under a blond oval, the name of his mother's father, *Mr. Ira Duff;* under some dark plaited threads, *My husband Henry O. Tower;* and a lifeless wisp, marked in a woman's handwriting, *My little son Oliver,* and beneath it, in another script, in ink of another color, *Deceased Dec. 4th, 1867.* Alwyn was bewildered when his grandmother explained that this book took the place, in those days, of a photograph album. He was unable to deduce a face or a life from a lock of hair; but an incongruous refinement rose like a ghost or a perfume from between its pages, and was added to his conception of the early days—a refinement which was the fancywork of a woman with an unimaginable face, a woman without history, whose only son was dead.

Serena Cannon was famous for her hair work and had left to her husband's family another masterpiece, a wreath as large as a funeral wreath: more than one head of hair wound and tied on a skeleton of wire; padded flowers in the form of Turk's-cap lilies, frayed leaves and swollen buds all bristling with the ends of individual hairs; and the wreath as a whole—when the old hat box was opened and the tissue paper lifted—quivering like a venomous spider.

Alwyn saw in his mind's eye a pallid woman, the veins on her hands very blue, the hands themselves moving in a mass of hair piled on her lap."

[Glenway Wescott, *The Grandmothers,* pp. 10–11]

The newspaper reprinted a news service engraving of servicemen sitting under a tree. They look to be in their mid-twenties. Caption: "Writing Home to Mother— A Familiar Scene at Chickamauga."

[6/23, National]

"There was a large crowd of people at the depot Saturday night to bid good-bye to the boys from here who enlisted with the Neillsville company for the Cuban War, it having been ascertained that they would go through here on the 11:18 train that night. . . . it seems possible that they may be called upon to go to the front without drill and without time to become acquainted or toughened to the hardships of army life."

[6/30, Town]

"Working men at Kenosha found the body of a man hanging from a rafter. The body was badly decomposed. Nothing was found to identify it."

[7/7, State]

"Lydia Berger, a 15 year old girl is in jail having confessed to the crime of arson. Several days ago she left her home on a farm north of Milwaukee and went to town to go to . . . the carnival. . . . She was out late that night and the next day her father whipped her for staying away without his permission. She sought revenge by setting fire to the little cottage in which they lived. It was burned to the ground. A neighbor gave the family shelter and the next day the girl set fire to the house of their benefactor. Her mother ordered her to harness a team of horses which was temporarily quartered in a barn belonging to the Wisconsin Lake Ice Company. The girl went to the loft and set fire to the barn, which, with 64 tons of hay, was burned to the ground. The girl says she set fire to the places simply to have revenge on her father for whipping her." [7/19, State]

"Peter Ludoff, a tailor of Fond du Lac who had been out of work for some time, committed suicide by hanging himself. . . . he was a man about 50 years of age." [7/21, State]

"The crushing of Admiral Cevera's fleet (at Santiago) has had a beneficial effect on the lumber market. . . . A large number of Eastern buyers are negotiating some large purchases at Marinette. Hayes and Company bought 2,000,000 feet of good lumber from Marinette growers." [7/21, State]

"Queer stories are afloat concerning a mysterious apparition that has appeared at St. Cloud. Thomas Kane, one of the best known residents in that section and a man who is known for his veracity, tells the following story of his dealings with the ghost: 'On Saturday evening I started out to repair the switch on the water tank and had gone some distance when I noticed a man coming toward me. At first I did not think anything about him, but as the person drew nearer, I saw he was a strange man and was dressed in white. Upon close examination, I noticed that the man was not walking, but gliding along the rails. When a short distance away I asked him who he was and where he was going. Hardly had I finished the questions when he vanished in the air. I felt rather peculiar, but on Monday night I made the same journey. I saw the same object coming and when a short distance away it spread out its arms to full length and melted away.'" [8/4, State]

"An army of tramps, estimated at 250, gathered about the railroad yards at La Crosse, all bound, as they claimed, for the harvest fields. It was the largest number ever seen there. They were marched to the river, made to wash themselves, given something to eat, and rushed out of town." [8/4, State]

"Governor Scofield has received many letters from people in the state urging that something be done to check the abuse of Wisconsin troops at the front. Mothers and wives, particularly, are vehement in their demands that some steps be taken to prevent a recurrence of severe forced marches." [8/4, State]

"A woman about 35 years of age was taken off the Northwestern train at Fond du Lac who had the appearance of being demented. She boarded the train at Oshkosh and when the conductor asked her for a ticket, he received no answer. When Fond du Lac was reached, she was [taken] off and the police notified. All efforts to get her to talk were useless. . . . she was taken to Dr. Mayham. It was found upon examination that her jaws were firmly set and all efforts of the doctor to force them apart were useless. She could understand what was said, but made no answer." [8/18, State]

"The trustees of the cemetery association wish to extend thanks to all who assisted in the entertainment last Thursday, including the orchestra. . . ." [8/25, Town]

"Grim death entered the village yesterday morning and the spirit of Ole Peterson passed over the river, never to return. Mr. Peterson . . . became afflicted [about a year ago] with a cancer in the face. . . . all the efforts of the physicians proved unavailing and it was the ultimate cause of death." [10/13, Town]

"Westfield was excited a little over a year ago by the mysterious disappearance of John Breckholz, a well-to-do farmer of the town of Springfield. Every effort had been made to find a trace of him, but all hopes of finding him had been abandoned. The other day William Guderjohn while hunting . . . discovered the body with its back against a tree. Breckholz had evidently been taken sick and sat down and being unable to get up had perhaps died of starvation. $1,500 was found in his pockets." [11/3, Town]

"James Langston of North Bend, was adjudged insane Monday forenoon by Judge Barclay, in examination of Drs. Cole and Krohn, and was taken to the Mendota asylum." [11/3, Town]

"Admitted March 8th, 1901. Town of Garfield. Norwegian, aged 45. Married. Five children. Youngest 8 months old. Farmer in poor circumstances. . . . Deranged mostly on money matters. Constantly worrying and thinks he owes different parties. . . ."
[Mendota State, 1899 Record Book (Male, J), p. 377, patient # 8756]

The 3rd Wisconsin regiment came home from Puerto Rico. They said they hated the heat, the bad rations, and the filthy transport across the ocean. [11/3, Town]

"Eight of the Kaukauna public schools have been closed by order of the district board of officers on account of the further spread of a diphtheria epidemic. Five or 6 families are now quarantined, and in one of these, 8 of its members have the disease." [11/10, State]

"Mr. and Mrs. John Bahls, aged 76 and 65 years respectively, were brutally murdered in the village of Mishicott. Mr. Bahls was killed in his barn and his wife was slain in their cottage. The face of the victims was hacked to pieces with an ax. Robbery was supposed to have been a motive. Ernest Messman, a laborer who had worked about the village and who had been allowed to sleep in the barn, has been arrested on suspicion." [11/17, State]

"A hired man named Carty had been lynched. He worked in a German family consisting of an old farmer, his wife, and an orphan grandson named Chris. The old man sold a wagonload of hogs and brought home the money. He went down into the cellar through a trapdoor to fetch some cider, and when he came up Carty hit him on the head with a hammer. The little boy ran out the back door and hid in a cornfield. Carty struck the old woman and forgot the money.

The neighbors heard the old woman scream. The murderer was found before midnight, shuddering and moaning in a haystack.

The next morning a neighbor's wife, a strong, sick woman, went around from house to house with the child Chris; she shouted and rolled her eyes, and the little boy whimpered all the time. Women stood on front porches wringing their hands; men in barns leaped for their axes and pitchforks, not knowing what to do with them; and a crowd collected around the post office.

About four o'clock the mob took Carty, who turned pale and prayed or pretended to pray, out of jail. Someone's fast trotting horses were hitched to a cart. The murderer was roped to the axle; the horses raced up and down the road; his body dragged in the dust. Someone set his pet hound on the man, and all the dogs of the town followed—mongrels, hunting hounds, shepherds, and terriers alert as birds—all barking and some tearing the victim with their teeth. Then the mob hanged Carty from the limb of a tree."
[Glenway Wescott, The Grandmothers, p. 127]

"Ernest Messman, who was arrested for the double murder of Mr. and Mrs. John Bahls . . . was found dead in his cell, having taken his own life by hanging. . . . He first killed Mr. Bahls in the barn with an ax, and then went to the house where he murdered the old lady, killing her instantly with a large stone." [11/24, State]

"Justina C. Merrill, daughter of Humphrey and Esther Merrill, was born on May 15, 1830. She was the youngest of 6 children, 2 sisters and a brother having preceded her to the spirit world. . . . She bore her distressing sickness with Christian fortitude and patience, and at one time exclaimed, 'All is well with me. God's will be done.' When asked if she wanted to see her sister, she said: 'Oh I shall surely meet her there,' pointing upward. The Bible was read to her and she prayed very earnestly and besought her husband to be sure and meet her in heaven." [12/8, County, from Melrose]

"At Cameron a child was born in a family named Dunn. The father, in celebration of the event, is reported to have become intoxicated, and returning home seized the babe and dashed out its brains. He was on the point of strangling his wife when neighbors intervened." [12/8, State]

"South Milwaukee is greatly excited over the elopement of Minnie Wortel, a pretty white girl, with Eldred Moore, a Negro. The pair . . . was married by . . . a colored minister. The father of the girl followed and overtook them shortly after the marriage ceremony had been performed. He caused their arrest. The girl is 18 years of age with blond hair and blue eyes. Moore is very dark." [12/15, State]

D. J. Spaulding had himself declared bankrupt by the U.S. District Court. [12/15, Town]

Charles Van Schaick was born in Rochester, New York, in 1852. He had three brothers, but the older one, John, died right after the whole family moved out to a little place in Columbia County just fifteen miles from Portage. Charley was a schoolteacher to start with. He taught in little towns like Disco and Wrightsville and got paid just about as much as Bill Price did when he first went to work for Jacob Spaulding. He learned photography from a fellow named Cottrell who had a studio in Black River. In 1885, Charley took his own studio and stayed in it for about sixty years until the Jackson County Telephone Company bought it out from under him. He and Ida Betty got married at the end of December in 1881. She had been the schoolteacher in Town Creek. They had three sons and a daughter, but the daughter died. Ida had a reputation of being a brilliant woman; this was because everyone knew she had migraine headaches. She would memorize poetry whenever she had them since she knew there was nothing else she could do then. By the time she was an old lady she'd memorized a lot of poetry. She also had the reputation of being a good woman. This was because she belonged to the WCTU. In spite of it, she loved Charley enough to let him take a picture of her with nothing on but a handkerchief over her face. She died in 1924. On her deathbed she couldn't rest easy, she worried, she fretted. She said, "Oh, who'll make Charley change his underwear now?" She was right. No one ever did. Two of his sons had become doctors so they sent their dad all sorts of new clothes, but he never wore them; he just stuffed the pack-

ages away. By the time he was ninety he was walking around town with a sweet smell coming off him, stuffing trash in his pockets. Up until the end he lived a genteel existence. He never had to worry about making money from his pictures, so he charged as much as the trade could bear. He got himself a reputation of being a society photographer even though a lot of the pictures that he took throughout his life were of the Indians. His obituary said he had served as Justice of the Peace for forty years, had been a secretary of the Beavers, and sung tenor in the Methodist-Episcopal Church choir. Mostly he made himself friendly and took pictures when he felt like it.

"Gottlied Wagner, an old farmer living near Montello, set fire to all his farm buildings and then threw himself into the flames. All his grain and farm implements were destroyed. . . . The cause of the act was supposed to have been a divorce procured by his wife. He destroyed the property to prevent it falling into her hands. Wagner kissed the children good-bye, gave each some money, and sent them to school. His wife left him a week before." [12/29, State]

"Mrs. Anna Ross, a Marquette widow, went insane over religion. A Chicago revivalist representing Dowie faith healing held meetings there and an attempt was made to cure Mrs. Ross of lameness. Prayer was tried at several meetings and the final result of it was insanity for the woman." [12/29, State]

"Miss Minnie Rose of Beaver Dam shot herself in the Plankinton House in Milwaukee. She left a letter in which she asks that her body be destroyed by electricity. . . . In the letter she says that untrue stories circulated about her drove her to suicide." [12/29, State]

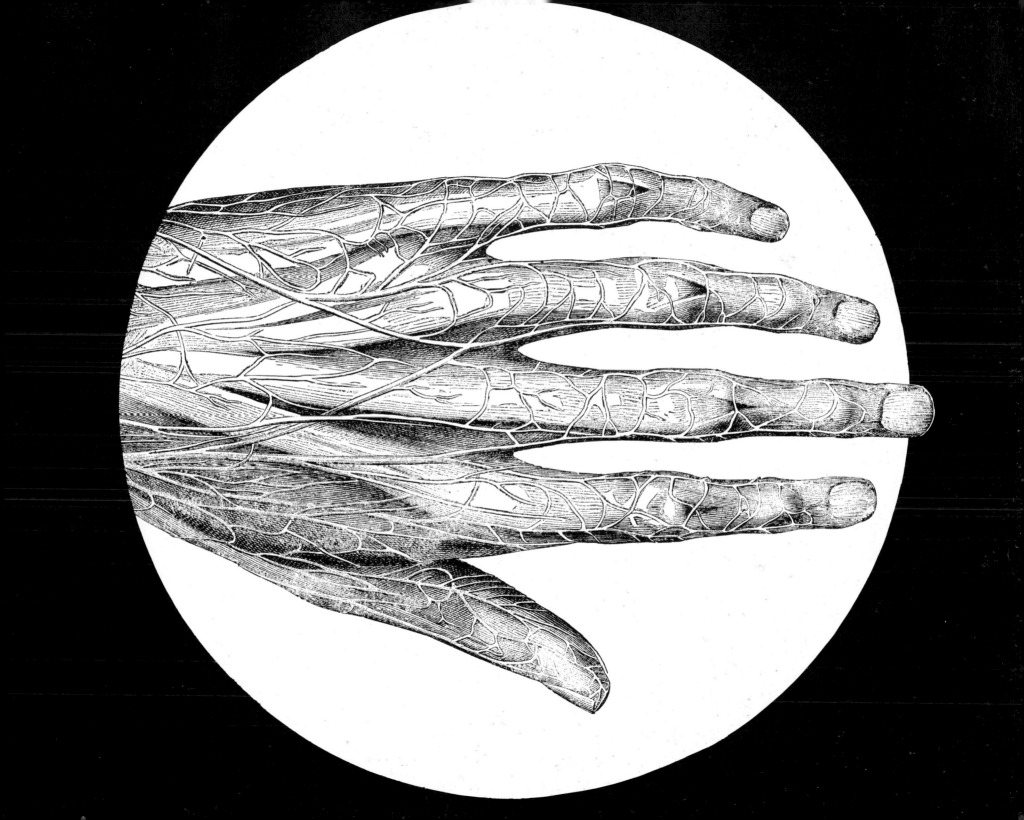

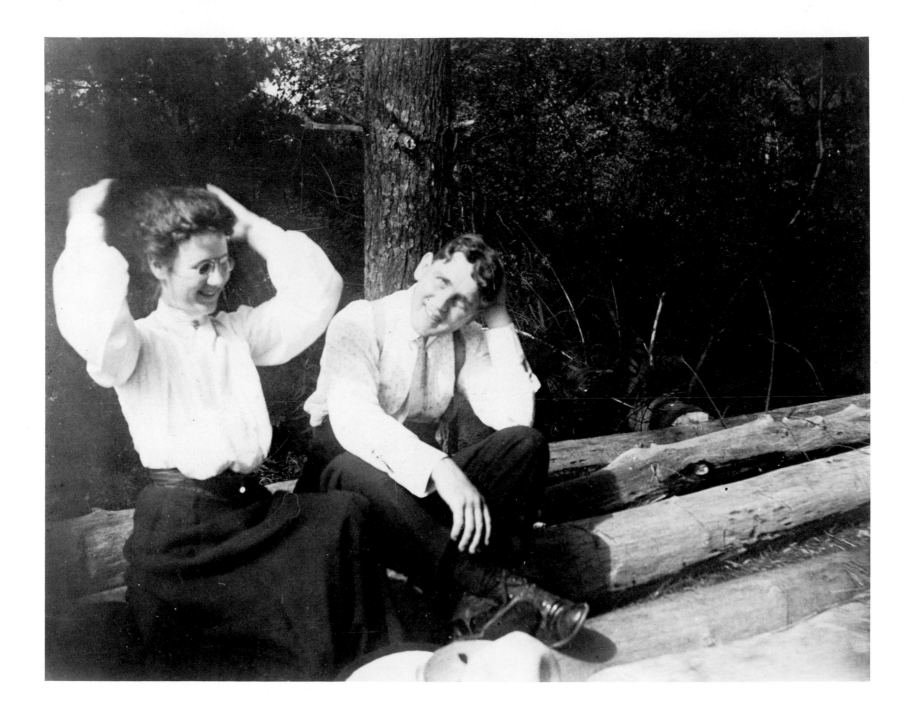

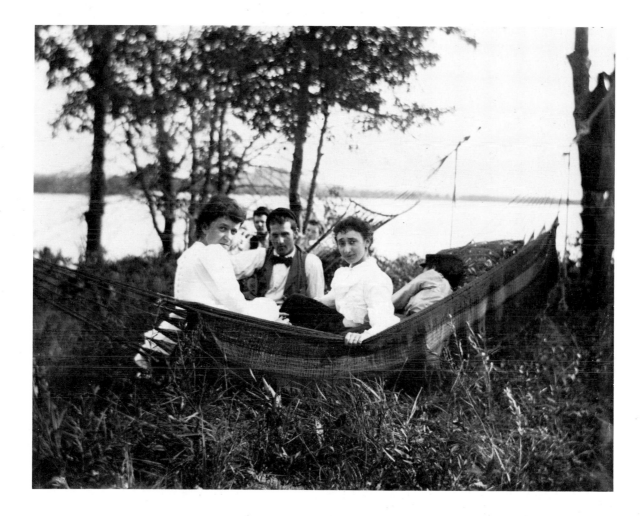

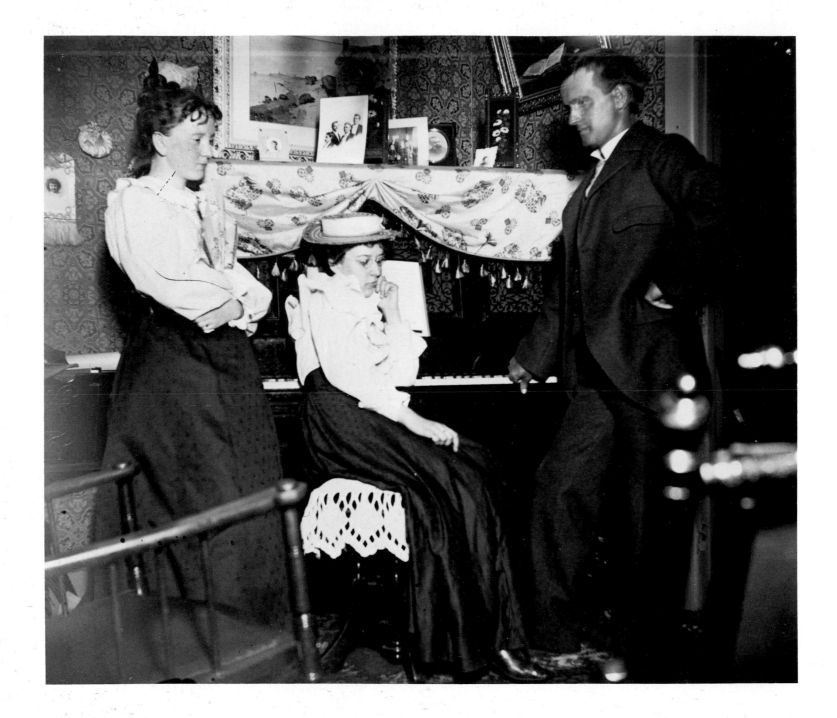

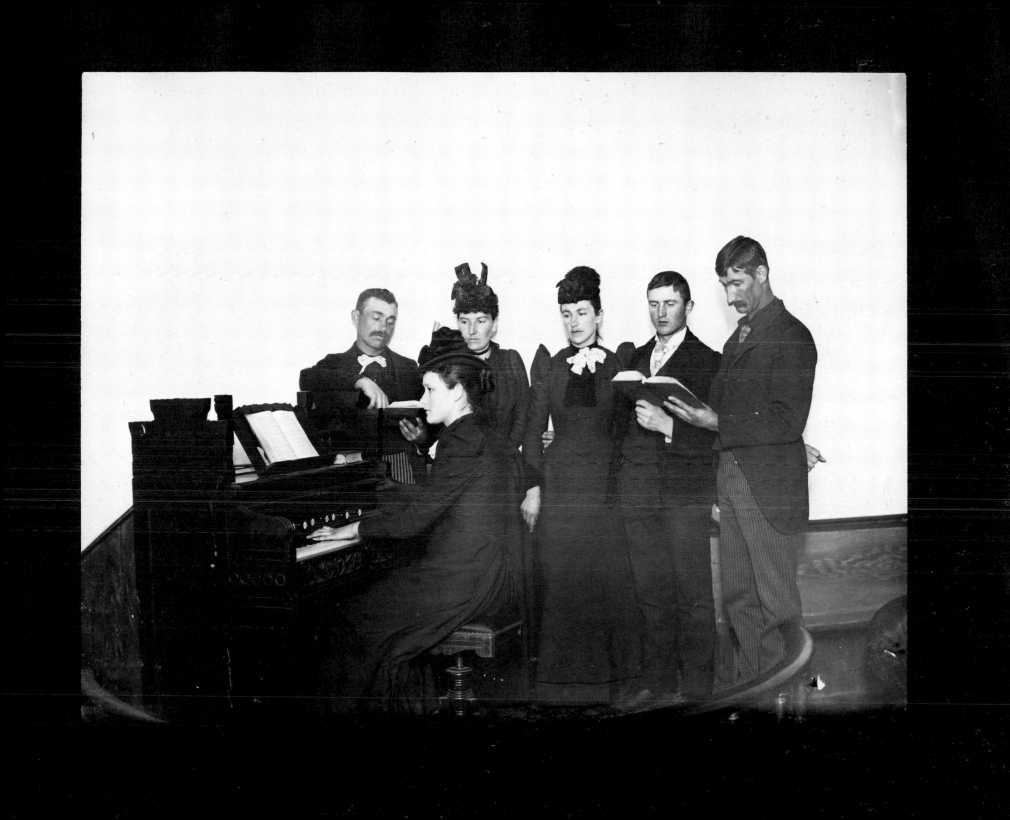

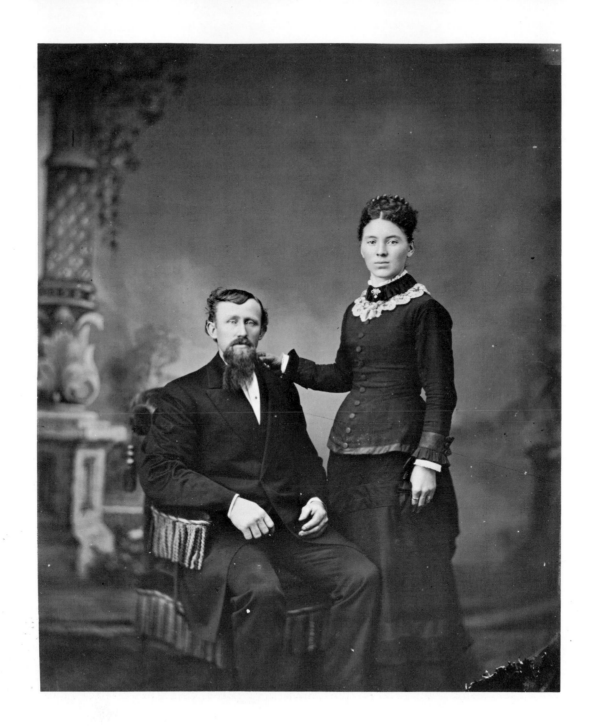

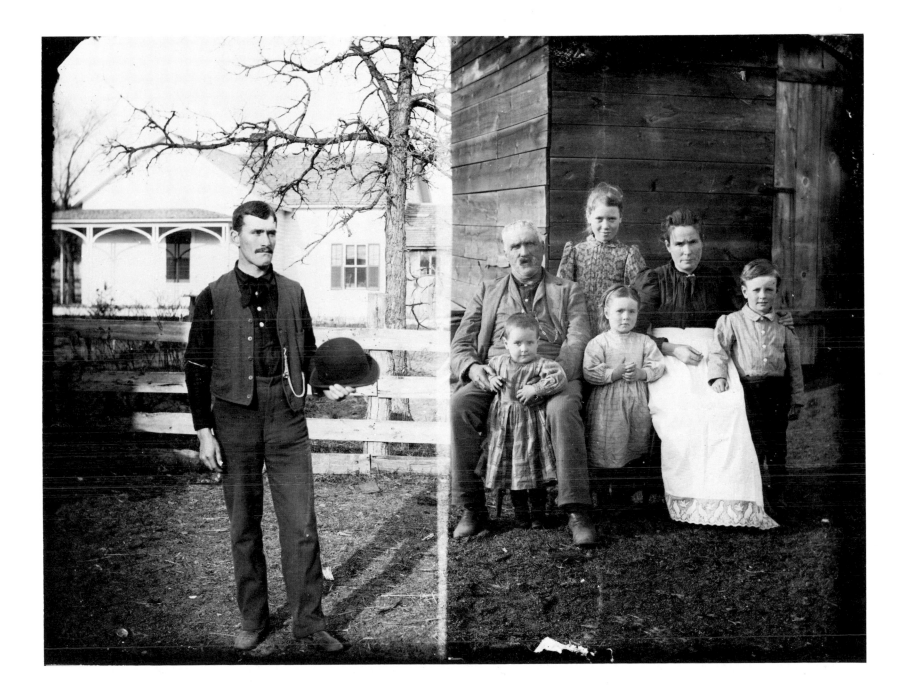

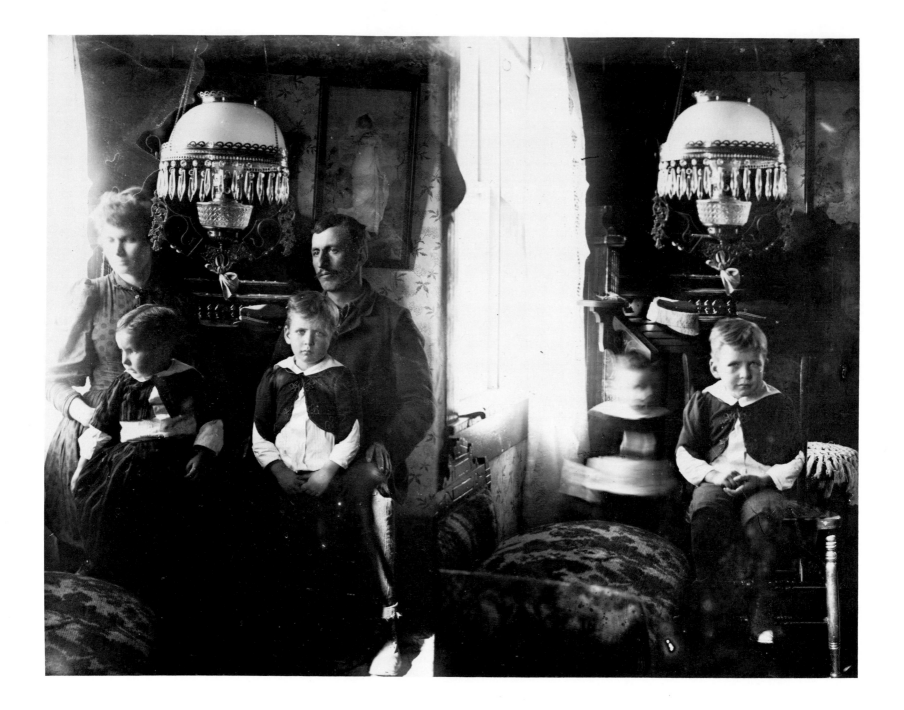

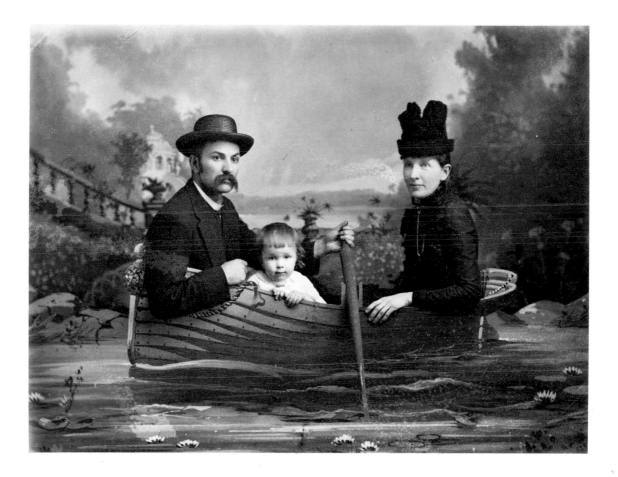

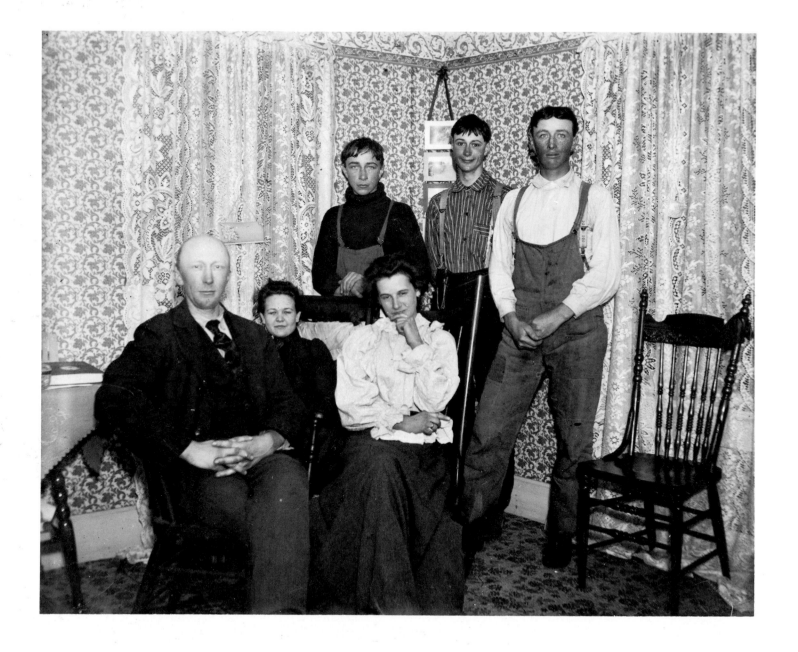

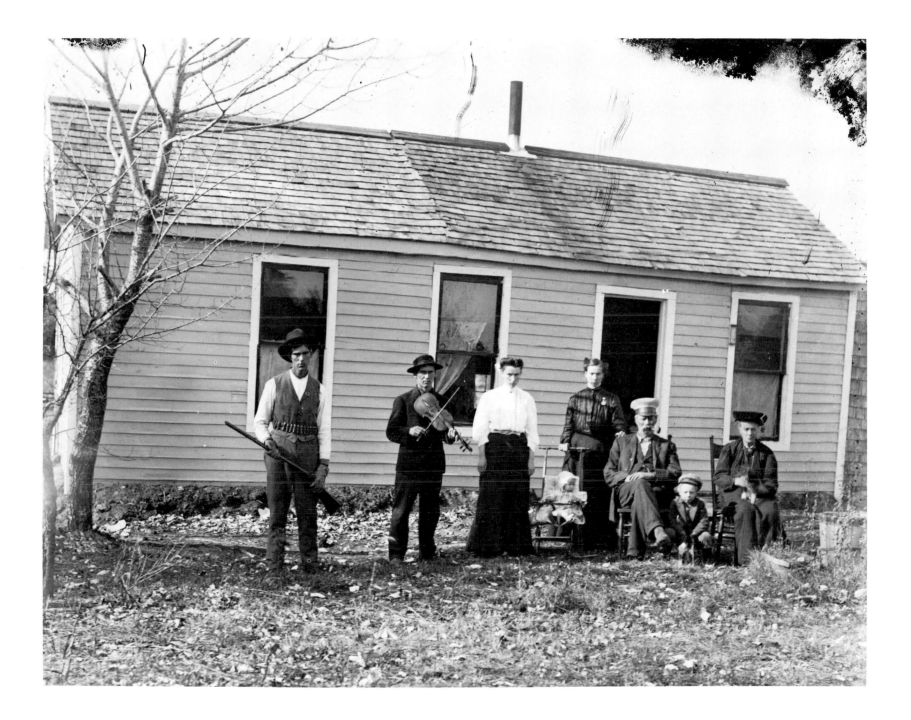

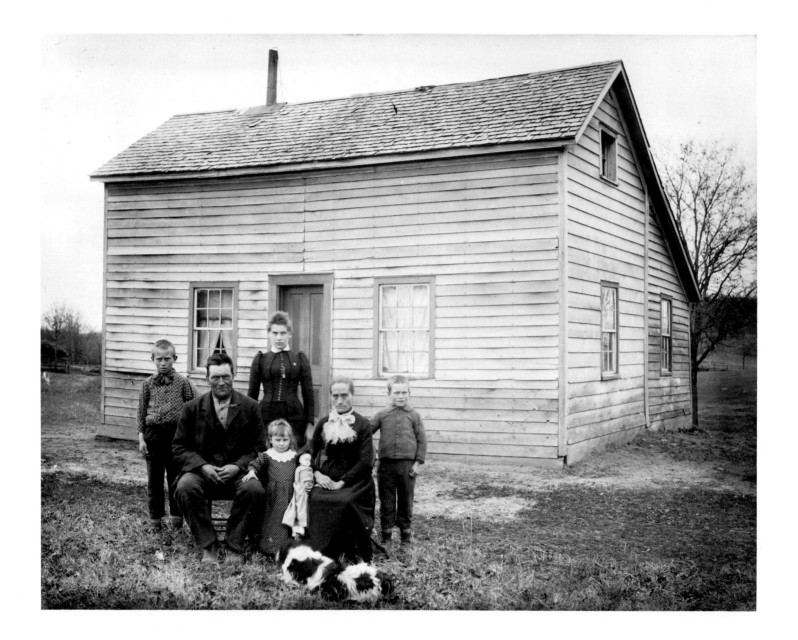

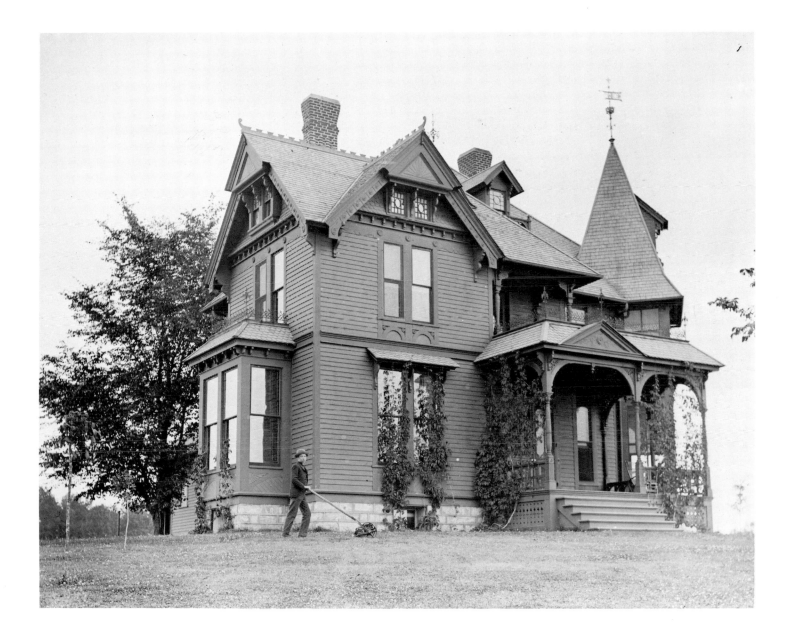

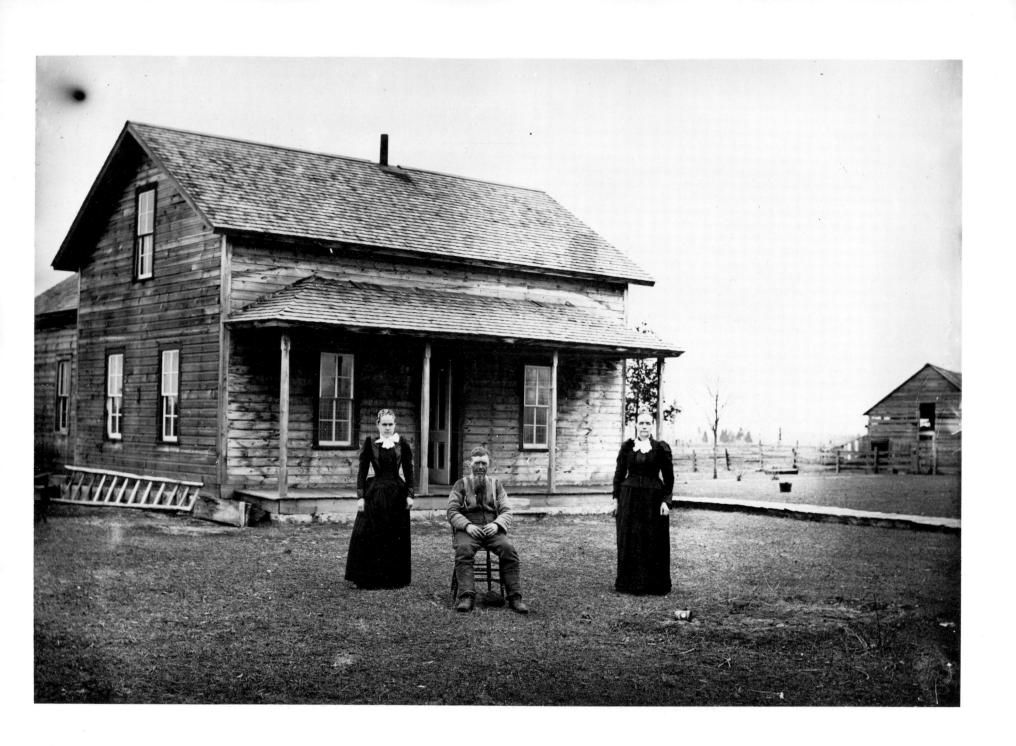

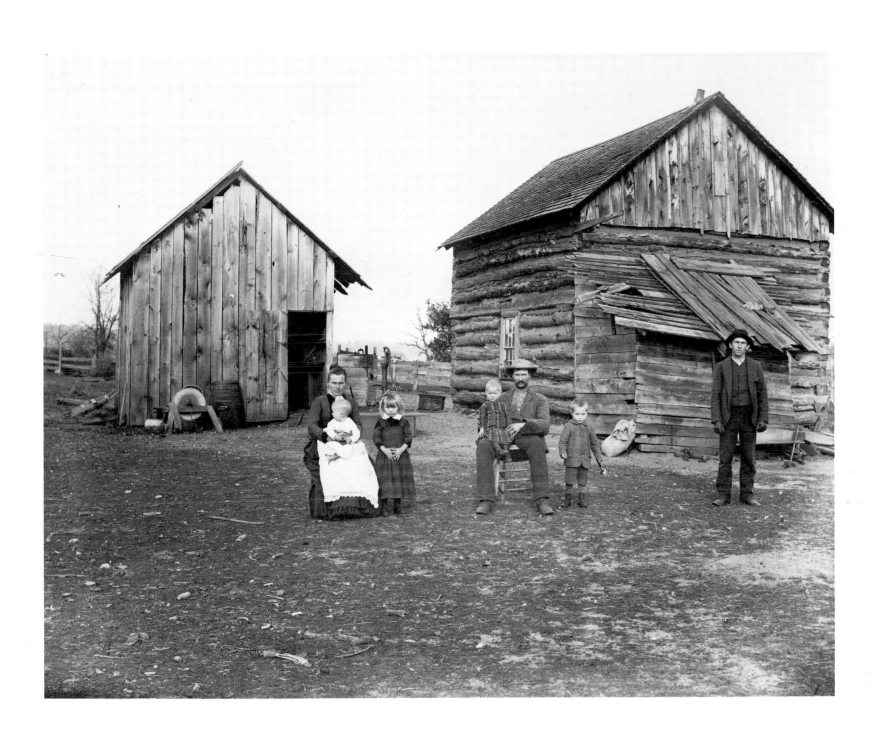

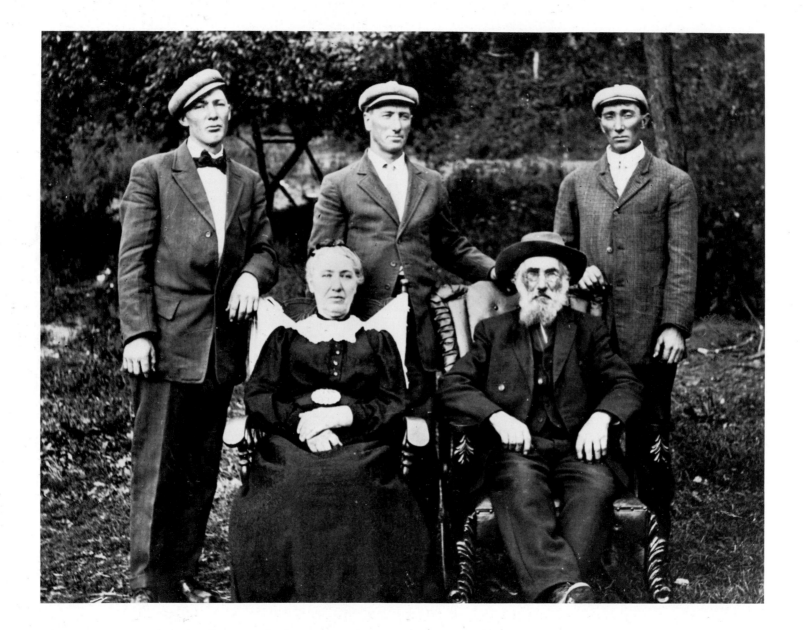

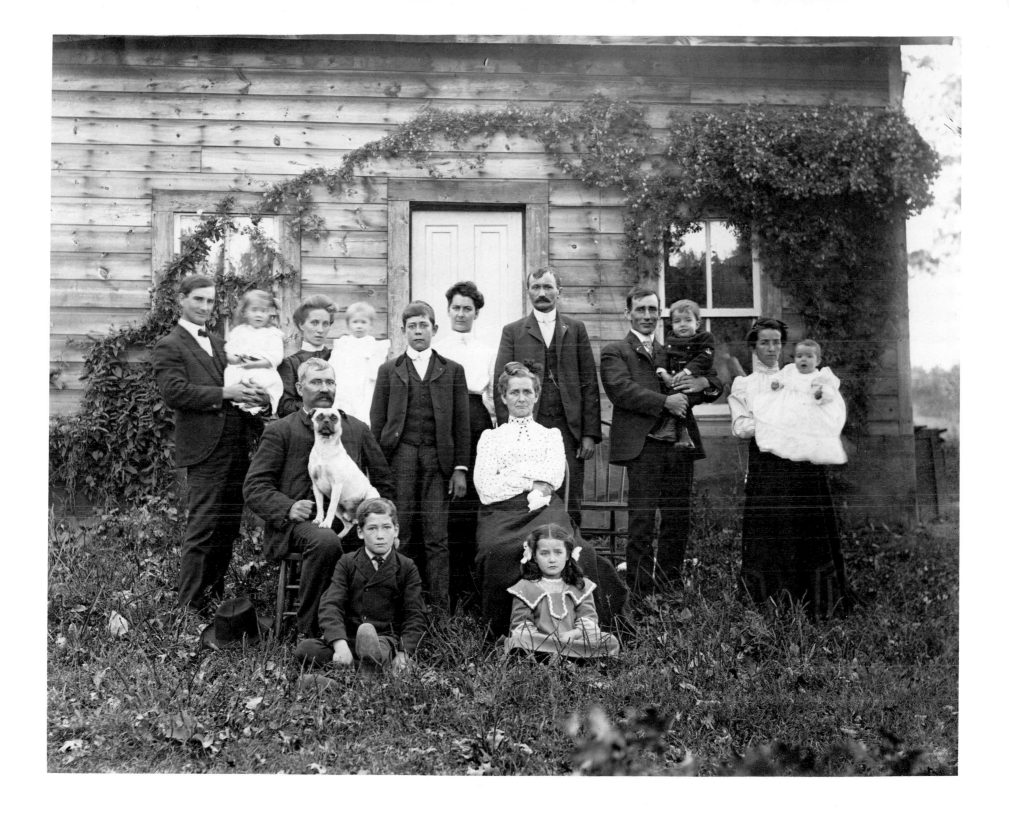

"George Kanuck, a laborer, is alleged to have sold his 7 year old boy to Italian peddlers who have been working at Manitowoc. The sale is said to have taken place at Kanuck's house during a drunken orgy in which all participated. The Italians, 2 women and a man, left town next day with the boy." [1/5, State News]

"At Oakfield Mrs. William Tanzer killed her 6 month old baby with strychnine and took the poison herself. This failing to end her life, she secured her husband's razor and cut her throat. . . . The couple was young and [the husband] says the relations of himself and wife were happy." [1/5, State]

"Some of the boys and young men who loiter about the front door of the church on Sunday evenings had best make new resolutions regarding their actions there or the matter will be placed in the hands of authorities. Complaints are made of petty thefts, unhooking lines and harness on standing teams, and various other pesky annoyances. Boys have a care. Such disregard of the property of others has laid the foundation for many a life of crime and prison sentence. No matter how small and trivial the article, if it is the property of another, don't touch it. The strings of conscience once loosened, it is hard to tell where the end will come." [1/5, County, from Merrillan]

1899

He sells his child to an Italian
Baby murder crazy mother suicide
Loitering immorality Little boy
burns himself Little boy drowns
Himself Endless sleep Hysteric
Racism Confirmed Perpetual motion
Perpetual motion Suicide – unemployed
Remorse Diphtheria Death in the asylum
Railroad death Chivalrous Vigilantes
Industrial sabotage Infant death
Memorialized A teacher beaten Death
Anticipated High school optimism
Farm sabotage Arson Wildman
Colored somnambulist thief Diphtheria
Sabotage Murder – suicide Insanity
Family poisoning Blew his head
Off with dynamite Suicide Butcher
Bled to death Decapitation between
friends
A frog from her stomach Wandering
The private made public clinical death
by
Unrequited love Insanity Tobacco crazy
Suicide – financial despondency Imbecile
Incendiary Churchwomen with whips
Insanity Women molested Witchcraft
Armed tramps Incendiary fires Magnetic
Healing Endless sleep Incendiary fires
The private made public Cigar stub
Suicide Gang of tramps Ungrateful
Tramp Diphtheria

A case history from Mendota; a local story about doctors and diseases

"Two little children, a son and daughter, aged 4 and 2 respectively, of Mr. and Mrs. Herman Burger have burned to death in their home at Lincoln. It was believed that the fire was set by the little boy because he was punished and that part of his plan was that his sister should die with him. . . . The boy had been punished and was heard by his mother to make a remark that he was going to die and take his sister with him. The fire was started in a room where there was no stove and it is believed the boy carried out his threat as planned." [1/12, State]

"Ferdinand Thieman, 10 years old, jumped into a cistern and drowned himself because his sister wanted him to go on an errand. The mother conducts a home for aged Germans at Wauwatosa, and was away at the time." [1/26, Town]

"The daughter of Edward J. Martin, a Marinette ex-alderman, has awakened after sleeping nearly a week. During that time her slumber was wholly unbroken and the strongest efforts of her attendants failed to waken her. Physicians ascribe her strange condition to a sort of nervous prostration due in a measure to the death of her mother last summer and a fright she received about 6 months ago. She is 17 years old." [2/2, State]

"Marinette physicians are puzzled over the case of the 18 year old son of S. Glyckman. Last week he acquired suddenly a mania for talking and kept up a constant jumble of words. His father finally told him to keep quiet. The young man has not uttered a word since." [3/23, State]

"The right of colored people to attend public places of amusement under the laws of Wisconsin is to be tested. Rachel and Clara Black are the nearly white and attractive daughters of a colored barber, Alfred Black. The young women visited the Century Roller Skating Rink at Oshkosh as spectators. The next day they received a note requesting them to discontinue their visits. They went again and were invited to leave, which they did. The reason assigned by the management of the rink is that it had established a rule not to let colored people frequent the place." [2/9, State]

"George Cordes of Baraboo is working on a model which he thinks is a solution to the perpetual motion problem. His device consists of two tracks with a curve in each which are about the shape of the spinal column. He rolls a ball down an incline, up a short ascent, down again, and when it rolls up a second time, the ball strikes a wire spring which throws it over on the other parallel track. The second track is the reverse of the first and when the two are inclined at the proper angle, the ball will roll round and round." [3/9, State]

Bob Werner and his brother Leslie said they could repair anything anyone could break. They ran a place called The Novelty Repair and Manufacturing Company. They took care of umbrellas, sewing machines, bicycles, lawnmowers and hair clippers, slot machines, gasoline coffee boilers, sausage and coffee grinders, ice cream freezers, Gramophones and talking machines, music boxes and mandolins, guitars, violins, and organs. They cleaned furniture, ground knives, repaired door bells, set the tips back on billiard cues, and restored the hair to violin bows. They were also expert gunsmiths. Leslie sold the business at a nice profit two months after he opened it in 1905.

"John Guiddinger of Newton claims to have discovered perpetual motion and will leave for Washington to apply for a patent on his invention. The machine can be built by an ordinary blacksmith at an outlay of $25 for one horse power and can be enlarged at a greater expense to 500 horse power or more." [3/9, State]

"Adolph Kuhlmann committed suicide at Sheboygan by shooting himself with a revolver. . . . Mr. Kuhlmann had been in the employ of the Mattoon Manufacturing Company for 20 years, having obtained the position of superintendent of the plant. A few months ago he lost his position and his inability to obtain another place made him depressed in spirits. He had gone to the barn to get his horse and take his children to school when he put a bullet in his brain." [3/23, State]

An outbreak of diphtheria and the exposure of a whole fourth grade class to the carrier was reported in the Third Ward. [4/13, Town]

"County Judge Barclay has received notice that Mrs. Honora McNulty who was sent from Millston to Mendota 4 weeks ago died in that institution on Monday, the 24th." [4/27, Town]

"When a passenger train on the Wisconsin Central Railway arrived in Neenah about daylight the other morning the lifeless body of Theodore Bartean of West Menasha was found on the front end of the engine, sitting erect and covered by the upper part of a carriage and a robe. He was driving home and his rig was struck by the train, the train crew being ignorant of the accident." [5/4, State]

"A farmer living in the town of Cutler was severely whipped by masked men. This is said to have been done for his alleged cruelty to his wife. The man was called from his house to help repair a broken wagon and when returning, was caught by the men who administered the punishment." [5/11, State]

"An attempt to destroy the large plant of the Moore and Golloway Company at Fond du Lac has been brought to light. On a recent night 2 young men discovered a blaze in the rear of the large saw mill property. . . . An investigation revealed the fact that some rags had been saturated with kerosene and ignited. The Moore and Golloway Company have had large fires during the past 2 years that have resulted in the loss of nearly a quarter of a million dollars." [5/11, State]

"Saturday afternoon J. B. Jolly, of the First Ward, accompanied by 2 of his children and little Ruth Felt, went down to the river to enjoy an afternoon's fishing. Mr. Jolly. . . . was convalescent after a long illness and was thoroughly enjoying the sport, the warm sunshine, and balmy breezes. The children, too, were happy. 'Twas not often they were permitted to sit by the rushing river and listen to its sweet and noisy tune. But between 2 and 3 o'clock they tired of this pastime and determined to go on a little voyage of discovery in search of new wonders. Silently they slipped away. Over the pier they scrambled, down through the long avenues of willows . . . free from all restraint —for they were screened from Mr. Jolly's view by the drooping willows—and with no thought of danger, the juvenile explorers tripped lightly down the narrow timber on the east side of the pier, with the rushing waters only a few feet below. Suddenly—no one will ever know how it happened—little Ruth Felt, who was in advance, stumbled, slipped, and fell. Her cry was the first intimation that Mr. Jolly had that the children were not near him. He ran with all haste to the spot where the child had made the fatal misstep, probably a rod from the south end of the pier, but too late! Just one glimpse of a blue apron fluttering in the angry waters, and was o'er. No, not all. Refusing to believe the awful tidings, the grief-stricken mother hurried to the scene, where hope sped away on the wings of despair. The bright, active child who had been her pride and joy but 7 short years had been ruthlessly snatched by the hand of death. All that afternoon the river was dragged in vain. The search was continued Sunday without result. . . . It is probable that the body has been carried down the river, and if so it may never be recovered. The bereaved parents have the sympathy of all in their hour of sorrow."

"Even in the most exalted state
Relentless sweeps the stroke of fate."
[6/1, Town]

"Miss Mary Jeffrey, a teacher in one of the schools of Centerville, was badly beaten by one of her pupils, a 14 year old girl. The teacher, for some offense committed by the girl's brother, proceeded to punish him, when the sister interfered and struck the teacher in the face. The teacher, in attempting to avoid the blow, dodged, throwing back her head, with the result that her hair caught on a hook in a hat rack and held her. While in this position, the girl rained blow after blow on the face of the defenseless teacher who was not a match for the strong, husky country girl. . . . She had just been pounded into unconsciousness when people attracted by the teacher's screams ran in and released her." [6/1, State]

"Fred Maresh committed suicide at his home in Manitowoc by shooting himself through the temple. During the morning, in conversation with friends on the street, he bade his friends good-bye and said they might attend his funeral in three days. His actions were very strange and aroused suspicion. Maresh was a partner in a firm . . . dealing in clothing and novelties. He enlisted in Company H, Second Regiment, and did valiant service as sergeant major of the regiment. He was looked upon as a man of irreproachable character and habits." [6/1, State]

Class Motto: "Well Try—We'll Succeed."
[6/8, Town]

"John Pickard had 13 cows poisoned on his farm near Calvary. 10 of the cows died. It is believed to have been the malicious work of a gang but there is no clue to trace." [6/29, State]

"Red Granite, a farming community, is stirred up over a supposedly incendiary fire and the disappearance of Helen Schultz, 17 years old, who may have been cremated. While the Schultz family, with the exception of Helen, was at church, a large hog barn was burned. Foul play is suspected." [7/20, State]

"A wild man was captured in the woods 50 miles north of Chippewa and placed in the county jail there. He is 60 years of age and has lost nearly all resemblance to a human being. His hair and beard are 2 feet long and his raiment consists of a solitary gunny sack wrapped around his body, and on his head a coonskin cap. It is impossible to hold conversation with him as he has lost all knowledge of speech. This strange creature has been seen many times for the past 10 years by land hunters and is a hermit." [7/13, State]

"Harry Davis, colored, was convicted of burglary at Oshkosh, the jury being out 12 hours. His defense was somnambulism." [7/20, State]

"Dr. Krohn reports one case of diphtheria at Squaw Creek and 2 cases, of doubtful outcome, at Little Norway." [7/20, Town]

"A man by the name of Garrity attempted to burn the large mill of Bird and Wells Lumber Co. at Wausaukee, but was intercepted by the watchman who gave the alarm." [7/27, State]

"Gust Hanson Litke, a prominent farmer of the town of Knox, shot himself through the heart after shooting at and missing John Anderson, against whom he had a grudge." [8/3, State]

"Gus Gilbertson, of the town of Irving, was yesterday adjudged insane by the County Judge and taken to Mendota last night by Sheriff Trondson." [8/3, Town]

"At Menawa, Pauline Farg attempted to poison the family of James Keating for whom she was working, by putting paris green into the family coffee pot. The peculiar taste of the coffee aroused suspicion. . . . The girl, who is only 14 years old, confessed. . . ." [8/10, State]

"Christ Wold, a farmer near Poskin Lake, committed suicide by deliberately blowing off his head with dynamite. He placed a quantity of the explosive in a hole in the ground, laid his head over it and touched off the fuse, exclaiming: 'Here I go and the Lord go with me.'" [8/17, Town]

"The police at Kenosha are of the opinion that a young girl took her own life by throwing herself into the lake near that city. The belief of the police is based on a bundle which . . . 2 boys . . . found on the beach. The bundle contained a dress evidently belonging to a girl about 15 years of age. It was carefully folded and on the inside was found a note as follows: 'My father and mother abused me and kept me working hard, so I thought it best to end my life now. Here is my dress. Good-bye, all.'" [8/24, State]

"Henry Ehlers, a Milwaukee butcher, died from nosebleed. His nose had been bleeding for 9 days. . . . He was 37 years of age and had been a great meat eater." [8/24, State]

"George Roedl and James Rau both got drunk at Beaver Dam, and George in some way got the impression that he was Herrmann, the great magician. He told Rau he could cut his head off and put in on again. Rau bet he could not do it. Roedl got a knife and began operations upon Rau, who sat down in a chair entering into the spirit of the entertainment. The decapitation act began but ended abruptly when Roedl inflicted 2 long gashes on each side of Rau's neck. The doctors finished the performance by taking 16 stitches in Rau's neck." [9/28, State]

"Mrs. Johanna Soll of Fond du Lac, who had been an invalid for years, recently expelled a big frog from her stomach. A young son was with her at the time and his story is corroborated by the family physician. . . . For years Mrs. Soll has been troubled with her stomach, and had frequently told her physicians that she believed her condition was due to something alive in her stomach. This idea was scouted by all. All the physicians in the city are deeply interested in the case."

[10/19, Town]

"Leonard Johnson, 15 years old, lost his way in dense woods near Marshfield. For nearly 2 days and 2 nights he wandered aimlessly and frantically through the forests. Searching parties located him 2 days afterwards. He was temporarily deranged by his terrible experience." [10/5, State]

"The home of E. P. Grant, about 10 miles northwest of this city in the town of Brockway, was the scene recently of a violent death inflicted by the hand of the victim, it is said because of unrequited affection for his young wife. Ira Wilcox rose early. . . . and proceeded with his chores as usual . . . the morning meal was dispatched in gloomy silence, and as soon. . . . as an opportunity presented itself, Mr. Wilcox slipped out of the house and went directly to the barn, taking his somewhat dilapidated but none the less serviceable double-barreled shotgun with him. Mrs. Wilcox had scarcely noticed her husband's absence when she was startled by a report. Running to the barn, she found him lying prostrate in a stall, the blood gushing from a ragged hole in his left breast and the smoking gun lying beside him. . . . for about 2 hours afterward the victim remained conscious. Although not openly admitting that he had attempted to take his own life, he said that his wife did not love him and would not even speak to him, and therefore he did not care to live longer. . . . An autopsy was held at which it was found that the gun had been placed close to the body, and that the shot had broken 4 ribs, and torn the left lung to shreds, the charge passing in behind the heart and lodging near the spinal column, death caused by hemorrhage and shock." [10/5, Town]

"Dan Mills, a son of Dick Mills, of Halcyon, was taken before Judge Barclay Saturday last to be examined in regard to his sanity. After examination by Drs. Cole and Wagin, he was discharged."

[10/19, Town]

"John Pabelowski, a 16 year old boy of Stevens Point, was made idiotic by the use of tobacco." [10/19, Town]

"Peter Peterson of Porterfield, one of the best known farmers in Marinette County, committed suicide. He was found dead in his barn, having hanged himself. Worry over a tax title case which he lost in Circuit Court led to despondency which finally resulted in suicide. He was worth considerable money." [10/26, State]

"A large barn in Pleasant View known as the Jack Smith barn was burned Sunday night. . . . Circumstances seemed to indicate that it was the work of an incendiary, and on Tuesday afternoon, William McKinney was arrested. . . . The accused is little better than an imbecile and if his was the hand that applied the torch, a better brain probably did the planning."

[11/9, Town]

"At Marquette, Mrs. Nesbitt, a well-known church worker, and Miss Kaufman, both having horsewhips, attacked a welder named Edward Patten, while he was at work in the Stevens factory. . . . They plied the black snakes vigorously and Patten was given a severe whipping. . . . They claim that Patten has been slandering them." [11/9, State]

"Knut Olson, of the town of Franklin, was adjudged insane Monday in Judge Barclay's court . . . and was taken to Mendota hospital on Tuesday. . . ." [11/23, Town]

"Admitted Nov 21st, 1899. Town of Franklin. Norwegian. Age 50. Married. Ten children, youngest 3 years of age. Farmer in poor circumstances. . . . Has an idea that people are taking what little he has—that they will come to his house even when he is there. Is not homicidal. . . . Poor physical condition. . . . January 24th, 1900: Died today. Exhaustion. . . ."
[Mendota State, 1899 Record Book (Male, J), p. 99, patient # 8315]

"'Jack the Hugger' or James Moore who for more than 10 years past has followed the occupation of waylaying lone women after sundown and hugging them then disappearing before assistance could reach them was caught. . . . and taken to the office of Mayor Hoskins [of Fond du Lac]. There after a rigid examination he admitted he had committed the offenses of which he was charged. He was badly frightened, but on the advice of the Chief [of police] and the Mayor, who threatened prosecution unless he left the city, he drew his pay check and left for the north to work in the woods during the winter." [11/23, State]

"Last August Mrs. Herman Dalke of Center died under mysterious circumstances. Shortly afterward her children, Mary, aged 14, August, aged 8, and Antonio, aged 6, also died. The peculiar circumstances surrounding the death caused a lot of talk, and the name of John Dalke, her brother-in-law and a cripple, was mentioned unfavorably. Then a queer disease attacked stock in the neighborhood and several head of cattle died. This caused great excitement and the German settlers of the vicinity accused young Dalke of witchcraft. The cripple, instead of denying the report, claims he has supernatural powers. The neighbors threaten to lynch him." [11/30, State]

"Kenosha is overrun with a lot of tramps. . . . it is reported that an organized gang attempted no less than 4 robberies in one night recently." [11/30, State]

"There were 6 incendiary fires in Stevens Point on a recent morning." [11/30, State]

"ANNOUNCEMENT! MAGNETIC HEALING (Weltmer Method). I take pleasure in saying to the citizens of Black River Falls and adjacent towns and surrounding country that I have secured Dr. J. B. WORLEY, Graduate American School Magnetic Healing, *and have opened a school and sanitarium of magnetic healing at my residence, Lower Falls, town of Brockway* where the afflicted may exchange their aches and pains for ease and comfort. . . . We are living in an age of advancement and investigation where light is pouring in so distinctly and he who shuts his eyes and scoffs and sneers because others open theirs and see is not only recreant to duty, but does society in general and mankind in particular an irreparable wrong. . . . Consultation free. Strictly private and confidential. . . . I am most respectfully yours for humanity, E. L. Brockway, Black River Falls." [12/7, Front page ad]

There were a lot of doctors because there was a lot of disease. In the eastern part of the country there was rickets, and a little scurvy. All of them were diseases of malnutrition. Before and after them, there was a constant, vulnerable frailty and debility. By the late nineties, when the trees gave out, the whole county was poor, but the eastern half was the worst: the land had always been deep sand and pine barrens and the people who lived on it were still the children of the French Canadians who had been too tired or too lazy to move west with the logging.
[Local History]

"Medical science is baffled by the strange case of Nancy Yolton, 18 years old, of La Crosse. She will go to sleep sometimes voluntarily and then again involuntarily and will wake up only after she has remained in this condition for a week or longer. . . . these strange attacks came on last spring. One Monday she noticed she could not open her left hand. When she went to bed that night, she went to sleep and did not awaken until the following Friday noon. These attacks have continued during the summer and fall."

[12/7, State]

"At Stevens Point an incendiary fire destroyed sale stables and 13 fine draft horses, the property of Green Brothers. . . . This is the ninth incendiary fire in the city in a week." [12/7, State]

"The State Board of Control has issued an order to compel persons who have relatives in state asylums to pay for their board and care by the State. The new order will do away with secrecy which now obtains and make these cases a matter of public record." [12/7, State]

"G. Drinkwine, father of Miss Lillian Drinkwine, who committed suicide a few days ago, attempted suicide at Sparta. He swallowed a large quantity of cigar stubs." [12/14, State]

"Kenosha is again in the hands of the gang of tramps which have been making the outskirts of the town their rendezvous for the past 3 months. . . . Three daring burglaries have been reported."

[12/14, State]

"A tramp attacked the 8 year old son of Samuel Wright at Cleveland, striking him several blows on the head with an iron poker. Mrs. Wright, in attempting to save her son's life, was attacked by the tramp, but before she was seriously injured her husband appeared. The tramp then escaped. The man had been given shelter and food by the family for the last 2 days and attacked the boy when the latter called him a tramp." [12/28, State]

"A young son of August Dietz died of diphtheria at Beloit. This is the third death of almost 30 cases in the city and vicinity this winter. All the other patients are well. Antitoxin has been issued in nearly all cases with gratifying results."

[12/28, State]

Charley Van Schaick never did take a picture of a certain very special lady called Pauline L'Allemand, even though he ended up with a few of her promotional post card photos. There's a picture of her opposite the heading 1891, that circular one with words, as brittle and crackly as laurel leaves on the brow of a dead poet, written around it. The thing that made her so special was something called Dramatic Irony, a force which the professors now call a mere device but which other men, when actually enclosed by it, understand to be as animate and as capital as Fate. Pauline L'Allemand was special because she re-created an ancient occasion: she was so much the right *person in the* wrong *place at the* wrong *time that she nearly turned everything inside out and upside down. That is, she was so complete yet so inappropriate a creature that she caused others, who had been trapped with her within the same geographic quadrant by no longer imaginary lines of latitudinal and longitudinal chance, to pause and to think and to wonder and to consider whether it was she or they who were crazy. Her wrongness was nearly orphic, nearly hypnotic: it was as if she were an itinerant mesmerist who, by convincing the audience that they could fly, could make them seriously wonder, once the trance was suspended, what it was like to have wings and, as they got up to leave, what it was like to have arms, and, as they rode home behind their horses, what it was like to actually be as they were, since for seconds they had imagined themselves to be what they were not.*

She was, to begin things simply, a

Famous European Opera Star, a coloratura, fin-de-siècle soprano, who got herself stuck in a small town in the northern part of a northern state whose name begins with one of the last usable letters in the alphabet. What follows is what happened. Only God and his Chief Archangel of Mathematical Probability know how it came about.

She was born in Syracuse, New York, in 1862. She was even christened Pauline Elhasser. By the time she had studied at the Dresden Conservatory, and made her debut at Koningsberg as Zerlina in Don Giovanni, *things began to change. The* International Encyclopedia of Music and Musicians *and* Annals of Music in America *claim that she married an actor named L'Allemand, but people in Black River Falls, who eventually came to know her in a less professional capacity, claimed that she met up with some Austrian nobleman. At any rate, she changed her name and gave birth to a child she named Edgar. The books say that after her debut and early marriage, she studied with the ballet and opera composer Leo Delibes, who gave her the leading role in the premier performance of his opera* Lakmé *in 1883. She and the encyclopedias remain faithful to one another until the end of March 1886: in January they say she made her American debut with the National Opera Company at the Academy of Music in New York. In March she is recorded as renewing an interest in Delibes' opera, three years after it had been indifferently performed before a New York audience. At this point, somewhere toward April Fools' Day, she took her leave of the musicolo-*

gists. The 1964 edition of the International Encyclopedia of Music and Musicians *believes that she ended up in Beaver Creek, Illinois, but the people of Black River Falls knew better:*

About thirty years after her American debut, she and Edgar were in Milwaukee; they had gotten there because Pauline had written a comic opera called De Capite de Confusis, *and in spite of the sage advice of an agent and the polite disdain of several producers, she had taken her own money and used it to transport her masterpiece across several state lines. Unfortunately the critics in the provinces refused to rise to the occasion when, in their reviews, they spoke of artificial respiration to corpses and the beating of dead horses. Unused to such abusive ridicule, L'Allemand's resolve lasted only until Chicago, but her money held out until Milwaukee. Then she and her production fell apart. She wasn't exactly* stranded; *she was still Pauline L'Allemand and Edgar still had his telescope and his camera and his violin; there was still some cash left to get back to New York and Edgar's father, the Count, might still be depended upon if things became desperate . . . But how could she return in the sackcloth and ashes of her failure?*

As she stood in her hotel suite surrounded by the excited chatter of the local poets and artists who had never before been invited to attend an after-theater party by such a Famous European Opera Star, all she could think of was peace and solitude, rest and renewal. As she continued to talk to the charming gentleman who had introduced himself as M. Vaudreul, she even mentioned to him, touched by his attentive

understanding, that now all she hoped for was a quiet cottage nestled at the foot of some mountain. To her surprise, her words brought forth from her listener a proposal so visionary yet at the same time so exactly appropriate to her deepest longings that she was once again flooded with her sense of Special Destiny. Since that first time, when standing alone with Edgar in her arms on a storm-tossed deck, somewhere in the middle of the dark Atlantic, she had prayed to the spirits that the tempest might cease, and they had listened to her mother's plea—since that first time, she had braved all odds, certain that they kept eternal watch over her and her child even as she slept. True, she had been shaken by the abusive taunts that had greeted her inspired masterwork—but that Fate should have arranged that she meet this prophetic man in the very hour of her despair—this was a sign of more than ordinary favor. His ideas were so marvelous, so daring, yet so right—to construct from nothing but the very earth of its site an indigenous city. A city of concrete since the land was sand; a city with a cannery since blueberries grew everywhere; a city with a wagon factory since the hills were covered with stands of pine; a city with an inn and a hotel where its workers and craftsmen might refresh themselves at the end of a day of toil. That this man, this prophet, should have, by mere chance, attended her reception and, sight unseen, resolved to offer her, for such a reasonable sum, a site to build her mountain cottage so close to his metropolis—this renewed her special faith in her guardian spirits. But things were not as they seemed.

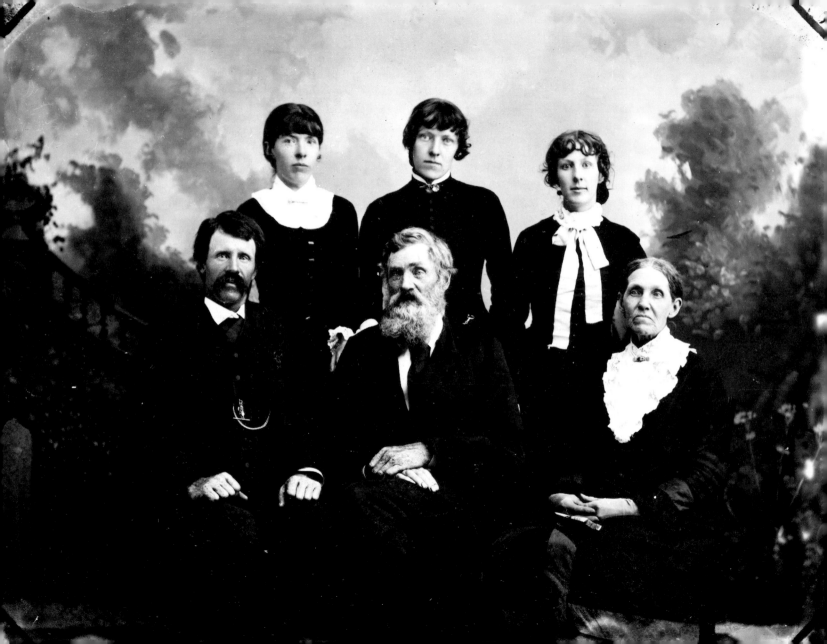

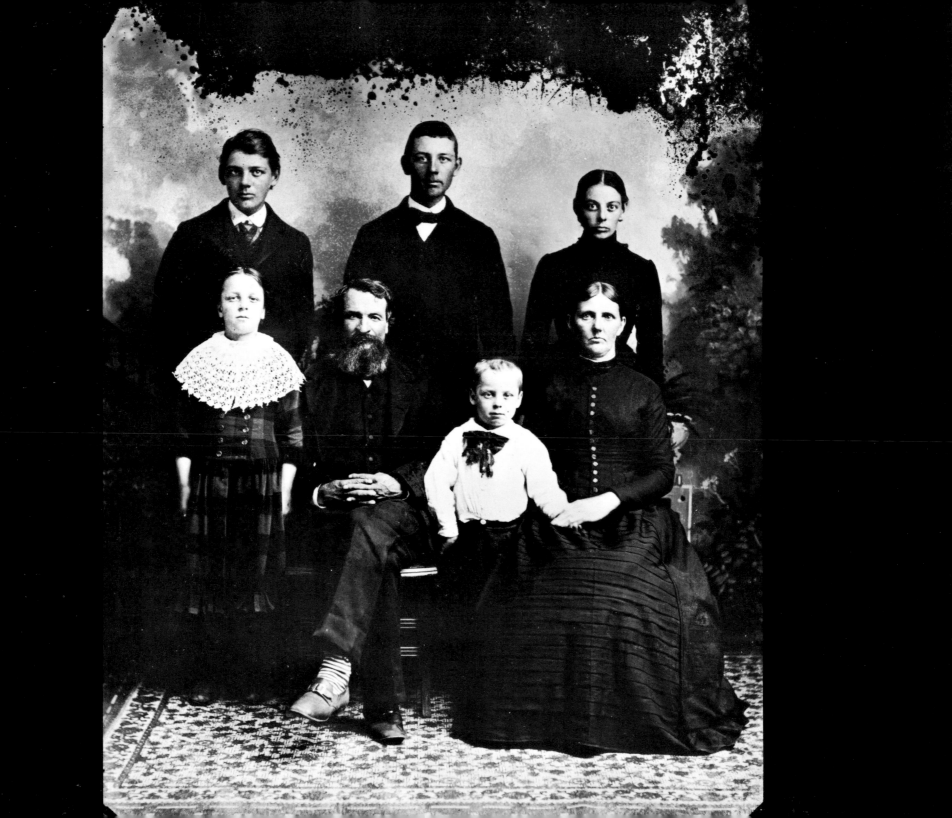

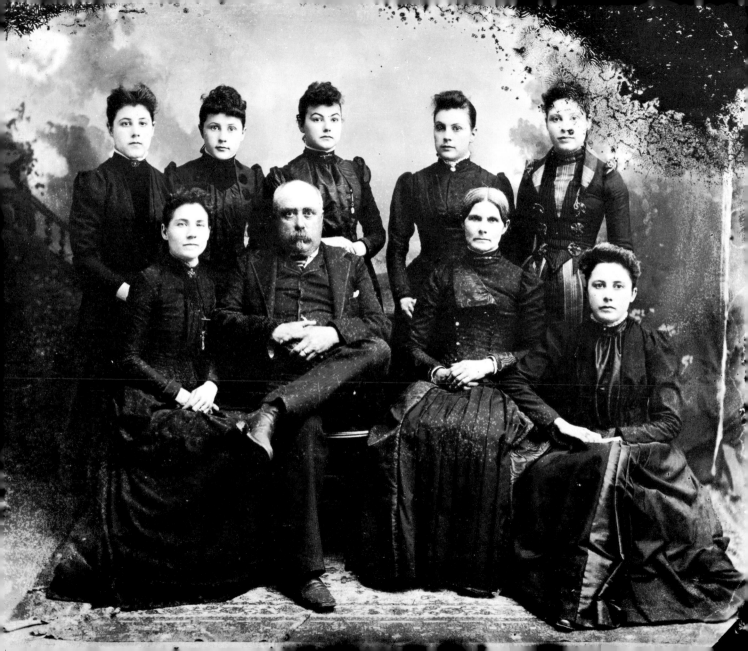

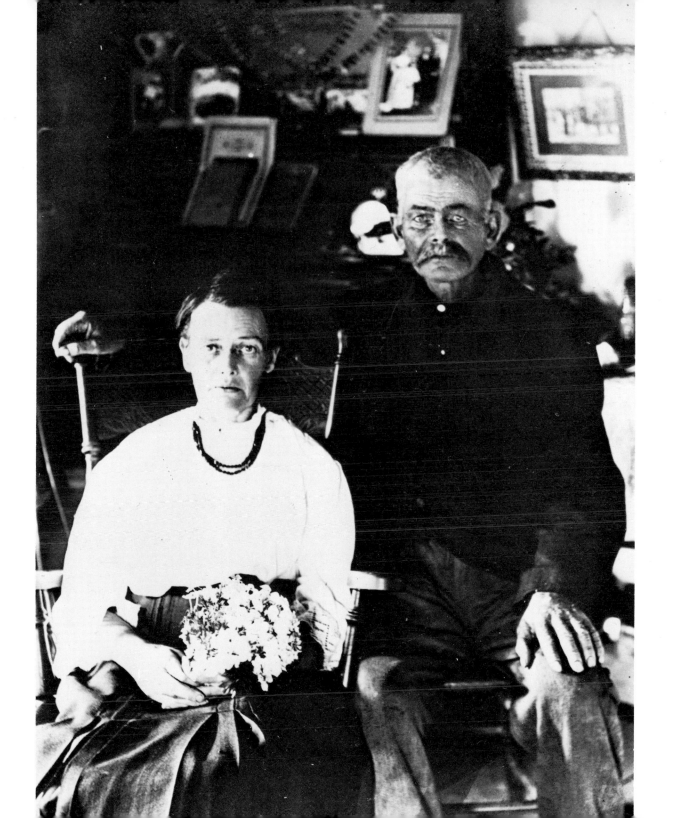

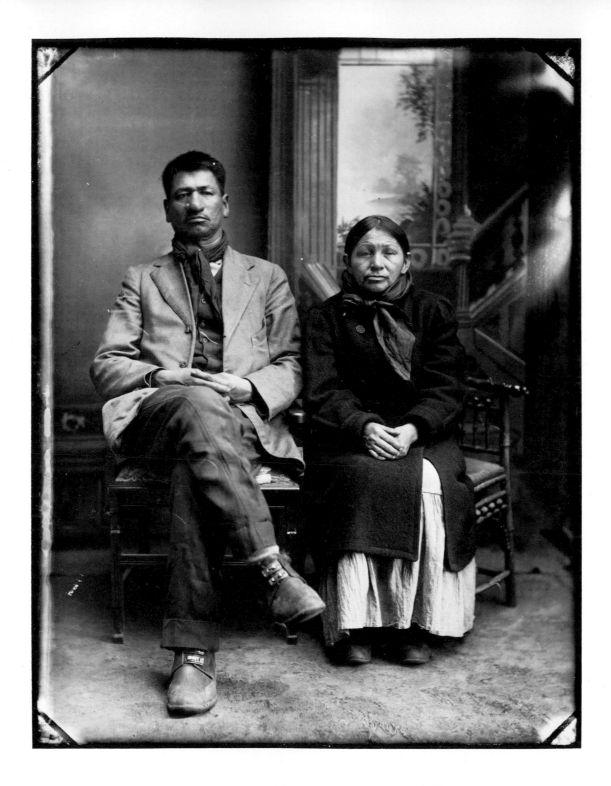

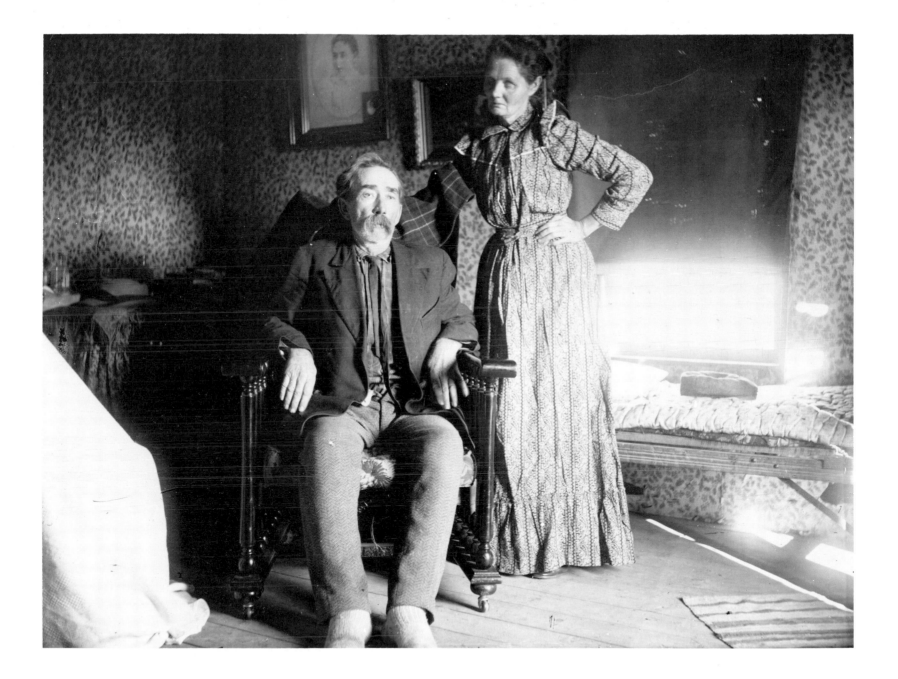

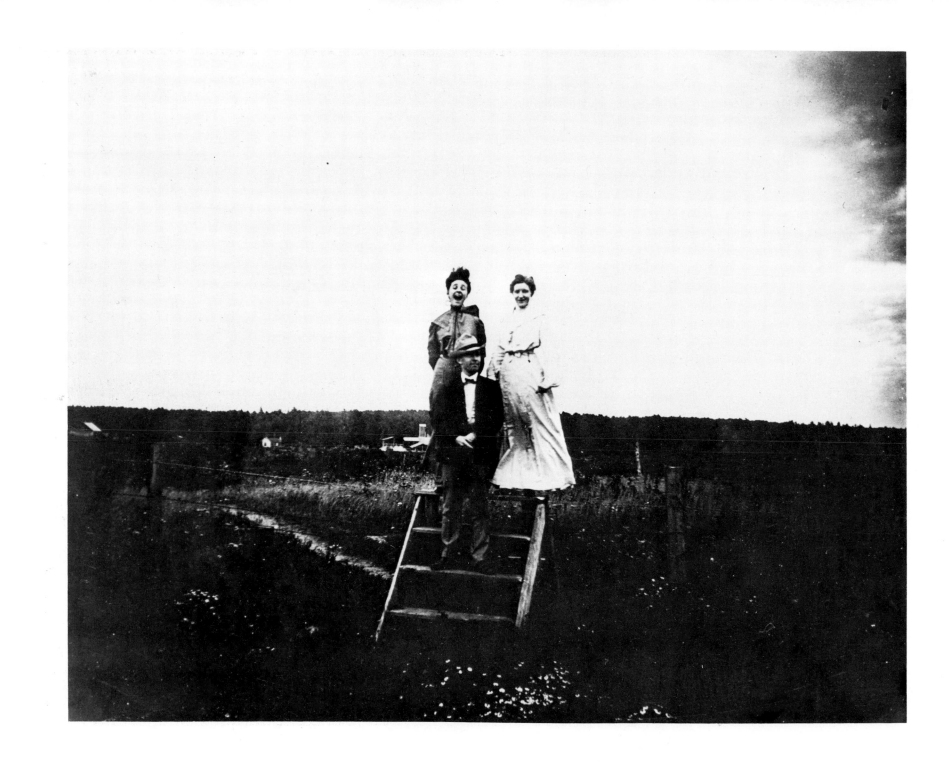

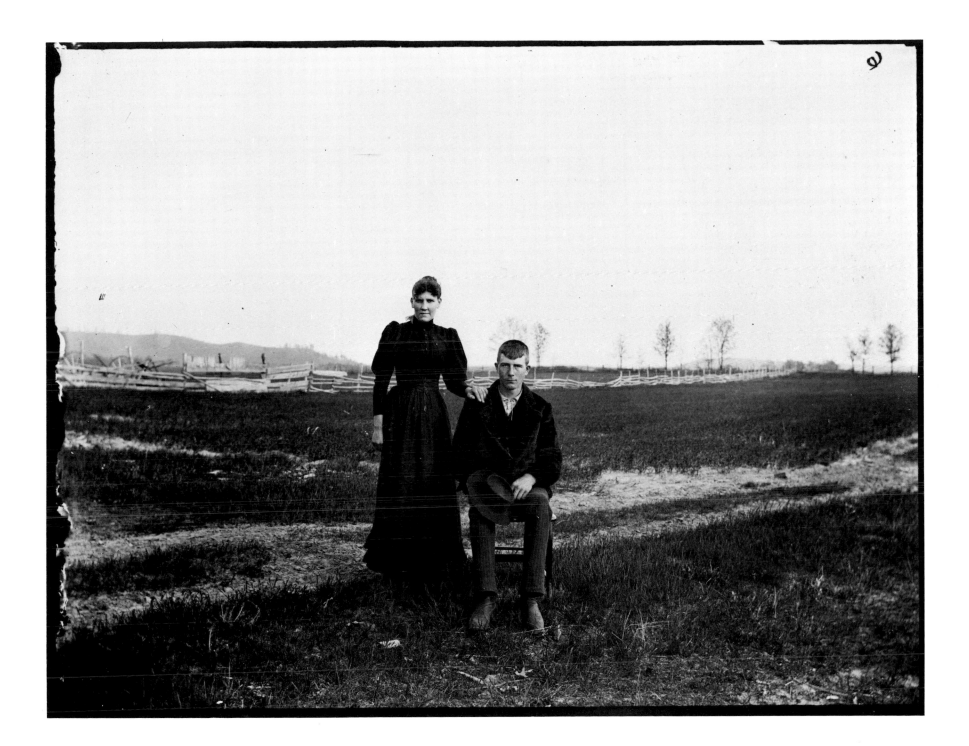

"Coroner Kortsh and Dr. Selback of Eau Claire in response to a telephone call from Rock Falls drove 13 miles in the country to hold an inquest on Michael Khilo, a Bohemian laborer, aged 60. He had been in an open field from midnight until 7 o'clock and was supposed to have been frozen to death. The coroner and doctor found him laid out stiff at the widow Tomaschek's farm house, but Khilo thawed out and sat up just before the inquest began. The doctor and coroner worked over him until he was fully restored. It is said he had fallen into a fit on his way home." [1/4, State News]

"Undersheriff Pierce captured a wild man in the woods 4 miles east of Barron. The man lived in a small cave on the bank of a river. He gave his name as Owen O'Sullivan and claims to hail from Ishpenning, Michigan. He talks rationally but tells various stories as to his recent whereabouts. He has lived in the cave at least 4 weeks and possibly all summer. He was nearly starved when caught." [1/11, State]

"The details of finding the supposed skeleton of Peter F. Nelson, leading to the arrest of Eugene J. Buell for murder, were related by Buell's father-in-law, R. J. Boardman, on the witness stand at Ashland. Boardman testified that 3 weeks after Nelson's disappearance in September, 1896, the ghost of Nelson appeared to him and said, "I am killed," and than vanished. He thereupon engaged experienced Indian woodsmen to search for Nelson's body and it was found 9 months later." [1/13, State]

1900

Frozen to death he is restored
Wildman Dreams reveal his murder
Tobacco insanity Good labor market
Good times market Paranoid murder
Mob hysteria Body preserved
 Funeral
Death Paranoid defiance Perpetual
Motion insanity Incendiary sabotage
Drunken frenzy High school motto
Inspiration Unloving sons Baby's
Broken heart Suicide – ill health
Black man and white girl Smallpox
Tramp robberies Wildman Family
Wipe out Insanity – diligent service
Matchbox suicide Suicide – hammer
Necrophilia Arson Religious insanity
Black barber Thomas Nichols
 Insanity
Suicide before divorce Suicide before
Marriage Hard times suicide Jumps
from his coffin Diphtheria The
Enterprising undertaker Frozen
Wreck Deathly anticipation
 Voluntary
Insanity Diphtheria Insanity Crazy
Father son murder

Local gossip about a man down in Irish Valley and Al and Aggie Sermon; Hamlin Garland's bitter farm women; a story about T. H. Nichols; "Indignation" Jones from Edgar Lee Masters

"Rollo Tracey, a well-known young man of Oshkosh, has been adjudged insane by Judge Cleveland and admitted to the Northern Hospital for treatment. His mental ailments were attributed to excessive cigarette smoking. He was arrested on a warrant sworn out by his wife charging cruelty. According to the statements of his wife he smoked several boxes of cigarettes a day." [2/1, State]

"Dealers in logging camp supplies report business in that line has been 50% better than during last season which furnishes evidence to the fact that the cut this year is to be a heavy one. It is with difficulty that camp crews are kept up to the required quota, for men who may have been already hired to go into the woods are in many instances approached by others. . . . and an advance of $5 or more per month over what they have been previously offered. . . . they can not resist. There are no unemployed men. . . . It is safe to estimate that there is 15% more logs on the banks of rivers and lakes now than there were last year . . . and the woods are full of skidded logs." [2/1, State]

"There has not been in 15 years as small stocks of lumber on hand as at the present, and the strong demand has caused prices to stiffen again. Five of the large Marinette sawmills are in operation this winter, an unusual occurrence, and the railroads have already brought in over 40,000,000 feet previously involved. The scarcity of snow in the pineries has made logging slow and expensive. . . ." [2/15, State]

"Middle Ridge, a prosperous little German settlement, was the scene of the most terrible crime ever committed in La Crosse County. Edmund Ott, while temporarily insane and fearing death at the hands of an imaginary mob, sought to put his wife and baby out of the way of the desperadoes he thought were about to hang him. He shot and killed his 3 year old daughter. He shot his wife twice, but she will recover. He then killed himself. The gunshot set fire to Ott's clothing and also to the house. His body was burnt to a crisp and the house destroyed." [2/22, State]

"Mike Grazialny, an employee of the Menasha Wagonware Company, went violently insane while at work. He was taken with a fit of insanity and rushed out of the shop where he was employed and started to yell frantically. It was not long before every one of the thousand employees of the Menasha Wagonware Company joined in the chorus with his yells, not knowing the man was crazy. . . . The entire city was awakened by the din. Grazialny was finally taken in charge by an officer. He is a man of family and his insanity is said to be due to religious troubles." [2/22, State]

"The body of John C. Hanover, which had been buried 11 years, was exhumed at Avon, to be reinterred in Beloit. On opening the casket, the body appeared to be in a perfect state of preservation excepting that it had become somewhat darker." [3/8, State]

"At the funeral of George Smith. . . . in Beloit, while the relatives were taking a last look at the remains at the grave, one of the cross staves supporting the casket broke, letting it plunge forward, breaking the coffin." [3/29, State]

"Barricaded in his abode and guarding the approach with a double-barreled shotgun, Fred Greenwald of Gills Coolie defied the officers of the law to arrest him. Greenwald is an elderly man and a tiller of the soil. For some time he has been acting very strangely and in order to guarantee the neighboring farmers that no violence will result from his demented condition it was decided to bring him into court and ascertain whether or not he is insane." [4/12, State]

Down in Irish Valley, there was a man who'd shut himself in his bedroom. He had a big family, so they ran the farm to keep it going. No one ever saw him, but at night he'd crawl out the side window, and go out and inspect. And the next day, if the barn was still dirty, or the oats still weren't cut, he'd yell through the door at them. He managed it all from bed.

Then there was a lady who went to bed and stayed there, but she knew if a scissors wasn't put away or a pan was left dirty. She'd get up at night and sneak around to make sure that everything was just right. Of course everyone thought she was bedridden. [Town Gossip]

"Constant worrying over the thought that he would be unable to solve the mysteries of perpetual motion has driven A. J. Dayton of Janesville insane. . . . For the past 14 years . . . the study of perpetual motion [has] occupied the greater portion of his spare time. On this subject he would study at night till way into the morning. It is said that he spent considerable money in his efforts to solve the mystery of perpetual motion." [4/19, State]

"Another fire unquestionably incendiary was discovered in a long row of slab piles in the most dangerous section of the La Crosse Mill district. . . . This makes the fifth fire of this sort within a week." [6/7, State]

"James McCarthy, proprietor of the Iron City Hotel at Mellen, almost killed his wife and 2 children while on a drunken frenzy. Had it not been for the timely interference of the police, he would have probably succeeded." [6/7, State]

Class Motto: "We Have Reached The Hills; The Mountains Lie Beyond." [6/11, Town]

M. Vaudreul, Pauline's visionary city planner, had begun his career as Mr. Vaudry, the real estate salesman. His metropolis had begun as a stretch of sand barrens covered with jack pine which he'd tried to offer on reasonable terms to the forward looking people of Jackson County as an ideal site for modest bungalows, palatial mansions, burgeoning factories, and endless fruit orchards. Unfortunately the inhabitants of Jackson County lacked imagination; they found it difficult to forget that no one had ever been able to do anything with the jack pines but burn them, or do anything with the soil but scratch at it. Vaudry ran quite a few full-page illustrated advertisements. He even reprinted a testimonial signed by an internationally renowned German soil analyst, who spoke of nitrogen and legumes. The local paper paid him back by including the new town site in its weekly County News, listing the phantom journeys of people who had come to inspect the cement plant or the newly completed sash, screen, and door factory. But nothing worked. By the time Vaudry stood chatting in Pauline's hotel suite he had begun to understand that the only way he could unload the lots was to sell them to rich people from Chicago as ideal vacation investments, and that the only way he could attract their money was to make them think that other people with even more money were in a mad rush to grab choice locations in the future Saratoga Springs of the North. It was an old American story but Pauline had never heard it. All she knew was what she needed, and all Vaudry knew was that you had to have some kind of bait and Pauline was the freshest available.

She and Edgar got into Black River Falls just in time for the 1911 flood that washed out most of the town's business block. While they were living in town that winter, Pauline made inquiries as to the exact location of the mountain and Edgar occupied himself by prefabricating the walls of their future cottage. Edgar built the walls just as he had seen dozens of set designers construct everything from Egyptian pyramids to Faustian dungeons: first he laid out the two-by-fours, then he nailed them together at the joints, and then he secured them with several layers of chicken wire. He modeled the structure after the Malraux Castle but, forgetting that the walls only looked like stone, he neglected to insulate them. When spring came he hired a hayrack and had everything hauled out and set up on a prelaid concrete slab where he wired the walls together at the corners. They were eight miles from the new town and about 700 miles from any mountains. In the winter they were about twelve hours' journey from Black River Falls by pung on roads that were nothing more than two deep ruts on either side of a big hump. Since these roads weren't so much roads as parts of the terrain, it was important that the pung's runners were a certain distance apart and the pung's body a certain distance above the ground. But since Edgar was only eighteen and was not exactly familiar with local conditions, the pung he built had runners too close together. People used to watch them sitting dignified but askew, being pulled along by a steer and an Indian pony with one runner in the ditch and the other skidding along the side of the hump.

The only people who ever visited them were hunters who stumbled in, half-frozen, lost in some snowstorm, or high school teachers so bored they didn't know what to do with themselves. From the accounts of such people grew the L'Allemands' reputation. They were said to live in two huge rooms: one was absolutely empty but for a pair of fine lace curtains; the other held a beautiful organ, an expensive camera made all of polished wood and brass, a low stove, salvaged from some schoolhouse, that burned nothing but three-foot wood, a table, and a homemade bunk bed. On those rare occasions when they had visitors, Mrs. L'Allemand was said to step out of her home-tanned rawhide moccasins and stuff her swollen feet into high-heeled pointy-toed pumps done up with binder twine. Edgar was said to wear a velvet jacket with a frill about his neck, his long hair flopping over his collar. On such occasions she and Edgar performed musical interludes for their visitors: Edgar was said to play a violin made of aluminum which had been specially constructed so that he might perform the legendary, theoretically possible but practically impossible feat of playing the same note on the same string six consecutive times. Often he acted as his mother's accompanist. On these occasions Mrs. L'Allemand was reported to project such sweet clarity of tone that it was only possible to separate violin from voice when she was forced to interrupt herself so that she might replace the paraffin wax which had inadvertently fallen from her toothless gums. This musical hospitality was all that their guests ever reported accepting from them, since, having broken all their dishes, they had left only a sterling silver sugar bowl

and creamer from which they took turns eating a mush made of what locals called "brown feed"—a nutritious porridge of grains normally served only to cattle.

Sometime in the fall of 1917 Pauline began to confide to those callers whom she considered to be trustworthy that she and Edgar had become the victims of a conspiracy. She spoke of a persecution so nefarious that its agents thought nothing of coming to her window and shooting the ivories off her organ in broad daylight. Even though her visitors told her such marksmanship was impossible and that from appearances her ivories had more likely been prey to rot than to vandals, she took their amazed protests as only further proof of the awesome cunning of her enemies.

A year later her struggles had become public knowledge. Someone had accused Edgar L'Allemand of stealing four sacks of cement, and so he and Pauline gave their first and last public performance before a judge, a jury, and a courtroom packed with spectators. It was Pauline who'd insisted on the jury, since the county would have preferred the quick cheapness of a non-jury trial. Nevertheless Pauline was afraid that since she and her son were already the victims of an anti-Catholic conspiracy, they might be subject to some form of lettre de cachet served upon them behind the closed doors of a secret tribunal. Edgar had decided to mount his own defense in this last effort to keep open the jaws of the trap he and his mother had been thrown into. They had nothing left but their stage clothes, which they wore with the air of proper Englishmen who

had dressed for dinner, even though it was they who were in the cooking pot. Edgar argued his case dressed in his tuxedo while his mother sat by his side in a fitted full-length formal gown whose jet buttons ran from her throat to the floor. Unfortunately the advice she gave him was often interrupted by the paraffin wax which refused to stay in place, while Edgar's arguments to the court were hampered by the bear grease which he had used as a pomade but which, melted by the heat, had dripped into his eyes.

The trial progressed in this manner: Edgar explained to the court that he had purchased the cement from a strange man who had stopped by and offered it for sale. He further explained that he had intended to use the cement to surprise his mama by curbing the well in the middle of their living room. In response to this the plaintiff claimed that he had tracked Edgar's pung to and from his very door. He claimed to be absolutely positive that the tracks were Edgar's since there was no one else in the whole county whose runners were so close together and whose team consisted of such a strange pair of animals. On the basis of this testimony the jury reached the following verdict: they found Edgar L'Allemand to be not guilty of stealing the cement, but they required him to pay the other gentleman the full price of the four sacks he hadn't taken. However, Edgar declared to the court that he and his mother neither could nor would pay the damages imposed. In addition, when the court offered them, under the circumstances, the refuge of the county poor farm, this offer was also refused. The court therefore dismissed the

jury but requested Mrs. L'Allemand and her son to remain so that they might be interviewed by two physicians retained by the county. Edgar was asked about his aluminum violin, while Mrs. L'Allemand was asked about the conspiracy directed against her. Since both she and her son answered to the best of their ability, Drs. Cole and Krohn, as authorized by the court, had them committed to Mendota State Hospital in Madison where they were taken by the sheriff. The town believed it had acted as humanely as possible under the circumstances, since there seemed to be no other way to care for them than to send them to Mendota for a complete rest and three meals a day. They were kept at Mendota for about a year, but they never returned to the town since in the interval anything of value that remained to them was stolen from their cottage. Mrs. L'Allemand was said to have died sometime before 1929, but Edgar was still heard of some years later. One of Dr. Krohn's daughters, who had moved to Chicago, claimed that she had seen Edgar countless times at her favorite supper club but had never introduced herself. She said she knew how embarrassed he would have been if anyone had recognized him as the club's strolling gypsy musician.

"John and Leo Koelbel, well-to-do farmers residing in the town of Newton, had a hearing in Manitowoc in the county court before Judge Anderson, having been cited there on the charge of contempt for failing to comply with an order of the court commanding them to pay 60 cents a week each for the support of their aged parents. . . . The 2 sons have positively refused to give a single cent toward the support of their father and mother. The court ordered them both to be committed to the county jail until they saw fit to comply with the order. . . ." [6/11, State]

"Elsie Whitsan, 4 years old, child of Henry Whitsan, died at Neenah of grief. . . . Her mother died a few days before and from then until her death the child cried without stopping. Physicians say that death was caused by a broken heart." [6/11, State]

"Mrs. David Phillips committed suicide at Lime Ridge by hanging herself with a halter in the barn. She was despondent because of ill health." [6/21, State]

" 'I hate farm life,' she went on with a bitter inflection. 'It's nothing but fret, fret and work the whole time, never going any place, never seeing anybody but a lot of neighbors just as big fools as you are. I spend my time fighting flies and washing dishes and churning. I'm sick of it all.' " [Hamlin Garland, "Up the Coulee," in *Main-Travelled Roads*, p. 89]

"Clara Pappan, a white girl of Viola, eloped with George Carpenter, a colored man. Police officers from Viola tried to stop the marriage, but the girl being of age nothing could be done." [6/28, State]

"Five cases of smallpox were discovered in the family of Jerry Balza, an employee of the rag room of one of the paper mills at Appleton." [6/28, State]

"A number of tramps who had been around Chippewa Falls for a week combined forces on a recent night and robbed 7 ice boxes in the residence portion of the city." [6/28, State]

"A wild man is terrorizing the people north of Grantsburg. He appears to be 35 years of age, has long black whiskers, is barefooted, has scarcely any clothes on him, and he carries a hatchet. He appeared at several farm houses and asked for something to eat. He eats ravenously, and when asked where he came from, points to the east. He secretes himself in the woods during the day and has the most bloodcurdling yells that have ever been heard in the neighborhood." [7/5, State]

"Matthew Sullivan, aged 23 years, second son of Mr. and Mrs. Sullivan, was buried at Kaukauna. This is the tenth child which they have been bereaved of, 7 of them being interred in St. Mary's cemetery. Four children survived." [7/12, State]

"J. B. Powers has been adjudged insane at Baraboo and taken to Mendota for treatment. He was an agent for the Elgin Creamery Company. . . . Overwork and the desire to please his employers is said to have been the cause of the derangement of his mind." [7/12, Town]

"Mary Karban, wife of Wenzel Karban, a farmer of the town of Neva, committed suicide by eating the heads of 4 boxes of matches. She was only 16 years of age and had been married last fall." [7/12, Town]

Up the road were Al and Aggie Sermon. They had a great big family, but years before it was different. They'd got married when she was 14 or 15 and gone up to the North Woods of Minnesota, way out alone up there, and she got shack-wacky. That's why they came back here. She had some kind of nervous breakdown or something from being alone. Not that she was the only one. It happened to an awful lot of women. [Town Gossip]

"Abraham Zweekbaum of the town of Holland committed suicide by battering himself on the head with a hammer. . . . He attempted to take his life a few days ago by cutting his head from his body with a sharp instrument, but was prevented from doing so." [7/12, State]

"In sight of her mother's grave Ada Arlington shot and killed her former lover, John Resburg, at New St. Louis. She then carried him into her house, crossed his hands on his breast, placed nickels on his eyes and sat up all night with the dead body. She went to West Superior the next day and gave herself up. She states that the man was intoxicated and tried to break into her house." [7/19, State]

"Anna Myinek, a 15 year old Polish girl of the town of Burnside was sent to Milwaukee industrial school by County Judge Odell. She set fire to her employer's barn, burning it with 48 loads of hay, and also set fire to the house. The next morning she set fire to 2 loads of hay and set fire to the house twice. . . . She is suspected of having set fire to a barn at the same place last spring and also a house and a barn at 2 other places she had worked before all of which were destroyed. She told the judge she had set the fires because she was lonesome and homesick, and wanted excitement." [7/26, State]

"With an open Bible in one hand and a dagger in the other, John Isaacson held 3 officers and 25 citizens at bay at a missionary meeting in West Superior. . . . Isaacson became crazed with religious excitement and believed that God sent him to kill the devil. The lunatic was taken to the Mendota asylum." [9/13, State]

"Thomas H. Nichols, Proprietor of EUREKA BARBER SHOP, and The Fin de Siècle Tonsorial Artist, Cranium Manipulator, and Capillary Abridger. *All Manipulations executed with ambidextrous facility.*" [9/20, Front page ad]

Nichols was the town's other black barber. He'd been brought up North the same way Lyons had after the Civil War. He died just as disastrously as Lyons did, but he was a different sort of man. He was a very elegant, light brown man. He dressed exquisitely. His shop was a place of debate and discourse. He had educated himself and so gave over his mind to startling opinions. He called himself a Debs socialist. In 1914, he took a stand against the war. On Armistice Day, some men got drunk and hauled him and a white man named John Diedrich up on the back of a truck and made them kneel and kiss the flag. Nichols had been in the town for thirty years, but he never got over that one day. He closed his shop, left town, and died of a broken heart. [Local History]

Judson Thompson was committed to Mendota. [9/20, Town]

"You would not believe, would you, that I came from good Welsh stock? That I was purer blooded than the white trash here? And of more direct lineage than the New Englanders and Virginians . . . ? You would not believe that I had been to school and read some books. You saw me only as a rundown man, with matted hair and beard and ragged clothes. Sometimes a man's life turns into a cancer from being bruised and continually bruised, and swells into a purplish mass, like growths on stalks of corn. Here was I, a carpenter, mired in a bog of life into which I walked, thinking it was a meadow, with a slattern for a wife, and poor Minerva, my daughter, whom you tormented and drove to death. So I crept, crept, like a snail through the days of my life. No more you hear my footsteps in the morning, resounding on the hollow sidewalk, going to the grocery store for a little corn meal and a nickel's worth of bacon."
[Edgar Lee Masters, " 'Indignation' Jones," in *Spoon River Anthology*]

"Frederick Haedrich, aged 50 years, committed suicide at his home in Fond du Lac by hanging himself in his woodshed. He . . . was summoned to go into court and make answer to divorce proceedings recently instituted by his wife whom he drove from home a few weeks ago. The hour for him to appear was 10 o'clock . . . it was a few minutes after that time. . . . that he hanged himself." [9/27, State]

They kissed. They kissed again. They got married. It was a small town, either you got married or you died alone. It was a practical solution. If not love, then at least company. Either you got married or you went crazy.

Courtship was a matter of patience. The girls packed the lunches, the boys brought a little beer. The boys put up the hammocks. The girls swung and talked. So many picnics equaled so much courtship. So much courtship equaled so much engagement. So much engagement equaled so much marriage. So much marriage equaled. . . . It was all a greased track.

Clara married him even though she knew how his father had once planted all potatoes for the starch factory, and how he'd gone nearly crazy when the factory had had to shut after three weeks. Clara married him even though she could still remember how the old man had warned everyone off with a shotgun while he set all the potatoes on fire, and how the sheriff had had to come finally after he'd taken a shot at Art Oberdorfer's son Teddy who'd run in too close.

Charles married her even though everyone knew about her Aunt Min and how she was always talking about witches. He married her even though he'd heard that every Sunday after church, Min used to drive the horse and wagon to Millston and sell them to Ace Hardy and that every Sunday Ace Hardy would buy them for exactly twenty-eight dollars and then wait for her husband Fred to come and buy them back, till next Sunday when Min would do it again.

Either you got married or you left. Either you left or you got married. You only got married because you actually thought it might all turn out different.

"Frank Whitehead, a Whitewater farmer, killed himself rather than get married. Whitehead was engaged to Miss Lillie Taylor. The prospective groom had ordered a new outfit of furniture for his house and everything was in readiness for the wedding ceremony. The furniture dealer is also an undertaker, and as he was loading the furniture a message came to him to leave the furniture and bring a coffin instead. . . . Whitehead had shot himself to death. The man [had] been nervous because of the approaching event and no reason is known for his self-destruction except pure fright over the wedding ceremony." [10/18, State]

"Harry S. Morrison committed suicide in some vacant rooms in a house in the First Ward of this city some time Friday last. At least his body was found there that afternoon. . . . a coroner's jury determined that he came to his death as the result of carbolic acid administered by himself. An empty bottle labeled carbolic acid which he had himself purchased and several whisky bottles were found in the rooms. Morrison was 26 years old. . . . [He] was rather a bright man of some literary attainments, but had fallen into hard times." [10/25, Town]

"Frederick Schultz, an old resident of Two Rivers, cheated his undertaker by suddenly jumping out of the coffin in which, supposed to be dead, he had been placed." [11/15, State]

"The spread of diphtheria in Oshkosh became so rapid that the health and school authorities determined to close the schools, both public and parochial." [11/15, State]

"Nichols Nelson, the enterprising undertaker, has received and put into use an automatic arrangement known as the Natural Burial Device for lowering coffins and caskets into graves which works in a very smooth and satisfactory manner." [11/15, Town]

"Theodore Hansen drove a livery team, taking a gentleman into the country, Wednesday night . . . coming home about 10 o'clock. . . . at the bridge . . . the night being very dark and the roads rough, he was thrown from the buggy . . . when he came to he found himself in the water, excepting his head. One hand was so numb he could do nothing with that and after a long time succeeded in crawling out, but being so numb and a cripple besides, he could not rise. He screamed for help but was not heard. About 8 o'clock the next morning he was found, frozen to the ground, and his clothing had to be cut off from him. His hands are both badly frozen and both limbs below the knee were without feeling for several days."
[11/15, Town]

"Hans Gjerseth of this city was adjudged insane Tuesday by Judge Johnson. . . . and was taken on the Wednesday morning train to the Mendota asylum by Sheriff Trundson. He realized his condition and was desirous of going for treatment."
[12/13, Town]

"Dr. Krohn reports 2 cases of diphtheria in the family of Adam Stich, in the town of Albion."
[12/13, Town]

"Olena Anderson was adjudged insane in Judge Johnson's court last Thursday and committed to the State Asylum at Mendota. She was a resident of the town of Garfield and has a son about 8 years old."
[12/27, Town]

"There was a most curious premonition in connection with the death of D. S. Holcombe, who is supposed to have drowned in the Wisconsin River near Kilbourn. J. A. Rhodes of Baraboo says he was fishing with the cattle buyer not long ago when he told him how he had dreamed of drowning in the river. Mr. Holcombe described a rocky point which he saw in the dream and also described the sensation of losing his life in the water in exactly the same way he is supposed to have drowned. The rocky place to which he was traced is a counterpart of that seen in the vision. On 2 subsequent occasions he told Mr. Rhodes that the dream had been repeated, and that it was always the Wisconsin River."
[11/29, State]

"William Voight, who resides 3 miles south of Amherst, became violently insane and attempted to kill his 3 children, all boys ranging from 8 to 14 years of age. He took an iron poker, it is alleged, and went to their bed about 10 o'clock at night and commenced to beat them over the head. . . . He is a farmer in comfortable circumstances and has a wife and 3 boys."
[12/27, State]

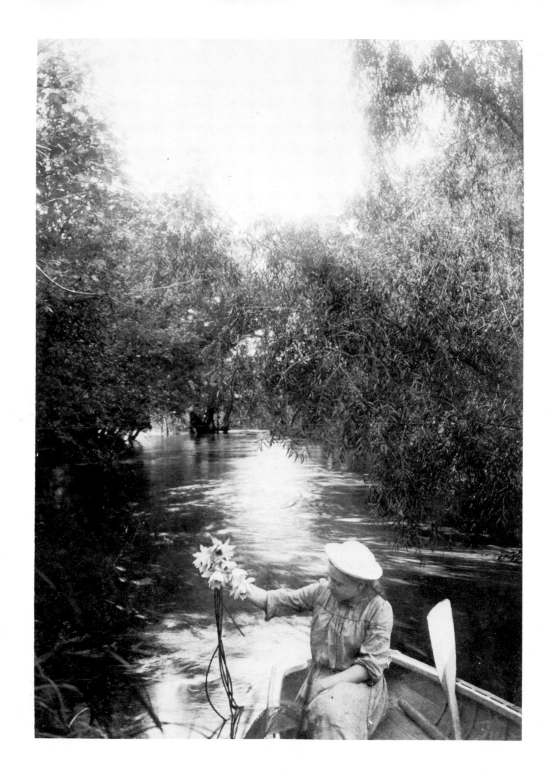

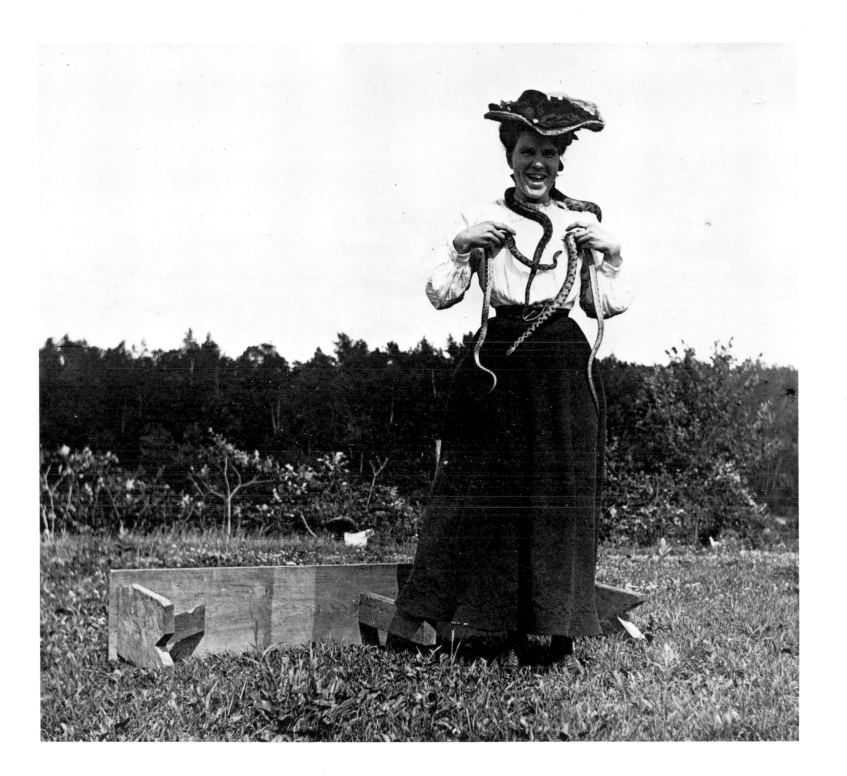

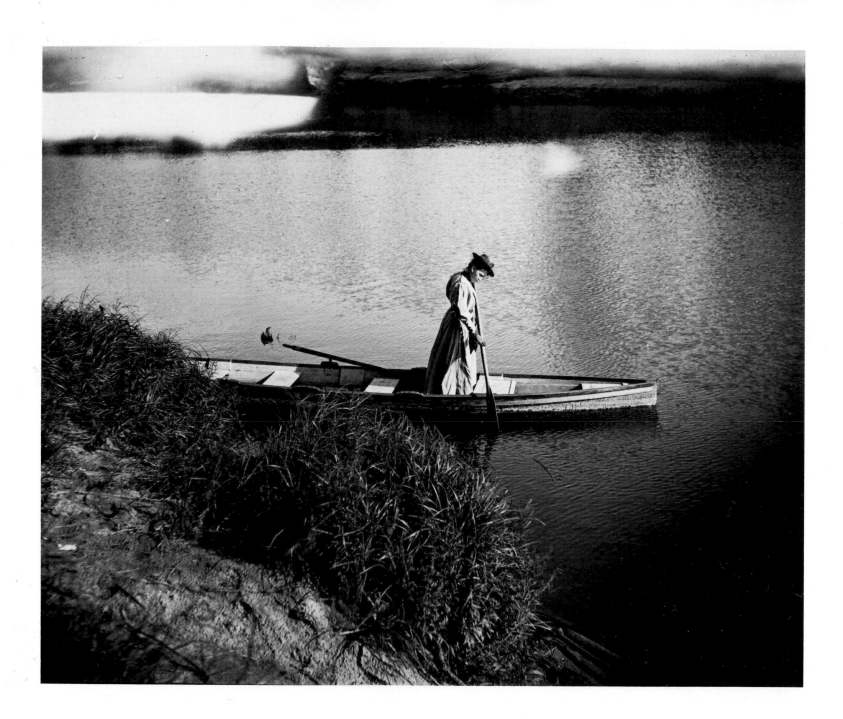

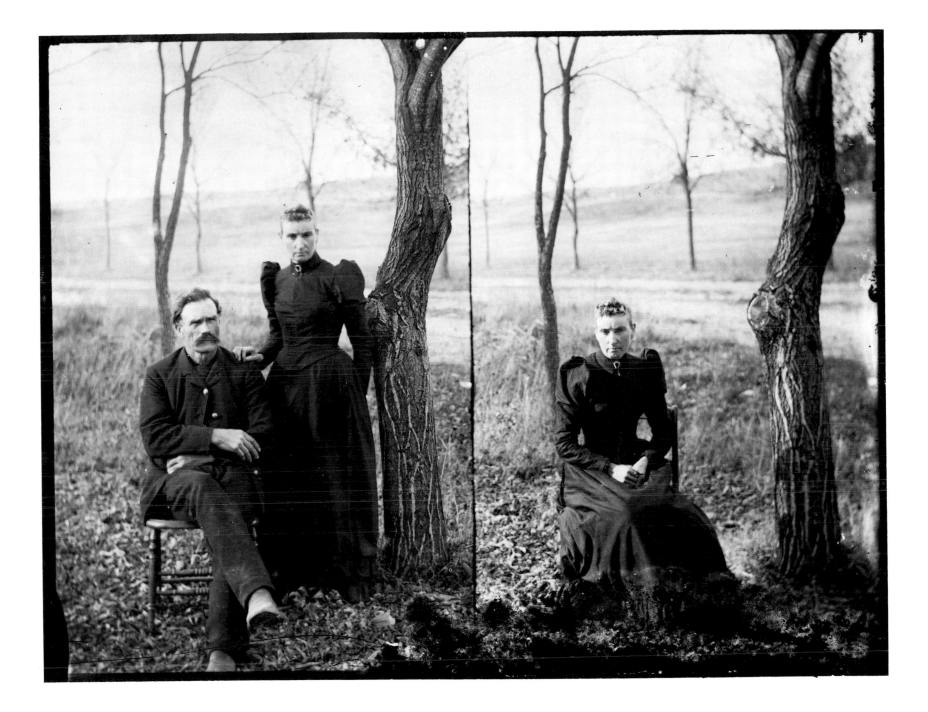

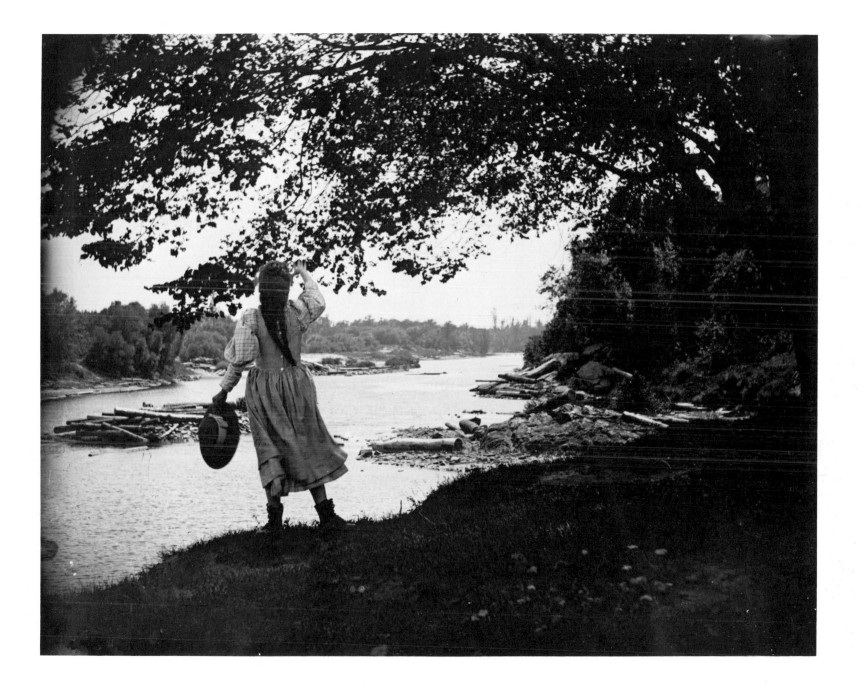

Conclusion

Pause now. Draw back from it. There will be time again to experience and remember. For a minute, wait, and then set your mind to consider a different set of circumstances: consider those scholars and social philosophers who never knew that Anna Myinek had burned her employer's barn or that Ada Arlington had shot her lover, but who nevertheless understood that something strange and extraordinary was happening in the middle of the continent at nearly the same instant that they sat in their studies, surrounded by their books. Such men did their best to understand what it meant, and in the process they tried to predict that future in which we are now enmeshed.

Between 1874 and 1876, a scholar named Robert Dugdale was employed by the New York Prison Association to report on the conditions of the state prisons and county jails of New York. In the process of his investigations, Dugdale discovered "one of the crime cradles of the state"[1] nestled not between tenements and alleys and sewers and lamp posts, but between the forest trees that grew down to the shores of a group of five lakes. The creatures who infested this region were neigher Irish nor German immigrants, even though they ate and washed and slept as if they were in tenements. Nor were they recently emancipated blacks, even though they lived in shacks that looked like slave quarters. Rather, they were a family of "native" Americans descended from a Dutchman whose presence was first recorded in 1720. For so long had they been the whores and criminals of their country that their name had become a common insult. Dugdale called them the Jukes. He studied them with such an amazed thoroughness that, forty years later, their name was still used in arguments to prove the hereditary origins of poverty and crime.

Dugdale calculated that the family's founder had spawned 700 descendants. He estimated that half of all the women had been harlots, and that seventeen of the founder's twenty-nine living male heirs were routinely guilty of such things as assault, murder, attempted rape, and cruelty to ani-

[1] Robert Dugdale, *The Jukes: A Study in Crime, Pauperism, and Disease,* p. 13.

mals. He further calculated that 22 percent of the Jukes were paupers, and that this was seven times the state average. What was most extraordinary was that of this 22 percent, more than half were diseased. Most of them had active or hereditary syphilis. Many of them drank.

It was from these data that Dugdale constructed his axioms, and from these axioms, his theories of rural crime and poverty, degeneracy and renewal. He believed that there was such a thing as hereditary poverty, and that it was the "sociological aspect of physical degeneration." He posited a degenerative process that began with wasting disease. Such disease, bred mainly by fornication and sexual licentiousness, produced "a deadening effect upon the moral sense." Such coarsened moral sensibilities produced "a waning vitality,"[2] which was, in turn, responsible for intemperance. It was this combination of ill health, fornication, drunkenness, insensitivity, and exhaustion that bred poverty, and it was poverty that was responsible for criminality the same way a maggot is responsible for a fly.

Above all, fornication and its filthy diseases of body and soul were responsible for the fate of the Jukes. "Just as in the training of certain idiots, one of the great impediments in ameliorating their condition is found in the sexual orgasms to which they are addicted [and which]. . . perpetuate their idiocy"; so in the reform of hereditary paupers, their licentiousness is chiefly responsible for their foul condition, since it dissipates their vital force, squanders their energies, and releases their passions, all of which must be contained before they can be cured. In the case of criminals, industrial training was the best hope of reform. Its primary effect was "to curb their licentiousness." Above all, it developed and reformed the criminal's degenerate senses of touch, hearing, sight, smell, and taste. Indeed, "the cure for [all] unbalanced lives was a training of cerebral tissue, producing a corresponding change of career."[3] In these ways Dugdale defined rural poverty in terms of sexual appetite and rural crime in terms of a degeneration of the senses.

Twenty years later, there were still sociologists who talked about the countryside with the same cynical disillusionment and moral disdain as Dugdale. Periodically, in such places as the *American Journal of Sociology*, they would display a picture of two identical dolls holding hands, one of which was stuffed with hay and came from the country, while the other, they claimed, was filled with rags and came from the city. Both dolls had unusually large sexual organs and coarse smiles painted on their faces.

"It is a popular belief that large cities are the great centers of social corruption, and the special causes of social degeneration, while rural districts and country towns are quite free from unmoral influence. . . . Yet the country has its own social evils."[4] In this way, one year after Bryan's presidential campaign, a sociologist named Frank Blackmar began to talk about a family that lived in his own state of Kansas. Blackmar called his family the Smoky Pilgrims, and used them even more symbolically than Dugdale had used the Jukes. By the time Blackmar had them photographed, cut

[2]Ibid., pp. 38, 59–60.

[3]Ibid., pp. 60, 54–55, 60–61, 56.
[4]Frank Blackmar, "The Smoky Pilgrims," *American Journal of Sociology* 2, no. 4 (January 1897):485.

out of their backgrounds, and pasted into hypothetical groups with initials and interchangeable first names to identify them, he had turned them into shadow puppets in a Manichaean drama of rural decay. There in the East, in the sun, they had begun as a widowed mother and her four children, poor but respectable, only a hundred dollars to their name, but determined to start a new life. By the time the sun had set and they had reached Kansas, the mother had been changed into a twisted old woman, her eldest daughter had disappeared into the unapproachable silence and dubious respectability of marriage to an industrious black farmer, her two sisters had become harlots, the mothers of mulattoes, and, covered with grime, the occasional washerwomen to the town, while the only son had sunk into the agreeable but thick-witted stupor of a lazy and idle man of bad personal habits.

Even before he had described this family, with their photographs as evidence enough, Blackmar used them as an occasion to answer two questions: why the countryside suffered from a social degeneracy similar to the city's even though it was filled with air and sunshine, and why it suffered from "economic overcrowding" even though it was so deserted that the only things that seemed to be moving through it were ragged covered wagons drawn by ruined teams, carrying whole families of tramps looking for places to beg. Blackmar answered the first question in terms of the second: he said that for some reason most of the people who were worth anything at all had left, and the ones who stayed formed a social residue of tramps and vagabonds who were "a product of the method of settlement of the West."[5] All of them suffered from undervitalization as well as a lack of sanitation, and

were often driven mad by the morbid states that inevitably arose from the economic overcrowding they experienced on the now deserted frontier. Even the itinerant farmhands who managed to find work and avoid the madness were crippled by a vicious cycle of boredom and immorality.

> The lack of variety in life, the little time to be devoted to books and papers, and the destruction of all taste for the same, bring [their] minds to a low state. [Their] spare time on the farm and when out of employment is spent in telling obscene stories, in which perpetual lying is necessary to keep up the variety of conversation, and the use of vile language is habitual. All this tends to weakness of mind and the decline of bodily vigor and health.[6]

Genteel social scientists like Blackmar and Dugdale thought that the Americans who lived in the countryside suffered more from bad personal habits than from their condition, and that their condition was so inevitable that it could only be named and not ascribed. Lying and exaggeration, obscenity and boredom, filthiness and illiteracy, fornication and intemperance, were as responsible for rural degeneracy as isolation and "economic overcrowding." While such theorists were making the land into a swamp of sexual degeneracy, others were transforming the cities into plateaus of nervous decay.

In 1881, George Beard discovered a disease called American nervousness, and wrote a book about it. He thought that people became nervous when they suffered from a deficiency of nerve force, the same way one of Edison's new lights become dim when it received insufficient current. Beard observed that Americans, particularly those of the better classes who lived in cities in the North and East, suffered

[5]Ibid., pp. 485, 487.

[6]Ibid., p. 489.

greater deficiencies of nervous energy than any other people who had ever lived. "The chief and primary cause of this development and very rapid increase of nervousness is *modern civilization,* which is distinguished from the ancient by these five characteristics: steam power, the periodical press, the telegraph, the sciences, and the mental activity of women."[7] These characteristics of modern life made well-bred Americans far more sensitive than their ancestors to such things as alcohol, coffee, tea, tobacco, and opium. In fact, these sensitivities were responsible for the modern Temperance Movement. If the lives of such Americans were compared with those of their ancestors of fifty years before, many more of their sensitivities became clear: unlike their ancestors who ate pork morning, noon, and night, and followed each of their gargantuan meals with powerful cathartics, modern Americans preferred the milder flesh of beef and fish, ate little even of that, and suffered less from a tightness than from a looseness of the bowels. While their ancestors had been bushy-haired and sharp-eyed, modern Americans were bald and nearsighted; while their ancestors had had strong teeth and deep lungs, they suffered from tooth decay and hay fever caused by increasingly delicate mucous membranes, and while fifty years before, Americans had lived pleasantly in rooms heated to 60 degrees, their descendants moved about in apartments kept ten or even twenty degrees warmer.

The causes of such sensitivities were obvious: steam power, introduced into factories, had broken manufacturing processes into a series of repetitive tasks, so that "artisans [were] restricted to a few, simple, exiguous movements, to which they [gave] their whole lives. . . ." Steam power not only broke patterns of work, but speeded them up, pushing men beyond their accustomed limits. Clocks and watches, which before had only approximated time, were now so perfected that they drove men as surely as the steam that turned their machines. People were now expected to compare their progress with the sure intervals marked off by these timepieces, and so "were under constant strain, mostly unconscious, oftentimes in sleeping as well as waking hours, to get somewhere or to do something at some definite moment." The public conveyances that had once taken them from place to place were now expected to take them from appointment to appointment, while the very process of traveling long distances on board a steam locomotive created "molecular" disturbances that sapped the traveler's vital nervous energy.[8] These new steam conveyances and factory machines filled cities with harsh and jarring sounds that proved as debilitating as the most vigorous physical exertions. The telegraph speeded the transaction of business, and so was responsible for an unparalleled increase in the frequency and volume of capital exchange. Prices fluctuated more quickly, competition spread and intensified, and businessmen were as often driven beyond their accustomed limits as their workers. Beard thought that the telegraph, the periodic press, the recent discoveries of science, and the growth of history in all its branches, in conjunction with the religious and political factionalism so characteristic of a free and Protestant country, created an atmosphere of such rapid change and constant argument that modern Americans constantly teetered on the very edge of nervous exhaustion.

Less than fifteen years after Beard had formally re-

[7]George Beard, *American Nervousness,* "Author's Preface."

[8]Ibid., pp. 101, 104, 112.

corded the first general consequences of the modern age, Max Nordau wrote of the physical and moral degeneracy of its composers, artists, dramatists, novelists, poets, and philosophers, all of whom he claimed displayed the same mental and physical characteristics as "criminals, prostitutes, anarchists, and pronounced lunatics."[9] Nordau believed that the aesthetic and literary sensibilities that characterized Western civilization at the end of the nineteenth century resulted from physical degeneracy, fatigue, and hysteria, and that such physical decay and hysteria were the result of the large-scale and longtime poisoning of urban populations.

> A race which is regularly addicted, even without excess, to narcotics and stimulants in any form (such as . . . alcohol . . . tobacco, opium, hashish [and] arsenic), which partakes of tainted food (bread made with bad corn), which absorbs organic poisons (marsh fever, syphilis, tuberculosis, [and] goitre) [will beget] degenerate descendants who . . . rapidly descend to the lowest degrees . . . to idiocy [and] to dwarfishness . . . that the poisoning of civilized peoples continues and increases at a very rapid rate is widely attested by statistics . . . to these noxious influences, however, one more may be added . . . [This is] residence in large towns. The inhabitant of a large town . . . breathes an atmosphere charged with organic detritus; he eats stale, contaminated, adulterated food; he feels himself in a state of constant nervous excitement, and one can compare him, without exaggeration, to the inhabitant of a marshy district . . . the victim of malaria.[10]

Nordau's city-fever victims were pressed in upon by the same letters, newspapers, books, magazines, loud noises, and too quick machines that pursued Beard's genteel Americans. Once caught by these modern conventions, Nordau's first generation died in a quiet frenzy of heart disease and nervous exhaustion, but not before it had raised and nourished a second generation of congenital hysterics. Some of these were bound to shrivel into idiots by their fifteenth birthdays. Others became criminals, lunatics, or artists. Those that became Impressionist painters filled canvases with shifting points of color to approximate the wild quivering of their decayed eyeballs and the spastic transmissions of their degenerate optic nerves. Still others, who suffered from decayed brain centers, became either Realists, overcome by the pessimism of a premature old age, or Expressionists, caught up in the random chaos of associations, unable to think consecutively. Whether they wrote, painted, or composed, all of them were unable to accurately experience the outside world, and so, buried within a rotting network of decayed nerve endings, they suffered egomaniacal frenzies.

In this way, by the end of the century, the cities had been overrun with neurasthenics and the land had been filled with sexual degenerates. The streets and the machines and the conveyances and the clocks compressed time, intensified experience, and gave no pause. Creatures in the cities grew tired and sank into convulsions in the middle of their naps. In the country, syphilis bred poverty, and loneliness filled the silence with dirty jokes.

Where was there to go? Back to the cities that filled their theaters with degenerates wildly applauding the seizures of madmen or the rantings of lunatics? Back to the land that had driven the best away, and turned the worst into contorted piles of flesh? The equations were too brutal; the differences too empty. Between 1900 and 1911 the social philoso-

[9]Max Nordau, *Degeneration,* "Author's Introduction."
[10]Ibid., pp. 34–35.

phers made their choices the way a man who's just lost his leg looks for his shoe.

In November 1901, L.H. Bailey, a professor at the New York State Agricultural College at Cornell, wrote an essay to explain to his subscribers in New York, Boston, Philadelphia, and Washington what his new magazine, *Country Life in America,* stood for.

> We would preach the sermon of the out-of-doors where men are free. We would lead the way to the place where there is room, and where there are sweet, fresh winds. We would relieve the cramped and pent-up life [of the city] with visions that everyone may have for only the trouble of opening his eyes. . . . To the person who resides permanently in the country, we would give him a broader view and a closer intimacy with what he has . . . we would put him into harmony with his environment . . . we believe we have an economic and social mission. The cities are congested; the country has room. We should check the influx into the cities by opening the eyes of the countryman to see the country . . . the abjectly poor live in the cities. No one starves in the country.[11]

The more Bailey wrote, the more delicious and magical it became: "The ideal life is that which combines something of the social and intellectual advantages of the city with the inspiration and peaceful joys of the country." Did he mean the inspiration experienced by the Jukes? Did he mean the peaceful joys of the state of Kansas? Had he forgotten all the social advantages that Beard had talked about, and all the intellectual brilliances of Nordau's brain damaged artists? Somehow Bailey had forgotten it all; he and his staff, with their model farm and greenhouses, imagined a land covered with palatial estates, farmed by "countrymen" like Levi P. Morton, who had made so many trips to the hog trough that he'd been elected governor of New York and appointed minister to France by President Garfield. By the second issue, Bailey had made farming a way for city men to spend useful and enlightening vacations, and had turned abandoned farms into weekend retreats from the "temptation and stress" of modern life. By the third issue, there was a picture of "the Noble Hacienda of Mrs. Hearst, in one of the Valleys of the Coast Range," and by the fourth, photographs to provide "a glimpse of Skibo Castle. How an Eminent American Lives Across the Sea— The Scottish Home of Andrew Carnegie." Nine months after it had begun, *Country Life in America* advertised real estate in Cuba at the same time that it advised its readers that the "real solution of the agricultural problem . . . is to give the countryman a vital, intellectual, and sympathetic interest in the things with which he lives. Genuine nature-study will do more for him than mere technical agricultural training. Agriculture must be spiritualized."[12]

Nine years later, Bailey had begun to change his mind. In 1908, he had served as chairman of President Roosevelt's Commission on Country Life, and had listened as hundreds of men and women talked about their lives in the dozens of country schools that housed the commission's hearings. They told the commission about large corporations that paid no taxes and monopolized mining, transport, merchandizing, and manufacturing; they complained on and on that the cities sent nothing but tramps and hoboes and trouble. They told about how they were robbed by land speculators,

[11]L.H. Bailey, *Country Life in America* 1, no. 1 (November 1901): 24-25.

[12]Ibid., pp. 24-25; vol. 1, no. 2, p. 59; vol. 1, no. 9, p. 113.

and kept from their streams and forests by developers. They talked about saloons and typhoid and hookworms and patent medicines. The men complained about filthy slaughterhouses, long hours, and bad food. The women talked about monotony, drudgery, and an early old age.

Bailey listened to it all, and after the commission had made its own recommendations about railway rates, water pollution, temperance, and the social responsibilities of the country church; after it had written about Scientific Agriculture, extension stations, the drudgery of farm wives, and the monotony of hired hands, Bailey wrote his own book. It is a long book, full of recommendations, but at its center is one of the clearest visions of the American land that any man had had since the Civil War. For Bailey understood

> that one of the greatest insufficiencies in country life is its lack of organization or cohesion, both in a social and an economic way. Country people are separated both because of the distances between their properties, and also because they own their own land. . . . There is a general absence of such common feelings as would cause them to act together unitedly. . . .[13]

In spite of this, Bailey believed the Country had evolved a unique civilization, separate and superior to that of the City. While the city bred men who were so refined that they believed in such vague things as brotherhood and utopian world-politics, the country bore men who were so rugged and practical that they put their faith only in their own two hands and their trust only in the politician who'd look them in the eye. Above all, the farmer was a steady, conservative, and law abiding provider who believed in the eternity of the land, the sanctity of family enterprise, and the inheritance of a farm passed faithfully from generation to generation. Unlike the parasitical men of the city who believed in nothing but the quick profits of speculative corporate enterprise, the men of the country comprised the naturally balanced middle wheel upon which the entire nation rested.

Bailey's central judgment may have been more acute than any that preceded it, but he still did not understand that the men who farmed raised wheat and corn and cattle and hogs for essentially the same market as the men who mined ore, cut timber, milled cotton, and rolled steel, and that both varieties of men were driven by the same beliefs to pursue the same ends. For forty years, men like Dugdale and Blackmar had drawn constant but confused analogies of erotic degeneracy between farm and city. For just as long, men like Beard and Nordau had tried to quarantine modern-life disease to the city, even though it was no more and no less a disease than the private ownership of the means of production, the fetishism of commodities, and the presence of surplus value. In 1901, Bailey, who was a professor of agriculture, believed the land could and should be turned into a vast sanatorium for city-fever victims, but by 1911, one year after the fourth edition of *The Jukes,* he claimed to have discovered a Country Civilization, severely faulted, but nonetheless distinct from the venal and parasitical speculations of city life. In this way, over a period of forty years, an analogy between city and country life was implied, denied, and then transformed into an illusory choice between distinct civilizations. It is this imaginary choice, put under a walnut shell and pushed about the table like a pea for sixty years, that makes us even now believe that there is somewhere else to go.

[13]L.H. Bailey, *The Country Life Movement in the United States,* p. 97.

By now, anyone would have a right to wonder what actually happened eighty years ago: the men burning houses and barns and horses so that for ten years and more the countryside was an inferno of revenge, broken by a fifth season of arson. The tramps who packed guns and overran whole towns. The old men who went mad with jealousy. The old women who jumped down wells. All those mothers: the ones who carried their children into rivers, and the ones who fed them arsenic and strychnine so that, if they had to die, at least it wouldn't be of epidemic disease. All those women who purified and punished themselves with kerosene and matches. All the men who cleansed the putrescence of their lives with carbolic acid. All the others who killed themselves with the same insecticide they'd used on potato bugs.

Do you recall? The hypnotists. The hydrophobes. The somnambulists. The tireless inventors of perpetual motion who tried to conquer time as if it were a disease. The doctors who went to heaven, and the railway men who saw ghosts along the tracks. The farmers who saw monsters pull squealing pigs into lakes, and the others who accused their neighbors of witchcraft. The men and women who received messages from the dead in their dreams, and the sick and injured who believed electricity was the elixir of life. All those suicides, like litanies, like mechanical refrains, like the repetitions of a machine. The stories of salvation and religious insanity. The accounts of berserkers who kept their villages at bay. All the wildmen who howled, naked in the winter nights. Do you wonder about the florid obituaries and the funeral association notices? Have you forgotten the rapt attention payed to coffins broken, bodies preserved, and people buried alive. Did you keep count of the epidemics of smallpox and diphtheria and typhoid and meningitis that no invention of prayer or perpetual motion could prevent?

What was it? How was it? What more? There was money and all its diseases. There were rich men who founded dynasties that lasted thirty years, only because their sons tried to outdo them and speculated so wildly that they went bankrupt, and only because their daughters couldn't part with either their money or their memories, and so died alone or barren, full of cancer. There were the mothers and fathers, husbands and wives, who withdrew to their bedrooms, scouting at night to discover the filthy and wasteful disorder that they knew surrounded them. There were the hermits who refused to touch the fortunes that awaited them in Chicago, and the misers who buried thousands in lard buckets and woodpiles. There were the poor farmers who killed themselves because of guilt and suspicion, and the inheritors of fortunes who wrapped dynamite around themselves and stepped out on the smoking platform. Do you remember the bankruptcies and all the accounts of failure? The arson for the insurance, and the industrial sabotage for back pay. The mayors and the judges who died in poor farms. The imbeciles pursued by children, and the tramps frozen and in fever. What did it mean that well-to-do farmers could afford to hang and shoot themselves and hired girls always poisoned them with paris green?

Here is a different kind of information about either the state of Wisconsin or the county of Jackson or the town of Black River Falls between 1890 and 1910:

In 1890, the median population for counties in Wisconsin was 19,121. By 1900, it had increased to 23,111. Between 1890 and 1900, the size of an average county increased by 23 percent. In 1890, Jackson County had a population of 15,797. Thus, in 1890, it just barely resembled that group of medium-sized counties whose populations ranged from 15,682 to 23,211. By 1900 Jackson had grown in size to 17,466. This was an increase of only 10 percent.[14]

Between 1890 and 1900, the population of the town of Black River Falls had decreased by 14 percent. Only three other comparably sized towns registered such a loss (Chippewa Falls, Chippewa County; Alma, Buffalo County; and Altoona, Eau Claire County). Between 1900 and 1910, the population of Black River Falls simply stopped growing.[15]

During this time, Jackson's population was both more rural and more dispersed than the population of the state. In 1900, 63 percent of Jackson's families lived on farms compared to 40 percent of the state's population. Between 1890 and 1900, the average number of people per square mile in the state increased from 31 to 38. Between 1900 and 1910, it jumped again to 43. In 1890, there were only 16 people per square mile in Jackson, and in 1900, there were only 18. Between 1900 and 1910, this number decreased to 17.[16]

In 1895, there were 2,028 farms in Jackson County. Their principal crop was oats, as it had been in 1890 and would be in 1910. By 1906, there were 2,439 farmers in the county. There were also 1,770 farm laborers, 486 general laborers, and only 6 lumbermen and raftsmen. Even though in 1900 there were 23 percent more people living on farms in Jackson County than lived on farms throughout the state, by 1910, the county had 2 percent fewer farmers than it had had four years earlier. Of the 2,382 farmers in the county at the end of 1910, only 2,087 of them actually owned the farms they worked.[17]

In 1900, 24 percent of the citizens of Jackson County were foreign born. Half of them were Norwegian, the other half consisted mainly of Germans and Swedes.[18]

In 1891, the total assessed value of all property in Jackson County was $2.2 million. During the next eight years, property values grew by a mere 3 percent. However, between 1900 and 1902 they suddenly quadrupled to total nearly $9 million. By the end of the decade, values had grown by another $1.3 million.[19]

The sudden growth that occurred between 1900 and

[14]*Wisconsin Blue Book,* 1890, pp. 406–7; 1900, pp. 162–63; 1901, p. 490.
[15]Ibid., 1900, p. 133; 1911, p. 102.

[16]Ibid., 1900, pp. 196–97; 1911, p. 101.
[17]*Biennial Report of the Secretary of State,* 1896, p. 367; Office of the Secretary of State, *Tabular Statements of the Census Enumeration,* 1906, pp. 386–89; *Wisconsin Blue Book,* 1911, p. 112.
[18]*Wisconsin Blue Book,* 1911, pp. 180-83.
[19]*Biennial Reports of the Secretary of State,* 1891–1910.

1902 and that was more or less sustained for the next ten years was based on real rather than speculative values. Consider these examples: In 1899, the town of Merrillan had 98 horses; in 1902 it had 406. In 1899, the town of Albion had 1,420 head of cattle; in 1902 it had 3,022. In 1899, Springfield had 64 wagons and carriages; in 1902 it had 381. In addition, within this two-year period, land values doubled or tripled in every town but Black River Falls.[20]

There are four pieces of data that are difficult to reconcile with this record of economic revival. The first is that during the two-year period of growth at the turn of the century, the total value of all personal property in Jackson County actually decreased from $2.3 to $2 million. The second is that during this same period, the number of inmates in the county poor farm grew from 14 to 21.[21] The third is a marked increase in the county's rate of insanity within five years of its sustained economic revival, and the fourth is a slight increase in the county's rate of suicide within this same period of time. Both of these rate increases will be elaborated.

In 1900, one out of every 472 inhabitants of Jackson County was certified as insane. In that same year, an average of one out of every 400 inhabitants of all the other counties of the state was so certified. These ratios of insanity to population changed throughout the years. In 1901, the county's ratio was 1:448 compared to the state's 1:412. In 1903, the county's was 1:426, while the state's was 1:385. Here are a few of the other ratios for some of the other years throughout the decade: 1904: county ratio of 1:406; state ratio of 1:373. 1905: county ratio of 1:418; state ratio of 1:394. 1906: county ratio

of 1:419; state ratio of 1:455. 1907: county ratio of 1:400; state ratio of 1:373. 1908: county ratio of 1:366; state ratio of 1:359.[22] Only in 1906, four to five years after the actual end of the great depression of the nineties, did the county record a greater rate of insanity than did the state. Unfortunately, numerical data are insufficient for such comparative studies of state and county rates before 1900.

During the years 1903–1904, Jackson County's suicide rate was .8 per 10,000. For the next six years it hovered somewhere between 1.1–2 per 10,000. Even though these slightly higher rates indicate a somewhat greater frequency of suicide, they were nevertheless identical to the state average.[23] Unfortunately, numerical data are again insufficient for a comparative study of the rates of suicide before 1900.

Between 1890 and 1910, 121 people from Jackson County were committed to the State Hospital for the Insane at Mendota. Seventy-eight of them were men; 43 of them were women.

The records of 54 of these people have been preserved. Thirty-eight of these case histories, as well as 6 additional histories from the years 1887–88 were considered to be of sufficient clinical detail to merit study.

Of these 44 case histories, 16 (approximately 34 percent) displayed symptoms that are now described as paranoid. The projected fantasies of these patients concerned their neighbors, crops, cattle, or money.

Of these 44 case histories, 31 were of men, 13 of

[20]Jackson County Board of Supervisors, *Official Proceedings,* 1899, 1903.
[21]*Biennial Report of the Secretary of State,* Jackson County Board of Supervisors, *Official Proceedings,* 1903.

[22]*Wisconsin Blue Books,* 1903–1909, "State Institutions."
[23]State Board of Health, *Reports,* 1903–1910.

women. Approximately 40 percent (or 12) of the men displayed paranoid symptoms.

Eight of these 44 patients (17 percent) were severely depressed due to the death of a child or spouse, or because of a debt or unrequited love.

All but one of the 44 men and women were described as poor farmers, laborers, or housewives.

That is, 51 percent or 24 of the 44 patients whose case histories were judged of sufficient detail to be studied displayed symptoms that the examining physicians either partially attributed to or described as related to socioeconomic conditions.

In addition, among the 20 other patients: there was one case of alcoholic poisoning, 3 cases of epilepsy and brain damage, and one case that the examining physician attributed to typhoid fever. Two young men, one of whom displayed paranoid symptoms, were considered to have been driven insane by masturbation. Two other men behaved in a manner that would today be labeled as catatonic-schizophrenic. Five patients (3 women, 2 men) were described as manic. The mania of one of the women was said to be hereditary.

There is a single meaning that runs through those figures and through the understandings of the social philosophers, as well as the anecdotes, literary excerpts, and newspaper accounts that preceded them. What follows is a discussion of that meaning.

By the end of the nineteenth century, country towns had become charnel houses and the counties that surrounded them had become places of dry bones. The land and its farms were filled with the guilty voices of women mourning for their children and the aimless mutterings of men asking about jobs. State, county, and local news consisted of stories of resignation, failure, suicide, madness, and grotesque eccentricity. Between 1900 and 1920, 30 percent of the people who lived on farms left the land. They fled. Not as refugees, but as pilgrims. In spite of all the disease and all the poverty, they remained Platonists who believed America to be an idea. They held to their faith only because of the fantasied existence of early twentieth-century cities.

In comparison to the country and its towns, these cities had the appearance of life without end. They were filled with an almost heavenly radiance of change and refreshment. These cities were symbols, occasions, and places of choice. The people who lived in them were believed to be free to choose when to be private and when to be public, when to be known and when to be unknown, when to be intimate and when to be aloof. It didn't matter that some of the cities were filled with immigrants as vulnerable as the poorest farmers. It didn't matter because such people were foreigners; they were unreal; they were nonpeople whose vicissitudes were identified with the very strangeness of their natures. The country people knew that the cities were theirs and would receive them. They believed them to be places of refuge. They felt them to be filled not so much with jobs and running water as with magical devices that could overcome and perhaps even eliminate fate. Such devices are now called roles and special-

ized responsibilities, and are thought to be sources of alienation. In the 1890s, they were experienced as ways of liberation.

In the middle of the nineteenth century, Marx said that an ideal natural state would be characterized by a man's ability to do one thing in the morning, another in the afternoon, and a third in the evening. Marx implied that this would lead to happiness. By the end of the nineteenth century in America, it had led to despair and exhaustion. The country people left the land because they could no longer bear its crushing responsibilities. The things that crushed them have already been mentioned, and will be elaborated later. For now consider the many things that the anonymous strangers of a city could do for someone who was exhausted of doing everything: those strangers, those anonymities, could slaughter animals in a secret place, butcher them, prepare them, cook them, and serve them, all for a small sum of money which, once presented, obligated the bearer to nothing more than the satisfaction of his appetite. The same strangers could fill the streets with constant spectacle and movement, and so imply by their hurry that there was still some place to go, some goal to achieve, some purpose to serve, and some opportunity to take. Others of these strangers were capable of secretly preparing entertainments and, without warning, of presenting them with no thought of any reward but a sum of money which, once presented, obligated the witness to do nothing more than enjoy himself. There were still others who presided over places called hospitals which, again for nothing but a sum of money, would contain all disease, conceal all suffering, shelter all frailty, dispose of all death and mortality. Others of them filled newspapers with gracious drawings of handsome young men and angelic young women whose immortal fresh-

ness guaranteed that the products they advertised could provide to anyone an ease, a grace, and a mastery unimagined. Still others of these strangers employed anonymous men to constantly change and redecorate countless streets and buildings, so that it seemed that nothing was left to grow old and bear the marks of time. In this way, the strangers of the city provided refreshment and entertainment, change and renewal, hope and mastery in return for nothing but money.

The people who left the land came to the cities not to get jobs but to be free from them, not to get work but to be entertained, not to be masters but to be charges. They followed yellow brick roads to emerald cities presided over by imaginary wizards who would permit them to live in happy adolescence for the rest of their lives. By leaving the land, they disavowed a certain kind of adulthood whose mature rewards they understood to be confusion and bereavement. By going to the emerald cities, they chose a certain kind of adolescence forever free from frailty, responsibility, and death. It is this adolescent city culture, created out of the desperate needs and fantasies of people fleeing from the traps and tragedies of late nineteenth-century country life, that still inspires us seventy years later.

It may be that in comparison to the country, the cities were unreal places. But consider the realities, the alternatives and the rewards offered by the country.

In return for being a woman and bearing children, the country offered fatal epidemic disease. These diseases not only killed children but created a state of mind that Robert Lifton, in his book about the victims of the Hiroshima bombings, has called survivor guilt. Such guilt has already been discussed in the introduction: it results from a grotesque and

sudden inversion of the natural order of death which leaves the parent to survive the child. In the presence of such disease, death, bereavement, and guilt, the countryside had elaborated a lengthy ritual of mourning that began with a florid public obituary, proceeded through a funeral designed to provide public witness and participation in the mourners' grief, and continued with the distribution of photographs of the dead prepared for burial. This ritual permitted the grieving parents to express and then accustom themselves to the irreversible facts of their children's death. By permitting them to be comforted by the whole town, it made them understand that no one was blaming them for their loss. Even so, it was inadequate. Although it could comfort, it could not cure. It could neither restore the dead to life nor protect others from dying. The regularity of such newspaper obituaries, accounts, and reports may even have created a greater sense of doom. While some were comforted, others, overcome by foreboding, killed themselves and their children so that they might at least master the time and conditions of a death that seemed inevitable.

In return for being a man of ambition, the countryside offered economic dependency and vulnerability. Such vulnerability has already been mentioned in the introduction and has been elaborated in the newspaper accounts and numerical data. Since rural and country town culture was primarily an elaboration of secular Calvinism and Smithian egoism, a man's success and a man's failure were judged to be reflections of his soul. When confronted by such a judgment, many men committed suicide.

In the 1890s, newspaper reports made distinctions between suicides that resulted from insanity, that is, suicides whose motives were imaginary, and suicides whose motives were real, suicides that resulted from old age, incurable disease, unrequited love, the death of a spouse, the loss of a child, or the loss of a job. In the 1890s, there were apparently a wide variety of unimaginary, very real reasons for a man to do away with himself. Such reasons were reported and described not only to console desperate people with the reminder that, since they could still read about someone else's misfortunes, they were still alive, but because such acts of self-destruction were assumed to be as horrendously ordinary as bank failures or smallpox epidemics. Today, a suicide is never reported and its motives never described because everyone assumes that there is no good, objective reason for anyone to do such a thing. Today, public health officials actually believe that if a potential suicide would just take the trouble to pick up his phone and call a prevention center, he could be talked out of his ill-considered opinions. In the 1890s, a man was offered no imaginary hope that he could be charmed from his despair by a few well-placed words of sympathy or perception. Rather, the newspapers reminded him that quite a few others, perhaps even people he'd met, had taken two from two long enough to know that their remainder was always zero, and that his problem had nothing to do with his opinions or attitudes, but with the conditions of his capture at birth.

If a man didn't kill himself or if a woman didn't murder her own children, the countryside had other things to offer them to pass the time. In particular, it offered two varieties of personality, two forms of psychic identity. One of them was associated if not with prosperity, then at least with gentility, if not with dominion, then at least with success. The other was associated with pure and simple failure. The character type of genteel success is now described as obsessive-

compulsive. The character type of failure is now called paranoid. Both were models of adult behavior, one apparently promising, the other apparently threatening. With luck, one could become an admirable obsessive-compulsive; without it, one could hope only to be a miserable paranoid. Unfortunately, to an adolescent, the "goodness" of compulsive behavior must have seemed as self-destructive as the "badness" of paranoia. To a man or a woman young enough to choose, both must have seemed equally faulted ways of dealing with the passive vulnerability, anxiety, guilt, and suspicion that characterized country life at the end of the nineteenth century. To a man or a woman old enough to *have* to choose, such alternatives must have seemed as uninviting as the devil and the deep blue sea. Those who refused to choose left for the cities, hoping that there the alternatives could be made to disappear. Those who stayed and chose could look forward to the following:

Paranoia, according to Erik Erikson, may originate in the early anal projective stage of psychosocial development. This is a stage characterized by fantasies of flooding and swamping figures of authority with love or hate. Paranoia may also result from an even earlier state of basic mistrust. That is, it may result from emotions intensely experienced during the early oral as well as the early anal stage of development. During the oral stage, the infant either trusts that his mother will feed him the right thing, in the right way, at the right time, because she understands his needs, or he mistrusts his mother because he is passively vulnerable to her indifference, inability, uncertainty, or hostility. If, as the infant matures, his mother should also fail to encourage in him a sense of willful and righteous autonomy so that he is confident that he can retain and eliminate intimate bits of himself in an approved manner; if the infant's mother should punish him severely for the mistakes of his muscles or reward him inconsistently for his successful mastery of them, then his sense of mistrust will be strengthened by serious doubts as to the goodness of his mother's true intentions. That is, during this period the infant may begin to believe that his mother is intent not on training and nurturing his will, but on breaking it. If the infant should resolve the conflicts between self-will and self-doubt (shame) more in favor of mistrust and self-doubt, if he should come to feel that the world, as personified by his mother, is not only inclined toward but capable of overwhelming his precious self with such things as the unrelieved anxiety of hunger and the shame of isolation, he may, in later life, become extraordinarily, even unnaturally, suspicious of certain people and situations that recall in him his earliest states of helpless dependency and passive vulnerability.

If R. D. Laing's arguments, based on the tape transcripts he presents in *Sanity, Madness, and the Family*, have any truth in them, then paranoia must not be understood to originate from hints and inferences so subtle that they are perceived only by minds made morbidly sensitive by earlier encounters which they have subjectively elaborated into superstitious fantasies. Paranoia must be understood to at least partially originate from actual encounters with the outright lies and barely disguised hostilities of parents and figures of authority.

In this way, the paranoia attributed to those men from Jackson County who were committed to the Mendota State Asylum between 1890 and 1910, and whose case histories were considered of sufficient detail to warrant study—

their paranoia may be understood as an ordinary, adaptive reaction to suddenly extraordinary circumstances. Those men from Jackson County who began to suspect their friends, neighbors, relatives, and circumstances suspected them rightly in so far as they suddenly understood a truth they had never before imagined. This truth was that there was a real difference between what was said and what was done, between what you saw and what you got. Once they realized that someone up there hadn't made a mistake, that they were poor and destitute for none of the good reasons they always believed to apply to such circumstances, then they understood that someone was lying to someone else. The truth that 40 percent of the men committed from Jackson County understood and shared with all those other people the local papers said had suddenly shot up their towns or gone after their friends for no good reason—that truth was that, contrary to what President Lincoln or President Grant or President McKinley had said, contrary to what the sheriff or the schoolteacher or the immigration official had implied, contrary to what everyone of any political, economic, or moral consequence had claimed, the socioeconomic system of the United States was not only just as bad as a side show shuck, it was worse, it was a trap. They'd been told to work hard, take orders, and hold their breath. They'd been promised respectability and a roof over their heads. All they got was a lot of gossip and a mortgage—if they were lucky. Those farmers in poor circumstances first went crazy because they were ashamed. Then they went even crazier because of the shock of understanding that that intricate webwork of friends, neighbors, officials, purchasing agents, rivals, relatives, creditors, and dealers didn't exist to help, sustain, and encourage them,

didn't even exist to give them a good run for their money, but actually conspired to rob them blind, strip them naked, and steal the pennies off a dead man's eyes. Paranoia was the clear vision the countryside offered its failures.

The alternative to paranoia was obsessional thinking and compulsive behavior. Obsessive-compulsive behavior resembles paranoia in that it is a response to intolerable states of subjective and objective anxiety, hostility, or despair. Also like paranoia, it derives its logic and energy from the anal stage of infantile psychosexual development. Erikson would claim that obsessive-compulsive behavior is the result of the infant being made to severely doubt his autonomous ability to choose how and what is right or wrong to treasure or deny in himself. In this way, an early failure of self-will and self-control would later be revealed by such symptoms as unvarying, orderly rituals of procedure, overdefining of boundaries and categories, overstructuring of sensory, emotional, or informational input, inability to undertake or understand any "meaningful" activity except in terms of its goal, and an entrancement with all or nothing, in or out, either/or choices.

Freud spoke of the anal stage of psychosexual development as that period in which the infant introjects the moral implications of his ability or inability to control his sphincters, and from which may arise adult obsessions with cleanliness, orderliness, efficiency, neatness, and regularity. He characterized an adult anal personality as obstinate, stingy, and perfectionist. Others have described such a character as constantly compelled to manipulate ideas, objects, and people as if they were excreta. Freud further spoke of impulses to collect and preserve such things as stamps or money as characteristics of the anal ego.

Wilhelm Reich described obsessive-compulsives as living machines whose intellectual, emotional, and physical reactions were of almost mechanical rigidity. Neo-Freudians have further identified the constantly focused concentration and singleness of purpose of obsessive-compulsives as resulting from a fear of being overwhelmed by their own inadequately repressed impulses. While the object of a normal will is most often an external other or thing, the object of an obsessive-compulsive will is often the internal self. That is, an obsessive-compulsive may so fearfully separate himself from himself that he will often issue orders, reminders, and warnings to himself as if he were charged with disciplining a particularly unruly and uncivilized criminal.

A person who is afraid of being overwhelmed by fantasies resulting from inadequately repressed anal impulses lives in horror of those physical or metaphysical empty spaces in whose far reaches live the barely secret temptations that will make him lose all control. A person obsessed by anal fantasies will indulge in compulsive acts to avoid, disguise, or fill such empty spaces of threatening imagination. Obsessive fears of uncontrollably injuring oneself, one's children, one's friends, or one's relatives—fears which may have originated in enforced, vulnerable passivity or in unconsummated desires for revenge—may result in compulsive acts of withdrawal and avoidance. Obsessional ideas that repeatedly intrude upon consciousness may result in compulsive silences lest the silently droning word, phrase, or idea be inadvertently pronounced. Obsessional images that repeatedly and vividly appear in the mind's eye may result in compulsive blindness or sensitivity to light lest the violent, sensual, or scatological pictures actually be seen. Obsessional rumination may result in compulsively quantified rituals lest the prolonged, inconclusive thoughts of impossible or fearful events go on forever. Obsessional fears of death and decay may result in compulsive washing, tasting, and looking, or in compulsive gestures, labeling, or counting, all of which are rituals to preserve the moment from imminent disaster.

Because elements of obsessive-compulsive behavior were so deeply incorporated as ways of survival into the daily lives of the people who lived on farms or in country towns at the end of the nineteenth century even the florid exaggerations of truly compulsive activity or obviously obsessional thinking were rarely considered indications of madness. There were the hermits who had withdrawn muttering about their enemies, and the wildmen, dressed in skins, howling gibberish. There were the old misers who sat behind boarded windows, keeping their money safe. There were the men and women who left their bedrooms only at night and only then to make certain that nothing, absolutely nothing was out of place. There were the suicides who killed and cleansed themselves with fire or carbolic acid. There were the men who stuffed and collected animals, living creatures transformed into things, and other men who spent their lives trying to defy death and time with perpetual motion. Here and there were women who refused to speak and men who had been miraculously cured of their blindness. Everywhere were Norwegian immigrants who kept the chaos of an Anglo-Saxon world at a distance with strict and cleanly rituals of orderliness. Everywhere else were the Yankees who didn't drink, rarely swore, tried not to smoke, went to church, and cut down the wilderness as if it were a hateful strangeness, whose self-contained, empty, otherness threatened them. It was these Yankees, the ones who believed in constant work, constant money, and constant accumulation who raised daughters who so much

believed in the tight perfection of their parents that they never married. It was these Yankees, the ones who believed in goals and control, who raised sons who indulged in such shortsighted speculation that before they'd gone bankrupt, they'd exhausted the land whose generosity had been the only source of their wealth, and whose health was the only guarantee of their future.

Paranoid behavior was always quickly eliminated by commitment to an asylum since its violent aggressions and florid accusations could disrupt a community already trapped between a lengthy depression and recurrent epidemics. However, obsessive-compulsive behavior was tolerated since it resulted in such activities as silent withdrawal, eccentric ritual, or ceaseless labor, none of which were disruptive, most of which were harmless, and some of which were economically productive. Paranoia and obsessive-compulsive behavior resulted from the same grim realities. Both were forms of behavior that sought to master childlike feelings of helpless panic re-created by the inhuman, amoral fluctuations of a market economy and by the equally inhuman ravages of epidemic disease. Such terrifying realities were first communicated to the infant through the fretful touches and anxious admonitions of a mother, and the moral exhortations and repudiating punishments of a father. They were later recalled by the matured individual in the presence of such simple things as sudden unemployment and early death.

Bibliography

The *Badger State Banner* is on file in the Microfilm Reading Room of the State Historical Society of Wisconsin, Madison. The asylum records are on file in the Medical Records Library of the Mendota State Hospital, Madison.

Bailey, L. H. *Country Life in America*, vol. 1, nos. 1 and 2.
_____. *The Country Life Movement in the United States*. New York: Macmillan Co., 1911.

Beard, George. *American Nervousness*. New York: G. P. Putnam & Sons, 1881.

Blackmar, Frank. "The Smoky Pilgrims." *American Journal of Sociology*, vol. 2, no. 4 (January 1897).

Cable, Mary. *American Manners and Morals*. New York: American Heritage Publishing Co., 1969.

Chapin, John B. *A Compendium of Insanity*. Illustrated. Philadelphia: W. B. Saunders Co., 1898.

Chetik, M. "The Therapy of An Obsessive Compulsive Boy." *Journal of the American Academy of Child Psychiatry*, vol. 8, no. 3 (July 1969).

Coke, Van Deren. "Nineteenth Century Photographers at Work." *Creative Camera* (1970).

Deutsch, Albert. *The Mentally Ill in America*. New York: Columbia University Press, 1949.

Dugdale, Robert. *The Jukes: A Study in Crime, Pauperism and Disease*. New York: G. P. Putnam & Sons, 1910.

Erikson, Erik. *Childhood and Society*. New York: W. W. Norton & Co., 1963.
_____. *Youth, Identity and Crisis*. New York: W. W. Norton & Co., 1968.

Evans, Richard I. *Dialogue With Erik Erikson*. New York: Harper & Row, 1967.

Feifel, Herman, ed. *The Meaning of Death*. New York: McGraw-Hill Book Co., 1965.

Foucault, Michel. *Madness and Civilization*. New York: Pantheon Books, 1965.

Gard, Robert, and L. G. Sorden. *Wisconsin Lore*. New York: Duell, Sloan, & Pearce, 1962.

Garland, Hamlin. "A Day's Pleasure" and "Up the Coulee." In *Main-Travelled Roads*. New York: Signet Books, 1968.

Goodwin, D., S. Guze, and E. Robins. "Follow-up Studies In Obsessional Neurosis." *Archives of General Psychiatry*, vol. 20, no. 2 (February 1969).

Hjer-Pederson, W. "The Compulsive Personality Type." *Acta Psychiatrica Scandinavica*, vol. 44, no. 2 (1968).

Hurd, H., and W. Drewry, *et al. The Institutional Care of The Insane in The United States and Canada*, vols. 1 and 3. Baltimore: Johns Hopkins University Press, 1916.

Jackson County Board of Supervisors, *Official Proceedings*, 1899, 1903.

Kovel, Joel. *White Racism: A Psychohistory*. New York: Pantheon Books, 1970.

Laing, R. D., and A. Esterson. *Sanity, Madness and the Family*. Middlesex: Penguin Books, 1970.

Lewis, Sinclair. *Main Street*. New York: Signet Books, 1961.

Lifton, Robert J. *Death in Life*. New York: Vintage Books, 1969.

Masters, Edgar Lee. *Spoon River Anthology*. New York: Collier Books, 1962.

Nordau, Max. *Degeneration*. New York: Howard Fertig, 1968.

Pickford, R. W. *The Analysis of an Obsessional*. London: Hogarth Press, 1954.

Rachman, S. "Treatment of an Obsessive-Compulsive Disorder by Modeling." *Behavioral Research and Therapy*, vol. 8 (November, 1970).

Reed, G. F. "Some Formal Qualities of Obsessional Thinking." *Psychiatria Clinica*, vol. 1, no. 6 (1968).

Roth, Nathan. "Some Observations on Obsessive Compulsive Behavior." *American Journal of Psychotherapy*, vol. 6, no. 1 (1952).

Shapiro, David. *Neurotic Styles*. New York: Basic Books, 1965.

State of Wisconsin. *Biennial Report of the Secretary of State*, Madison, 1891–1910.

————. *Blue Books*, Statistics of Population, Madison, 1890–1911.

————. *Blue Books*, "State Institutions," Madison, 1903, 1905, 1907, 1909.

————. Board of Health, *Report*, Madison, 1902–1904; 1904–1906; 1906–1908; 1908–1910. Wisconsin State Historical Society, Government Documents.

————. Department of Collections and Deportations, County Bills, Madison, 1893–1910.

————. Department of Health and Social Science, Division of Mental Hygiene, "Staff Assignments, Community Mental Health Districts," September 1, 1970.

————. Department of Public Welfare. *Wisconsin State Prison, Prisoners Descriptive Record*, 1870–1889, Registration nos. 587–4645; Wisconsin State Historical Society, Archives, no. 42/3/22, vol. 2.

————. Office of the Secretary of State, *Tabular Statements of the Census Enumeration*, Madison, 1906.

Stone, Michael H. "Cultural Factors in the Treatment of an Obsessive Hand Washer." *Psychiatric Quarterly*, vol 4, no. 4 (October 1970).

Vanderbilt, Paul. Official Correspondence, Department of Iconography, Wisconsin State Historical Society. Letter to Editors, *Life Magazine*, File no. OA67391 (12,13/65).

Walker, Valerie, and H. R. Beech. "Mood State and the Ritualistic Behavior of Obsessional Patients." *British Journal of Psychiatry*, vol. 115, no. 528 (1969).

Wescott, Glenway. *The Grandmothers*. New York: Atheneum Publishers, 1955.

Williams, James M. *Our Rural Heritage*. New York: Alfred A. Knopf, 1925.

————. *The Expansion of Rural Life*. New York: Alfred A. Knopf, 1926.

Willner, Gerda. "The Role of Anxiety in Obsessive Compulsive Disorders." *American Journal of Psychoanalysis*, vol. 28, no. 1 (1968).

ABOUT THIS BOOK

CHARLES J. VAN SCHAICK (1852–1946) began his photographic business in Black River Falls, Wisconsin, in 1885 and continued as town photographer for fifty-seven years. The 30,000–40,000 glass-plate negatives known as the Van Schaick Collection were acquired by the Jackson County Historical Society after his death. Dated about 1885–1915, it consists of Van Schaick originals and the work of two other photographers—C. R. Monroe and N. L. Ellis, traveling photographers who went around the area with wagons, rather than operating studios. From that collection 2,238 plates were selected by Paul Vanderbilt, Curator of Iconography at the State Historical Society of Wisconsin, in 1958. The 140 or so images that Michael Lesy has chosen for this book are drawn from that selection. Using images and words from the local archives, Michael Lesy has fashioned an exciting new approach to history, a book that shows us the other side of the American past, a haunting and brilliant perception, reminiscent in some ways of the experiments of the early surrealist film makers, of the unknown aspects of our life that psychohistorians are only beginning to explore.

In Michael Lesy's own words, "This book is an exercise in historical actuality. It uses photographs as if they were events, and the words of newspapers, novels, madhouse records, and recollections as if, taken all together, they were the carbon, hydrogen, and oxygen molecules of a single, solitary minute of time and air. The book relies upon various photographic, cinematic, and audial conventions to re-create and re-vision a past time so separated from the present by the cunning sleights of the fearful memories of one human lifetime, that to recall, reveal, and re-create such a past is as difficult as driving a tunnel through a granite mountain to the sea."

Michael Lesy was educated in Ohio and then went on to get his degrees from Columbia and the University of Wisconsin and his doctorate from Rutgers. He held a Woodrow Wilson Fellowship at Rutgers and was able to combine his work as a photographer and an historian, in this book, which was accepted by Rutgers as his Ph.D. thesis. He is now teaching at Hampshire College in Amherst, Massachusetts.